EDWARD HICKS

Alice Ford

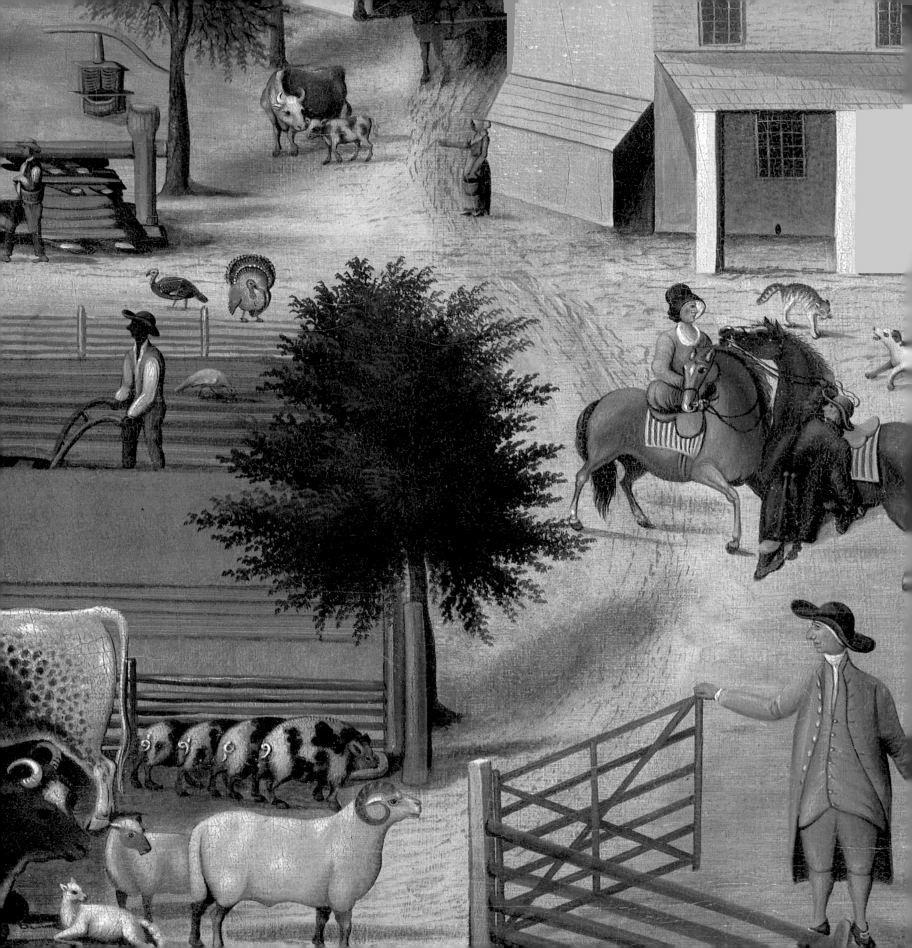

Alice Ford

EDWARD HICKS
His Life and Art

Abbeville Press · Publishers · New York

Editor *Walton Rawls*
Designer *James Wageman*
Picture Researcher *Sarah Kirshner*
Copyeditors *Don Goddard, Alison Mitchell*
Production Manager *Dana Cole*
Production Editor *Robin James*

Library of Congress Cataloging-in-Publication Data

Ford, Alice, 1905–
 Edward Hicks, his life and art.

 Bibliography: p.
 Includes index.
 1. Hicks, Edward, 1780–1849. 2. Painters—
United States—Biography.
1. Hicks, Edward, 1780–1849. II. Title.
ND237.H58F6 1985 759.13 {B} 85–15705
ISBN 0-89659-570-6

Contents

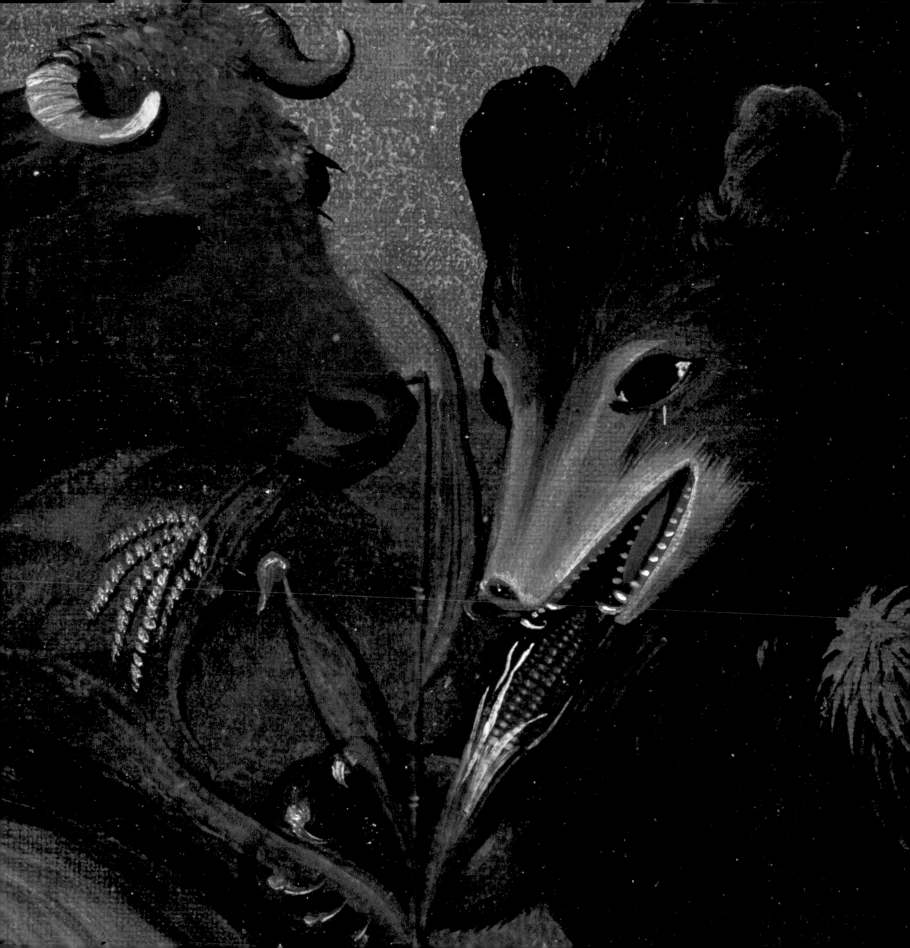

Foreword

Much of modern art is made with "found" objects of metal, glass, and wood, composed in expressive figures. The prophetic message of Edward Hicks was delivered with the aid of prints and book illustrations chosen at random, to attract to scriptural prophecy. If one sets store by definitions, the spectrum—especially that of genius—is "a series of images formed when a beam of radiant energy is subjected to dispersion and brought to focus." The "beam" of Hicks was of a mystical order blessed with the exercise of power over the beholder through what appears, at first glance, to be a jigsaw or collage of sometimes recalcitrant figures.

Many more of his landscapes have surfaced since first I wrote about him. Heretofore unknown sources of inspiration now emerge, the discovery of which increases rather than diminishes his astonishing achievement. Letters previously undiscovered help to draw the struggles and antithetical forces of man and artist into a deeper perspective. The long quest and its rewards are the stuff of this book, written that they may be shared and bring new understanding of the place of the painter in the mainstream of tradition.

Two centuries have passed since the birth of the Friends minister who is now regarded as one of the best of all untrained painters. Yet it is as if the hiatus between his death in 1849 and the earliest recognition of

The Peaceable Kingdom
(detail), c. 1844.
Oil on canvas,
24 × 31¼ in.
Photo courtesy Sotheby,
Parke, Bernet, Inc.

his gifts in the present century had never existed. Until about the year 1952 his paintings had been acquired only by the few. Today his landscapes hang in more than two dozen of the nation's leading cultural strongholds—north, south, east, and west—from coast to coast. They fall to museums and connoisseurs for sums once undreamt of . . . undreamt of, that is, in the days when I was greeted each morning by a *Peaceable Kingdom* at the top of a flight of stairs in the Brooklyn Museum. That work was seminal to my venture into the wider world of American folk art, published in 1949, before I wrote the first book about the painter a year or two later.

Edward Hicks was by no means unrecognized in his own time. How the local newspapers hailed his painted signs a little before his death will be seen. In 1880, the leader of the first Quaker Sunday school in Bucks County, Doctor Lettie Smith, wrote a paper on his ministry and talents. She remembered the frail little Friend from her childhood as "tall." Two years later the Bucks County Bicentennial exhibition included a few of his landscapes. But from then on his self-styled "monkey's art" went into eclipse.

His debut in the second decade of the present century was a wry one. The connoisseur Harold Eberlein included a landscape chimneypiece, or fireboard, in his *Practical Book of Early American Arts & Crafts* (1917), the bible of collectors. The charming *Peaceable Kingdom*, painted when Edward Hicks was about forty-five, was dropped from subsequent editions. The scathing dismissal of it was repeated. "Frankly hideous, clumsy, and grotesque folk art," forgivable only for its "sincerity," wished on it by the Friends. Its "insufferably bored" lion, "phlegmatic fatling," and "truculent" wolf that looked "daggers at the lamb and leopard" amounted to no more than a "chêf-d'oeuvre of grotesquerie," unworthy of "the name of art." To Eberlein it appeared that in the Hicks version of Trumbull's *Declaration of Independence* one of the signers had lost a leg to another who seemed to have three.

Seven years later critical perspective began to change. The Whitney Studio Club showed landscapes by Hicks in a small exhibition held in New York City. But the bellwether was an exhibition at the Museum of Modern Art in 1932, *American Folk Art: The Art of the Common Man* (1750–1900). In an introduction to the catalogue, Holger Cahill, moving spirit of the event, wrote the first scholarly appreciation of the coach painter. The exhibition was immediately succeeded by another of the kind at the Newark Museum under the direction of Beatrice Winser, who acknowledged the guidance of Cahill.

The purchase of a *Peaceable Kingdom* in 1934 was the occasion for an elucidation of the landscape that hangs in the Worcester Museum. What Louise Dresser said of it in the *Bulletin* remains a model of truth to what Hicks himself said of it, by inference, in a sermon delivered at Goose Creek Meeting, Virginia, in 1837, and published in 1851.

A year later the National Committee on Folk Arts in the United States held the first one-man exhibition of the artist. A quarter of a century afterward the first retrospective, directed by Mary C. Black, paid an impressive tribute in Colonial Williamsburg (1960). The collection of paintings by Hicks at the Abby Aldrich Rockefeller Folk Art Center in Williamsburg remains the largest.

The numerous paintings by Edward Hicks bequeathed by Edgar and Bernice Chrysler Garbisch to the National Gallery of Art, Washington, D.C., are representative of the best of his career. They become, at last, the treasure of all the people of his beloved "young Republic."

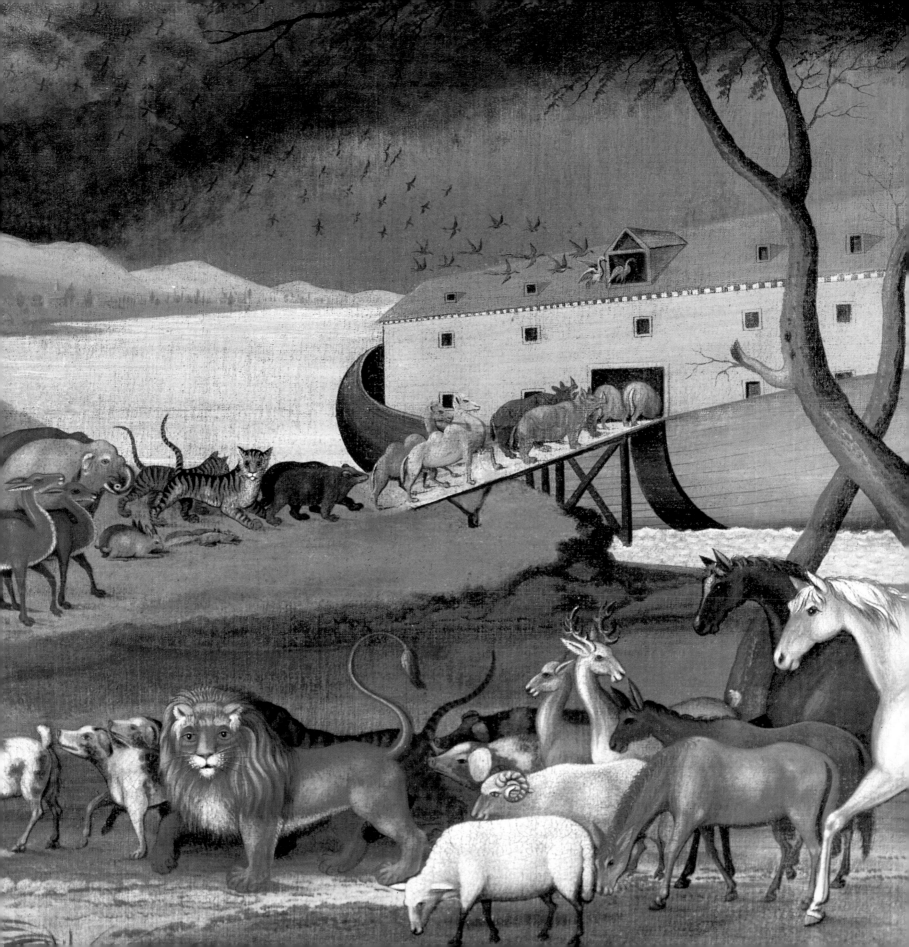

Noah's Ark *(detail), 1846.*
Oil on canvas,
26½ × 30½ in.
Philadelphia Museum of Art,
bequest of Lisa Norris Elkins

Acknowledgments

To four great-grandchildren of the artist—Hannah Hicks Lee, Cornelia Carle Hicks, and the brothers Robert W. Carle and Edward Hicks Carle—I owe abiding gratitude for faith in efforts that began in their lifetime. They shared letters and memorabilia. To their aunt Sarah Worstall Hicks, steward of the family papers and paintings, I remain deeply indebted, although we never met. Most graciously, her grandniece Eleanore Lee Swartz reopened the collection for review and offered perceptions of value. Her cousin Edward Richardson Barnsley, Bucks County historian of note, cannot have forgotten how he guided me through the maze of court and historical society records in Doylestown, as well as to the old books and documents of the Newtown Library Company. His scholarly articles for the now silent *Newtown Enterprise* enabled me to familiarize the reader with the Leedom and Cornell families and their farms of the famous landscapes.

For the provenance of certain paintings by Hicks and indeed for introducing me to a certain few, I am beholden to Eleanore Price Mather and Dorothy Miller, and their recently published catalogue raisonné. To Mary C. Black, who presented the first retrospective exhibition of Hicks for the Abby Aldrich Rockefeller Folk Art Center, and to Peter Brown, Beatrix Rumford, Carolyn J. Weekley, and assistants of Colonial Williamsburg, I am grateful.

To James E. Ayres, Esq., Director of the John Judkyn Memorial Museum, Bath, England, all who study the art of Hicks will remain indebted for his having discovered the source of *The Falls of Niagara* and *The Natural Bridge of Virginia* that appear in the *Kingdom*s. During my own pursuit I enlisted the aid of the American Antiquarian Society as a likely source, but in the end the cartouche found by Mr. Ayres was the prize.

Howell J. Heaney, Rare Book Librarian, Free Public Library, Philadelphia, opened the way to exceptionally rewarding research in the Rosenbach Collection of Children's Literature. Robert F. Looney, Head of the Print Department, also guided my efforts. J. B. Post, Map Librarian, facilitated my search for the Tanner atlas that held the cartouche. (The venerable Library Company, Philadelphia, owns a presentation copy inscribed by Tanner, and other rare references that advanced my searching.) Catherine Stover, Archivist, Pennsylvania Academy of the Fine Arts, shared her expert knowledge. So, too, did the Library of the Society of Friends, London, and the Arch Street Friends Meeting, Philadelphia, Miss Helen J. File, Director.

Nowhere in Philadelphia did I engage in more research than at the Historical Society of Pennsylvania, James E. Mooney, Director, at intervals beginning in 1949. Roy E. Goodman, Reference Librarian, American Philosophical Society, Philadelphia, repeatedly responded to my quests. The library of the Academy of Natural Sciences, Philadelphia, through one of its rarest and most beautiful volumes, advanced the cause. Friends Historical Library, Swarthmore, its directors—Frederick B. Tolles, his assistant Dorothy Harris, and their successors J. William Frost and Albert W. Fowler—entered the long research train early and late, and importantly. The Spruance Library of the Bucks County Historical Society at the Mercer Museum, Doylestown, Terry A. McNealy, Library Director, has been of the essence from the outset. Mark Osterman of Yardley and the George School, Newtown, rescued an important Hicks family Bible for posterity.

The National Gallery of Art and its Department of American Paintings provided indispensable information. Mrs. Russell Quandt, United States Library of Congress conservator, gave me the benefit of her late husband's technical knowledge as well as her own. Also, in Washington, D.C., the White House and the State Department provided photographs of several paintings. The National Archives held the secret of the missing passport of Thomas Hicks (concerning whom, in New York City, the National Academy of Design assisted). Mona L. Dearborn

of the National Portrait Gallery aided my pursuit of questions raised by the portrait of Andrew Jackson.

A public presumed largely unaware of the role of conservancy in its service to the paintings of Hicks, and others, will share in my appreciation of the fascinating lines contributed by Caroline Keck. Sheldon and Caroline Keck are master conservators.

The University of Virginia, Charlottesville, through its Alderman Library, Rare Book Department, Science Library, Washington Papers, and Fiske Kimball Library of Art and Architecture, was a vital source during the 1970s. Mrs. Pauline Myles Page, of its Photographic Services, deserves my thanks. During my residence in that city, the librarians Philip Williams and Doris Frantz of the Central Library of the Jefferson-Madison Regional Library responded countless times to my needs.

The Museum of Fine Arts, Boston, the Department of American Paintings, gave me the history of the portrait of Washington by Thomas Sully. The Worcester Museum, Worcester, Massachusetts, was an early contributor of information.

The Henry Francis du Pont Winterthur Museum, Wilmington, Delaware, and its staff assisted; Dr. Frank H. Sommer III, Librarian, was more than once a gracious cicerone.

I am indebted to the Rush Rhees Library of the University of Rochester, New York, for the privilege of quoting the published journal of Mathias Hutchinson.

At the instance of Sir John Pope-Hennessy, former Director of the British Museum, London, Reginald Williams, Esq., of the Department of Prints and Drawings contributed significantly. Dr. Christopher White, Director of Studies at the Paul Mellon Centre for Studies in British Art, London, lent fruitful advice. The Royal Academy of Arts, London, Miss Constance-Anne Parker, Librarian, conducted a search for one of the more elusive lion models, which, however, remains at large. The Tate Gallery, London, Mrs. J. Egerton, Research, corresponded to my advantage. Ralph Hyde, Esq., Keeper of Prints at the Guildhall Art Gallery (City of London Libraries), helped me come to grips with the fresco and print of the *Happiness* engraving.

A clue in *American Prints* (New York Public Library, 1933) as to the possible link of Major (later Lieutenant Colonel) Edward Hicks led me to consult the curator Scott Robeson, Esq., of the Nova Scotia Museum, Halifax, and also the Public Archives, Ottawa. Elizabeth Roth, Keeper of Prints and Drawings at the New York Public Library, responded to many queries, as did the Genealogy and Local History Rooms, the Rare Book

Room, and the Picture Collection. How richly the library of the General Theological Seminary, New York City, served my pursuit of family history will be seen. Across the bay the Staten Island Historical Society was informative, as was the Long Island Historical Society across the East River.

Deserving of special mention is the Galerie St. Etienne, New York City, which shared three letters that shed important light on certain mysteries, now nearer solution.

Those museums, galleries, and collectors whose cooperation was essential to the illustration of this book are recognized throughout this volume.

To my friend Alan Brady, photographer, I remain beholden in more ways than one; perhaps most of all for precious glimpses of old Newtown. To Norman C. Kitchin whose collection of nineteenth-century photographs of Newtown and the county—presented to the George School for its archives—I am also thankful. Harriet Ermentrout and Elizabeth Mayer do honor to what has become a flourishing art tradition in Newtown.

The following persons are also entitled to honorable mention: Mr. Theodore Barash; Mr. and Mrs. Robert H. Bartels; Mr. and Mrs. James R. Blackaby; Mr. and Mrs. Robert Carlen; Miss Elizabeth Carroll; Mrs. Mary Denman Capouya; Mrs. Daniel Collins; Mrs. Dorothy Shulze Edson; Mr. Russell Ferguson; Miss Francis C. Ferris; Professor Bliss Forbush; Mr. Charles Hamilton; Mrs. R.V. Hennessy; Mr. Asa Moore Janney; Mr. Wilbur H. Johnson; Mr. Thomas Lainhoff; Mrs. Shirley Payne Low; Mrs. Lucretia Mott Mammel; Mr. and Mrs. J. Irwin Miller; Miss Denise McColgan; Miss Grete Meilman and Miss Martha Richardson; Mrs. Margaret Bye Richie; Mrs. John D. Rockefeller III; Miss Anne-Marie Salgat; Mr. Clifford Schaeffer; Mr. Eugene Sussel; Miss Edna Sweely; Professor David Tatham; Mrs. Lillian Tonkin; Mrs. Charles H. Torongo; Miss Dorothy Twahig; Miss Bailey Van Hook; and Mrs. Helen Whitelaw.

Walton Rawls, editor of this book, and his assistants Sarah Kirshner and Alison Mitchell were its first friends and its lightships.

The charming new research rooms of the Newtown Historic Association in the Old Court Inn, Newtown, will aid others as it did me in an eleventh-hour inquest.

Finally, the centuries-old Temperance House of Newtown, in one of whose upper chambers I transcribed the Hicks family letters, will please take a bow.

EDWARD HICKS

Childhood and Youth

*E*lizabeth Lewis Twining carried her Bible out of her farmhouse into the sunshine. Seated in the shade of a young white elm she read aloud in a sweet solemn voice to her foster child Edward Hicks, aged seven. He himself was only beginning to read. She had not learned to read or write until the age of twelve. For all the wisdom of their favorite Book of Matthew that she so lovingly imparted, and for much more, the little boy would remember her as innocent as a child and "truly above rubies."

That such a tender bond should have existed between Edward and his keeper, David Twining, then sixty-five and fifteen years his wife's senior, it would be idle to imagine. The child was not his own but the son of Isaac Hicks, whom he had known for many years. Twining had also known Isaac's father, Gilbert Hicks, who had been the chief justice, or prothonotary, of Bucks County, Pennsylvania, before he was forced to flee the county seat of Newtown and his residence four miles south in the village of Four Lanes End at the start of the Revolution. He died a fugitive in Nova Scotia. Isaac Hicks also fled, having risen from clerk of the colonial court in Newtown to an appointment—at the eleventh and futile hour—to four Crown commissions, expediently conferred on him after the untimely death of his uncle William Hicks. When Isaac returned from recently British-occupied New York City, a widower with

The Residence of Thomas Hillborn *(detail)*, *1845*. *Oil on canvas,* *23⅝ × 31⅞ in.* *Abby Aldrich Rockefeller Folk Art Center, Williamsburg, Virginia*

three young children, his hopes of regaining office as a freeholder and respected citizen of Newtown and Bristol were frustrated by contempt on the part of former friends.

What happened to Isaac's children on his return from exile was this. Gilbert, ten, became the lodger and pupil of the Presbyterian minister James Boyd. Eliza Violetta, five, was accepted by one Catherine Heaton. Meanwhile, three-year-old Edward, puny and tearful, tagged along with his late mother's sixteen-year-old black servant girl Jane while she went from place to place for work by the day. It was at the farmhouse of Thomas Janney east of Newtown that Elizabeth Twining saw the forlorn infant and heard that he was the child of "Kitty" Hicks, whom she had known. Margaret Thomas, daughter-in-law of Gilbert and cousin of Isaac, had loyal friends among the Twinings and others of a rural Friends Meeting near Newtown. They were one day to welcome her upon the death of the dissolute Joseph Hicks, father of her seven children.

The House of Thomas Janney.
Drawing by Elizabeth Mayer

It did not take Isaac Hicks long to act on a hint from Jane. She had overheard Elizabeth Twining—mother of four daughters—exclaim that if her husband would have him she would take the baby Edward. He carried the boy the scant mile to the Twining farm and returned alone. That evening he wrote in his ledger: "David Twining in account with Isaac Hicks for board.g youngest son, 1783, June." The solution was an ideal one. The Quaker, whom Isaac had known when Twining was a member of the Provincial Assembly, bore him no ill will, having adhered to his pacifist principles during the Revolution. Twining's sympathies had become clear enough when he played cordial host to Brigadier General William Alexander, the officer second in command under General George Washington. This self-styled "Lord Stirling" (whose title the Scottish House of Lords refuted) and his ways the Twinings had not forgotten. However, just before—and immediately after—the Battle of Trenton, General Alexander occupied the fine house of the Justice family in town.

There were more reasons for Isaac to be pleased. Twining would set a fine example. He was a self-educated, cultivated man. His copy of *Essay Concerning Understanding* by Locke was the first volume of thirty-five for which he had had a bookcase built, to serve the town. His farm was the birthplace in 1760 of the Library Company of Newtown, the third oldest in Pennsylvania. "Twining was one of those extraordinary men . . . upright and dignified either as pillars of the church or sinews of the State," Edward Hicks wrote of him.

When the time came for Isaac to call for his "little weak boy" and apprentice him to coachmakers in Four Lanes End, Twining was near death. At this time Edward's brother Gilbert was working as an intern in Bristol for James De Normandie, son of the doctor John De Normandie, who had been a partner of Judge Gilbert Hicks in real estate ventures. Eliza Violetta was attending the Newtown female seminary and doing herself credit. She alone of the three children had just been remembered in a will, by a cousin, for the sum of fifty pounds sterling, while Edward, not yet twelve, was about to face the world in a state of poverty and bewilderment. Of these he was never to be quite free.

Only lately Isaac Hicks had written in desperation for the intervention of a cousin, Thomas Ricke of New Windsor. His plea was about to bear fruit after he argued that, as the son of an esteemed colonial justice whom he had served, he was the "most suitablest person" for one of three county offices that had become vacant in Bucks County. "I am poor and I am proud and wish still to be above the durt." His admission that he had "dwindled to nothing" helped win him the office of surveyor.

Henry and William Tomlinson agreed to allow their new apprentice time enough from duty to finish grammar school during his first year with them, though Isaac considered his son unsuited to "scholastic learning." By that time he had changed from timid to witty and spirited in the hail-fellow-well-met company of the young mechanics with whom he worked. His "natural fund of nonsense" soon made him used to the "low slang and vulgarity" around him. Indeed he had become happy enough, and a favorite, at about the time his father announced his marriage, at Christ Church, Philadelphia, to Mary Gilbert, widow of Edward Young. Moreover, William White, who with Samuel Seabury was called the first Episcopal Bishop in America, had officiated at the wedding. (The two clerics had been ordained together in London after the Revolution.) Isaac could say proudly to White that the late Mary Hicks Seabury was the daughter of his late Uncle Edward. Just outside the south portal is a long marble slab, engraved with the name of Isaac's aunt (the letters now invisible), and close by her lie six signers of the Declaration of Independence: "In Memory of Violetta Hicks, the wife of Edward Hicks, who departed this life December 22, 1747." Ten years younger than Isaac and childless, Mary was not disposed to take a motherly interest in any of Isaac's children.

When the Tomlinson shop burned in the mid-1790s, Isaac refused to allow Edward to go to work as a "lackey, shoeblack, hostler and barkeep" in his masters' tavern. Among "rowdies" and adventurers bound westward, as well as carousing militia men whose martial music and parades he took to, Edward was bound to change. Had it not been for the good, sensible Mrs. William Tomlinson, his zest for excitement might have led to worse. But her resemblance (noted by Hicks in his *Memoirs*) to the women of *Proverbs* when death claimed her "dear little girl," and also her concern for his welfare, restrained him.

When the shop was again ready in the spring Edward was reunited with his mischievous mates and led off by them to apple "frolics" and spinning-bees, and finally onto "the broad way that leads to destruction." The years of adolescence "darkened round." Whenever a coach was finished the owner treated the apprentices to some tippling that led to Edward's "besetting sin," lewd talk and unruly passions.

By the time his apprenticeship came to an end in April 1800, the wiry, slight twenty-year-old was adept with paint and varnish but not strong enough to work as a wheelwright. For once his father showed concern enough to offer to pay down on a house for Edward that was owned by the Masons of Newtown. The Tomlinsons did all of the

coachwork for Newtown, and so kept him on for some months. "Weak, wayward . . . susceptible of strong and tender attachments . . . fond of society," he feared to take the advice of "respectable people" and gamble on his family's one-time importance. Instead, he hired himself out to Joseph Fenton, a doctor of Northampton township, for board, room, and ten dollars a year, to paint the house and help build a carriage designed by his employer.

Court Street, Newtown, Pennsylvania.
Photo by Alan Brady

The Fentons wanted him to join the Presbyterian Church and let them find him a suitable bride within their congregation. They knew that sweet, demure Sarah Worstall, a Quaker girl whom he fancied in Newtown, would not "marry out of meeting." Her father Joseph Worstall, a thriving tanner, would have put his foot down. That may have led Edward Hicks to make friends of the Quakers John Comly and James Walton at the debating society meetings in Attleborough, the new name of Four Lanes End. Comly thought he perceived something more than "a light airy disposition" in Edward. On November 16, 1800, he wrote in his journal: "The Divine Power at work in his soul is all-sufficient to give the victory." But that soul was not yet ready to resist the Saturday night amusements of Philadelphia. All he knew was that he was a far cry from the schoolmaster and farmer Comly, who was known to read the Bible when he reached the end of a furrow. But, while Edward persevered as "a witness" on trial, Comly took note of his "sobriety and seriousness."

After another lapse the prodigal returned to the uplifting meetings of the debating society. He borrowed serious books from the Library Company of Newtown, which was a stone's throw from the house of "Sally" Worstall. One can still see the name of "Ned" Hicks there, charged with the *Letters* of his hero Washington, and his favorite poets Cowper and Pope, among others—and even Voltaire, who nurtured his lively bigotry. He gave up membership in his volunteer militia regiment and his dress uniform, but not before enjoying one more frolic in the city. He returned so ill and remorseful that he ceased to sing hymns at home with the Fentons.

One Sunday he declined their invitation to come along to church once more. Instead he traveled to Newtown and south to Middletown Meeting, close to his birthplace. From then on he was present every First Day for worship. Lest there be temptation of the kind he had known in the shop of the Tomlinsons, he declined an offer from Joshua Canby, a Milford Quaker, of a coach-painting job. Between spells of weeping and praying at the Fentons' he continued to see Sally Worstall in Newtown, dressed in a new suit of Quaker gray, and to address her as "thee."

The question of which Quaker persuasion to follow remained, the evangelical Orthodox of Philadelphia or the provincial Hicksites, which better suited the country boy who hated things royal, and disliked ritual. What helped win him over to the Hicksites was the discovery that their leader, a Long Island carpenter, Elias Hicks, was his kinsman. Robert Hicks, a tanner who came over on the *Fortune* a year after the *Mayflower*, had a grandson, Thomas, who became first justice of Queens County,

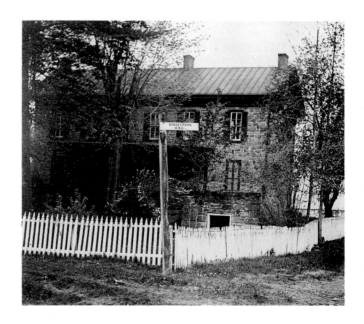

Harris Residence,
Headquarters of
General George Washington.
Late nineteenth-century photo
after a fire and some restoration.
Norman C. Kitchin Collection,
George School Archives,
Newtown, Pennsylvania

Joseph Worstall House,
Newtown, Pennsylvania.
Drawing by Harriet Ermentrout

Long Island, and a colonel in command of the militia. By his first marriage Thomas also became a Quaker and the grandfather of Elias. By his second he became the great-grandfather of Edward Hicks. All things considered, it was time to quit the Fentons for Canby in Milford.

Edward found comfortable lodgings with a Quaker family, the Hulmes. John Hulme lent him a copy of the apologetics of Robert Barclay, close follower of Friends founder George Fox, and assured him of the rightness of "humble industry." Hulme's son George knew all eight of the Worstall children and encouraged Edward to join the Friends, woo Sarah, and settle down. Rides to Newtown became more frequent. The fine red brick house of Joseph Worstall on Court Street was only yards away from that of Squire Isaac Hicks on State Street. An interesting bit of history was its having fallen to Worstall for twelve pounds sterling at a sheriff's sale after the Tories lost power. It was no mean honor to be courting the daughter of the man who had fitted Washington to boots.

In the spring of 1803, Edward Hicks and Sarah Worstall were much nearer a union. He was received into the Society of Friends at Middletown Meeting where, in November, they were married.

Mary Hicks was born in rented rooms in October 1804. To his everlasting sorrow, Edward borrowed in order to build a small fieldstone house on Oxford Street in Milford. From then on he was never to be free of usurers and the despair they caused him.

His conversion was neither forced nor expedient. If anything it was so intense as to be perfervid—apt to offend his Deist neighbors whose views he scorned, and offensive at times to Friends. He railed against activist support of Temperance and Abolition, calling both a matter of conscience, and moral issues—and not, he insisted, to be utilized by politicians. Beside himself when Middletowners refused to listen any longer, he threatened to withdraw to the Methodists. The mild little Sarah took a stand against forsaking her birthright for evangelism. One of her friends, a Quaker minister and fearless lady, took him to task as an "uncommonly dogmatical disputant." Her words drew tears but did not succeed in stilling the occasional uncontrollable outbursts. Hicks could not contain his fears of creeping orthodoxy among the Hicksites. Those fears neither he nor his fellow worshipers could allay.

With the passing of the years Hicks knew that, for him, silent worship was a yoke, a bridle, against a "solemn and awful desire" to proclaim the Christian message throughout eastern Pennsylvania. He was thirty, and the father of two more children. First, he had to prove his maturity, his capacity for silence. To remain seated and not to speak left him weak on one First Day, and on the next he gave free reign to "the cause of Christ" and his desire for ministry. His fervor brought Friends to their feet. He sat down, wept for a moment, then strode out of Middletown Meeting on something like a cloud of "tenderness, love and joy."

Joy was not the ordinary order of the day during that winter of little coachwork and many bills and dues. To raise cash, and with the wish to move his business to Newtown, he sold his house to Dr. John Mitchell of Bristol for $1,150 down and $500 payable within three years.

The red brick house close to the old Court Inn and the Worstalls' was for sale for $1,200 cash, a sum beyond his reach. He returned to Milford sick with disappointment. Next morning, First Day, he felt almost too despondent to attend Meeting. But something, his "inner voice," told him not to grieve. The cough—of Joseph Worstall, his brother-in-law, behind him—roused him from a quiet "sweetness." Afterward Joseph told him excitedly that the house would be his after all, for a down payment and a promissory note. But he would have to agree to accept the owner, widower Abraham Chapman, as a paying guest at two dollars a week for one year. In 1813, the lawyer would be moving to Doylestown, the new county seat.

War with England drew nearer. There was growing defiance of the

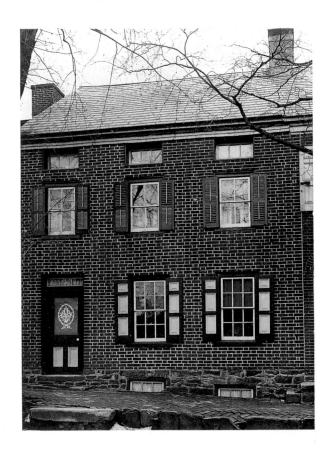

First house of Edward Hicks,
Newtown, Pennsylvania

Embargo Act by the marauding English and their coastal vessels. It was hardly a propitious time for a start in business. But, for Sarah, the return to Newtown before her confinement was a blessing. Although Gilbert Hicks was married and practicing medicine far off in Catawissa to the north, Eliza Violetta, wife of Sheriff Thomas Kennedy and mother of three young boys, was but a street away from the Chapman house. Beulah Twining Torbert had inherited the farm and was in full charge since the death of her mother. After a stormy divorce in the Supreme Court of Connecticut she had returned home. Her Meeting had taken her back into the fold. She and Edward Hicks had remained close, if less so than he and his favorite Mary Twining, wife of Jesse Leedom whose farm was west of Newtown.

Unlike most coachmakers, painters, and wheelwrights, Edward Hicks had no farm or tavern that would assure him of a steady income. His first year on his own, a trying one, was made no easier by the troubled state of the Society of Friends.

After the birth of Elizabeth he set out alone on horseback on his first missionary journey. He had borrowed again to make it possible. His preaching on the way to Wilmington Meeting drew praise. Until he arrived there he began to feel "something like a head and shoulders high." Then he caught himself echoing a sermon remembered, but given once by another, as if the words were divine inspiration. One rather cosseted English Quaker visitor whose sympathies were orthodox rather than, necessarily, with the "primitive Christians" took firm exception. Hicks resolved never again to drift into the words of another, a practice worse than borrowing money. But borrow he had, and would again, as an always unpaid minister.

Middletown Monthly Meeting acknowledged his "gift" and gave him permission to represent it, as a minister, at a Hicksite meeting in Philadelphia. He took his place in the minister's gallery but soon began preaching from the floor. The "rich, pompous merchant" William Sansom arose and told him to keep quiet. Stunned, Hicks donned his broadbrimmed hat and strode out. An elderly Hicksite ran after him and brought him back to the gallery, whereupon he apologized to all, but with the assurance that he was a newly recognized minister from Bucks. That did not satisfy three elders who followed him to the house of his host before the evening session to demand an explanation for his rash preaching.

Next morning he braved the Orthodox stronghold on Pine Street after a bad night and in "a state bordering on despair." When he arose to

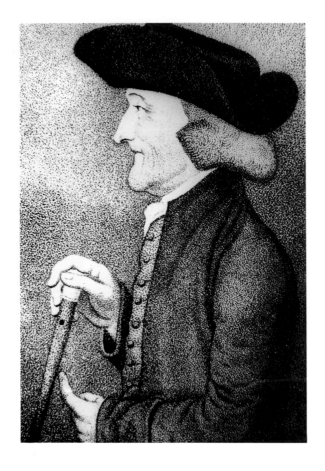

preach "in fear and trembling," the leaders, Nicholas Waln—"a lion" of an adversary—and Jonathan Evans—"a bear"—glared their contempt. Nevertheless, he left his mark on both camps in Philadelphia; and his report to Bucks Quarterly Meeting on his return home prompted it to have a condemnation of William Sansom posted in the Coffee House in Philadelphia.

Artist unknown,
Nicholas Waln.
Friends Historical Library
of Swarthmore College

Artist unknown,
Jonathan Evans.
Friends Historical Library
of Swarthmore College

Nowhere in his *Memoirs* does the name of Mary Gilbert, stepmother of the painter, appear. She died on February 22, 1812, and was buried in the cemetery at the rear of the already very old Presbyterian Church on Sycamore Street in Newtown. Her grave (like that of her husband Isaac) is among those now without headstones, but close to those of patriots and Hessian mercenaries who died in the church when it was used as a hospital.

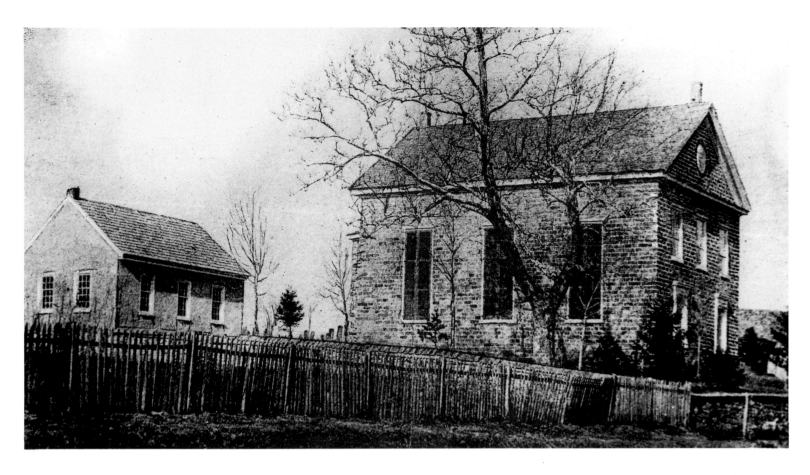

Old Presbyterian Church.
Photo c. 1892.
Photo courtesy
Norman C. Kitchin

During the first year of the War of 1812, Hicks waged a bloodless war of his own on a 165-mile circuit of preaching. That was, he mused, more than Jesus had traveled in his three years of wandering. Once on his way, he despised himself for fleeing "despair" and setting a bad example for his children by leaving them needy, while he himself was warmly received and praised. For despair there was reason enough. To satisfy his creditors he had persuaded Chapman, a Quaker, to assume the Milford mortgage and make the travel possible.

Again, on his return, he felt guilt over his "fondness" for sign painting, to which he applied himself with a will. It was gratifying, nonetheless, to receive fifty dollars each for elaborate signs ordered by John Hulme and Daniel Larrew. Neither sign is extant. Their designs are unknown. But "for painting the Pennsylvania coat of arms on a tavern sign," at the same time, he had the print of an emblem with spirited steeds to guide him. Cost, "$25."

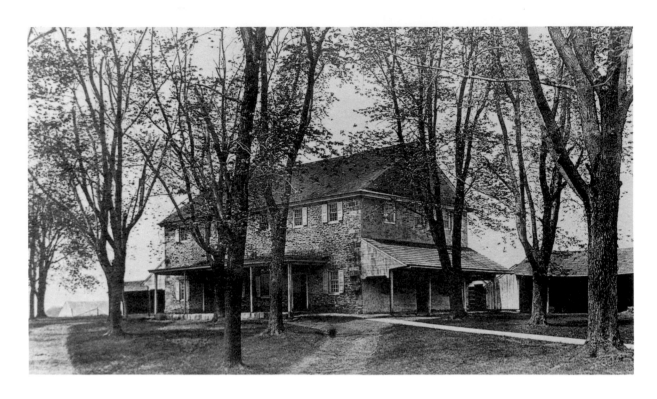

*Middletown Meetinghouse
(built 1793),
Langhorne, Pennsylvania*

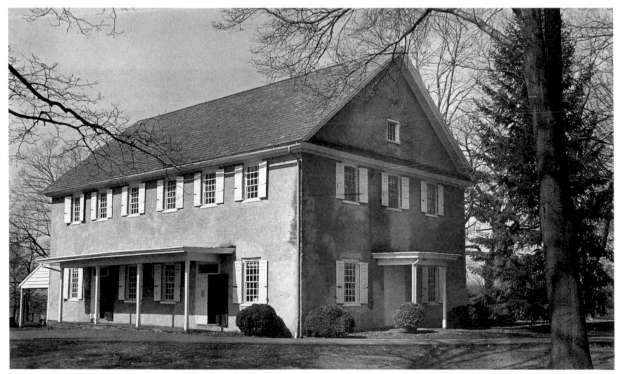

*Wrightstown Meetinghouse,
Wrightstown, Pennsylvania.
Photo by Theodore Barash*

On his next mission, in the spring of 1813, he went across New Jersey to Great Egg Harbor and vicinity. Stephen Comfort, a Quaker elder, accompanied him. Well received abroad, he remained an uncomfortable prophet in his own land—as he was made to realize, painfully, after he reported to Middletown Meeting. At a discussion called for by a dozen of its members, to hear him justify certain of his precepts, doubts of the validity of these caused him to resign.

By the close of the War of 1812 in December 1814, Hicks had only just begun his campaign for the Hicksite cause as a minister of Wrightstown Meeting north of Newtown. But on April 1, 1815, in the courthouse, which had stood empty for a year, he preached for the first worship service held there.

By another spring he was ready to try farming, a life more consistent with Christian living and much needed for the sake of the family. His father offered to let him farm his forty acres east of town for half a share, with the option, in due time, of buying the rest at eighty-six dollars per acre. Edward would have to pay the hired hands. He agreed. His coach painting and other artisan work were put aside for the first planting.

The harvest was a disappointment. The "farming speculation" showed a loss after Hicks paid his father and the wages.

Hicks's shop ledger—and it still exists—is barren of artisan work until 1817. Abraham Chapman gently reprimanded Hicks for turning his back on his shop: "Edward, thee has now the source of independence within thyself, in thy peculiar talent for painting. Keep to it, within the

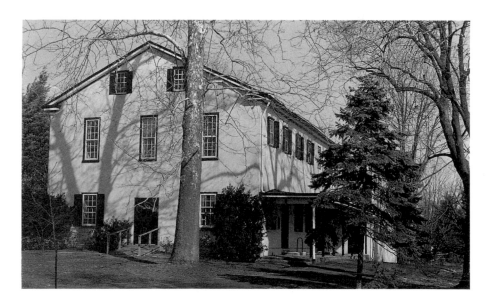

Newtown Meetinghouse,
Newtown, Pennsylvania.
Photo courtesy
Lucretia Mott Mammel

bounds of innocence and usefulness, and thee can always be comfortable." Hicks had no choice. For six straight days in May he advertised in the *Star of Freedom* for "Coach, Sign, and Ornamental painting: of all *descriptions*, in the neatest and handsomest manner." President James Monroe's "era of good feelings," and the widening of the nation's borders by sixty thousand square miles, gave reason for hope on all sides.

The paid notice horrified John Comly and James Walton. Comly hurried over from Byberry to protest such pandering to vanity when Edward should be preaching against it, and not risking his reputation as a minister. Hicks could only argue that, because his father's demands had ruined his start at farming, he would lose the roof over his head unless he did ornamental painting.

Comly was determined that his friend should not quit the "cause of truth." In June 1817 he took the bold step of approaching a retired, wealthy merchant cousin of Edward's (Isaac Hicks by name), after having made a futile attempt to raise money among local Friends with the aid of Walton. They neither knew nor dared ask how much was needed. All that was certain was the existence of debts no longer to be postponed. In the first of seven letters, Comly invited the Long Islander to help take care of this "very serious concern," involving the possible loss of a much needed and valuable minister tempted by the "forbidden tree." Comly said that the powers of darkness had already begun their mischief, as proven by the return home of Edward when a wheel broke on the way to meetings in New Jersey and on Long Island. Discouraged, Hicks gave up and resumed his painting.

Comly did not deny that his friend had "a native genius and taste for imitation which, if the Divine law had not prohibited, might have rivalled Peale or West." (In the absence of proof as to how deft Hicks had become by 1817 this statement is significant. An oil as crude and childlike as the *Peaceable Kingdom* at the Cleveland Museum of Art—attributed to Hicks and dated "*circa* 1820"—would not merit such high praise. The paintings of 1825 and 1826, the first dated ones, well might.)

Hicks admitted to "inconsistency" and to a "vain mind" inclined toward "contradiction." In fact, Comly confessed, the return to "ornamental painting" was done with "eagerness, and with such application" that Hicks was often "up till near 12 o'clock at night painting pictures." The balance of scruples against temptation appeared lost unless Friends were to step in.

The response of the master of the Andalusia estate in Westbury, Long Island, a practical man, was a call for more details. The head of a

Artist unknown,
Eliza Violetta Hicks, *n.d.*
Silhouette.
Newtown Historic Association,
Newtown, Pennsylvania

huge commission business in Manhattan was not easily spurred to hasty action.

Comly still dared not let Edward Hicks know what he was up to. To keep cousin Isaac happy, while he tried to find out for him how much Edward needed, he sent him a bundle of meeting minutes and proceedings. All he then volunteered was: "His plans are to pursue this very lucrative branch of his business for a time, hoping to clear $1,200 a year by it—a delusive dream!!—and then, when his debts are paid, quit it. This, he says, is the only way he can see to get along, while people require interest [payments]. . . . But if he could obtain money without hiring it he would gladly quit painting." Otherwise his ministry must be dropped—for painting—because he could not go on in his "tired state." Comly conjectured that the financial "embarrassments" came to about "two or three thousand dollars." Then he waxed bolder: "What would it be for Isaac and Samuel Hicks to loan their cousin such a sum, without interest, as would relieve him, set him at liberty to run on his Master's errands, unshackled, help him out of the deep mire of paint, and set his feet, through the blessings of heaven, on firm ground?"

Comly pointed out that Hicks was "thus bemired" by unwise expediency, but *absolutely not* by "extravagance and speculation." Hicks was still hoping to make his half-share of land bring in two hundred dollars a year to feed the family. He was sorry to have to add that, since the dedication of a new Friends meetinghouse in Newtown—at which he spoke inspiringly—Hicks would no longer break his silence.

The cousins temporized in a silence of their own without indicating readiness to contribute to the proposed fund of "one thousand dollars."

Unbeknownst to John Comly, Hicks traveled to Andalusia in June. He knew nothing about the drive to save him. The Long Islanders were more than puzzled that he said nothing as to his predicament or about his painting. Comly explained this by supposing that Edward's "tired state of mind" and his faint hopes of a decent harvest were behind his reticence. But he was not sure. Nor did he understand why, after Hicks had stopped to see him in August on his way to a quarterly meeting in Haddonsfield, New Jersey—and to tell about his trip to Andalusia—he did not return by way of Byberry. However, he soon found out. Hicks had decided to stop off for a meeting in Rahway instead, and, while silently praying, he was seized with a presentiment of evil. He hurried home but arrived too late for the funeral of Eliza Violetta Hicks Kennedy. His sister had drowned the day before while trying to rescue her six-year-old Edward from Newtown Creek a few yards below her house. Her husband saved the boy but nearly drowned in an unsuccessful attempt to rescue her.

Comly went at once to offer his condolences to the broken Hicks. He learned that Edward's house, buildings, and land were worth about $5,000, or so Edward thought. A usurer had offered to assume a mortgage and pay all debts, provided he could foreclose if ever payments lapsed. Comly begged Hicks to wait before giving up.

Again he importuned Andalusia. If there were "upwards of $100" a year, for interest payments, Edward could get on with his "active benevolence" as the "armour bearer of Elias Hicks." Thus his "precious gift" would not be thrown away. Comly was adamant: "I shall yet pursue the theme, for my heart feels for the trials and difficulties of my valued friend."

Daniel Comly, a brother, offered to match whatever sum the cousins might agree to contribute, provided Hicks would limit his labors to the painting of coaches and houses only. John Comly was about to leave for Westbury when a storm prevented him from doing so; he chose instead to write a letter. (He had no more than begun it when the mail brought more questions from Andalusia, anticipating what he was about to say.) First, Edward's estimate was mistaken. The "20 cleared acres," run-down house and lot, and four and a half acres east of town were worth about $4,100. The interest and debts came to five hundred dollars or so. Finally, Edward would have no part of asking his father to deed him the twenty acres and drop the merely "verbal contract." He refused on account of his father's "decline in years and in character." Then too, the land might have to be shared with his brother and sister and "other heirs."

In still another letter to Andalusia, Comly asked, "What then is to be done? Shall we let him pursue his chimerical scheme of extricating himself by ornamental or portrait painting, in violation of the scruples in his own mind, and in contradiction to the testimonies he has borne?" He was refusing to "give up to his creditors" and painting from necessity. "I fear you will never again see him . . . as a preacher of the gospel." But if more fortunate Friends would unite to "preserve his standing and usefulness in Society, and keep his character unblemished . . . and his mind clear and at liberty to attend to his Master's business," the crisis would pass over.

*E*dward Hicks began to sense that Comly's many questions had their origin in a scheme of some sort. He asked Comly to keep all that he had told him to himself and not "expose" his confidences. This put a stop to the quiet canvassing for help in Bucks County. The frustrated and piqued Comly again risked friendship with Andalusia by daring to write

that a Friend who could count "his thousands as we count hundreds or tens" was the only hope. He and Walton would gladly "plunge in" were it not for the danger of "drowning" financially if they did so.

Plunge in they did, through the dust and mud of Bucks County, when nothing arrived from Long Island. Comly was proud to report to Andalusia that they had collected more than half of the requisite sum, and that he and Walton would not give up until after one more round of solicitations. He rejoiced that Hicks was again "fishing" for souls whose "worldly concerns" hurt "public confidence in Quakers." Success brings more success. Samuel Hicks, the brother of Isaac of Andalusia, at once sent five hundred dollars. Isaac promised to pay the balance due on his pledge of one thousand. The last round by the two gallant Friends "through very muddy roads" brought in "about nine hundred dollars" in two days.

*B*y its very intensity, the return of Hicks to his ministry presented Comly with a new rash of worries. He had been exchanging differences with James Boyd, local Presbyterian minister, in the public prints. And to Comly's dismay he had been sending copies of the published letters to Elias Hicks of Jericho, Long Island. Lest Beulah Twining inform Westbury of this on her coming visit, Comly let Andalusia know. But those cousins apparently did not see eye to eye about the original problem. Robert, the son of Isaac, sent a mere eighty dollars and not five hundred in May. Comly acknowledged the sum with a subtle warning to "keep an eye single to the pointings and limits of the safe guide, Truth," amid "gettings and merchandising cares." Not only did this reprimand succeed, but it elicited from Isaac a promise to pay interest on debts yearly until all were satisfied.

Finally, Comly wrote the last of his many letters, to say with joy that his friend was finally out of danger and moving on "with renewed animation." He would keep to coach painting and serve the Lord by his "humble industry" for the sake of his higher calling.

It was at about this time that Hicks painted an appropriate sign for the Bird-in-Hand tavern, a place well known to his grandfather Gilbert in his day. The old adage of Benjamin Franklin had inspired a printed motif that the painter copied. The sign is long gone. The frame tavern has since become a dwelling, one of the oldest of its kind in Pennsylvania.

Painting remained a lifeline, a stringcourse, a bulwark against ceaseless anxiety and, at times, the threat of derangement. Hicks would seek a way to make it an instrument of the power of peace and love among more and more divided factions. He was, at any rate, ready to try.

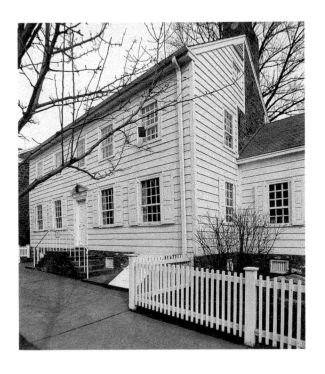

Bird-in-Hand Tavern,
Newtown, Pennsylvania
Photo by Alan Brady

The Mire of Paint

*F*ar from withholding his fall into what Comly perceived as "the mire of paint," Edward was to bring up the problem repeatedly in his *Memoirs*. "Harsh circumstances" were to blame. He decorated clock dials, oilcloth, floor-cloth coverings, chairs, tables, and an occasional sled or dog cart, all noted in his ledger. To Thomas Goslin, his young hireling, he left the more taxing and monotonous business of painting houses, sheds, and interiors.

The county and township responded to his advertisement of readiness to letter street and road signs—"directors and Index boards"—cut by a carpenter. He lettered black leather buckets for the volunteer firemen in his best Caslon style. At the time of Comly's first alarm he was apparently finishing a decorated chimneypiece, or "fire board" for Phineas Jenks, doctor, neighbor, agriculture expert. It brought forty dollars and an order for another for the physician's father, who also wanted a "landscape." Father and son were men of culture and secular taste, and, as patriots, not likely to have wanted to display a religious subject, a *Peaceable Kingdom* which, in any case, Hicks had in all probability not yet undertaken. If he had done so, how could Comly have raised such a fuss? The first Mrs. Jenks was the daughter of the hero General Francis Murray, and the second the daughter of Governor Simon Snyder. The Jenks house in the center of town was one of the finest.

The Peaceable Kingdom
of the Branch
*(detail), c. 1825.
Oil on wood fireboard,*
36¼ × 44⅞ in.
Yale University Art Gallery

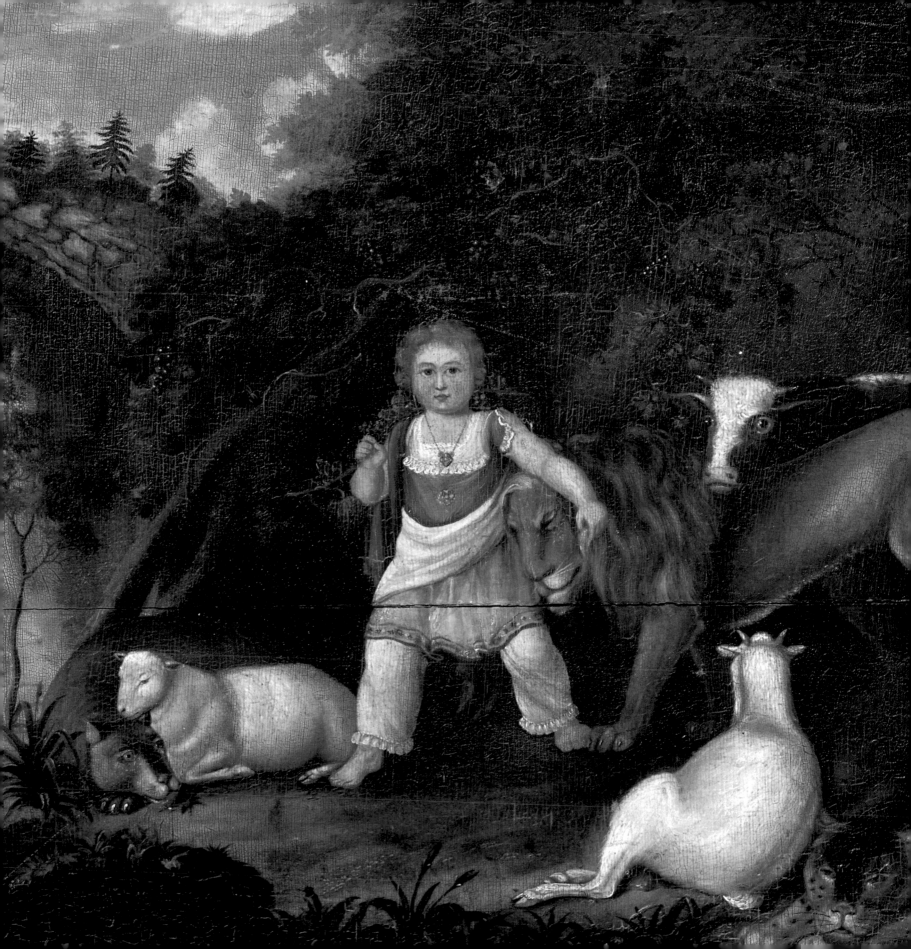

Toward the time of the last of the Comly letters to Andalusia, Edward Hicks painted another chimneypiece, a smaller one if judged by the more modest cost, twenty-five dollars. Then he sold three more "landscapes" for fifteen each, whether on wood or canvas the ledger does not say.

This new, expedient escape from poverty into the painting of landscapes, for which there was a demand, prompts at least a passing glance at the state of the arts in nearby Philadelphia. The Columbia Society that began in 1797 with high expectations soon died out. Six years later, on the day after Christmas, the Philadelphia Academy opened the first American art school for the "promotion and cultivation of the fine arts." Its aim was to turn youth away from "depravity of conduct" toward "innocent employment." Public subscription provided a building that opened in 1806. After the War of 1812 it held annual exhibitions that were meant to weed out the dilettantes and less talented students. Copying oils by both great and less gifted Europeans and sketching from casts of classical sculpture did nothing for the development of an independent, healthy American art. To imagine that there was anything in the rural experience of Hicks, from childhood onward, to steer him in the direction of formal instruction would be effete, specious nonsense. He was, in fact, constantly steered away from it. Nevertheless, art did touch his life, through the cult of the imitative art movement all around him. Even his last paintings continue to signal his dependence (although rather less so) on prints for the elements of his composition. If Jenks wanted a scene for his fireboard, chances are that he had to come up with a model for Hicks to copy. Not only Bible publishers but many others were hiring engravers to copy illustrations for their texts, and in a spirit not of plagiarism as we think of it, but of quid pro quo. Often the copies were copies of copies. John Singleton Copley, one of the country's first great painters, began by copying old-master prints.

Residence of Dr. Phineas Jenks,
State Street, Newtown, Pennsylvania

A consumptive cough had plagued Hicks for as long as he could remember. He was up and down during the winter of 1819 and unfit to paint if he had wished to. Sarah and the children were astonished by his announcement, in the spring, that "the Heavenly Shepherd" had laid a new "concern" on him to travel. He argued that a journey on horseback would do him good. This was the year, remember, of the 170th Anniversary of the Society of Friends. It was the time to go forth and follow the example of the founder George Fox and his disciples, especially Robert Barclay.

The Friends of New Brunswick, New York City, and Westchester County in New York state were treated to rousing sermons against the Orthodox "lions" and "leopards," to say nothing of the "bears." Hicks charged them with using those Quaker principles called "the Discipline" not as "a shepherd's crook" but as a sword against himself and Elias. He criticized visiting English Friends for "thundering out" against the good old rules, and for defending Protestant "theology" and Anglican "priestcraft." He dismissed them as "British lions." He blamed superfluous education and privilege, seeing them, perhaps, as the cause of the fall of his immediate forbears. He blamed the two evils on the supposed ways of "lawyers, doctors, office holders, speculators, lecturers, conjurers, and merely professional Christians." Of course there were exceptions to those "busy bodies," such as his devout brother Gilbert. Often, though such folk were to be the inspiration for his text, none earned quite the contempt that he continually expressed against the "usurers."

Never had he gone about his painting chores with more resolution than after his return and until autumn. Hopes of undertaking a longer journey, admittedly bold and risky, was the impetus. By mid-September he was on his way to Ontario with two companions, hardly less eager than he to help unite widely separated Friends in far places. The portly Isaac Parry, a close friend from Horsham, was an elder of Abington Quarterly Meeting. Young, studious Mathias Hutchinson had barely time enough to finish his harvest near Fallsington in time to join them. He kept a log of the journey.

At the hospitable house of the Quaker William Foulke on the first night out, Hicks had to borrow an old pair of saddlebags to replace a small trunk that had galled his horse's back.

In Catawissa, Gilbert Hicks made room for them on their tenth night away from home. Thus far Mathias was well pleased with Edward's preaching, which, though "passionate," reflected a simple faith not weighed down by theology.

One listener walked twenty miles to the town of Hartland, New York, but he may or may not have been disappointed. If so, it was the fault of much "womanish quarreling, fretting and weeping" over the state of the Society. In his *Memoirs*, Hicks speaks of this occasion and how, for what may have been the first time, he was seized by "the Divine presence" and able to speak forcefully above the din. It would not be the last such favor.

There was no doubt of the precariousness, perhaps even the folly, of leaving so much to providence. Like the "lost children of Israel" the three on horseback crossed the Alleghenies and descended into the deep valleys

dotted with gloomy swamps, in hopes of finding shelter by nightfall. Over a miserable pike they reached the region of Sandy Creek and an inn. But it had closed on account of the death of the owner, a victim of yellow fever. The next inn was also shuttered. At a third the proprietor was ill. "A walking corpse as yellow as saffron" appeared and told them to move on, that the place was filled with dead and dying. Finally, four miles north, they found lodgings and stabled their horses in the dusk. The ordinarily jovial and amusing Parry fell "silent and sad."

On the way to Niagara Falls, a Vermont youth asked to join them.

At Lewiston they crossed the Niagara River.

At Queenstown Heights they became impatient to see "the mighty wonder of the world," seven miles distant. In Newtown, the year before, the news publisher had filled an order for a special printing of "The Foresters" by Alexander Wilson, poet and ornithologist, which had become associated with the Falls. Joseph Wilson, a brother, had Simeon Siegfried copy it from the Philadelphia magazine *The Portfolio*, which published it in 1809–10. Siegfried had printed "work wanted" notices for Edward Hicks and, too, forms used by Squire Hicks for civil marriages. The elegiac "Lines on the death of Violetta Kennedy—for the Author" was also from his press.

Immediately after they found an inn near the Falls and put up their horses, the three rushed through the damp cold air to behold the phenomenon. When a lackey refused to build a fire in the absence of his employer, Parry was ready to move on, and away from the "bad language." Hicks preferred to humor the rude fellow. Soon they had a good meal by a warm fire before being "sung and rocked to sleep by the roaring of the Falls and the shaking of the house." In the morning Edward Hicks did not join Parry and Hutchinson for a descent to the lower falls of Niagara.

The three Friends visited a few meetings to the north, but the dry, sandy shorelands of Lake Ontario tired the horses. They recrossed the Niagara at Black Creek, bound for home, but there the horses "stuck in almost unfathomable mud and water." They became "entangled in roots hidden in the mud" and stumbled among the stumps. Sometimes they lost their footing as they picked their way among logs scattered across the road, but no legs were broken. The offer of only "a bit of milk and cake" for supper at the cost of a shilling, in a rough inn, was no comfort.

The travelers were grateful to be warmly received by a Friend at Otsego Lake, Cooperstown. Once a resident of Pennsylvania and due to return upon his retirement, Samuel Johnson was to exert considerable

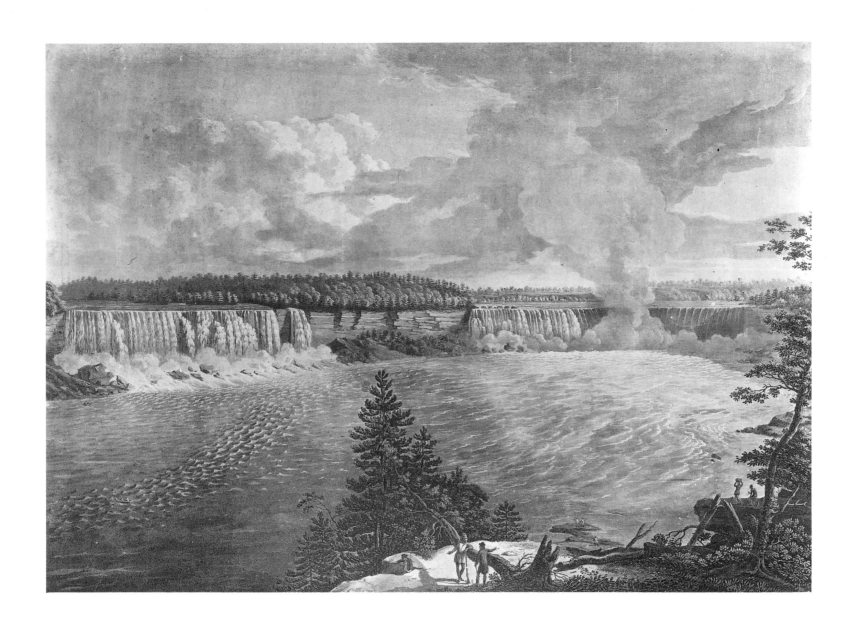

J. Merigot,
A Distant View of Niagara, 1804.
Engraving after oil by John Vanderlyn.
Courtesy New York Public Library

influence on Edward Hicks (short, however, of turning him into an abolitionist). Mathias Hutchinson was related to their genial host.

The hazardous crossings were over, and the "violence of wind and water" around Lake Erie were behind. There were to be no more frigid churches lent by Protestants curious to learn about Quakers. They had seen their last shy, dirty Indian salmon fishermen fond of rum. Wooded trails led to Scipioville below Cayuga, but with so much "traveling up and down" that the very portly Isaac Parry caught cold and asked to be left behind. The horses, which were not rough shod, "worried their way" slowly along the paths and roads. Parry caught up before too long.

Skaneateles and Manlius were unresponsive to the weary Edward Hicks. At Queen Street he rebuked Friends for singing hymns at worship. He was homesick, longing for news, short of temper. A letter that did catch up with him was a smart rebuke from Beulah Twining Torbert for having left his "domestic concerns" to her and his anxious family. He had already posted a bill of particulars to be attended to before his arrival. He reminded his son to "take good care of the calf, pig, and chickens, Turkeys, gees &c.," and added that he and Elizabeth "must remember their poor father in their prayers when they lay down to sleep." A pain in his breast made Edward stop short while writing.

On the third day of January 1820, after two mostly sleepless nights on account of the cold—followed by a blessedly restful stop in Quakertown with Henry Chilton—the travelers parted.

"Thankful to say an all wise, gracious Providence hath directed and supported us through all our trials and dangers, and given us health and strength to perform his holy requirings," Hutchinson closed his log of the two-thousand-mile journey.

In his *Memoirs*, as he looked back, Hicks praised those who had opened their homes to him. He doubted, however, that "such idle, shackling, gad-about ministers" as himself had any business hectoring those who extended charity to "some of the greatest spongers on their hospitality." He castigated the "carelessness and extravagance" that had made him depend on their charity.

He had little more than settled down at home again when he declared his intention to be off to Westbury for a talk with Elias. A heavy cold did not keep him from inviting James Walton to come along, and also to pay for their journey, to Jericho.

On the return he entered on a lively exchange of letters with Elias, who was sounding like the implacable foe of "the beasts of Ephesus." By comparison, Edward Hicks thought that his position was more that of the

sacrificial lamb. His was the martyr tone. Yet at meetings in Philadelphia he preached, that spring, with a candor that antagonized the Orthodox, some of whom thought him devilish.

Hicks lived so near the meetinghouse in Newtown that a sense of duty more than the twenty dollars a year led him to become custodian. In August he took over the broom, rake, shovel bucket, and scuttle, perhaps with the aid of a shop hand. He also supervised the gravedigging.

John Comly once more proved his rare friendship by paying Hicks what the Chapman house had cost, to enable him to build a roomier one on the corner of Penn and Congress streets, also near Friends Meeting. The family settled in quarters rented from the coachmaker Silas Phillips until the time came to move into the new stone house of seven or eight rooms in November.

House built by Edward Hicks in 1821, Newtown, Pennsylvania. Photo by Wilbur H. Johnson

So weary was Edward Hicks after the moving that he feared his attendance at Philadelphia Yearly Meeting, that autumn, might well be his last. He would therefore leave nothing unsaid. One Friend later pronounced the report on the mission to Canada "rather extraordinary," and described the meeting as filled "to overflowing." Hicks gave evidence of a mind deeply exercised, in a communication "deeply favored" beyond former occasions. The Friend, Townsend Sharpless, wrote that his "great eloquence" excited the admiration of all who heard him say that unless he was "spared," the sermon was likely to be his final one. But an Orthodox member, Caleb Pierce, thought little of what he heard and insisted that Hicks be "eldered" for certain of his ideas. Although Hicks appeared "much broken" by the forced "interview," he refused to retract "a single word he had said." Sharpless closed his letter to a relation by pronouncing Hicks "a great man, and, as many of us think, an eminent 'Minister of the Gospel.'"

The ride home in the frosty air was too long and tiring not to be interrupted by pauses at the homes of Friends. At the fifth place Edward Hicks was put to bed. Plumley the doctor was sent for, and so were Sarah Hicks and her son Isaac, who stopped for Beulah Twining at the farm on their way. For eight days the outcome was doubtful. On the way home, Hicks was still recalling one of his delirious dreams, about an unscrupulous banker of his acquaintance, a man in torment because failure was imminent.

A shock awaited him. His shop in the rear of his former home, which he was still using while another remained to be built, had gone up in flames during his absence. Little besides a singed ledger was rescued. Sarah and Samuel Hicks wrote to express their sympathy. Elias Hicks saw the loss of his "covert of temporal amusement and place of industry" as a sign that he should abandon all but honest work. Such "fiery Baptisms" had cleansed St. Paul and others. "If we are without chastisement, we are bastards and not sons," he philosophized.

Artist unknown, Elizabeth Robson.
Silhouette.
Friends Library, Euston Road, London

*T*he mild spring weather restored Hicks to his usual none too sturdy health. When his dream about the banker came true he interpreted it as a reminder that his own life had been spared "for a special purpose." He rode in his gig to Baltimore, to work for an end to rumored strife among Friends. Seeing that the differences were over even such local matters as the burial ground, he soon gave up. On the return he paused in Wilmington to see a friend who was one of the more prominent followers of Elias. Benjamin Ferris was a surveyor, clockmaker, and historian

known for his good judgment. Hicks soon forgot an incident of the night before. The steamer he had boarded on the Chesapeake Bay collided with a schooner. A son of the captain was drowned. The vessel limped into port at dawn minus several of its paddles.

Edward Hicks was not sorry to return to the second floor of his new paint shop and get on with workaday chores.

Long Island cousins Valentine and Abigail invited Hicks, along with his daughter Mary, to be their guest when he came to New York for Yearly Meeting in 1822. He brought his poised, personable sixteen-year-old Susan instead. The sessions were the stormiest in memory. Was worship to remain quiet and "internal"—the Hicksite contention—or become "worship" of Scripture by the Orthodox? The sight of Elias in tears nearly broke Edward's heart. He went home with little to cheer him but some orders for coachwork.

He was still in a mood for argument at Makefield Monthly Meeting soon afterward. The presence of the English Quaker Elizabeth Robson did not restrain him. Indeed she was a reminder of the close association of English Friends with Bible Societies. She took up the challenge. Friends "gloried," she said, in reading Bibles given them by the Societies; it had no effect on their adherence to traditional Quaker teaching. John Wister, whom Hicks had lately praised as "a prince of Israel," called him "a public liar" for his unorthodox ideas. Hicks stood corrected enough to invite the offended visitor home to supper, but she spurned the gesture.

More than conflict within the Society made the year 1823 one of sorrow. In Catawissa, whose name means "place of pure water," the only son of Edward's brother drowned in the Susquehanna River.

Squire Isaac Hicks still roamed the town paths and outlying roads in knee breeches and silver buckles, aloof and solitary, leaning a trifle more on his formidable cane. He hoped to finish a history of the world that he had begun.

Before Christmas, Elias Hicks visited Newtown Meeting. His despair of a return of peace to the Society cast a pall over the dying year.

The Marquis de Lafayette did not return to Langhorne, during his triumphal visit to America in 1824, in order to pay homage to those who had fought at Trenton under his command. All eyes were on the beloved general while he toured the nation that saluted him. An event of

greater importance to Newtown was the decision of its venerable Library Company to erect a fifteen-foot-square building on two lots donated by Squire Hicks. In the perspective of the history of American folk art the following year, 1825, was a momentous one. That is the date borne by a sign made for the library and a fireboard landscape, the earliest dated works by Edward Hicks.

Newtown Library Sign

Painted by Hicks in 1825 for the nominal sum of one dollar, on a board of modest size—17¾ by 37 inches, the Newtown Library Company sign was made by a local joiner. Hicks carried out a design called for by the directors, a portrait of Benjamin Franklin—founder of the Library Company of Philadelphia—encircled by the Latin motto: "*Bibliotheca est utilis, Juvenibus senibus jucunda.*" The oval is centered on a dark green ground of flat coach paint (recently restored), with the word LIBRARY and a shaded period mark beneath. It did justice to the growing collection of the third oldest library in Pennsylvania.

For the portrait Hicks had a choice of prints to copy. There was the engraving by J. B. Longacre after an oil done by David Martin in Paris when Franklin was sixty. It appeared in *Delaplaine's Repository* (volume II, Philadelphia, 1815); *The Portfolio* repeated it in October 1819. John Sanderson's book *The Signers of the Declaration of Independence* also made use of it. There is reason to believe, and hope, that the June 1818 issue of *The Analectic*, a prestigious magazine published in Philadelphia, was Hicks's source. The firm of C. Goodman & R. Piggott copied the Longacre engraving for that particular issue, which also happened to contain an anonymous plea in behalf of the arts. The writer, actually the painter Thomas Sully, wrote that as long as there was one "original genius among a thousand tolerable artists" public support of such talent must be assured. Readily available art instruction was his caveat—for those "powerful instruments of cherishing and animating public spirits and patriotic feelings . . . of every class of society."

Whether or not Hicks read the communication and was impressed by it, the need of money was his goad. In April—the time of his forty-fifth birthday—when not even the most absurd optimist would have predicted success for him as a landscapist of even the naive order, he wrote this disheartened memorandum in his ledger:

Top: Sign for Newtown Library Company by Edward Hicks, 1825. Oil on wood, 17¾ × 37 in. Newtown Library Company Collection, Newtown, Pennsylvania. Photo courtesy Frick Art Reference Library

Bottom, left: David Martin, Benjamin Franklin, 1767. Oil on canvas, 15⅛ × 40 in. White House Collection

Bottom, right: C. Goodman and R. Piggott after Longacre after painting by David Martin, Benjamin Franklin. Engraving from The Analectic, *XI, June, 1818. American Philosophical Society*

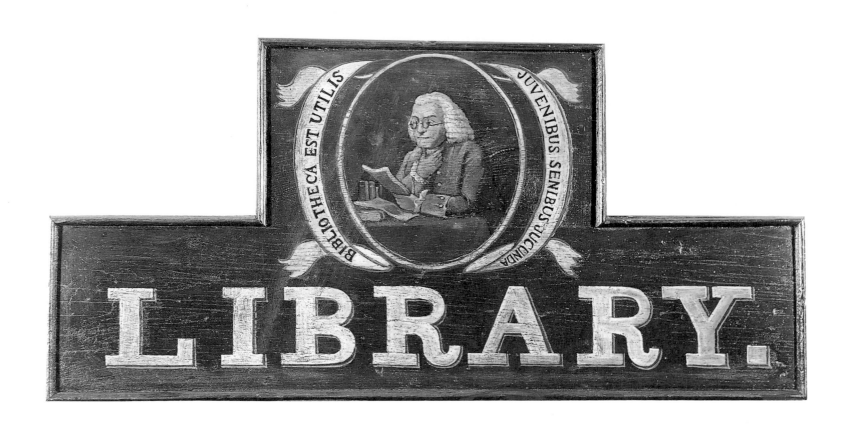

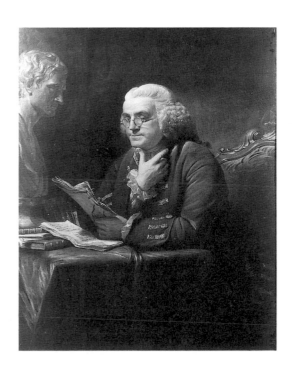

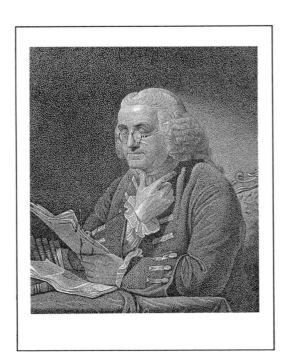

I think it proper to state in this place that I went to live with Dr. Fenton and work for him in the 9 mo. 1800 at making and finishing his chariage and was there till 8 mo. 27 1801. (I painted his house.) I think I received 10 dollars in cash which is all I ever received of him for my work during the period above stated. The cow . . . I felt probably was a present. . . .

By what must have been a supreme effort (but with repeatedly expressed reluctance), Edward Hicks began what became a stream of landscapes, painted from ineluctable necessity. One is inclined to think that it began, prudently, with a *Peaceable Kingdom*. John Comly and his strict circle could not very well have denied their imprimatur to such a theme.

The Peaceable Kingdom of the Branch
Isaiah, 11:6

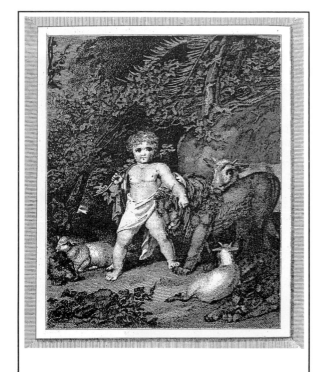

Drawn by R. Westall, R.A., engraved by Charles Heath in the Holy Bible (3 vols.; London: White, Cochrane and Co., 1815), The Peaceable Kingdom of the Branch, earliest example, 1813. Courtesy American Bible Society

The peaceable Kingdom of the Branch.

The source of a long sequence of landscapes in oil called by Edward Hicks *The Peaceable Kingdom of the Branch*, and later *The Peaceable Kingdom*, until he dropped the title, was an engraving of a drawing by the artist Richard Westall, R.A., tutor of the regent Victoria. Various English engravers copied it on steel for the Book of Common Prayer and the Bible, above these lines from Isaiah, 11:6.

The wolf also shall dwell with the lamb, and the leopard shall lie down with the kid and the calf, and the young lion, and the fatling together, and a little child shall lead them.

American publishers of the Bible, among them the Philadelphia houses of Carey & Lea and Kimber & Sharpless (Quaker) copied the copies. A choice of renderings was available to Hicks years before he saw the design in a Bible. It could have been that of Charles Heath, or Maverick & Durand, or—who knows, except that the family Bible used in connection with another painting, years later, did not provide it. There are numerous versions in often widely separated, independent editions.

An overwhelming desire to paint a sermon that might unite Quakers in their dangerously differing views proved too strong for Hicks to imagine how his dear friend and critic, Comly, could oppose it. A message of peace and love, through evocations in paint on board, could hardly offend the most rectitudinous of Friends. Well before the actual

Drawn by R. Westall, R.A.,
engraved by P. Maverick,
Durand and Co.,
for a Book of Common Prayer,
The Peaceable Kingdom
of the Branch.
Photo courtesy Mr. Robert W. Carle

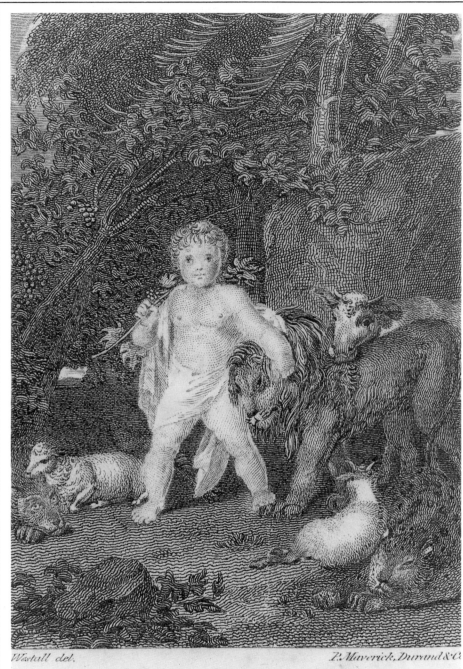

Westall del. P. Maverick, Durand & C?

"The wolf also shall dwell with the lamb, and the leopard shall lie
down with the kid: and the calf, and the young lion, and the fa
ling together, and a little child shall lead them."

ISAIAH Ch. XI. v.6

schism he chose the composition of Westall for a start, carrying it forward with variations for years but with no diminution of feeling or signs of ennui. Indeed his devotion to the design and the theme mounted, as did his skill, while the sermon remained constant. Toward his compositions he searched for prints—usually book illustrations—from which to sketch figures and details.

In 1825, he sold Beulah Twining a "landscape"—a *Peaceable Kingdom?*—for "$25."

Joseph Parrish, the eminent Quaker physician of Philadelphia, acquired two fireboards, a *Peaceable Kingdom* and a *Falls of Niagara*, the former now at Yale University, and the latter in Williamsburg. The moldings and measurements of the two fireboards are similar. A *Falls of Niagara* dated "1825" on its face, an oil on canvas in the Metropolitan Museum of Art in New York City, suggests their date. All three are indebted to a cartouche in the corner of a map of North America in the handsome oversize *New American Atlas*. The atlas was published in Philadelphia in 1818–23 by Henry Schenck Tanner. The cartographer himself had borrowed from prints to create this composite of Niagara Falls and the Natural Bridge of Virginia. The oak that joins the halves of the cartouche must have been adapted from a third print. Hicks did not hesitate to make use of the graceful tree instead of being true to the legendary elm of Penn's Treaty, for the vignette at the left. The discovery of the cartouche and its influence was, by the vigilant discoverer's own description, the serendipitous luck of James Ayres, Director of the John Judkyn Memorial Museum, Bath, England, in 1976.

Hicks adheres to the Westall engraving in the Yale fireboard, save for clothing the scantily clad "little child" in a discreet gown and pantalettes. Like that of all such cherubic figures in the paintings of the Italian Renaissance, the sheer drapery connoted "the purity of the beginning . . . goodness and purity of Creation." Hicks, however, had to take care as to modesty, lest he offend. To stress the peace message he made the most of the left-hand side of his canvas with the classic grouping around William Penn, inspired to add a detail of the legendary Treaty scene of Penn and Indians on the banks of the Delaware. For this he turned not to one of the popular engravings after the famous oil by the anglicized American Quaker Benjamin West, but to a book, a small flimsy one by Priscilla Wakefield in paper covers. The title page is signed by "Isaac W. Hicks," its owner, son of the painter. The frontispiece of *A Brief Memoir of the Life of William Penn, Compiled for the Use of Young Persons*, published in New York in 1821, is a sketchy Penn's Treaty scene, a woodcut. Its engaging legend runs:

The Peaceable Kingdom of the Branch, *c. 1823–25. Oil on wood fireboard, 36¼ × 44⅞ in. Yale University Art Gallery, gift of Robert W. Carle, B.A., 1897*

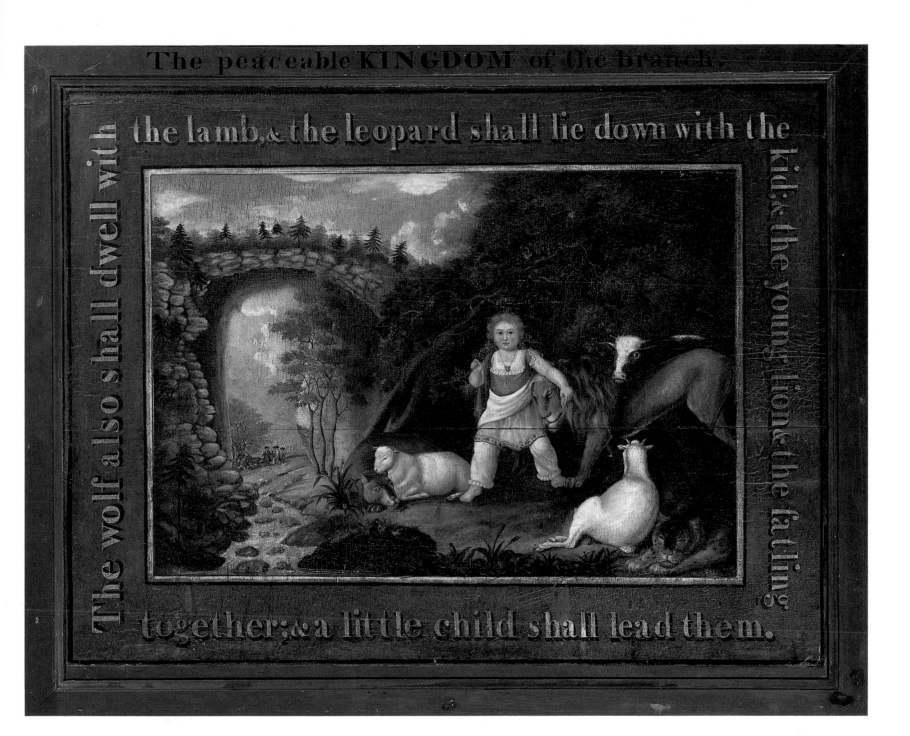

The peaceable KINGDOM of the branch. the lamb, & the leopard shall lie down with the kid; & the young lion & the fatling together; & a little child shall lead them. The wolf also shall dwell with

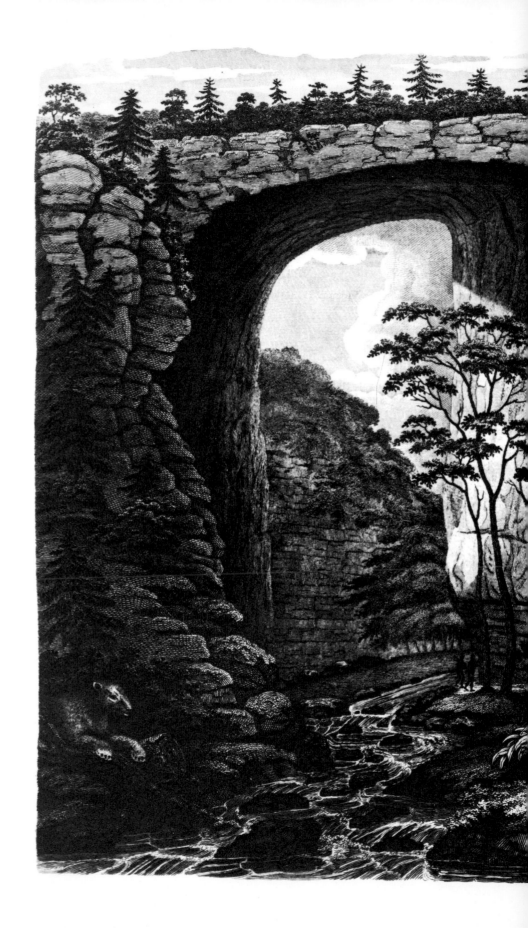

Henry S. Tanner, Cartouche
from "A Map of North America" in
New American Atlas
(Philadelphia: 1818–23).
Free Library of Philadelphia

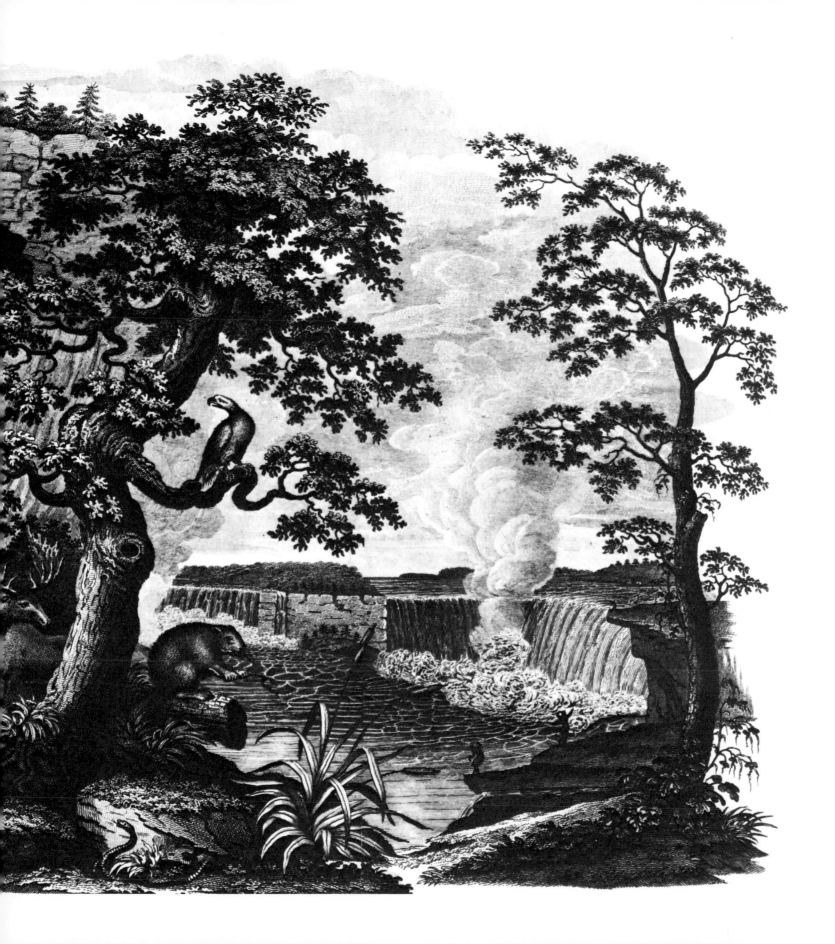

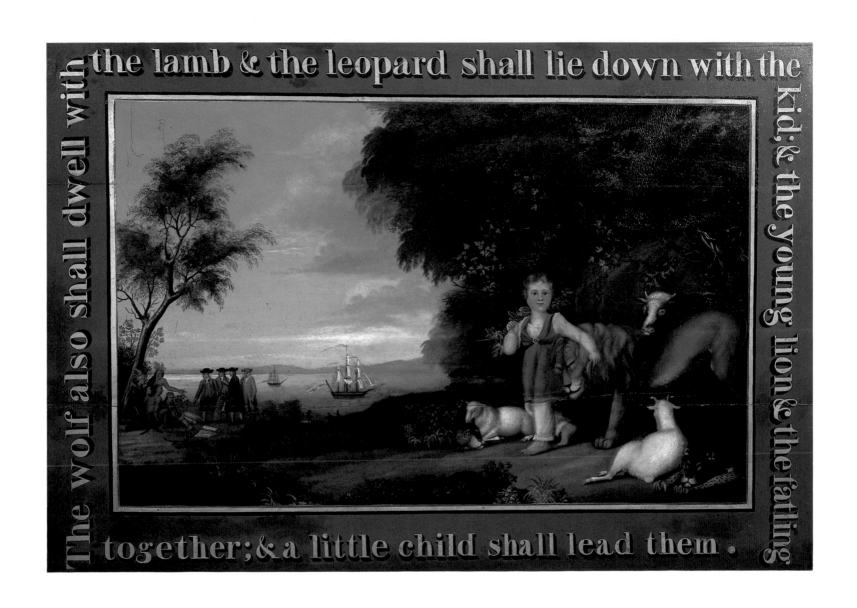

The Peaceable Kingdom of the Branch,
c. 1823–25.
Oil on wood fireboard, 33⅝ × 49½ in.
Private collection

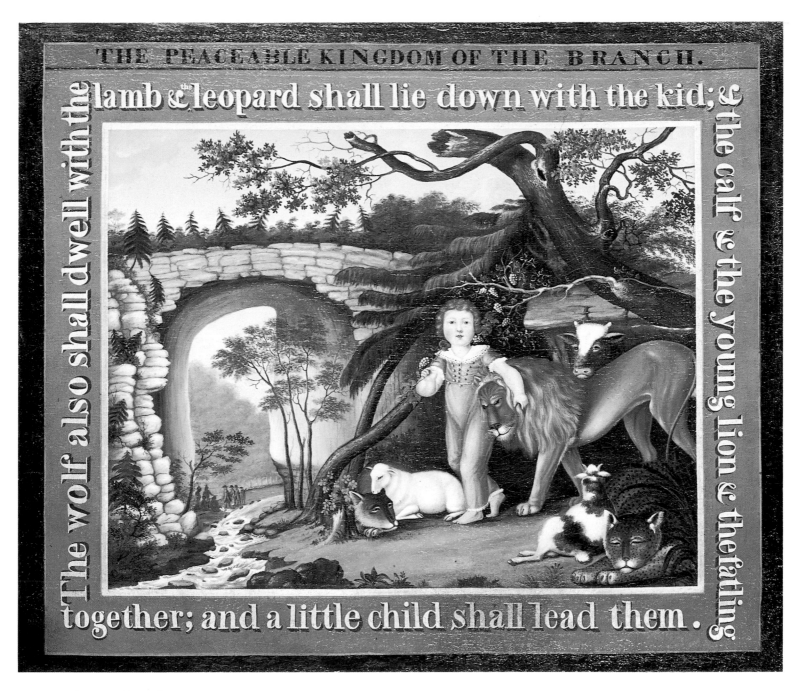

THE PEACEABLE KINGDOM OF THE BRANCH.

The wolf also shall dwell with the lamb & the leopard shall lie down with the kid; & the calf & the young lion & the fatling together; and a little child shall lead them.

The Peaceable Kingdom of the Branch,
c. 1824–25.
Oil on linen, 32¼ × 37¾ in.
Courtesy Abby Aldrich Rockefeller
Folk Art Center, Williamsburg, Virginia

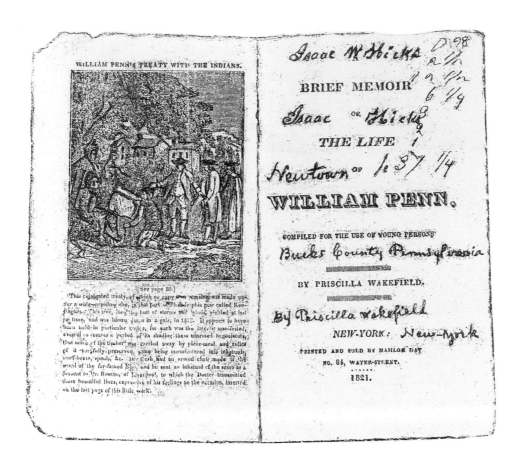

*Frontispiece and title page
from Priscilla Wakefield's
A Brief Memoir of the Life
of William Penn, Compiled
for the Use of Young Persons
(New York, 1821).
Rare Books, The Library
Company of Philadelphia*

This celebrated treaty of which no copy remains was made up under a wide-spreading elm, in that part of Philadelphia now called Kensington. This tree, long the butt of storms and winds, yielded at last in time and was blown down in a gale in 1812. It appears to have been held in particular notice, for such was the interest manifested, even at so remote a period of its shading these unarmed negotiators, that much of the timber was carried away by piece-meal and relics of it carefully preserved, some being manufactured into inkstands, snuff boxes, spools, &c. Dr. Rush [Benjamin Rush (1745–1813), noted Philadelphia physician whose father, a Quaker gunsmith, followed Penn to America] *had an arm chair made of the wood . . . and he sent an inkstand of the same as a present to Dr. Roscoe* [William Roscoe (1745–1831), English historian, poet, botanist, and republican] *of Liverpool to which the Doctor transmitted those beautiful lines, expressive of his feelings on the occasion, inserted on the last page of this little work.*

A *Peaceable Kingdom* fireboard of this stage is a disarming variant. Its history is unique. The antiquarian Eberlein ridiculed it as a folk art exercise in "grotesquerie," in his popular book on the decorative arts,

published in 1917. In this instance Hicks introduced a border consisting of one line from the prophecy of Isaiah. Instead of repeating the transparently gowned boy taken from Westall, he chose to substitute a little girl in her First Day best. She leads beasts tamed to perfection by her shining example, and seems unaware of the anachronism in the left distance, Penn and Indians. More than half a century later, Edouard Manet was to create a masterpiece, *Le Déjeuner sur L'herbe*, with the aid of an engraving by Marcantonio Raimondi after *The Judgment of Paris* by Raphael. He, too, was creating an allegory that was lost on the scandalized Paris Salon, and also the Salon des Refusés, of 1883. His central figures, a nude female opposite two modishly dressed Parisian boulevardiers, her companions, were simply the "juxtaposition of the traditional and the contemporary," players in an allegory. The classical nude is meant to represent Truth in the presence of the taste of the time and its complacency. (Hicks, too, admired and drew from Raphael, even as Manet took inspiration from Giorgione, and Courbet as well.) Not until a century after the uproar at the Salons was the painting discovered to have an allegorical meaning and to have taken its central composition from a print. Hicks used modern dress from the wish not to shock; Manet chose nakedness from a candid desire to do so. The concern of the Quaker was that only a figure well and charmingly dressed should be called upon to bring contemporary youth into his message. As in the memorial paintings in honor of Elias Hicks, the girl plays a secular as well as scriptural role in his allegory.

The figure of the boy, which returns in another *Peaceable Kingdom* of the time, and which shows a child in a jumper suit of a style worn by young Friends in the 1820s, raises a question. In this painting on heavy linen the head and luminous face reveal a gift, unrealized, rejected, for portraiture. The talent was suppressed, as witness the merely linear, schematic faces in the farmscapes of fully twenty years later. Hicks made the most, instead, of rural, vernal nature. Should one exclaim, "What a pity!" Probably not, all things considered. His calling was to enlist nature and such symbols as the Natural Bridge in this painting. The Bridge meant to him the beckoning of the divine continuum into a place of peace. Many before him had been attracted to the grace of the arch form in nature, Giovanni Bellini for one. Its appeal in architecture has come down to the present in the landscapes of Giorgio de Chirico and many others. For Hicks the elements of landscape were both medium and message, a message that he proposed to deliver on canvas without aspirations toward portraiture. That he was a naif no one knew better than Hicks himself, who often belittled his paintings.

William Penn's Treaty with the Indians.
Detail from Wakefield frontispiece

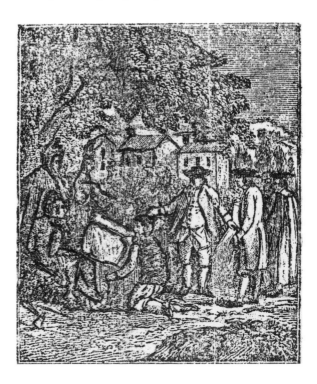

The Falls of Niagara

Of the two known examples of *The Falls of Niagara*, an oil on canvas dated "1825" and no longer in its original frame, is slightly smaller than the nearly identical fireboard. Both are richly autumnal in tone. Several minute corrections and alterations in the composition of the board indicate that the canvas is the earlier. As the only dated works, these landscapes remain, with the sign for the Library, bellwethers in the chronological study of Hicks's paintings.

John Peter Salley wrote the first description of the Falls before the spectacle began to attract artists. The Merigot engraving of an oil by John Vanderlyn (1776–1852) was the point of departure for Henry Schenck Tanner, who designed the cartouche copied by Hicks. *The Portfolio* magazine had published "The Foresters" by the poet and ornithologist Alexander Wilson, in full, with illustrations. A rattlesnake facing death at the hands of three hunters in one of the pages was not the model, but perhaps rather the inspiration, for the moving reptile in his cartouche. The rattler had appeared as early as 1776 on Spanish mill dollars in the South, with the slogan "Don't tread on me." It became one of the American ideographs, which included the tobacco cask, the Negro boy in Indian regalia, and figures of Liberty, Columbia, and the Indian Queen. Hicks added a beaver, moose, and eagle as appropriate symbols.

On both versions he quoted Wilson in his Caslon lettering but with poetic license. On the canvas he printed: "Rises on our view amid a crashing roar/ That bids us kneel, and Time's great God adore." The fireboard reads: "This great o'erwhelming work of awful Time/In all its dread magnificence sublime." (The change was apt; Friends do not worship on their knees.)

A *Niagara* sign painted by Hicks for the tavern of Joseph Oliver Victor Senez Archambault, former equerry of Napoleon on St. Helena, cost six dollars. It disappeared after having been discarded around the turn of the century. The tavern, built of local fieldstone about 1772, became the Temperance House, which still stands. Henry Tanner, whose cartouche was responsible for the decoration, was lifted out of obscurity and the shadow of his better known brother, the engraver Benjamin Tanner, by his *Atlas*. It was a model for cartographers for generations.

*The Falls of Niagara,
c. 1825.
Oil on wood fireboard,
37¾ × 44½ in.
Abby Aldrich Rockefeller
Folk Art Center,
Williamsburg, Virginia*

FALLS OF NIAGARA.

Above, below, where'er the astonished eye
Turns to behold, new opening wonders lie,

With uproar hideous first the *Falls* appear:
The stunning tumult thundering on the ear.

There the broad river, like a lake outspread,
The islands, rapids, falls, in grandeur dread,

This great, o'erwhelming work of awful Time,
In all its dread magnificence, sublime.

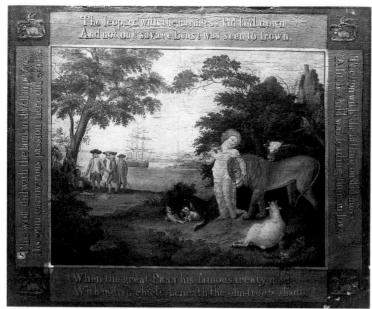

Condition before treatment (test cleanings lower left border), raking light

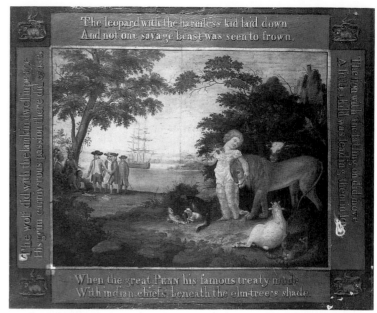

Condition before treatment (test cleanings lower left border), normal light

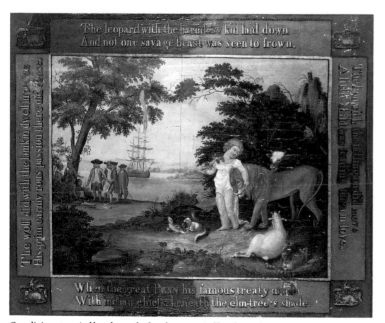

Condition partially cleaned, borders partially cleaned

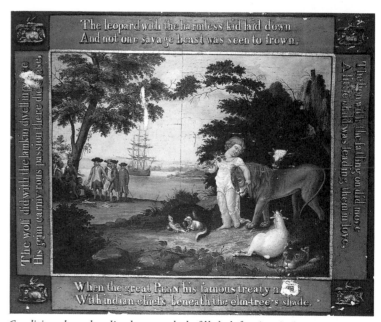

Condition cleaned, relined, restretched, filled, before inpainting

The Peaceable Kingdom, *c. 1825.*
Oil on canvas, 30 × 36 in. Private collection.
Restored by Sheldon and Caroline Keck

The Peaceable Kingdom
With Corner Vignettes. 1826–30

Detail, upper right corner during cleaning
(note wrinkle losses, damages in borders)

Detail, bottom border far right, repaint in
damage at "ade" and chip losses at corner

*I*f the *Peaceable Kingdom* landscape were to become monotonous through too much repetition, its purpose would be defeated. Those able to buy such a canvas might not do so. Moreover, the act of painting would itself become tedious. There would have to be some variation in the composition, based on different engravings, and in the borders with Hicks's own rhyming of the lines from Isaiah. He would even add a couplet to hail his idol William Penn, lest his presence in the picture not be understood.

Three days before his forty-sixth birthday, the painter inscribed a *Peaceable Kingdom* to Sarah Titus Hicks, wife of his cousin Silas of New York City. One of no fewer than half a dozen of its type that he sent to well-to-do city Friends, and sold on order at home, it was more personal and perhaps more mannered than its predecessors. But its intent and effect remained inspirational. A few weeks later, in May 1826, Silas acknowledged its arrival: "Dear Coz Edward Hicks: We have received the Painting thee was pleased to present us with. We feel much obliged and shall keep it as a Choice Memorial of thy friendship. A number of our friends have called to see it. They all united with us in its being executed in a masterly style, which must have taken a good deal of time and labor, which I, however, do not profess to be a judge of." He enclosed a check for one hundred dollars, and closed with a plea for Edward Hicks to come and have a voice in the expected "dispute" at New York Yearly Meeting.

A painting presented to the prominent New York City physician John Cheesman is known only by his letter of thanks, sent two full weeks earlier than that of Silas. He declared that he would not "be found backward" in remunerating Hicks for what may, in fact, be one of those of "unknown" provenance.

Another updated and yet associated example of the corner vignette genre actually may be earlier. Smaller than those just mentioned, it belonged to Mary Lawrence of Lawrence, Long Island. Its "little child" is closer to that of Yale's dated about 1825 than to any known example. For its exceptional grace, executed by Hicks with quite unusual success, he was indebted to a fortunate choice of models. It has the air of the fifteenth-century Florentines who were indebted in turn to the Praxitelean figures of the fourth century A.D.

For painting conservators Sheldon and Caroline Keck, the cleaning of this canvas posed "a typical Hicks problem." As they told me, he made

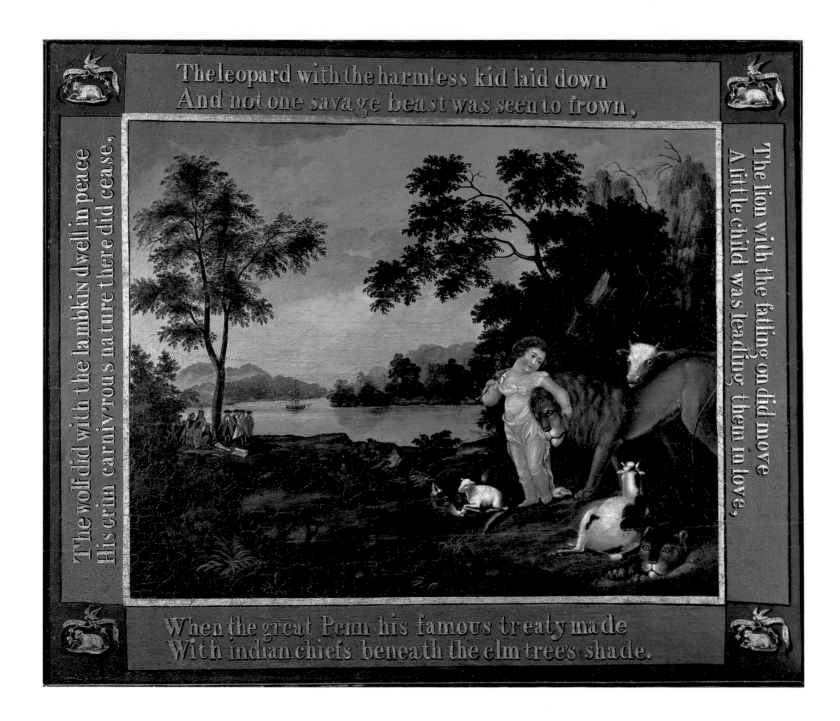

The leopard with the harmless kid laid down
And not one savage beast was seen to frown,

The wolf did with the lambkin dwell in peace
His grim carniv'rous nature there did cease,

The lion with the fatling on did move
A little child was leading them in love,

When the great Penn his famous treaty made
With indian chiefs beneath the elm tree's shade.

a practice of sealing in the black and gold lettering of his border messages with oil varnish rather than spirit varnish.

Oil varnishes, they know from experience, "darken unpleasantly." They were appropriate for coach panels and floor boards but not paintings. They are much less soluble than the painted words that they cover in paintings by Edward Hicks. Fortunately, he limited this impropriety to his borders and never applied the dangerous film to the pictorial parts of his pictures. In the course of preserving this almost ruined but charming scene we cleaned away discolored films, excess repaints and uneven fillings, then relined the canvas and compensated for only the comparatively small losses in the original. It was during the relining process that the nearly illegible inscription on the back of the original canvas was discovered and its faint image recorded by infrared photography: EDW HICKS painter for his dear coursin Mary W. Hicks, New York." (sic)

Because the painter felt the need for a more believable "little child," closer to his time, he had to abandon the nonetheless irresistible model of the ancients. Accordingly, for Mary Twining, mistress of the Leedom farm, he painted a *Kingdom* of the same genre but presented a child dressed like one of his own daughters or like a little girl in one of their juveniles. On the back of the canvas he lettered these words with his brush: *EDW HICKS to his adopped Sister Mary Leedom and her Daughters didecates this humble piece of his Painting. (sic)*

In a fireboard dated August 26, 1826, the day he presented it to Harrison Streeter, a Friend of Fallsington Meeting, "the little child" might also have stepped out of a storybook. A striking difference is that the squared corners do not contain the lamb, dove, clouds, and motto. The tree is not the Penn's Treaty elm of the Durand engraving of the Delaware River setting long since known as Penn's Landing. Rather, it is a great gnarled oak that Hicks borrowed from the cartouche by Henry S. Tanner, who, in his turn, had borrowed from a print by, one supposes, a Dutch seventeenth-century landscape painter like Jacob Ruisdael.

The Peaceable Kingdom
(for Silas Hicks), 1826.
Oil on canvas,
32⅛ × 38⅛ in.
Photo courtesy Christie,
Manson, and Woods
International, New York

Schism

John Comly called for Hicks on his way to Buckingham Quarterly meeting in February 1827, year of the crisis. Hicks handed him an unsigned letter. The writer described a dream in which Hicks tried to rescue part of a field of young corn damaged by frost. Comly saw in it a metaphor of the effects of disunity on Quaker youth. On their way north he cautioned Edward against remarks that might well prove detrimental to peaceful arbitration. His warning was soon forgotten. Comly was "alarmed" by the ferocity of Edward's stand, which would have better suited his ancestor Ellis Hicks, hero of the Battle of Poitiers, than a Friends minister. He likened the visiting English members to destroy-ing-angels bent on denying American religious freedom—so dearly won by the blood of Penn's descendants—as well as by the redcoats in the Revolution. His invective drew the ire of members of both camps, one of whom declared his utterances "inflammatory lies." Comly could no more subdue him than he could help loving him, despite his undeniable excesses.

A Friends school for Newtown had long been an aim of the Meet-ing. A hint dropped to the Long Island cousins drew $130 from the son of Samuel Hicks, collected from his family circle. Henry Willet Hicks wished it were more but offered to make up the deficit for the land should one exist. The cause of young Friends ceased to be taken lightly.

The Peaceable Kingdom
(detail), c. 1828–30.
Oil on canvas, 30 × 36 in.
Abby Aldrich Rockefeller
Folk Art Center,
Williamsburg, Virginia

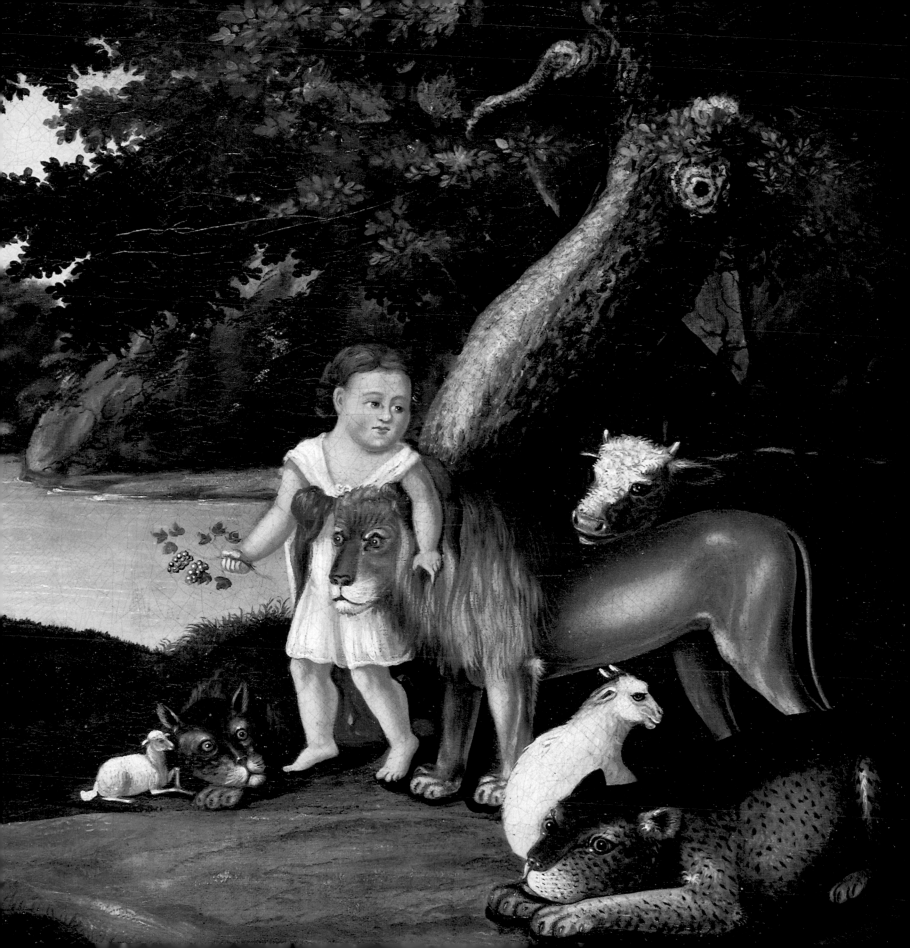

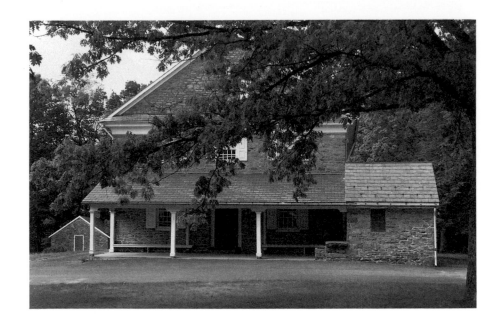

Buckingham Friends Meetinghouse,
Lahaska, Pennsylvania (built 1768).
Photo courtesy Milton Rutherford

However, the root cause of the Separation ran deeper than the theological differences believed harmful to youth. The dissimilarity of city and rural members had made communication more and more nearly impossible. His small town upbringing had led Hicks to think of the Philadelphians as "royal Americans," and even as the "hirelings" of their London brethren. He could not bear to hear Elias, Comly, and men of their goodness put down as "heretics" by Jonathan Evans. That intransigent leader of the Orthodox was ready to advocate "disownment" of rural Monthly Meetings by a "grand jury" made up of his peers.

At an August meeting of Hicksites from near and far in Green Street, their only Philadelphia stronghold, Comly pleaded for a spirit of reconciliation. He succeeded rather better than he intended when his proposition, for forming a Hicksite Yearly Meeting independent of the Orthodox, was rejected. In one of two sermons at these historic sessions, Edward Hicks preached that dissension would end only when all had mastered their "animal nature" and "come out of the horrible pit, to sing praises upon the banks of deliverance." They would also sing the blessings of American liberty. His words and imagery were close to those of his paintbrush.

He was to concede in his *Memoirs*, when he recalled these aggrieved days, that he had been prone to rash judgment. But, even as he did so, his well-known scorn for the professions, the Jesuits, the phrenologists, and mulberry tree growers—not to mention Orthodox physicians—had

in no way lessened. "Doctor craft," like "priestcraft," culled out of "a few books" and demanding "enormous fees," unfairly punished those of humble means. He reiterated his firm belief that slavery—barred in Pennsylvania—was a moral and not a political question. The temperance movement was still more abhorrent to him and for the same reasons.

Phineas Jenks and other leading citizens formed a Temperance Society in Newtown. Young Isaac, still living at home and farming, joined over his father's mild objections. The daughters did not take active sides but had minds of their own. Mary occasionally enjoyed a pinch of snuff on the sly. Hicks closed his ears to the arguments. He delved more and more into Christian history, the better to answer Orthodox invective, which he likened to that of the Third Ecumenical Council of the Church at Ephesus in 431 A.D. Great was the respect for his seriousness and learning within his local Meeting and among Hicksites unopposed to his extremes.

*P*hiladelphia Yearly Meeting, a month after the Green Street sessions, was the scene of the fatal confrontation, one not to be undone until the mid-twentieth century. It was not the first Quaker breach of unity. In 1680, John Wilkinson and John Story rebelled against the Code of Discipline that the founder of the Society of Friends, George Fox, formulated, finally, in 1699. They had argued that the Inward Light, revealed to Fox by God in a pillar of cloud in the beginning, must remain the foundation of Quakerism. Fox likened their attempted schism to that of Martin Luther against Rome. William Penn kept Fox in power and, in a spirit of brotherhood, took the two rebels to America aboard his ship the *Welcome*. No such happy ending was in prospect in the year 1827.

Two Orthodox scouts were sent to the Quarterly Meeting at Buckingham to single out Edward Hicks for "certain disownment." If his hot-tempered response had not ruled out such an analogy, he would have thought his dilemma like that of Christ before the Sanhedrin.

At the next session his fellow Hicksites ruled the Orthodox order invalid. But his enemies had not finished with him for his uncompromising stand. "Sly" attacks were made on his "private and moral character," and on his "public" image. A tale was spread about his having failed to finish a coach on time, a while back. The truth was that Hicks and the client in question, a Baptist lawyer, were friends until the man's dying day, when he called Hicks to his bedside. Nevertheless, the unpleasant rumor spread.

Late in the year an unsigned letter, a disturbing one bearing a Purchase, New York, postmark, informed Edward Hicks that he had been called "a great liar" and a "denier of the Christian religion." That was the opinion of the more evangelical Friends at Quarterly Meeting. Back went the letter to the Purchase postmaster with a request to return it to the sender. Valentine Hicks was guilty. Full of remorse he ordered a new carriage by mail and sent his apologies.

Hicks drove the carriage to Purchase. Valentine listened while Edward challenged the embattled "Tories" and wavering Hicksites. Elizabeth Robson, who had disdained his invitation that time at Makefield Meeting, held her fire until he sat down. Then she and her cohorts took the floor. She faced in Edward a man whose demeanor her earlier sympathizers had denounced as "loose and immoral."

There was much to be thankful for by the end of the sad year, as Edward Hicks chose to see it. The "dear Hicksite children" had not been "led off by the wolves in sheep's clothing." Nor had the "cold, supercilious spirit" of those who sought to "disown" him prevailed. The Orthodox of Philadelphia had tried in vain to confiscate the Newtown Meeting property with the aid of a hired lawyer. Makefield Meeting also defeated the attempts of two conniving families among its members to hand it over. Hicks deplored the doubts of those who did not know which side to choose and whose vacillating was like that of the "bat in the fable" of Aesop. He, the "poor mechanic," trusted that a republic that had driven out the "Tories" had nothing to fear from Friends still Loyalist deep down. Rejoicing in his own freedom from doubt as to his course, he managed to pay his father-in-law the thousand dollars, or nearly, that he had long owed him.

Arch Street Friends Meetinghouse,
Fourth and Arch streets,
Philadelphia, Pennsylvania

Soon after New Year's 1828, two Burlington spinster sisters gave Edward Hicks a piece of their mind by post. They accused him of having excited "a spirit of disaffection in the minds of the younger and more inexperienced class of Society" by his preaching at a Meeting they attended. He had failed, they wrote, to consult the elders before he said the things he said before a "mixed assembly." He at once replied that "true righteousness" is opposed to vain "show" and speaks out. The ladies, Mary and Elizabeth Allinson, had not deigned to speak with him, a visitor, nor bid him come home to supper—and he said so, and this: "'I suffer not a woman to teach or assume authority over a man but to be in Silence.'" Redoubtable words, taken from St. Paul.

The Allinsons had nevertheless made more of an impression than he allowed them to imagine. When he finished a "very hansom new 'chair'"

for Elijah Lewis (a Darby Quaker who had been expecting it for a year or nearly), he gave his dear Halladay Jackson of that place fair warning. He would drive the gig down and trust to Jackson to find him a ride home, but he would not preach. "I feel too poor and wicked to preach to anybody. But if dear Aunt Rachel Hunt would preach to me, so as to do me any good, I would not mind coming down . . . if life and death will permit." He was feeling too worn and "lean for anything but to paint 'chairs' [carriages] and sell them." Perhaps by early autumn he turned again to easel painting, and, in particular, to more *Peaceable Kingdom* oils with corner vignettes. But on his return from Darby he was in no condition for much work of any description, if indeed there had been enough to change his mood of desperation.

He swallowed his pride, rode up to Buckingham, and asked the miller John Watson the younger for a loan. He ventured to do so because the late father of this Friend had been "overseer" of his wedding to Sarah Worstall. Hicks admitted his plight. He thought it wiser for Watson to approach the coachmaker Alexander Van Horn for a loan in his behalf. The well-to-do Van Horn, to whom Hicks had passed along business from time to time, declined to take the risk. Watson turned next to his neighbors Thomas Paxson and Hugh Ely, and to the trustees of Joseph More—all Friends—who lent Hicks one hundred and thirty dollars. Hicks took umbrage at the rate of interest as if, in fact, none should be asked. He grumbled that his "friend and neighbor" Edward Morris, a "money changer," would have asked no higher.

Discouragement and truculence colored his preaching, damaged his standing. On October 9, 1828, Fallsington Quarterly Meeting handed him a damning "minute": The "Testimony of Disownment from membership in the Society of Friends on account of preaching unsound Doctrines." Even though the action had no more force than his earlier "disownment" by Buckingham Quarterly Meeting, he was chastened and sad. But his combative nature did not despair as he retreated to the solitude of his shop and, perhaps—yet who knows how soon?—to the solace of easel painting between coach jobs.

Proof that by well into the year 1830 Edward Hicks began to devote himself to a new, decidedly different expression of the *Peaceable Kingdom* narrows the choice, happily, for the dating of several remaining oils with corner vignettes.

The year 1828 and its frequent Hicksite meetings for strategy, and the poor health and morale of the painter as a consequence of the schism

and his money worries, could have left little time or inclination for easel painting. The alternative dating of corner vignette *Kingdom*s not yet mentioned—the number of which rules out their completion in such necessarily rapid succession—must, perforce, be 1828–30.

The corners of the version at Reynolda House in Winston-Salem, North Carolina, are empty. At some time the painting was divested of a part of its borders, probably owing to chance damage. Like the Amherst Art Gallery example, its background is the Natural Bridge of the cartouche. Both oils bear borders different from those with a Penn's Treaty salute: "When MAN is moved and led by sovreign grace/To seek that state of everlasting PEACE." The earlier of the two *Kingdom*s at Cooperstown has lamb, dove, and riband in the corners but no mottoes.

As for the mottoes in Greek, Latin, French, and English (in some but not all of the vignettes), their presence is not too baffling. Samuel Johnson, whom Hicks had visited overnight during his mission to Ontario in 1819, had recently retired to a farm near Buckingham. He was, in fact, living with his daughter and son-in-law Thomas Paxson, from whom Hicks had lately obtained a loan. Johnson had a good classical education and a bent, in his retirement, for reading and writing poetry. His was already a strong voice at Buckingham Meeting on the score of Abolition. A mutual fondness for Wilson's poem "The Foresters," and for versifying, narrowed the breach that their differences as to slavery might otherwise have caused between him and Edward. No more likely candidate for linguistic consultant can be imagined than Johnson, equally suspect when it comes to the vignette imagery. One of his poems, later published in a thin volume, lauds "the *Dove . . . the symbol of innocence, pure emblem bright.*"

The elder daughters of Hicks, Elizabeth and Susan, who were benefiting from a far better grammar school education than had been their father's portion, would not have failed to point out his errors of spelling and punctuation, his failure to use an apostrophe, and his misuse of capitalization. At any rate, the changes to be noted from example to example of the oils with corner vignettes suggest their order, from early to late. If it was not Johnson who tactfully hinted for some corrections, there is no doubt that such lines of his as these were to have at least some bearing on how Edward Hicks was to arrive at the composition of his next and most creative stage:

> *Should nations who thy emblem boast*
> *Adopt the Dove, like humble Penn;*
> *the Olive Branch precede the host*

Opposite:
The Peaceable Kingdom
(for Mary Twining), c. 1828–30.
Oil on canvas, 30¼ × 36⅛ in.
New York State Art Association,
Cooperstown, New York

Verso of The Peaceable Kingdom
(for Mary Twining): inscription
"Edward Hicks didicates. . . . "
New York State Art Association,
Cooperstown, New York

The leopard with the harmless kid laid down,
And not one savage beast was seen to frown,

The wolf did with the lambkin dwell in peace,
His grim carnivrous nature there did ceace;

The lion with the fatling on did move,
A little child was leading them in love,

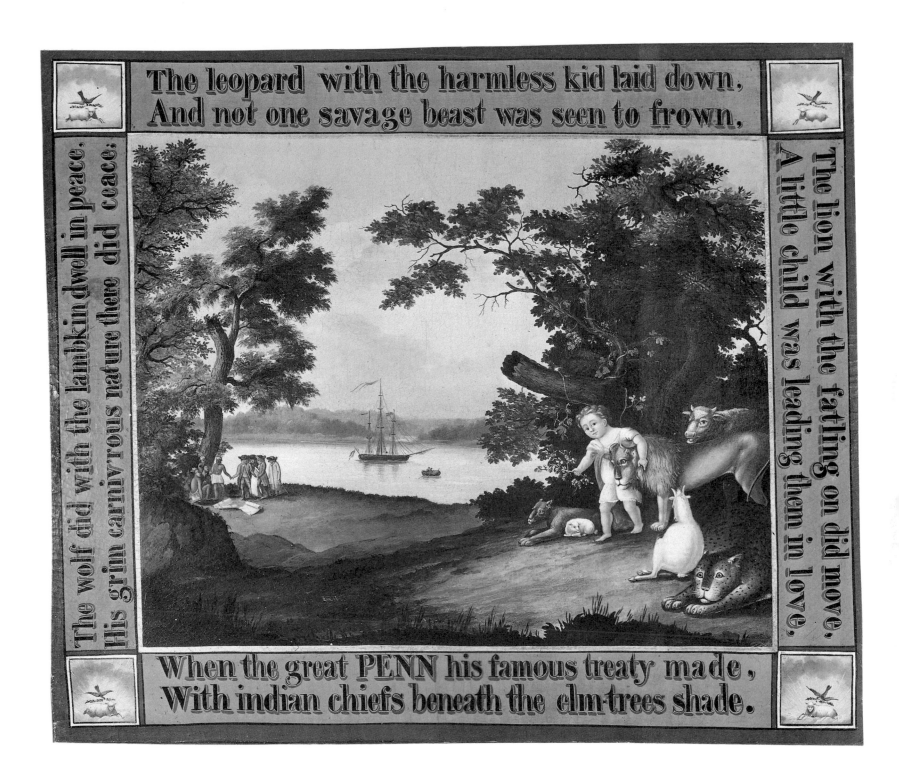

When the great PENN his famous treaty made,
With indian chiefs beneath the elm-trees shade.

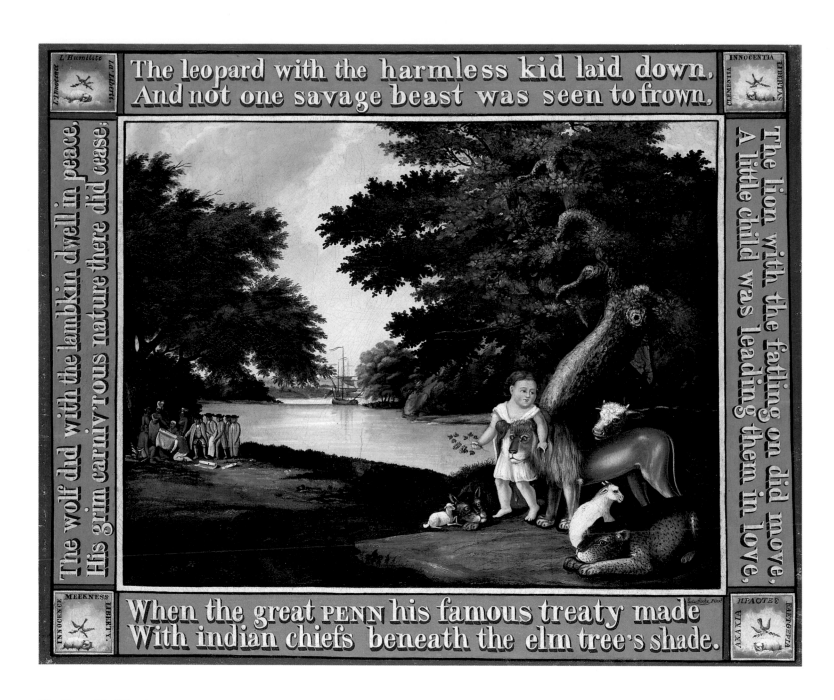

The Peaceable Kingdom,
c. 1828–30.
Oil on canvas, 30 × 36 in.
Abby Aldrich Rockefeller
Folk Art Center,
Williamsburg, Virginia

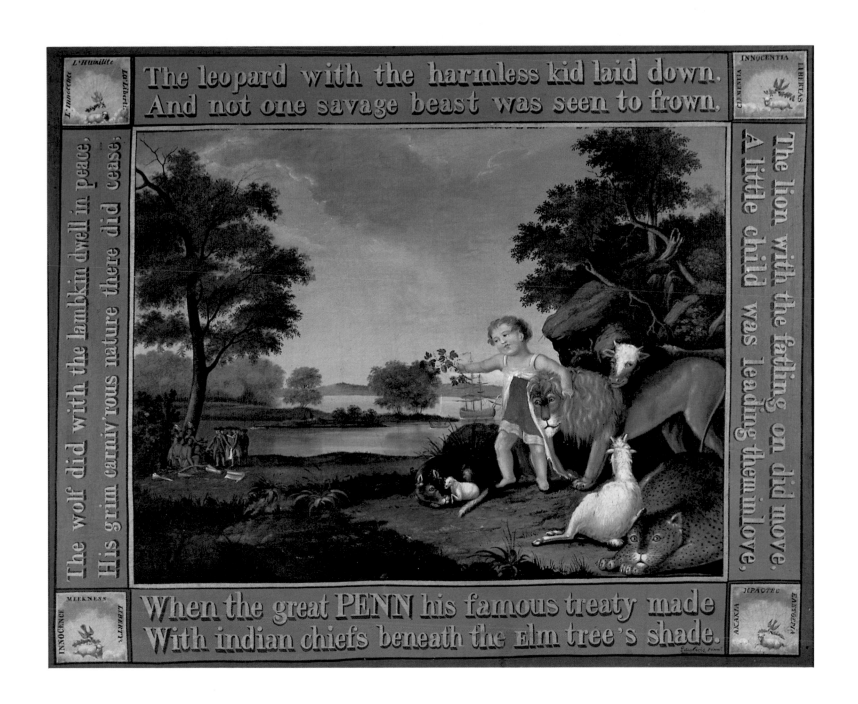

The leopard with the harmless kid laid down.
And not one savage beast was seen to frown.

The wolf did with the lambkin dwell in peace,
His grim carnivrous nature there did cease;

The lion with the fatling on did move.
A little child was leading them in love.

When the great PENN his famous treaty made
With indian chiefs beneath the ELM tree's shade.

The Peaceable Kingdom,
c. 1828–30.
Oil on canvas, 29 × 36 in.
Friends Historical Library
of Swarthmore College

Love—love would be their weapon then . . .
And peace would bless the sons of men?

Like Wilson, both Johnson and Hicks made much use of elision.

Finally, the observations of the conservator Russell Quandt concerning the Williamsburg version, shown at the Vatican in 1979, are of rare interest. To the lightweight fabric, nailed to a strainer (not to a stretcher), Hicks applied red oil along the outer edges to prevent the rusting of nails. He then drove the nails in, afterward coating them with the same blue-gray oil that he used for the undercoat. This preventive step was exclusively his. His joiner, perhaps Edward Trego of his district, drove only one nail into each corner before staining and varnishing the wood frame. Hicks applied paint sparingly in thin coats and finished his job with many coats of varnish.

He painted four lines of his own versification of the prophecy of Isaiah—without a picture—on carriage cloth, using his familiar black shaded Caslon lettering against the pale green ground common to these oils with vignettes:

A little child was leading them in love
And not one savage beast was seen to frown,
His grim carniv'rous nature there did cease
When the great PENN *his famous treaty made.*

Some observers regard the scowling of the lion as due to his displeasure over the schism. If we have Hicks's own word for it—that all frowning "did cease"—how can the reverse be true? Frowns and displeasure are not consonant with peace. No part of the *Peaceable Kingdom* is a contradiction in terms. Frowns are the fault of a limited choice of models. To what use this lettered strip was put, or for what it was intended, is unknown. It has remained in the Hicks family.

During the winter of 1829 tragedy struck. Hicks's father-in-law was the victim. Joseph Worstall had worked and saved in his tannery opposite his house on the courthouse grounds since ten years before the birth of Sarah. His son Joseph became his partner. His millhouse, currying shop, wagon house, barns, implements, and huge stores of bark, ground and ready for shipment abroad in April, burned down. Even the remainder of his farm produce was lost. To pay his debts and begin again at seventy-three he had to sell his farmland.

Late in this year of misfortune, Edward Hicks hit upon a plan by which he hoped to raise money for a missionary journey to southeastern

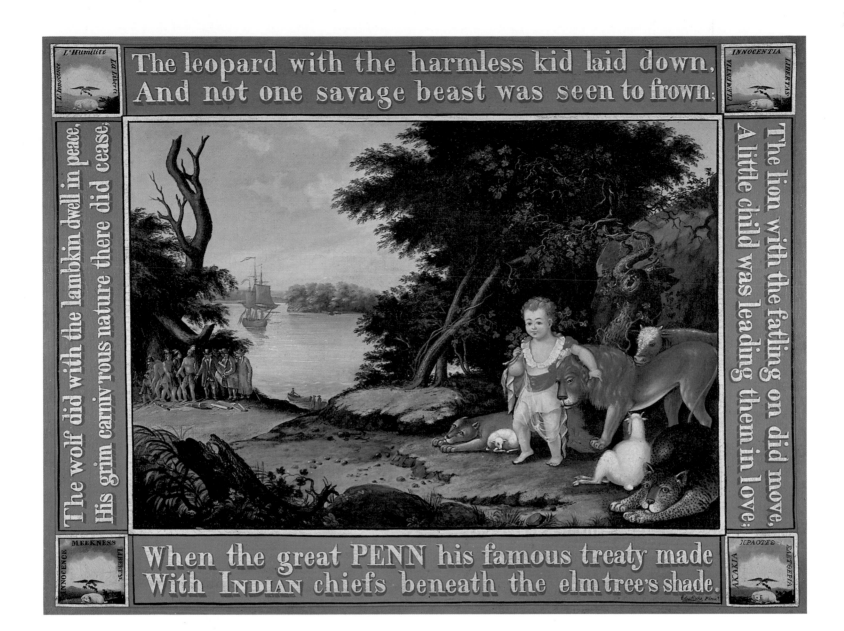

The Peaceable Kingdom,
c. 1828–30
Oil on canvas, 32½ × 42 in.
The Museum of Fine Arts, Houston,
Bayou Bend Collection,
gift of Miss Ima Hogg

Ohio. He wished to warn Friends out that way of the growing danger to the Society. Elias Hicks was no longer strong enough to venture so far away. Ministers were few. Edward prepared several coaches for sale, to be ready for hoped-for sales and cash payments. By December, however, not one had been sold. Not to be thwarted, he appealed to his wealthy and "beloved friend" Samuel Hart of Doylestown for help: "It is a time when the great fundamenttle stands of Quakerism will have to be saved or raized and rallyed round, if we expect as a Society to be preserved from right hand errers and left hand errers."

Ohio Mission

On December 14, 1829, Hicks departed for West Chester, where the farmer Benjamin Price was awaiting him. Price was leaving to his wife Jane Paxson, a brilliant minister, the care of the farm and his duties at Chester Meeting. The Westtown School of Friends graduate had cast his lot with the Hicksites over the mild objections of his father, Phillips Price, an elder who thought the Hicksites valuable enough souls in spite of all. Benjamin's sister, the wife of Jonathan Paxson, had also deserted the Orthodox. He was no ordinary farmer, having been the first to try a mower and to use hedges of Virginia thorn and underground drainage. Nor was he an ordinary Friend; before long he would join the underground railway and harbor runaway slaves.

Written by candlelight, entrusted to an uncertain post, the letters of Hicks were chronicles. Across the Pennsylvania German farm country to York, and over the south mountains to Hagerstown, Maryland, the two went. At Newcomer's Tavern, Edward downed a pill in molasses for "a very hard cough," which did not keep him from rising again before daylight, to travel on to Cumberland. The Yuletide merriment at Hurst the next night was an abomination. To escape a "talkative Methodist woman" he and Price went to bed after "a fervent spiritual exercise" of silent prayer.

It was necessary to stop three times for new horseshoes the day before Christmas, so rough were the roads. At Smithfield, West Virginia, there were "superstitious" festivities in the tavern by way of celebrating Christmas Eve. Edward and Benjamin were glad to be off early for Brownsville, Pennsylvania, where they could be sure of Quaker hospitality. But night fell before they found the house of Jesse Townsend after a groping search along the banks of the Monongahela. At the "quiet, good meeting" that was prepared for them in the morning they could not help

sensing that all was not well. Already the enemy had begun to poison "the mind of the public." This made the wearisome, treacherous crossing and recrossing of the river—and a hard climb to another meetinghouse that day—difficult to bring off. But with the aid of one sympathetic listener, Jonathan Morris, they managed to drive on from there to Wheeling, twenty-five miles yonder. A Quaker couple, "innocent old folks," took them in for the night, but before they slept they discovered that the Orthodox had already done their work beneath that roof.

On New Year's Day, 1830, the missioners crossed the Ohio to St. Clairsville, eager for news from home. When Hicks received none he wrote a gentle protest at the start of a full account of his wanderings. (To this place, after the victory of General Wayne over the Indians in 1794, came a tide of white settlers, including Quakers, bound for the Western Reserve and the frontier. It had been named for the governor of the first Northwest Territorial body established in Marietta in 1788. Ohio, a state since 1803, by now boasted nearly a million souls.)

Meetings in the scattered villages of Flushing, Gurnsey, Freeport, Brushy Ford, and Harrisonville were peaceful enough, but not entirely reassuring.

At Concord, a friendly place, it was a shock to be handed a rude warning from Jonathan Taylor, leader of the Orthodox at Mount Pleasant. At the "great Meeting house where the great battle of Ohio" had already been fought, Hicks would not be welcome, he knew.

The appointed Hicksite meeting at West Grove was postponed until afternoon at the request of the Orthodox who wished to meet there in the morning. Hicks and Price drove on, with no more than a glimpse of Mount Pleasant, the seat of the prevailing Quakers. They had to shorten the day's drives in the biting winds and heavy snows of January, as they went from meeting to meeting. One session, or meeting, a day was the limit. Through it all, Benjamin remained "kind, tender and affectionate, and an example of righteousness."

The lack of news began to tell, in the doldrums of February. Hicks was seized with such homesickness that he wrote Sarah to be ready to meet him the night of March 10 in Philadelphia. He felt sure that this would come about, but, if not, they would "meet again" in Heaven where all troubles "cease." Among the many to whom he sent greetings were his "hands," Louis Jones and Morris Croasdale, a descendant of his beloved William Penn.

In Trenton, Ohio, on February 21, Hicks preached to a meeting filled to overflowing and beyond the doors. Many stood outside on the thawing ground and strained their ears to hear him. He was also encour-

aged by a Meeting for Sufferings that followed, there, not too far from inimical Mount Pleasant. ("Sufferings" meant, traditionally, the persecuted.) It agreed unanimously to order and distribute two thousand copies of the "exposé of modern skepticism" by Edward Gibbon, to undermine the Orthodox establishment.

Grateful to be "reasonably well" and in that way "wonderfully favoured," he wrote to inform the family that he was homeward bound and that he had not "missed a meeting nor laid by a day." He would look back on a humble meeting held in an old cooper shop at Pike Run as the most memorable, he said. He asked that Louis and Morris shell "three or four bushels of corn" to mix with "two bushels of wheat shoots" for his horses. They were told to cut straw "fine and nice" for the stalls. "I shall travel steady on."

He departed before a distressed letter from Beulah Twining could overtake him. She had been supervising the farm work and Edward's hired man Charles, who had gathered about forty bushels of corn but not yet threshed the cut but disappointing buckwheat. She was critical of Hicks for having told Sarah to sell the stoves for the money to buy firewood. Rather than permit such a thing she had ordered Charles to cut some of her own trees instead. "This, Edward, I consider a duty," she wrote. As for Sarah, "her concern appears to be wholly for thee"; she would have cooked and lived by the open fire with the children for his sake.

Another piece of news did not reach him on his journey. When it did so, he suddenly felt much older, more careworn, as he faced the struggle for preservation of the "primitive" faith of Friends without their leader. Elias Hicks was dead.

A Peaceable Kingdom of Mourning
1830–32

*E*dward importuned his fellow Hicksites to close ranks and rest their hopes in the young, now that Elias was lost to them. He had doubts of his own time on earth. He pleaded that unity was more necessary then ever in those turbulent days of change under President Andrew Jackson.

To comfort the bereaved Friends with a reminder of their departed leader, Isaac G. Tyson of Number 240 North Eighth Street, Philadelphia, printed a small mourning card. It bore a full-length silhouette of

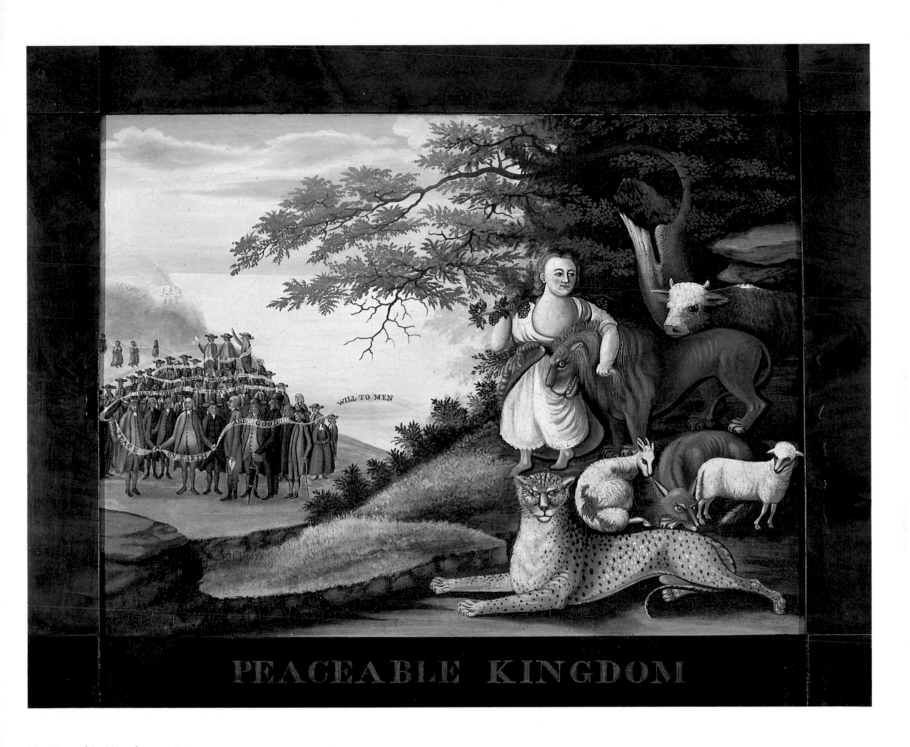

The Peaceable Kingdom, *1830–32.*
Oil on canvas, 17⅝ × 23⅝ in.
Courtesy the San Antonio Museum Association, San Antonio, Texas

Elias, after the larger original made by John Hopper some years before. The card remains among the Hicks memorabilia. It inspired a *Peaceable Kingdom*. Using it as a model for the figure of Elias, the artist sketched his composition lightly in pencil on the ground coat. He then applied color to suit his imagination. The precise meaning of the landscape has for long invited wide speculation. Undoubtedly, the following lines from the Book of Isaiah are answer enough:

> *This is what Isaiah, son of Amoz, saw concerning Judah and Jerusalem. In days to come, the mountains of the Lord's house shall be established as the highest mountain and raised above the hills. All nations shall stream toward it; many people shall come and say; "Come, let us climb the Lord's mountain to the house of the God of Jacob, that he may instruct us in his ways, and we may walk in his path." . . . He shall judge between the nations and impose terms on many peoples. They shall beat their spears into pruning hooks; one nation shall not raise the sword against another. . . . Let us walk in the light of the Lord!*

In his *Memoirs*, on page sixty-five, Hicks speaks of the "light" that was "secretly operating on visited souls in all nations" for Peace on Earth since the Nativity. On "the mountain of the Lord's house" he said that "all nations should flow," and reach "the kingdom that all men were to PRESS INTO."

Frederick Tolles hesitated to conjecture that the hatless central figure in the landscape, wearing a wig and shad-belly coat, was Washington, although he saw a resemblance. (Tolles, like others, took the mixed throng for a Quaker one because of the number of tentatively and also readily identifiable Friends.) Elias stands a little apart, as if a newcomer to the "men of all nations," among whom were Fox, Barclay, and Penn. Tolles thought the fire on the mountainside might be the pyre of the martyr Michael Servetus.

The cabalistic hooded females may be those mentioned in a long poem that Hicks was due to write. He saw them thus on "the holy mountain" of the mourning picture. If so, he paid them this tribute in verse: "On woman's mercy the whole man depends,/The first, the last, the best of earthly friends." Certainly to have left them out of the prophetic scene, as if women were forgotten, would not have been pleasing to Quaker womenfolk, many of whom were ministers.

In this endlessly fascinating, chimerical Quaker species of ex voto, the distinguished company of the dead is encircled by a banner that drifts on up the hills, to disappear on its way up the mountain. On it Hicks

lettered: "Behold I Bring you Tidings of Great Joy, Peace on Earth Good Will to Men." In two versions of this *Kingdom*, "Mind the Light," the admonition of George Fox appears, echoing Isaiah 2:1–5: "Let us walk in the light of the Lord."

Edward Stabler of Alexandria Meeting, whom Hicks had met at New York Meeting, wrote in a letter that the just would be lifted up to Heaven under the "banner" of love, a statement that is the answer to one art historian's belief that the banners were a demonstration against the Orthodox.

A new and docile enough leopard stretches full length across much of the lower canvas, as if to be both subject and protector of the girl in the Westall-inspired group that is the real strength of the picture. The righteous gaze of the leopard pricks the conscience of all before him. Instead of a "little child" we behold an adolescent girl in pantalettes and modest long skirt. She is Quaker youth personified, to whom Hicks was continually saying the future belonged. Her freshness and innocence contrast poignantly with the male throng no longer of this world. Her eyes, unlike those of her animal friends, are bewildered in one version; theirs are not hostile but somewhere between pensive and saturnine. The haunting left half of the picture is countermanded by symbols of life, hope, youth, and redemptive change.

The dead, broken tree of the Winterthur *Kingdom* contrasts movingly with the young one. It has its counterpart in a poem addressed by Hicks to Johnson, in which, a few years later, he speaks of the "liberty tree grown from the seeds of freedom," to whose shade "thousands repaired," until evil interfered: "When lo! a bad disease was soon descried/. . . The bloody lichens dire disease did stick/To all those limbs." His leafless branches that peer out of *Kingdom*s of every stage, his love of luxuriant foliage, and his massing of trees in the foreground and middle ground suggest Dürer and his followers. So does his introduction of smaller, distant trees. His crossed tree trunks call those of Giovanni Bellini and Claude Lorrain to mind. Prints of the kind were as near as Philadelphia. Any attempt, or the inclination, to draw Hicks's landscape painting into the mainstream of American art of the Romantic Age would tend to be sophistic. It is hardly in keeping with his free-ranging reference to whatever "period" suited his purpose, through engravings. He could not be, and was not, bound by periods or "influences." His purpose, at least in his landscapes, was wholly scriptural for fully forty years, when not patriotic or otherwise inspirational by good example. His "Age" is the mainstream—but in its deepest currents—of the self-

Printed by Isaac G. Tyson
after engraving by John Hopper,
Elias Hicks, *Silhouette.*
Enlargement of 3 × 2 in.
mourning card, 1830.
Hicks Family Collection

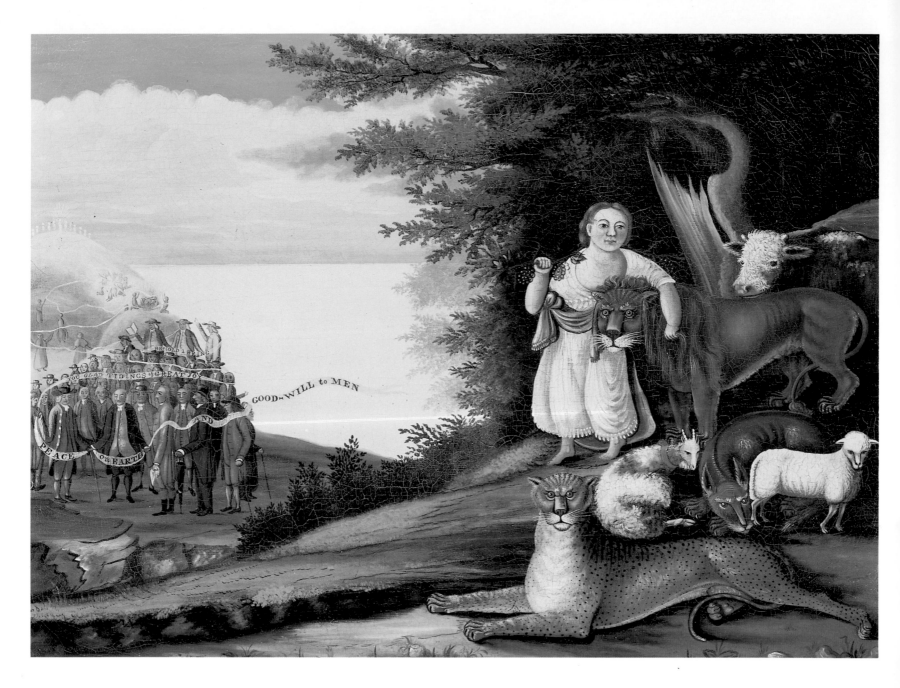

The Peaceable Kingdom,
1830–32.
Oil on canvas,
17½ × 23½ in.
Yale University Art Gallery,
bequest of Robert W. Carle, B.A., 1897

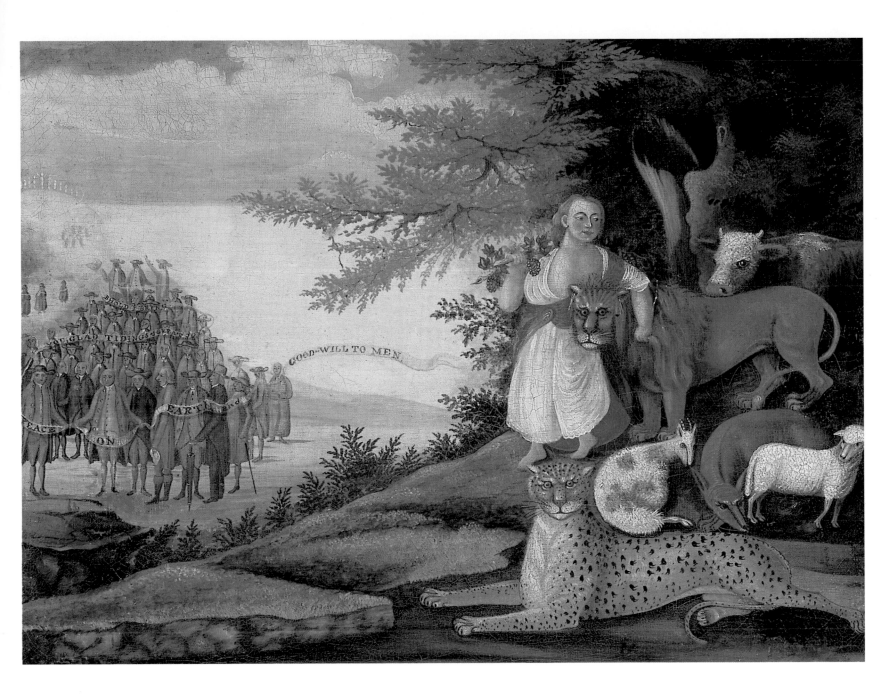

The Peaceable Kingdom,
1830–32.
Oil on canvas,
17³/₄ × 23³/₄ in.
Friends Historical Library
of Swarthmore College

taught. In his dependence on the direct observation of nature for color Hicks painted the wonderfully variable moods and hues of the skies of Newtown. Without hints from any trend, and from necessity, he did full justice to the changing seasons of Bucks.

My analogy of years ago, drawn between Hicks and Blake (1757–1827), now seems on the whole to be only a marginally interesting non sequitur. Blake remains an enigma, Hicks a paradox. Both are to be cherished as unique, the former as a somewhat possessed formal master, the latter untrained but brilliant in his fashion and far less tormented than Blake.

The mourning pictures are truly, and specifically, memorials to Elias Hicks, even as the *Kingdom*s are evocations of Isaiah's prophecies. Hicks abandons this genre for a return to Isaiah, and the fulfillment of his prophecies in the peace-loving efforts of William Penn.

Lamb

Hicks sketched a lamb in pencil on the back of one of his mother's two surviving love letters to Isaac. One of several painted versions appears in the mourning *Kingdom* at Yale University.

The lamb, an icon, is the first animal mentioned in the Bible, which alludes to it 179 times. Lambs may still be seen on the walls of the catacombs. The Book of John reads: "Feed my lambs (30:5); "Behold the lamb of God which taketh away the sin of the world" (1:25).

Shortly before Philadelphia Yearly Meeting in May 1831, the redoubtable old Emmor Kimber of Kimberton, thirty miles northwest of Philadelphia, gave Hicks a friendly reprimand. To the reluctance of Hicks to attend and witness further drifting away from tradition he responded without mercy. Hicks had no business to be "sunk" and "discouraged" at the very time when he should be ready to arise and defend the old Discipline "on the Meeting floor." Who, he asked, was not a "reformer" if not Hicks himself, and on at least a dozen counts. If he, his friend regardless, had been in Israel when God "commanded that a serpent of brass be set upon a pole," Edward would not have done as God told him. He would have fled the scene in a huff and told it on the mountain. "Reformers!" scoffed Kimber, "and thou, after all, art one of them!"

Lamb, c. 1831–32.
Drawn in pencil by Hicks
on back of love letter from
his mother to Isaac Hicks.
Hicks Family Collection

There was more than an aching disinclination to attend. Spring planting was underway. To provide young Isaac with the additional acreage that he wanted, and which the sale of a cow and fowl or two could not buy, Hicks was hard put to think of a way. Despite a mortgage of $207 held against him by the stage driver Sutherland, he borrowed $143. Forgetting his hatred of usury for the moment, he demanded of Benjamin Wiggins twenty dollars' interest on the thirty-seven that Wiggins had owed him for years for coachwork.

The sale of a new barouche to his neighbor John Taylor helped. Indeed it repaid the hasty loan. Soon after Taylor left for Virginia, Hicks received an aggravating letter from Loudon County. The writer invited him to drive a barouche like Taylor's down on approval, and permit an attempt to sell it at a profit. If the self-appointed seller failed to receive a gainful offer, he himself would buy the vehicle. If he succeeded, he would

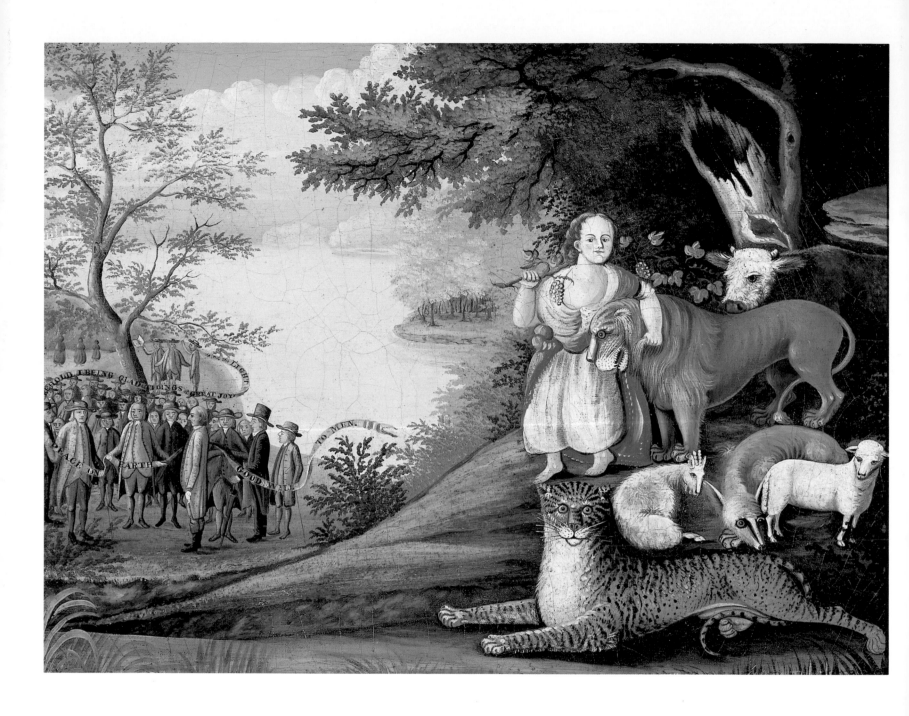

The Peaceable Kingdom,
1830–32.
Oil on canvas,
17⅝ × 28⅝ in.
Courtesy the Henry Francis
du Pont Winterthur Museum

order one for himself as well. Hicks rejected the proposition. He had other plans.

By mid-June, he was on his way to Salem, New Jersey, to preach. First he drove Susan to the stagecoach depot for the New Brunswick ferry. She had been invited to the wedding of Caroline Hicks, granddaughter of his dear Elias and daughter of Valentine, to William Seaman, a physician of Brooklyn. Her faithful but tedious and unacceptable suitor, Mahlon Buckman of Newtown, had brought the bridegroom's best man to call on her a few weeks earlier. She and the sensible, prosperous pharmacist John Jacob Carle of New York City had taken to each other. Save for visits from his maiden aunt Phebe Carle, he lived alone on Peck Slip northeast of the Battery. He was a descendant of the Valentine family and therefore a cousin, if a distant one, of Caroline and the Hickses of Jericho. The Valentines, Hickses, and Carles all stemmed from seventeenth-century Long Island settlers, mostly Anglican, who made fortunes buying, and sometimes seizing, large tracts from the native Indians.

New Horizons,
New Landscapes

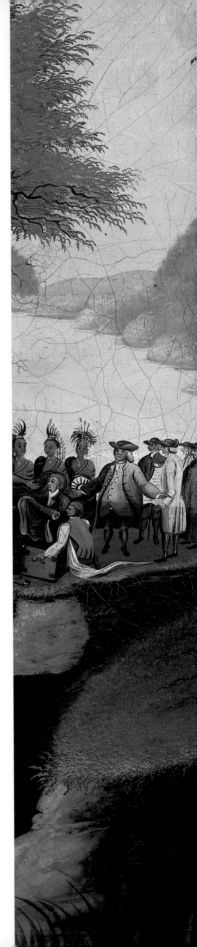

The Peaceable Kingdom
(detail), c. 1834.
Oil on canvas, 30 × 35 in.
The National Gallery of Art,
Washington, gift of
Edgar William and
Bernice Chrysler Garbisch

*V*alentine was supposed to meet Susan at the Jersey ferry but instead she was greeted by the "very polite" John Carle. "We dined on board and received every attention," Susan wrote the family. Seaman was at the wharf in Manhattan, waiting to drive her to Jericho by the light of a new moon.

Her own engagement was not long in coming. Edward Hicks wrote this poem for her:

> *True virtue leads to Glory*
> *Its right way's by the Cross.*
> *Neglecting it till hoary,*
> *Much precious time is lost.*
> *Dear Susan then be wary,*
> *While bright youth's on thy side,*
> *Deign not with fools to tarry,*
> *Such who glory is their pride.*
> *Thy days will then be joyful,*
> *Thou will have good friends in store,*
> *And shun all that is awfull*
> *Crown'd with peace forever, More.*
> *As the Moon doth shine, with borrowed light,*

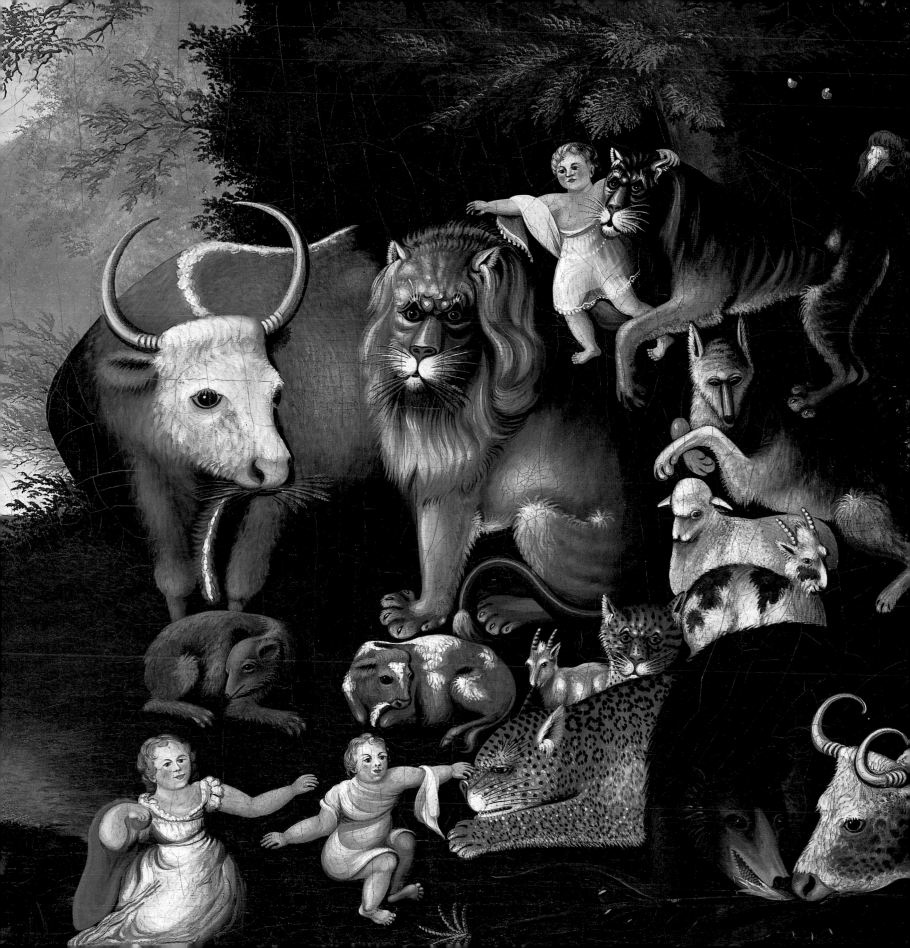

From the bright rays of the Celestial Sun,
So doth Virtue shine, with light divine,
From the Eternal, where light at first began.

Susan was married in Newtown in May 1832. There could have been no dowry at the time. It was with some difficulty that Hicks managed to pay a former "hand," Thomas Goslin, the ten dollars he owed him. Goslin wrote out this demeaning receipt: "Whereas, having had dealings with Edward Hicks for upwards of twenty years, and it appearing likely through his negligence that there would be some difficulty of making a statement of our account to full satisfaction, we have mutually agreed to pass receipts. . . ." An order from Benjamin Price for a carriage stout enough to carry his whole family helped save the day. Hicks promised his faithful friend a vehicle fit for a "load of wood."

Susan and John had little more than settled down in Peck Slip than rumors of cholera in Canada reached New York, which began to prepare for "that scourge of Europe." "A thorough cleaning of the city has commenced," wrote Susan. Gutters, cellars, yards, stores, and thoroughfares much in need of attention, even in good times, had to be showered with "chloric of lime" that left the streets "literally white." Camphor and lime, as well as drugs, began to be in great demand at the Carle establishment. Some of the city's "finest citizens" were among the first victims of the wave.

Susan wrote to let Newtown know that John had closed the house, and that she would be staying in Brooklyn with Caroline Hicks Seaman until the worst was over. She also imparted some advice. The family must avoid the night air and "exertion," and eat no "fruit, cucumbers, cabbage, green apple pies, or fruit pies, or peas, beans, new potatoes, or beets." Should any of them be stricken, they were to be covered to the wrists, feet, and ankles with mustard plasters. On no account was the victim to be rubbed if cold.

Newtown escaped the plague. Philadelphia experienced the horror. Twenty-one-year-old Edward Hicks Kennedy, son of Eliza Violetta who, it will be remembered, drowned to save him, was an intern at the Alms House. Although his reports were grimmer than Susan's, they were not without his Irish humor, acquired through grandparentage. Susannah Gain had arrived in Bucks County from Belfast with a New Testament dated 1599 in her trunk. She married James Kennedy, also of Irish origin.

Both were staunch Presbyterians. The young intern had been reared by stepmothers who were sisters. On account of Eliza Violetta, Edward Hicks had made a pet of him, and the fondness was mutual. During a recent visit to St. Louis, Kennedy had written to say that the fame of his uncle as a preacher had spread to Missouri.

Elizabeth was the recipient of his letters, which the whole family shared with great and understandable interest. He described the new Alms House as "elegant" on its twelve acres, and "more like Windsor Palace than a receptacle of filth." He was in charge of half a dozen aged patients whom he cupped, shaved before applying mustard plasters, and treated with pills as if he were an "oracle." In her silk gown, the daughter of the matron made the rounds with a tray of wine and crackers as if at a tea party. There was bedlam that caused Kennedy to consider chucking the whole business and returning to Newtown, for which he was homesick. He had had enough, too, of the drinking and stealing about him. Of Newtown he begged only that they pity him as they ought but stop fretting about him.

The ideal marriage of Susan to John Carle, coinciding as it did with the waning of the heavy mourning for Elias Hicks, can be credited with a radical change in the mood of the *Peaceable Kingdom*. Edward Hicks took leave of the melancholy, arcane scenes of death and youth that he had been repeating, and, with the cause of youth, returned to the light, to buoyancy, and what the future might hold.

*T*he Carles celebrated their first anniversary in Newtown. Susan persuaded her parents to drive back with them for a brief visit, after which she and John would drive them home.

The return journey from Peck Slip was pleasant except for the expectant Susan. They paused at Baker's Tavern to rest, and to water and feed the team. The lemonade and Jersey plums were a treat.

John had promised Susan a three-hundred-mile boat trip up the Hudson before she became housebound. Her account of the "grand" journey does credit to the post-colonial school system and its teachers. On the steamboat were the "celebrated Black Hawk" and six of his tribesmen. In Albany, John hired a coach and driver for a ride to Neskayuna, a tourist attraction on account of its "singular Shakers." Susan thought their dancing and singing "a complete burlesque upon religion." The couple returned to Albany by way of the Cohoes Falls, a spot pleasing beyond description, and continued south over the remarkable macadamized road from there to Troy.

Susan was fretful on the return. When she heard that one of the New York cousins had sent a carriage to Newtown for paint and repairs she wrote Mary and begged to ride back with the driver. Mary did not take up the invitation.

Growing dread of her confinement caused Susan to repeat her plea for a visitor in December. She asked that, whoever came, she should bring twenty eggs for John's favorite plum cake. It was Elizabeth who went to her, Elizabeth whom she would not let out of her sight, even to return the social calls of Caroline Hicks Seaman. At least, as she joked to her sisters in her letters, she did not have to dress chickens or milk "Splatterdash." Mary sent some "pattrens" with a request for dress goods. While her father nursed a cold beside the kitchen stove he, too, wrote. He said that her mother was close by him with her mending, but keeping an eye on Mary who was supposed to be watching the cider on the boil for apple butter. He spoke of a lively wedding they had attended but mostly of his wish that Elizabeth should come home and fill the "great void" caused by her absence. He thought that Susan could be left to the servants and to the "Heavenly Father who is able to strengthen her and bring her through every difficulty." He joked feebly that her discouraged admirer Jonathan Schofield had given up and moved to Ohio.

Elizabeth wrote to Edward Hicks Kennedy in reply to his outpourings. He asked whether she would follow Susan's example or make the best of "an old maid's annuity—and a lap of dogs and pet cats." He had been making the rounds of cultural events in Philadelphia with the Easton painter Samuel Moon, who was about to visit Newtown and paint his father's "superb face—a real sneezer on the Napoleonic order." They had admired an Adam and Eve painting (by Cranach?). Kennedy thought Elizabeth the image of a portrait of Anne Boleyn. His praises of "Rembrandt, Guido, Van Dyck, Reynolds, and West" could hardly have failed to be passed on to his "Uncle Edward." The replies of Elizabeth to his more than cousinly devotion took refuge in aphorisms.

Two days after Christmas 1833, Phebe Ann Carle was born. Susan and John did not choose the name without first consulting Newtown. Edward Hicks was more interested in Elizabeth and when she would return. He was too unwell to work and her mother was down with a sprained ankle for the second time. "We want to see thee and have thee home again," he fretted. Mary was worn out after the butchering of the pigs before the sausage-making. Elizabeth did not deny that she wished to "come home too bad for anything."

Things were not all bad with Mary. Her father mentioned in another

letter that she was still exchanging poems with the son and daughters of Halladay Jackson of Darby. Young Jackson had memorized, and could recite if urged, 120 lines of her favorite poet, William Cullen Bryant. He himself quoted Edward Young's "Night Thoughts on Life, Death and Immortality," after telling Elizabeth about numerous funerals she had missed. He thought that Isaac had fared best in what had been "a remarkable year." He had hired carpenters to build a house down the street, although Sarah Speakman, whom he was courting, did not seem serious. (Nor, if Isaac had but known, was she ever to marry; her lonely grave is only steps away from his in the Friends Meeting burial ground.) Hicks had a feeling that, somehow, his son would remain a bachelor for some time to come. A coughing spell put an end to his musings to Elizabeth.

The Peaceable Kingdom
An Enigma

From the day that Edward Hicks allowed his second cousin and constant, small shadow to amuse himself with pencil and brush in his paint shop, the boy was bonded to picture-making. Even the first of, his attempts drew attention, showed promise. A longstanding, quite generally acknowledged enigma, that of the *Peaceable Kingdom* of which the Cleveland Museum became sixth owner some years ago, still stands. Should it give way? It seems traceable to Thomas Hicks, aged eleven, before the start of his apprenticeship to Edward, one of brief duration because of his higher gifts. The precocious great-grandson of the colonial prothonotary and chief justice of Bucks County was to embark on a career of solid if not remarkable success. The evidence is ample. What is new and palpable is recognition of the role of his first master, Edward Hicks. Three controversial oils in the catalogue raisonné of Mather and Miller— Numbers 61, 65, and 88: a *Kingdom*, a *Penn's Treaty*, and a *Washington Crossed Here*—might better be reconsidered?

The hypothetical date long given this painting is, like the attribution, open to question. Signs and "landscapes" painted by Hicks before 1820 were highly regarded and handsomely remunerated. It is therefore inconceivable that a forty-year-old could then have perpetrated work so patently adolescent. In 1827, and repeatedly until 1833, the American Sunday School Union, of which Hicks was a member, published a vignette of a peaceable kingdom scene by an unknown engraver on wood.

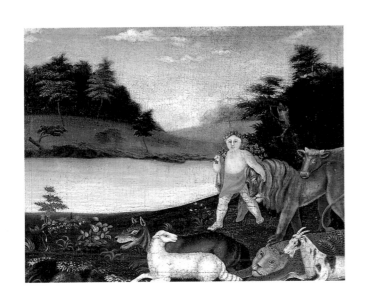

Thomas Hicks {?},
The Peaceable Kingdom,
c. 1833.
Oil on canvas,
18¼ × 23½ in.
The Cleveland Museum of Art,
gift of Hanna Fund

A

MEMORIAL

FOR

SUNDAY SCHOOL GIRLS.

FIFTH EDITION.

KNOWLEDGE OF THE LORD.

AMERICAN UNION.

SUNDAY SCHOOL

𝔓𝔥𝔦𝔩𝔞𝔡𝔢𝔩𝔭𝔥𝔦𝔞:

NO. 146 CHESNUT STREET.

1827.

Frontispiece of Knowledge of the Lord, A Memorial for Sunday School Girls *(Philadelphia, 1827, fifth ed.)* Rare Books, Free Library of Philadelphia

It decorated the title page of a paper juvenile, *Knowledge of the Lord, A Memorial for Sunday School Girls*, in a fifth edition in 1827, already alluded to. The little engraving was repeated on other penny booklets for young readers. It is significant that Edward Hicks signed a petition in the form of a poster put up by the Union in the London Coffee House of Philadelphia. The poster exists. The wolf with dripping tongue, the kid, and the lamb in the vignette are more than reminiscent of those in the Cleveland landscape, although the lamb is reversed. The print after Westall was of course the more motivating source. The background, easy for a beginner, relied on neither. The mood of the picture is hardly that of mystical prophecy, but one of jubilation. The somewhat morbid erosion is nearly obliterated by a charming stab at botany. The laurel wreath on the Westall boy, who seems to be dancing on air, is but another invitation to regard this *Peaceable Kingdom* as a pagan panegyric to nature from the spirited brush of an aspiring boy. That the picture was owned at one time by the Hayhurst family of Lambertville, not far from Newtown, is no hindrance to suggesting that it was by Thomas Hicks, apprentice of his cousin Edward, undertaken even before his apprenticeship.

The arched brows of the wreathed boy resemble those of Sally Hicks as he was to paint her about two years later, and again with academic skill near 1839. The brows of the girl in the next *Peaceable Kingdom* suggest that Sally was the model for Edward Hicks.

In view of the letter of John Comly in which he likened the potential gifts of Edward Hicks to those of Benjamin West, the date circa 1820 for so long assigned to this picture will not bear scrutiny. No essay so crude and childish could have inspired so much, if reluctant, admiration in 1817 for the possibilities.

The Peaceable Kingdom
With Sally as Youth. c. 1833

The importance of its youth to the future of the Hicksites in the Quaker schism becomes the keynote of the peace landscape. The detail of Penn's Treaty is restored. The landscape is once again luxuriant and relieved of the air of evening and unearthliness seen in the *Kingdom*s of mourning.

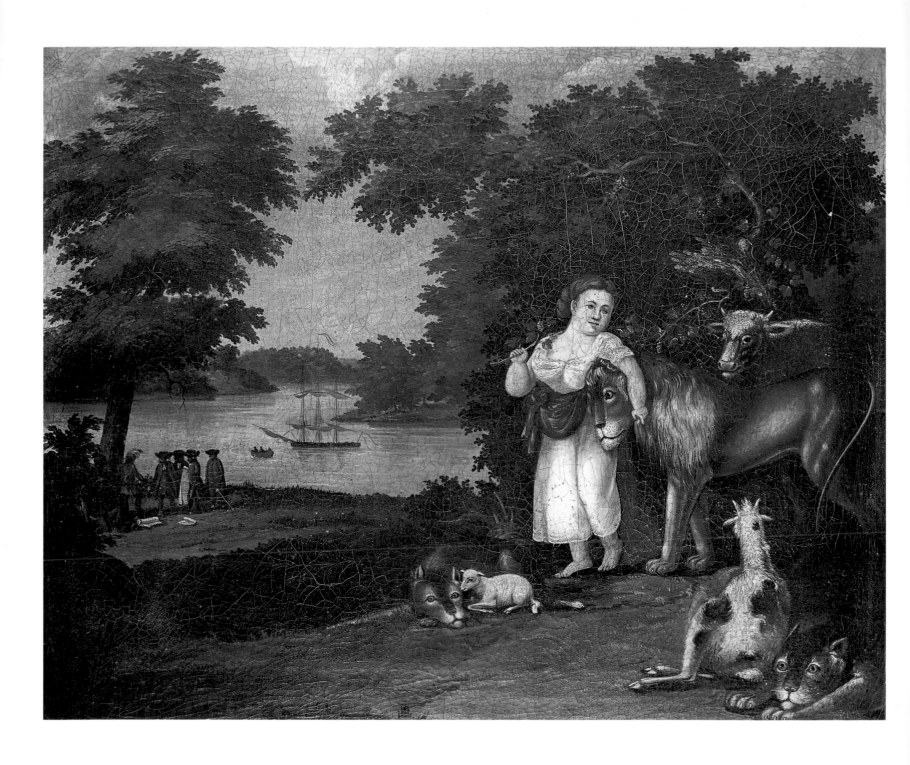

The fresh, living atmosphere reflects encouraging events in the family life of the painter. It follows the advantageous marriage of a daughter and the birth of the first grandchild.

This "little child" is almost womanly, and old enough to be Sally, Hicks's youngest. Her arched eyebrows and sweet demeanor match those in a likeness painted of her by her precocious cousin Thomas Hicks, before he became her father's apprentice. He was to paint her again, with much finesse, a few years later, and with the same stress on her noticeably arched brows.

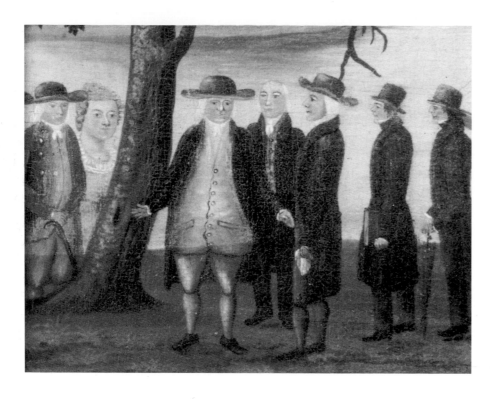

The Peaceable Kingdom
(detail), c. 1833.
Oil on canvas,
21¼ × 28 in.
Collection Peter Socolof

The Peaceable Kingdom
With Quaker Youth, Concerned Friends, and Columbia
c. 1833

*I*n this version, and there is none other similar to it, Penn and a fellow Quaker return to earth for a colloquy with two contemporaries of Edward Hicks, but no Indians, beneath a Liberty Tree. The other aged gentleman is sometimes identified as Washington. The woman whose mirage-like head is barely visible, to the left of the tree trunk, must surely be none other than Columbia, who figures in lines of verse addressed by the painter to Samuel Johnson of Buckingham:

> *The illustrious Penn this heavenly kingdom felt,*
> *When with Columbia's native sons he dealt;*
> *Without an oath a lasting Treaty made,*
> *In Christian Faith beneath the elm tree's shade.*

The winsome but by no means "little" child is manifestly equal to bearing the peace standard for young Hicksites. More mistress than playmate of the docile beasts, she is Youth.

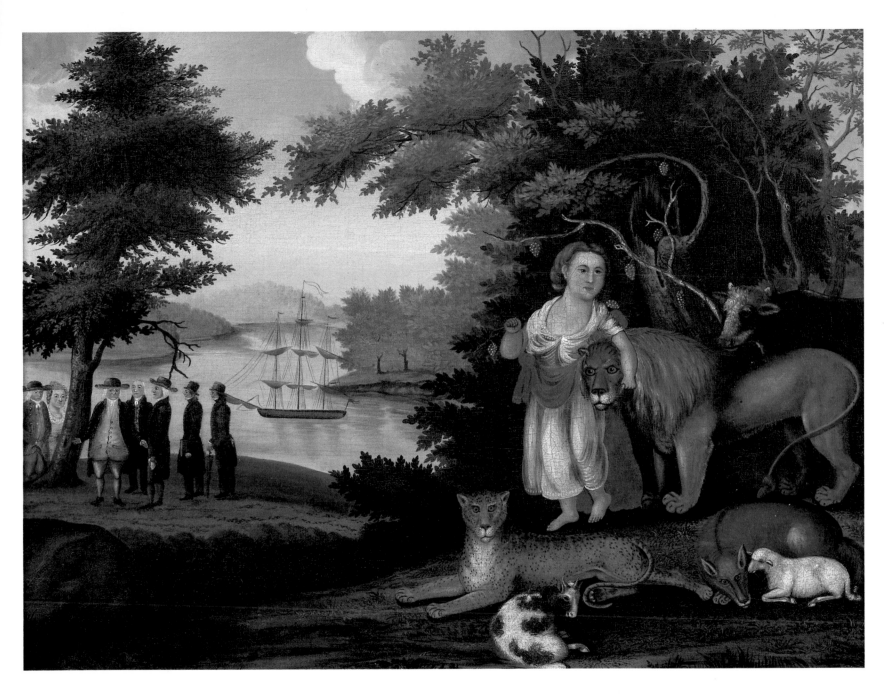

The Peaceable Kingdom,
c. 1833.
Oil on canvas,
21¼ × 28 in.
Collection Peter Socolof

The Peaceable Kingdom
With More Verses from Isaiah. c. 1833–34

The role of Quaker youth is again dominant. The elements of Verse 6, as conceived by Richard Westall, made way for Verses 7 and 8 of Isaiah with the introduction of new models. Instead of the Treaty scene Hicks celebrates a later moment in American history by means of a Liberty Tree, with two children in modern dress beneath it and near dens of asp and cockatrice. Scripture and patriotism are united. Hicks believed that the serpent symbolized cleverness and false pride, as well as empty attainment. He was still ambivalent as to naked, albeit innocent, figures and their suitability for the lesson.

"And the suckling child shall play in the hole of the asp,/And the weaned child shall put her hand on the cockatrice's den." According to legend, the glance of the cockatrice proves fatal if the serpent is hatched from the egg of a cock on a dunghill. As for the Liberty Tree, Hicks hails it in his reply to the poem addressed to him by the fervent abolitionist and friendly adversary, Samuel Johnson: "The illustrious Penn the needs of freedom sow'd/A Franklin watered, and the tree soon grow'd."

A lion seen leaving its watering place resembles one in a vignette of a peaceable kingdom scene on the title page of a children's paper booklet published by the American Sunday School Union—but one of many. A poster that still bears the signature of Edward Hicks as a supporter of the Union still exists. It was posted in the Coffee House, Philadelphia. The vignette appeared in the juvenile in 1827, and repeatedly until 1833 and perhaps later in still others. The lowering of the tail of the lion was a matter of spatial exigency on Hicks's part.

In his popular *Cyclopaedia*, published in Philadelphia in 1810, Rees wrote in his description of "*Felis*," the Lion, that "the lurking place of the lion is generally near a spring." Admitting "free use" of "a variety of works on nature," Chapman and Flagler in their juvenile of 1831, *The History of Animals, for the Instruction of Youth*, wrote: "The lurking place of the lion is generally chosen near a spring, or by the side of a river. . . ." Hicks was not without such guidance.

The painting went to Sally Hicks after her marriage in 1844.

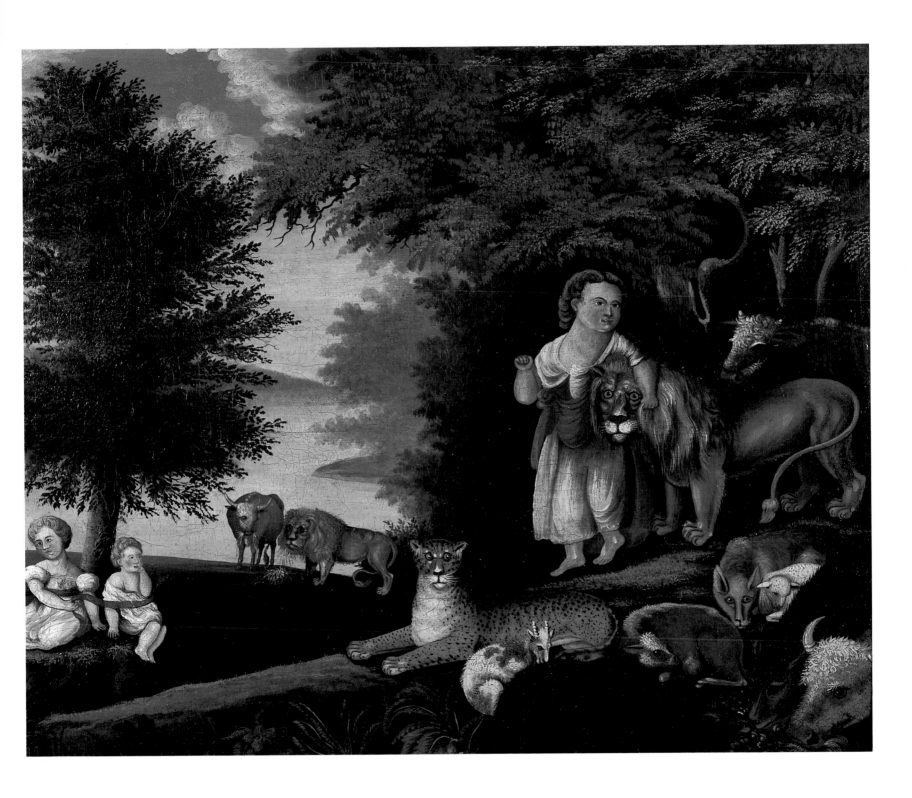

The Peaceable Kingdom

Were the landscapes of the prophecy of Isaiah to lose their freshness and variety, a source of occasional recompense toward Hicks's missionary travels would be lost. Praise and encouragement, and interest, would cease. Hicks took the logical but more demanding step of finding room for the teaching of Verses 7 and 8 as well as 6. Lest the extension be overlooked, he lettered the canvas below, "Isaiah, XI, 6, 7, 8." Why, one might ask, should he have chosen much less space on which to do so? A letter indicates that delivery of canvas from New York City to a merchant in Philadelphia, for relay to Newtown, was sometimes dilatory.

In this canvas of transition, the sleepy lion of Westall and Heath disappears, making way for a proud king of beasts who rests on his haunches while gazing formidably out of the canvas. He vies with the buxom adolescent girl for attention. Once more she is by no means a "little child" but rather the exemplar of Quaker youth. Again the Liberty Tree and the children at the serpents' dens take the place of Penn's Treaty.

The search for new models and sources of inspiration was by now never-ending. There was an ongoing lion hunt; he needed another, with eyes wide open. Having nothing else to guide him, the painter had much to learn, and doubtless did, from descriptions such as those of Abraham Rees, D.D., in the aforementioned *Cyclopaedia* of forty-one volumes published in Philadelphia in 1810–24. The work enjoyed the public confidence. Under "*Leo*," one reads in volume 14: "Tail long, body pale tawny . . . grand . . . shaggy flowing mane . . . huge eye-brows . . . round and fiery eye-balls . . . ears small, rounded . . . face covered with short, close hair of a pale tawny colour . . . mane descending, falls over the shoulders . . . heavy down almost to knees . . . belly and breast covered with very short hair, excepting the point of tail, furnished with a bushy tuft." Rees describes the leopard as to size, texture of coat, gradation of predominantly yellow color, and "rounded black spots" and circles such as Hicks painted with exaggerated care. To the circles, "dotted" in the middle, the white belly, the pale yellow eyes, striped white breast, and "fierce and cruel aspect," he was most painfully true. One cannot but wonder whether he saw the sorry stuffed lion at the Peale Museum upon its installation in 1810. In *Mr. Peale's Museum*, Charles Sellers writes that "the first lion was an unhealthy cadaver purchased for $50 from a showman . . . mounted and placed with the feline spec-

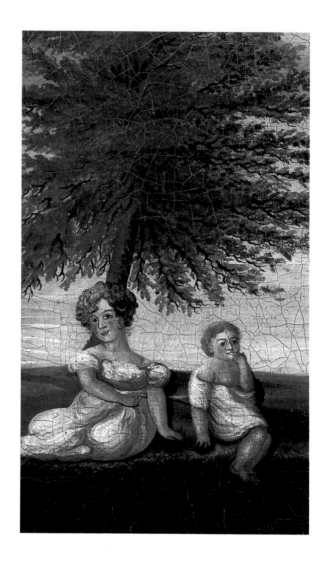

The Peaceable Kingdom
(detail), c. 1833–34.
Oil on canvas,
17⅞ × 28⅞ in.
The Metropolitan Museum
of Art, Garbisch Bequest

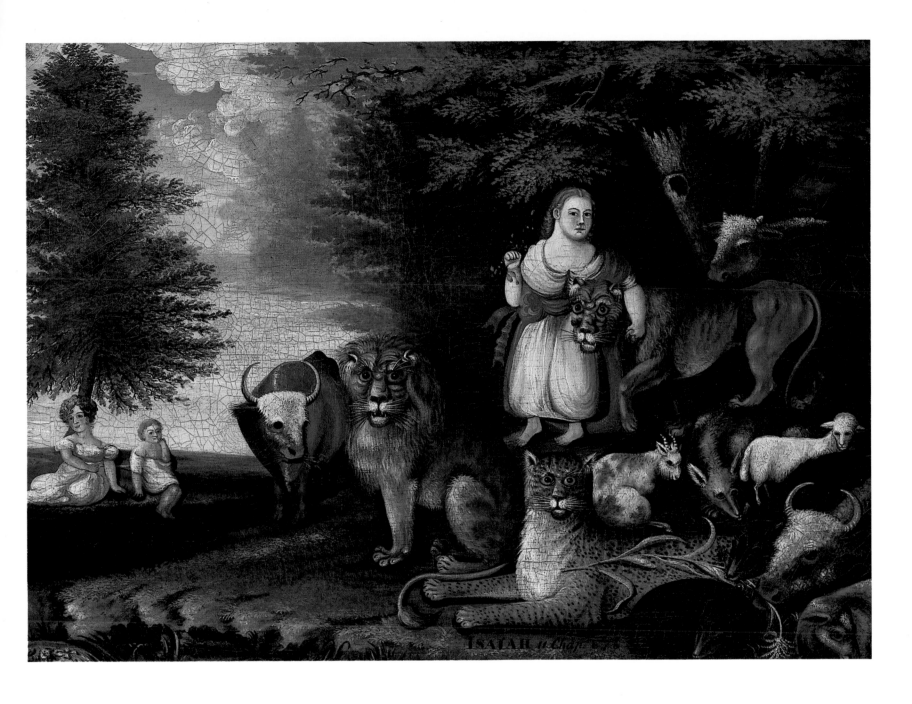

The Peaceable Kingdom, *c. 1833–34.*
Oil on canvas, 17⅞ × 28⅞ in.
The Metropolitan Museum of Art, Garbisch Bequest

imens." *Picture of Philadelphia* by James Mease reported in 1810 that the museum contained two hundred large quadrupeds mounted on pedestals behind an expanse of wire netting as well as smaller ones in glass cases. The famous skeletal "mammoth" stole the show.

One more departure from the design of Westall worth noting is the figure of a young lioness borrowed from the one in *Daniel in the Lions' Den*, borrowed in turn by its engraver Alexander Anderson, more memorable for his technique than for original compositions. (His indebtedness to Bewick, for one among many, is vast.) The engraving can be seen in more than one of the family Bibles in the Spruance Library, Doylestown.

Alexander Anderson (1775–1870), Daniel in the Lions' Den (detail). Illustration in Cornell-Krusen Bible. Wood engraving. Spruance Library, Bucks County Historical Society, Doylestown, Pennsylvania

*Left:
J. F. Rigaud, R.A.,
Happiness, c. 1799.
Watercolor study for one of
four frescoes for Guild Hall,
London. 20¾ × 16 in.*

The Peaceable Kingdom
With *Happiness*. c. 1833–34

Again chapter and verses are lettered low on the canvas. The Liberty Tree returns. Beside the lion is an ox more imposing than its forerunners. The "little child," entirely new, shows the influence of two engravings, the aforementioned vignette in a children's book, and an engraving, *Happiness*, by Thomas Burke after J. F. Rigaud, owned by

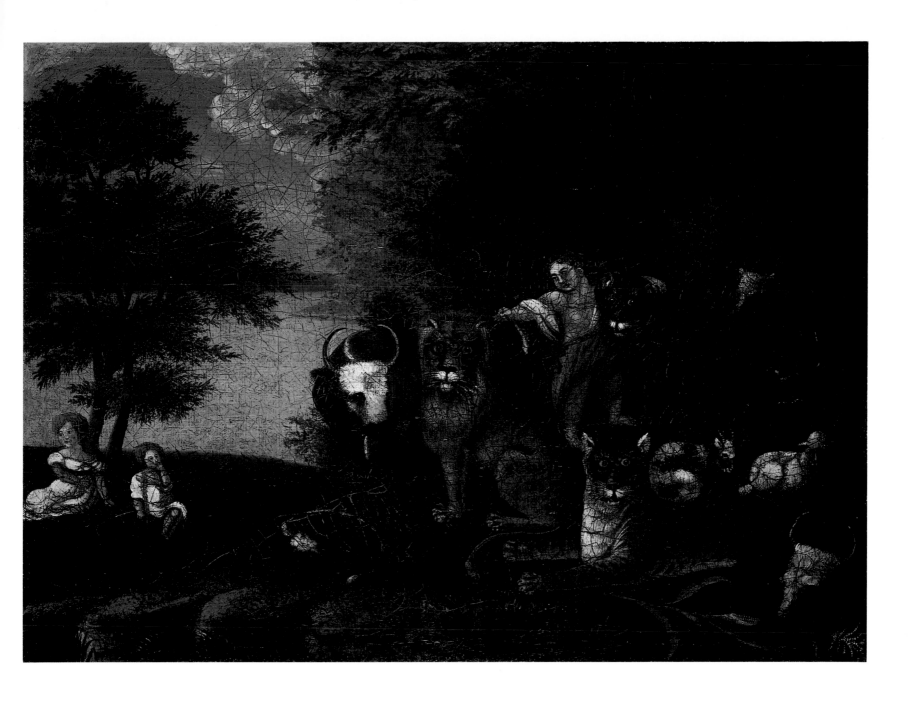

The Peaceable Kingdom (with Happiness),
c. 1833–34. Oil on canvas, 17³/₄ × 23⁷/₈ in.
Photo courtesy Christie, Manson, and
Woods International, Inc.

Hicks. *Happiness*, *Providence* (of which Hicks also had an engraving, by Benjamin Smith), *Innocence*, and *Wisdom* were published in London in 1799 by Boydell's Gallery. All four now exceedingly rare prints were engraved by public demand, owing to the popularity of the four fan-shaped frescoes high in the corners of the Guild Hall. The Hall, with its frescoes, is long since gone, but the watercolor studies by Rigaud, all slightly different from the engravings, have survived.

That the Burke engraving was Hicks's chief inspiration is confirmed by its use of an olive branch, instead of the grape used by both Westall and Rigaud (and, for that matter, the classical prototype, *Hermes and the Infant Dionysos* by Praxiteles). Logically, Hicks departed from his model by omitting the "serpent of brass" because there *is* none in the prophecy of Isaiah. "The branch of Jesse," from whence comes "the Peaceable Kingdom of the Branch," was the *olive*. Its use was not only correct but, from the standpoint of design, more expedient than the sacramental grape, a later Christian icon. This is not to theorize that Hicks, who had used the grape in many earlier versions, finally rejected it for theological reasons. He was simply following his model, as always, or so it would appear.

Here, there is the first hint of the painter's awareness of the *Madonna of the Chair* by Raphael. The source of the infant at the den of the serpent is unquestionable in versions to come. Hicks was not the first to borrow from Raphael. By his inability to do more than achieve a crude semblance of the infant of the master, here and in other such attempts, Hicks succeeded, in a manner of speaking, even when he failed. In aggregate, the awkward elements—imbued with extraordinary sincerity and unmistakable purpose—triumph, captivate.

The canvas is inscribed "Isiah [*sic*] 11 Chap. 6, 7, 8 1. c.[*sic*]."

Above:
Engraved by Thomas Burke
after fresco by J. F. Rigaud,
Happiness *(detail), 1799.*
Formerly Hicks Family Collection

Right:
Engraved by Edwin and
Maverick after Raphael,
Madonna of the Chair,
for Collins's Quarto Bible,
fourth edition, 1816.
Courtesy New York
Public Library

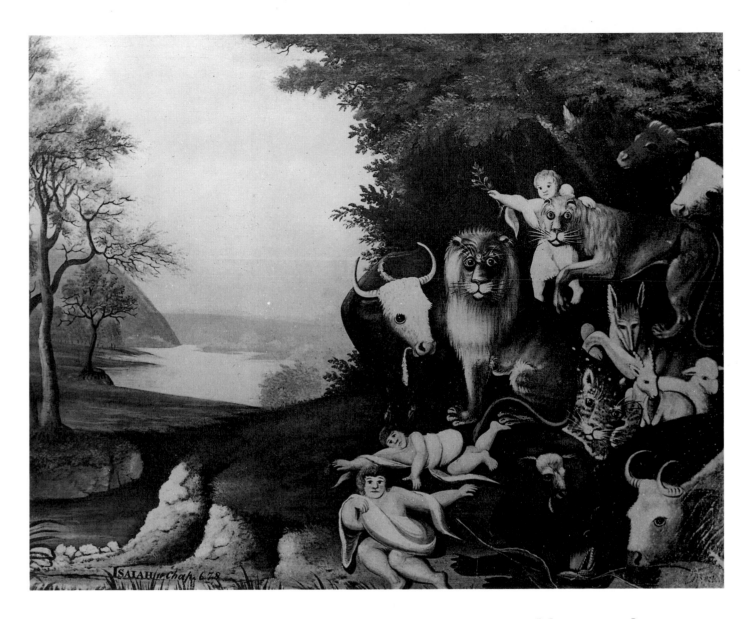

A Missing Peaceable Kingdom

The Peaceable Kingdom,
c. 1833–34.
Oil on canvas,
23½ × 17½ in.
Formerly in the collection
of Scripps College,
Claremont, California

This painting disappeared from Scripps College in 1966. Hicks's fascination with Raphael is paramount. The awkward, Italianate figures of boys refuse to scale down into infants. One lies prone beside a "den." This represents both their debut and their swan song in the *Kingdom*s. Both ox and lion are more formidable than heretofore. The lioness from the Bible engraving by Northcote comes closer to the model.

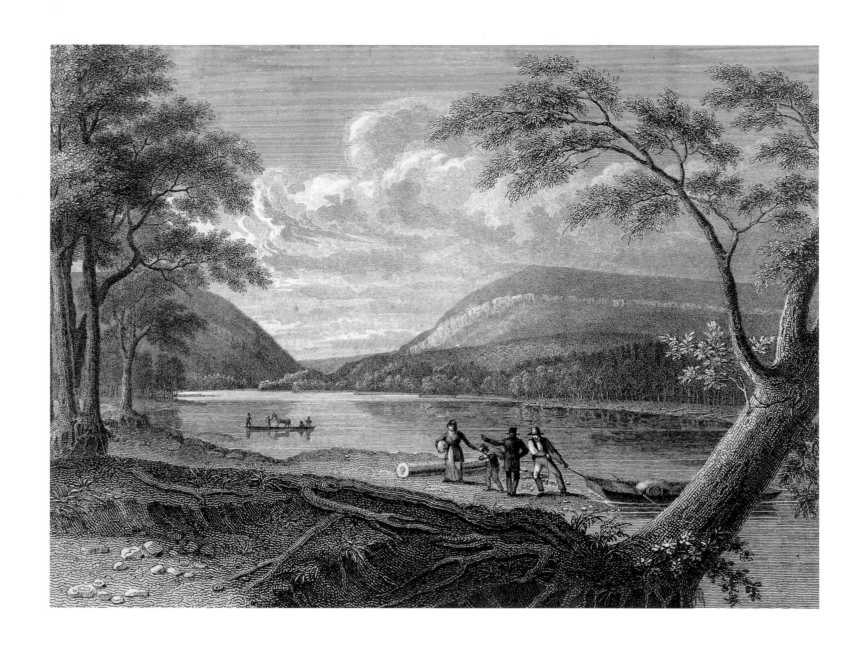

Drawn and engraved by Asher B. Durand,
View on the Delaware,
in The American Landscape *(New York, 1830).*
New York Public Library

After crowding three humans and a dozen beasts onto the canvas, Hicks inserts "Isaiah, 6, 7, 8," below left, again calling attention to the full dramatis personae of the prophecy. Gone, for good, is the Liberty Tree and, for the time being, the peace treaty scene, while Hicks makes the most of *The Delaware Water Gap* as engraved for *The New York Mirror* by Illman & Pilbrow. The printers had copied it from a handsome, formal engraving on steel by Asher Brown Durand. The son-in-law of Hicks often posted the paper to Newtown.

A wave of grippe seized Newtown in the spring of 1834. The neighbors took turns waiting on the Edward Hicks family. The son of one came each evening after work to bring in wood and mend the fires. Mary's alarming state caused her father to send to Philadelphia for the distinguished Quaker doctor Joseph Parrish. The aged physician had been making calls on foot from door to door in afflicted neighborhoods, and nodding for his mare to follow with his gig. It was out of "sympathy and love" that he chose to go to Newtown instead of to Joseph Bonaparte who had a coach and driver in Bordentown to transport him. To Edward's offer to pay, Parrish murmured, "No my dear friend, I cannot take thy money."

Halladay Jackson sent his carriage for refurbishing in April, with an invitation for Hicks to return it in person and preach to Darby Friends Meeting. But Hicks refused, saying, "I feel a renewed concern to finish the work that is given me to do." He had accepted the "responsibility" for meeting the tuition of "poor John Rohney," an orphan, apparently, enrolled in the school of Joseph Foulke, a Friend of Montgomery County. But he thought it would be helpful if Jackson could contribute "15 or 20 dollars" toward the seventy that were needed. He himself, ever short of ready money, painted a *Peaceable Kingdom* that he signed and dated "1834" for presentation to Foulke.

Benjamin Ferris sent his carriage up from Wilmington for fresh paint and new "ribs." With it came a letter advising Hicks not to relax his efforts to "reach the good judgment" of fellow Friends by his fearless ministry. No one took the words of Ferris lightly. He, and Hicks no less, admired Andrew Jackson whose party owed its victory in the autumn of 1834 to Hicksite support.

The Peaceable Kingdom
For the Tuition of John Rohney?

Edward Hicks presented a landscape to Joseph Foulke, presumably in lieu of cash for the tuition of a youth whom he chose to regard as his "responsibility." Foulke was a wheelwright by trade, but also founder of a Friends school for boys. Fifteen years later he would deliver Hicks's eulogy.

The decision of the painter to date his canvas "1834" has proved a boon to the approximations, by historians, of the *Kingdoms*' mid-1830s chronology. Here the "little child" of the *Happiness* by Rigaud appears again, replacing the figure of Quaker youth and stressing instead the new verses from Isaiah. To represent young Friends, however, a little girl sits close to the cockatrice's den; she is dressed like any other child of the day. The babe in her charge, inspired by Raphael's infant of the *Madonna of the Chair*, strokes the snout of the leopard for the first and only time in the compositions of the *Kingdom*. The oft repeated young lion appears here again but is due to disappear before too long.

The Peaceable Kingdom
A Sequence of Seated Lions

No fewer than five landscapes, more or less identical, and commanded by a lion that rests on his haunches, lord of all he surveys, have found their way into public institutions of note. None is dated; which one came first remains a mystery, but the letter to Hart supports the supposition that they were painted one after the other to pay for missionary travel. Having worked out the composition, Hicks could go ahead with greater rapidity than if he had not copied one after another, each from each. Minor variations were easy, incidental. Hicks wrote a poem, "The Peaceable Kingdom," for explanation and had it printed in Newtown. He hung a framed copy on a wall of his bedroom.

Below:
Edward Hicks's versification of Isaiah XI, 6–8, with which the artist explains his addition of symbolic animals to The Peaceable Kingdom. *Photo from Hicks's framed copy*

Opposite:
The Peaceable Kingdom *c. 1834. Oil on canvas, 30 × 35 in. The National Gallery of Art, Washington, gift of Edgar William and Bernice Garbisch*

PEACEABLE KINGDOM.
TAKEN FROM THE ELEVENTH CHAPTER OF THE PROPHET ISAIAH.

6. The wolf also shall dwell with the lamb, and the leopard shall lie down with the kid; and the calf, and the young lion, and the fatling together; and a little child shall lead them.
7. And the cow and the bear shall feed; their young ones shall lie down together; and the lion shall eat straw with the ox.
8. And the sucking child shall play on the hole of the asp, and the weaned child shall put his hand on the cockatrice's den.

OR,

6. The *wolf* shall with the *lambkin* dwell in peace,
His grim carnivorous thirst for blood shall cease,
The beauteous *leopard* with his restless eye,
Shall by the *kid* in perfect stillness lie ;
The *calf*, the *fatling*, and young *lion* wild,
Shall all be led by one sweet little *child*.

7. The *cow* and *bear* shall quietly partake,
Of the rich food the ear and cornstalk make ;
While each their peaceful young with joy survey,
As side by side on the green grass they lay ;
While the old *lion* thwarting nature's law,
Shall eat beside the *ox* the barley straw.

8. The sucking *child* shall innocently play
On the dark hole where poisonous reptiles lay ;
The crested *worm* with all its venom then,
The weaned *child* shall fasten in his den.

The illustrious *Penn* this heavenly kingdom felt,
When with Columbia's native sons he dealt;
Without an oath a lasting *Treaty* made,
In Christian *Faith* beneath the elm tree's shade.

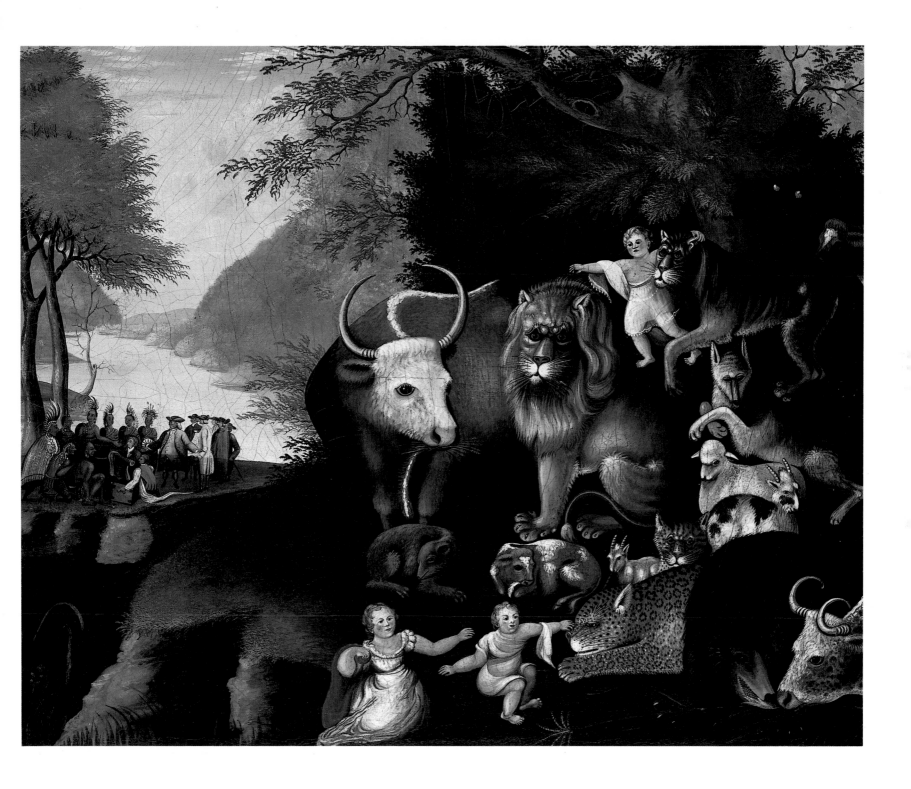

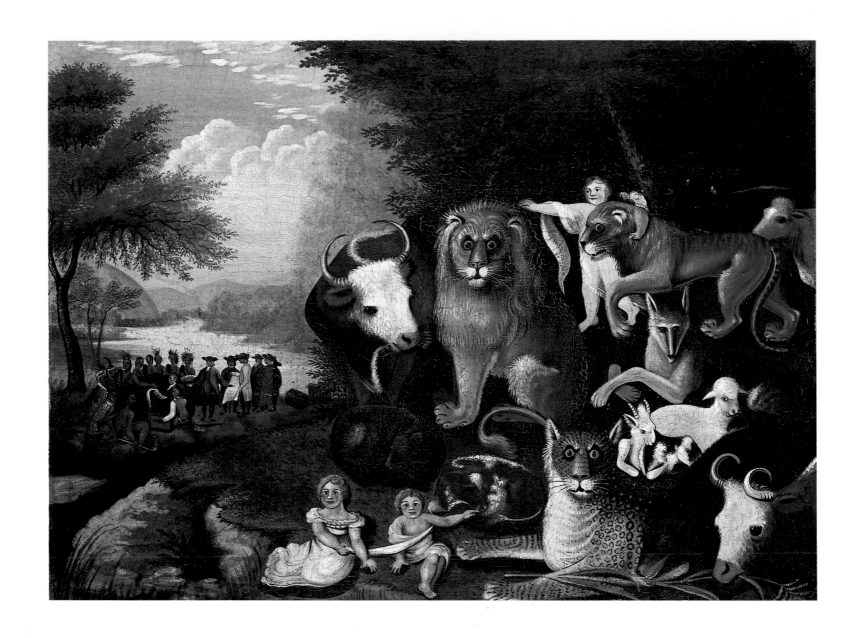

The Peaceable Kingdom,
mid-1830s.
Oil on canvas,
18 × 24 ⅛ in.
The Brooklyn Museum,
Dick S. Ramsay Fund

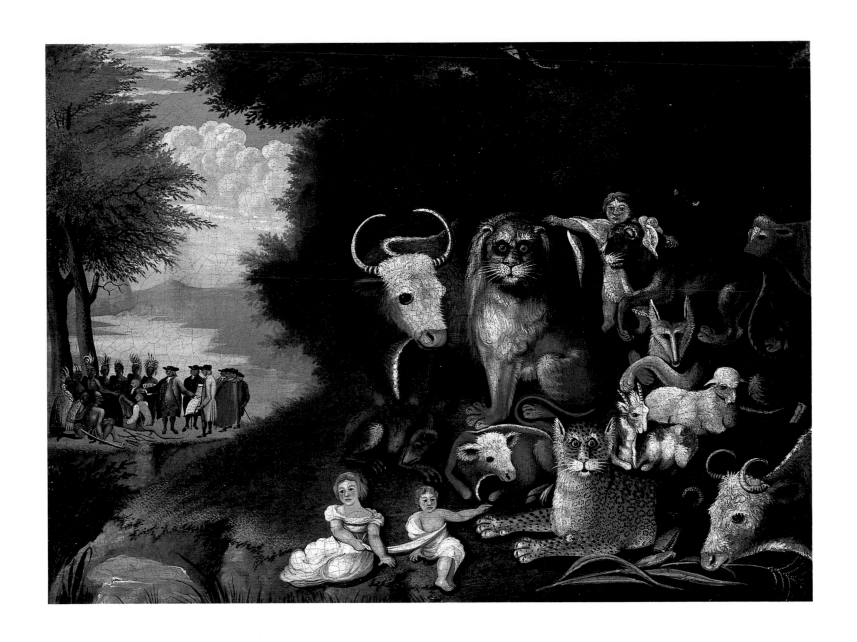

The Peaceable Kingdom,
c. 1833–34.
Oil on canvas,
17½ × 23½ in.
The Philadelphia Museum of Art,
bequest of Lisa Norris Elkins

William Penn and George Washington

*L*ively letters from Edward Hicks Kennedy continued to bring glimpses of the Philadelphia scene. He had heard the "roaring" of the "godlike" Daniel Webster, and viewed the parade of the Bakers Festival. Fifty thousand people rushed for fifteen thousand loaves of bread that "literally rained" from the decorated floats. His internship was over. The shingle that hung from above his newly opened office had attracted few patients. It took little urging on the part of his Uncle Edward for him to visit Newtown. He became the life of the more or less regular literary chats beside the fire. He favored Byron, Cadmus, and Rousseau. Elizabeth preferred to read the poets Halleck and Whittier. To tease her, he confessed that he agreed with the German travel writer Francis Seiber, who had found American women disappointing. Seiber wrote that the brides drooped "like a *Cactus grandiflora*" after blooming briefly, then became dull housewives. He himself had stirred the hopes of Mary Schofield, sister of Elizabeth's erstwhile suitor "Specktukles." But he did not intend to allow "unruly love" to propel him into a hasty, rash marriage. After he had returned to Philadelphia, Elizabeth directed this sharp riposte: "I regret that the folly of my sex should be exposed to one already too much inclined to think but meanly of their capacities." She blamed the male sex for making those of her own "the vain and trifling things they are." Indeed she thought it those "noble and enlightened beings," the men, who preferred "a pretty face" and "a showy appearance" to a cultivated mind.

William Penn's Treaty with the Indians *(detail), c. 1837. Oil on canvas, 17¾ × 23⅝ in. The Museum of Fine Arts, Houston, Bayou Bend Collection, gift of Miss Alice C. Simkins*

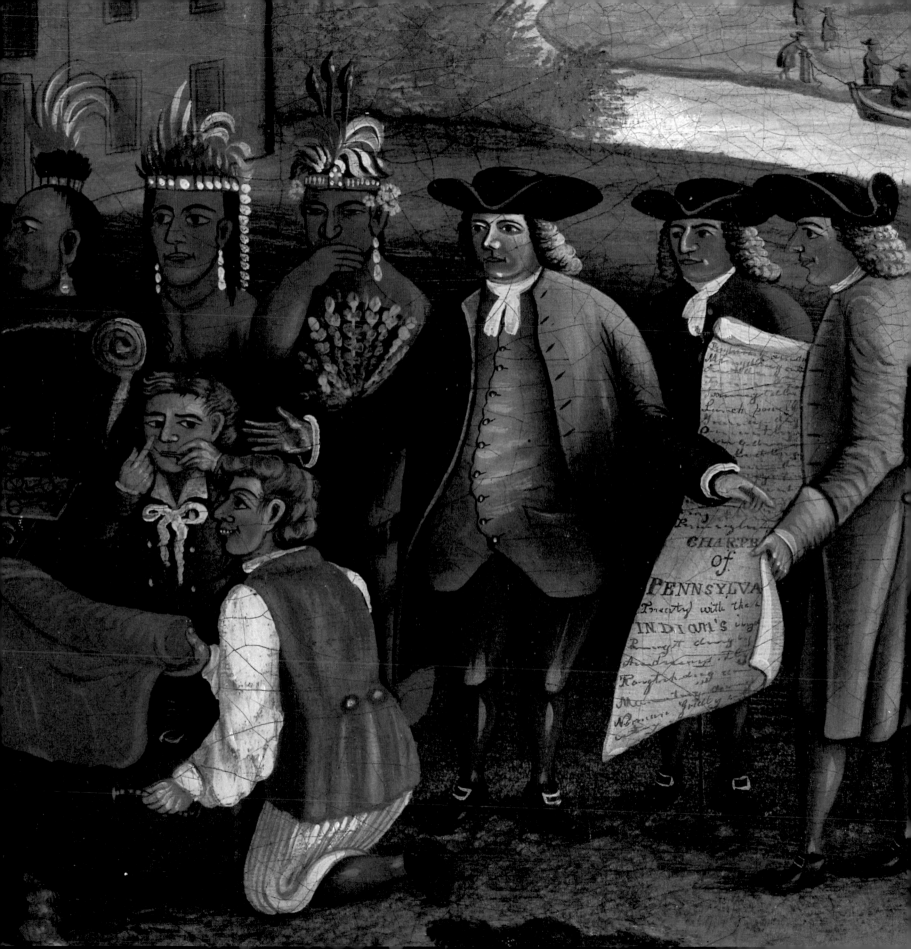

The indisposition of Susan early in the spring of 1835, and her appeal for help, did not produce an immediate response. Hicks reasoned that for her to look for Elizabeth was worse than untimely. Their mother's arm was crippled with rheumatism, and no one could come. In May, however, Elizabeth journeyed to Peck Slip. While Susan rested, her sister directed and helped with the spring cleaning, whitewashing, and painting. Her only recreation was an occasional afternoon visit from the cousins, or her copy of the actress Frances Anne Kemble's exciting *Journal*. There was no time for letters. In fact, her failure to write thanks to the Carles upon her return to Newtown in July brought a reprimand from both. Its sharpness incensed the family to the extent of allowing Susan a taste of silence.

Susan was both penitent and full of news by October. After a "hearty cry," she sat down to pen her apologies for her pique, and to describe the awful Wall Street fire. She declared it the worst since the burning of London and Moscow. John and his clerks helped carry buckets of water that froze almost on the instant. The glare of the flames was "beyond description or imagination." As if certain of success this time, she begged Mary or Elizabeth to come.

Edward Hicks went instead. Since his illness he had been painting steadily in hopes that Friends were ready to buy some *Peaceable Kingdom*s. A nationwide bank crisis got in the way. In order to visit Meetings in Manhattan and Brooklyn he had been hard put to raise money. His visit turned out to be well worth it, if only for his visit with little Phebe Ann. At Rose Street Meeting she sat enthralled between her parents while she listened to him preach. "Little pet," he began to call her. She recited the alphabet with ease and insisted that her grandfather read to her. With so much talk about the conflagration, Hicks did not fail to post a reminder to his young cousin and apprentice, Tommy Hicks, to keep his eye on the stove at the Meetinghouse. After preaching on Long Island he returned to Susan's, "coughing hard." Next morning he left for Rahway Friends Meeting in New Jersey and home.

Washington Crossed Here

*I*n 1836 Hicks accepted a bid to paint identical commemorative signs for the ends of a bridge near where Washington crossed the Delaware before the Battle of Trenton. They harked back to the event that turned the tide of the Revolution. Possibly he did so with tongue in cheek, while

Washington Crossed Here (*Pennsylvania end of bridge*),
1836. Oil on canvas mounted on Masonite panel, 31 × 31 in.
Collection of the Mercer Museum, Bucks County Historical Society

Engraving by G. S. Lang
after oil by Thomas Sully,
Washington Passing the Delaware,
Evening Previous to the
Battle of Trenton,
Dec. 25, 1776, *1825.*
Photo by Theodore Barash

remaining steadfast to his dedication to the "founder of the Republic."
Samuel Johnson of Buckingham Meeting had urged him, in a long poem,
to undertake a work in behalf of the cause of Abolition. He himself had
been wanting to try one on the theme of religious liberty. Both subjects
being beyond his capabilities, he turned to his commission with a will.
At the bottom of each canvas he explained the scene in bold letters,
mistaking the time as "eve" rather than night: "WASHINGTON Crossed
here Christmas-eve 1776 aided by Genls Sullivan, Greene, Lord Sterling
& St. Clair."

With a clear conscience he did justice, in his fashion, to the "noble
example for youth" and "instrument of the infinitely wise Jehovah." It
behooved him to do so inasmuch as Johnson had exhorted him to omit

Washington in the canvas that he proposed; many Friends had been shocked when the General turned up beside Elias Hicks in the memorial to their revered "Apostle." For, great man though he was, he had been a slave owner and soldier. In Edward Hicks, militant preacher, there were vestiges of "Ned Hicks," noncommissioned regimental volunteer in the militia, nineteen, who in the summer of 1799 had borrowed the *Letters of George Washington* from the Library Company of Newtown.

For his model he turned to an engraving by George S. Lang, after an oil painted in 1818 by Thomas Sully who, in turn, relied on a portrait of Washington by Gilbert Stuart, though the scene came from his own imagination. The print was published on May 26, 1825, by Samuel Augustus Mitchell in Philadelphia.

The sky of the Sully oil is gray relieved by yellowish hues and a pinkish horizon line, but that of Hicks is unremittingly gray and foreboding, save for his addition of a moon. During his "regimental dandy" sprees in Philadelphia he may have attended parades led by the General before his retreat to Mount Vernon in 1797. No less likely is it that he paid "25 cents" to see the Sully painting in the Philosophical Hall beside the State building on South Fifth Street, where it hung until 1822. It was no distance from the Arch Street Friends Meeting then, or after its removal to an "exhibition room" in the house at 11 South Fifth where Thomas Sully lived until his death. There the painting remained until Sully sold it to a Bostonian some years later. The State of North Carolina had commissioned it for its capitol. When no answer came to a request for the dimensions, Sully painted a canvas nine by six feet, too large for the space. He did not collect the promised one thousand dollars and finally let it go for four hundred.

A flood swept the bridge away in 1841. The sign at the Pennsylvania end was rescued, and eventually presented to the Mercer Museum, Doylestown, where it was restored. Its mate was presumed lost until, much later, it was found in a tavern near McKonkey's Ferry. If Sully heard of their prominence or of their fate, he could only have been indifferent. Portraits of Washington had long been the prey of souvenir peddlers, porcelain manufacturers, and journeyman printmakers, among others. The latest version of the subject by Edward Hicks to come to light emerged from an attic in Yardley, two miles away from his paint shop, from whence, presumably, it went, moonless, after his death. It remained uninscribed. His last will is accompanied by an assessment that includes unfinished paintings. For all its lack of a moon and destination, the work glows with life.

William Penn's Treaty with the Indians

To commemorate the settlement of Pennsylvania by William Penn, his son Thomas Penn commissioned Benjamin West to paint the scene of the storied treaty with the Indians, dated uncertainly 1692. West, a Quaker of Pennsylvania, was enjoying celebrity as a resident painter of London. He had to rely on boyhood memories of the site and of Indian regalia. Fond of dramatic subject matter and of coping with crowded compositions, he produced a work of heroic proportions, *William Penn's Treaty with the Indians When he Founded the Providence of Pennsylvania in North America*. Nearly a century later it found its way to the Pennsylvania Academy of the Fine Arts, Philadelphia. He pictured Penn not as the handsome twenty-two-year-old portrayed by Sartain, but rather as a decidedly portly old gentleman. He wears a brown shad-belly coat of a cut worn by West and his contemporaries.

On the west bank of the Delaware at a spot now called Kensington, but then known as Shackamaxon, Penn is believed to have met with the chiefs of the Lenni Lenape, Susquehannock, and Shawnee tribes. The parchment scroll bears his signature and that of five other Quaker companions. The Quakers, unarmed, proclaim their belief in peace within a benevolent free society. Only the Hicks copy in the Houston Museum of Fine Arts shows a boy demonstrating a Jew's harp from the supply of goods presented to the Indians. Penn received a beaded wampum belt, which is preserved at the Historical Society in Philadelphia.

John Boydell published a large engraving by John Hall after the West oil in London in 1775. From then on the print was imitated frequently and on all manner of ornament, on both sides of the Atlantic.

For his first renderings of the scene, Hicks turned to a print after the engraving by John Hall and to a pair of woodcuts in Watson's *Annals* (1829) of Penn's landing at Chester and in Philadelphia.

Evident corrections by Hicks in his *Penn's Treaty* formerly at Yale tend to give it precedence over the version in Williamsburg. The name of Thomas Janney, ancestor of the Friend of that name whose wife introduced little Edward to Mrs. Twining, does not appear on the scroll in the latter. Markham takes the place of "Mathews." Hicks included the name of Logan although he did not arrive to become Penn's secretary until 1699. Others had made this error in published accounts.

One version bears the notice: "Charter of/Pennsylvania/in North America/Treaty with/the Indians/in 1681 without an oath and never

William Penn's Treaty with the Indians, mid-1830s. Oil on canvas, 24¼ × 30⅛ in. The National Gallery of Art, Washington, gift of Edgar William and Bernice Chrysler Garbisch, 1980

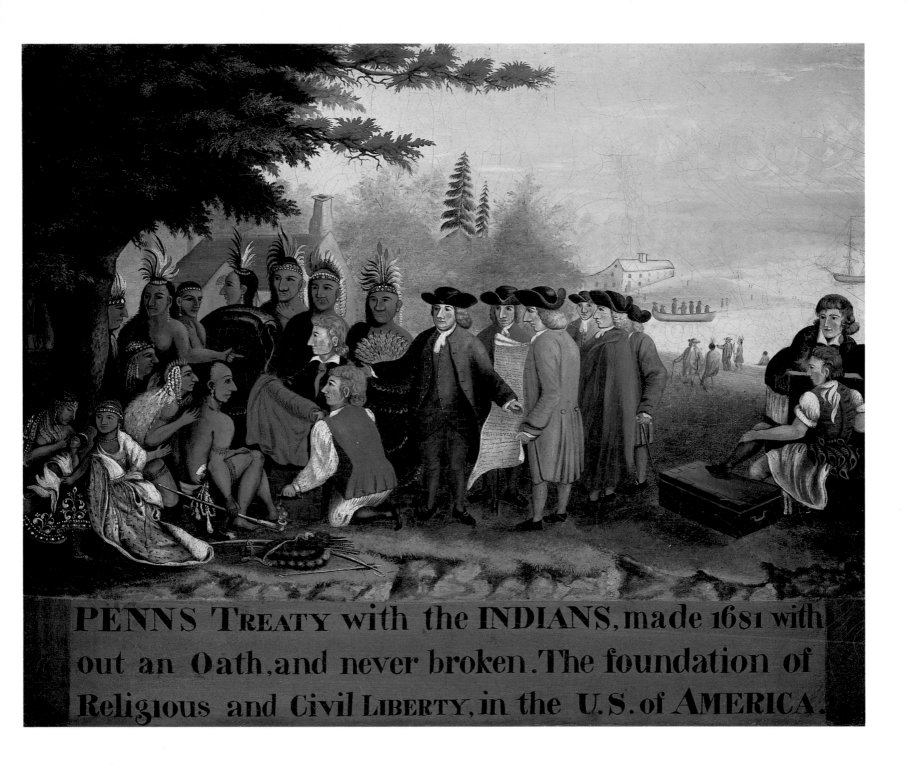

PENNS TREATY with the INDIANS, made 1681 with out an Oath, and never broken. The foundation of Religious and Civil LIBERTY, in the U.S. of AMERICA.

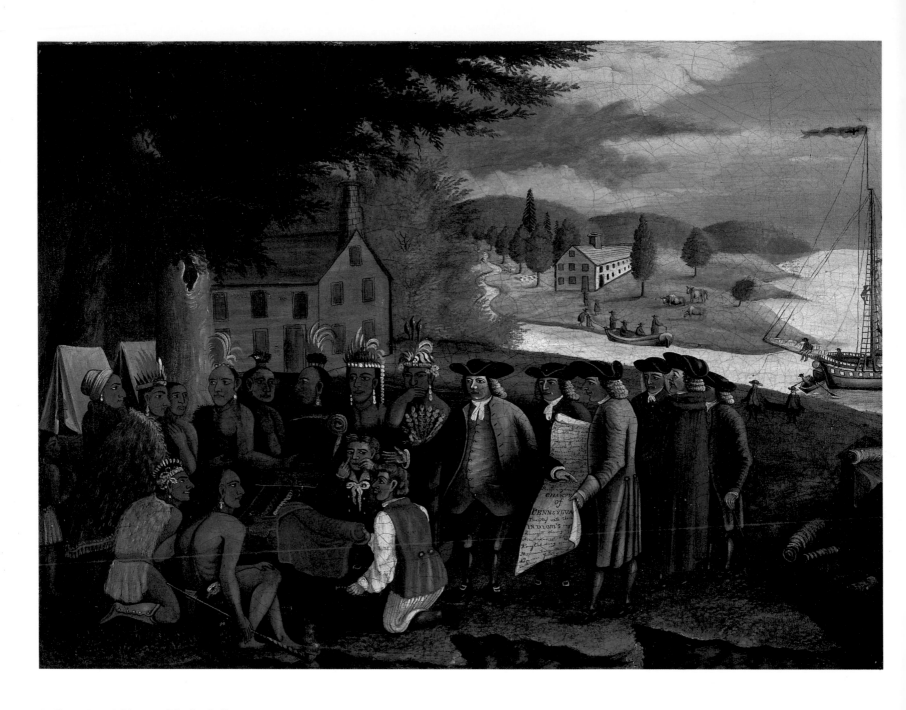

William Penn's Treaty with the Indians,
c. 1837. *Oil on canvas, 17¾ × 23⅝ in.*
The Museum of Fine Arts, Houston,
Bayou Bend Collection, gift of Miss Alice C. Simkins

broken." (Never broken, though the fall of the Quakers from power in 1737 ended the treaty.) The accepted date for the treaty is 1682.

A sign painted by Hicks for Bogart's Inn when the place was called The Sign of Penn's Treaty was declared by the historian Sherman Day in 1843 to be far superior to the artisan work of the time.

A *Penn's Treaty* at Rutgers College, a small oil on canvas, accepted as a painting by Hicks upon its presentation some years ago, has since been judged to be by an unidentified artist. Was it, in fact, painted by Thomas Hicks under the influence or upon the insistence of Edward in about 1836, when Thomas's talent was the talk of Newtown?

Engraved by John Hall after oil by Benjamin West,
William Penn's Treaty with the Indians,
Published by John Boydell (London: 1775).
19⅜ × 24¹/₁₆ in. New York Public Library

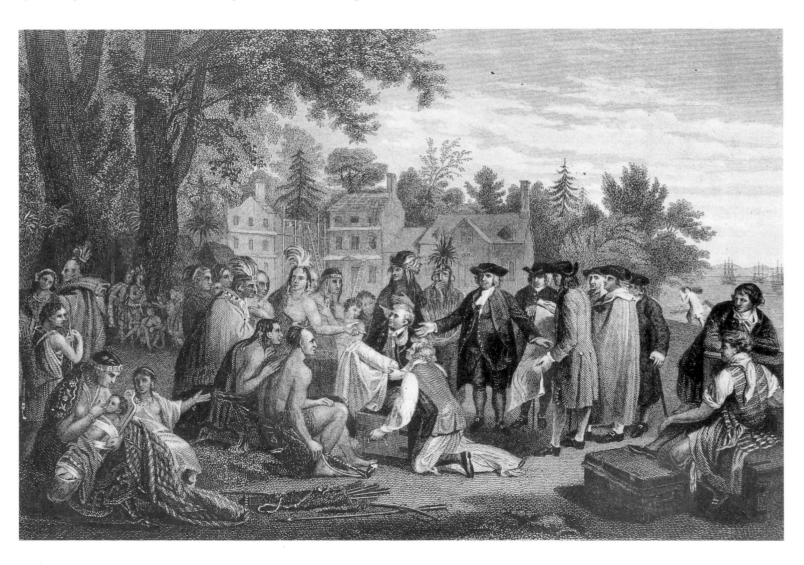

For a temperance inn at Chester, renamed The Washington in 1844 but called the Pennsylvania Arms after the American Revolution, Edward Hicks painted a sign that hung above the entrance until the place was razed. Samuel West, a Friend and temperance movement leader, commissioned the sign that bears *Penn's Treaty* on one side and *Penn's Landing at Chester* on the other. Watson's *Annals* was the source for the latter. Eventually, the five-by-five-foot board, painted in oil, was presented to the Delaware Historical Society, Widener College, Chester, Pennsylvania.

Phebe Anne came down with whooping cough so severe, as the year 1836 began, that Elizabeth responded at once to Susan's importunings, but over their father's almost tearful objections.

While she was away the grippe again swept Newtown. "That awful messenger that rides the pale horse" claimed many, Edward let her know in March. He complained that his father the Squire was fast failing and in need of much attention. As for her praise of a sermon by an English Quaker, he warned that she must not be spellbound by that visitor, no better than a "mercenary hireling." He bade her remind Valentine and Abigail that they must hurry to Newtown for a visit before the turkey he was saving for them "laid."

In the spring Edward Hicks painted a sign for the old Brick Hotel, built in 1761, but renovated and improved by its recent buyer, Joseph Oliver Victor Senez Archambault. He had added a story and a gambrel roof and, as postmaster, he had cut a letter slot beside the door. He wanted *Washington Crossing the Delaware* on one side of his sign and the *Declaration of Independence* on the other, both scenes to be copied from the prints. Archambault bought a turkey from Hicks for one dollar on the day that he called for the sign, which was doomed to disappear around the turn of the century. Archambault could well afford both the turkey and the sign. Since his arrival in New York from France he had fared well in that city and in Philadelphia as a lamp manufacturer and hardware merchant. Born in Fontainebleau, he was reared in the court of France, where he served as page first to Josephine and then to the Emperor Napoleon before being educated at the military academy of St. Cyr near Paris. As an aide-de-camp to Napoleon he served as a trusted messenger before the Battle of Waterloo, during which he was wounded. Until 1817 he was one of a dozen officers with Napoleon in exile on the island of St. Helena. (Briefly, after landing in New York at the age of twenty-two, he had put his knowledge to work on a model horse farm on Long Island.)

The Declaration of Independence,
1840. Oil on canvas, 26¼ × 29¾ in.
The Chrysler Museum, gift of Edgar William and Bernice Chrysler Garbisch

Once, while visiting Joseph Bonaparte, erstwhile King of Spain, at Bordentown, New Jersey, he passed through Newtown during a pleasure drive through lower Bucks County. It was then that he chose to sell out in Philadelphia and bring his wife and infant son to the village. To success as a veterinary surgeon and dentist, skills acquired at St. Cyr, he added popularity as a public servant. The mansion that he built remains one of the showplaces of Newtown.

Archambault was versed in literature and the arts. In thirteen-year-old Thomas Hicks, apprentice to the coachpainter, he recognized genuine talent. The boy had drawn a caricature depicting the displeasure of most of the townsfolk with its Freemasons. The Frenchman lent him his copy of Cunningham's *Lives of the British Painters*. The chapter on the Irish painter James Barry (1741–1816) inspired Thomas to escape the lot of a coachpainter and son of an improvident cobbler. He wanted, in fact, to become a famous painter.

Edward Hicks Kennedy heartily agreed with and encouraged those aspirations. Before Thomas reached fourteen he was painting portrait heads, each in one sitting for a dollar. Hicks paid him to paint a likeness of Elizabeth and urged him to begin keeping business records in an old ledger discarded by Squire Hicks.

Brick Hotel,
Newtown, Pennsylvania.
1892 photo. Courtesy
Norman Kitchin Collection

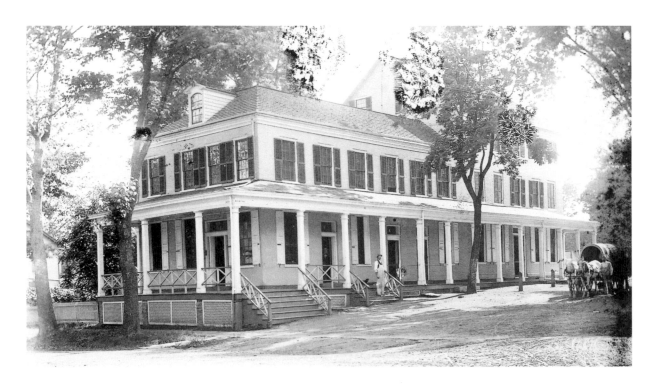

Thomas Hicks,
Self-portrait.
Collection Mercer Museum,
Bucks County
Historical Society.
Photo courtesy Newtown
Historic Association,
Newtown, Pennsylvania

In the autumn of 1836, Thomas began his thirty-second and the last of his Newtown portrait commissions, for which he now charged ten dollars. With savings of one hundred dollars he left for Philadelphia to seek out more orders, and with the blessings of Edward. He found sixteen sitters in short order. Hicks had no illusions or misgivings about the aim of his young cousin to rise above his lot. He himself had never been more downhearted over his own fitful attempts to make easel painting an extra source of income. By June 1836, he had been ready to apologize to Louis Jones of Doylestown for having asked him to help find buyers for a stock of *Peaceable Kingdom* oils—all similar, and representing a climax, of sorts, in extending the message of Isaiah. He had been painting them since the year before, and he had, in fact, begun to approach the crowded composition with a new realization of its shortcomings. But now he was in despair. "If I can get rid of them at almost any rate, I think I will never paint any more," he admitted to Jones. He had thought it "right to paint them in order to raise money" to attend the meetings in New York and on Long Island. "But alas; I fear the whole concern will come to naught, and the poor old good-for-nothing painter sink down to his proper place, the gulf of oblivion." Old at fifty-six? Too old to try portraiture, certainly.

Sarah Carle was born on October 4, 1836. A day later Squire Isaac Hicks died intestate at eighty-nine. Edward delegated the unenviable task of executor to his son for the handling of an estate more than two thousand dollars in debt. He himself prepared the obituary for a local paper, copied by the *Long Island Star*. He described his father as .e holder of six colonial offices before the Revolution, and as a "venerable magistrate," gentleman of "mental and personal endowments, well-known surveyor of the county," and justice of the peace who had united twelve hundred "souls" in matrimony. He touched on the loss of an estate and a wife in the "War of Independence," but did not mention Mary Gilbert, beside whom he buried his father the Squire.

Before year's end Gilbert Hicks died in Catawissa. The mother-in-law and brother-in-law of the painter died in Newtown; Joseph Worstall it was who had brought the good tidings so long ago about the Chapman house in Newtown.

Richard Westall, designer of *The Peaceable Kingdom of the Branch*, died in London in December. The artist to whom Edward Hicks (and other Americans too, if indirectly) owed so much had been the drawing master of Victoria, the princess royal. For nine years he had given her twice-weekly lessons of one hour at Kensington Palace without pay, in exchange for an allowance paid his blind sister by Victoria's mother, the Duchess of Kent. The duchess herself had little to spare and could only pray that the princess would ascend to the throne, as she was to do not long after the death of Westall. The close friend and disciple of Sir Thomas Lawrence had fared less well than the portraitist, but he had turned the quite remarkable talent of Victoria to account. He left a sealed request for the duchess, one that she willingly granted after his burial, for "100 pounds" a year for the support of his sister. Victoria wrote the following upon his death:

> *He died in the greatest state of pecuniary distress. This killed him. It grieves and pains me beyond measure that I could not alleviate his sufferings . . . Oh! this is sad, very sad!—to think that one whom I saw so often, knew so well, and who was so ready to oblige me, should die in want and overwhelmed by grief, is grievous indeed! . . . I could no more, as I hoped to do at a future time, make him comfortable and render his old days cheerful and without those worldly cares which . . . have brought him to the grave in a peculiarly distressing manner.*

Westall had admitted to the duchess that he was dying of a broken heart.

The Peaceable Kingdom,
c. 1836.
Oil on canvas,
29 × 35¼ in.
Everson Gallery of Art,
Syracuse, New York,
museum purchase with contributions from the Community and Friends of Syracuse and Onondaga County

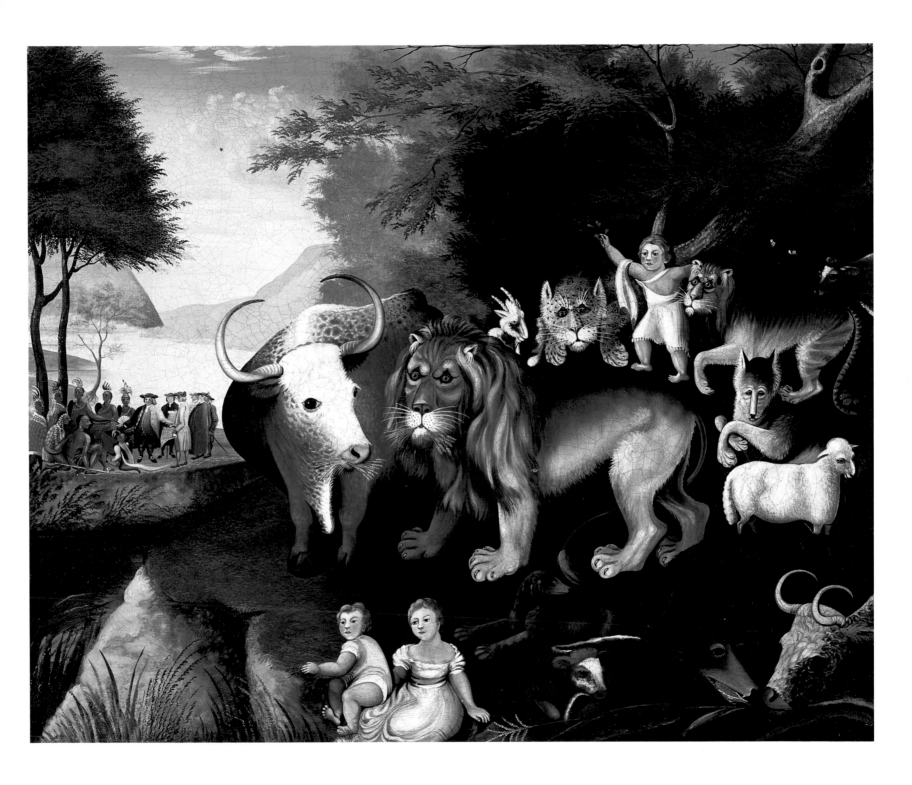

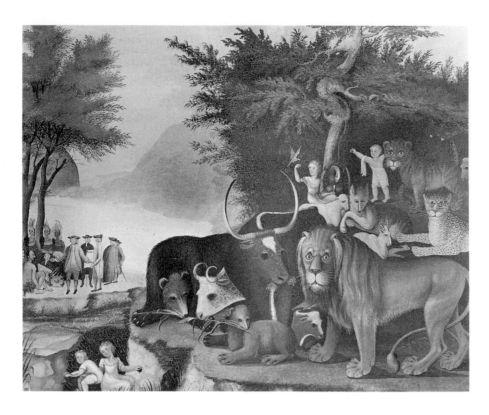

The Peaceable Kingdom, *c. 1836.*
Oil on canvas, 29 × 35¾ in.
Carnegie Institute, Museum
of Art, Pittsburgh

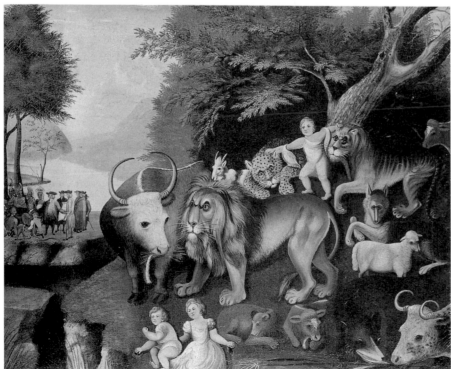

The Peaceable Kingdom, *c. 1836.*
Oil on canvas, 29 × 35¾ in.
Private collection

The Peaceable Kingdom
Three in Transition. c. 1836

*I*n the Carnegie Institute landscape, Hicks comes to grips with problems of space, perspective, and overcrowding. A new and more saturnine lion than any, thus far, deepens the view by standing on all fours. He is more accommodating than his seated, glassy-eyed, domineering predecessor, who was so like a stuffed specimen in his rigidity. The formerly prone leopard has temporarily disappeared. Here is another who rises, struggles, out of the "horrible pit."

The next, an oil in a private collection, has perhaps more sentimental associations than any before it or after, save for the one following. Thomas Janney, its first owner, was a boy of fourteen when Mrs. David Twining called on his mother and took pity on little "Ned" Hicks. His forbear, also Thomas Janney, a councillor of William Penn, is accorded the honor of having his name painted by Hicks on a scroll in at least one of the Penn's Treaty landscapes. He left the painting to his son Emmor Kimber Janney, named for the man who had enjoined Hicks against abandoning his ministry.

A nearly identical *Peaceable Kingdom*, now in the Everson Gallery in Syracuse, once belonged to that faithful friend but severe critic Emmor Kimber of Kimberton.

The young lion, seen a number of times before, makes its last appearance with the "little child." Its source was a detail of an engraved Bible illustration. Again Hicks adds stripes to the half-grown leo, despite their absence on his model and on young lions at this stage, turning it into a "tiglon."

Frontispiece of
S. Wood's New York Preceptor,
copyrighted Nov. 23, 1823.
Photo courtesy University of
Virginia, Alderman Library

Missions

Without his knowledge or consent, Edward Stabler, prominent Friend and minister of Alexandria, Virginia, had had his likeness painted in the hale days before his recent death. When Hicks heard the story, he wrote to ask whether he might borrow the portrait for Thomas Hicks to study. An itinerant, James Bowman, had painted it from sketches made secretly at a meeting for worship. He had also observed Stabler in his apothecary shop, which was famous for having provided Washington with pills and drams for himself and Martha.

Why should Hicks have taken a fancy to this portrait when Thomas had a host of choices in nearby Philadelphia? It was a simple case of rapport between two ministers. Stabler had preached about the "tree of life" in whose shade "the soul can sit with great delight." He had promised that under the "banner" of love the just would be lifted up to Heaven. The "young cow and two sheep" of prophecy contrasted sharply with the "fierce and destructive young lion," which, to change its nature, fed on "butter and honey." Like Elias Hicks, Stabler had dwelt on "animal fierceness like that of the lions and leopards."

Thomas Stabler, a nephew, left the portrait with the merchant Richard Price while on business in Philadelphia. In a few weeks Thomas Hicks brought the two-by-three-foot canvas to Newtown.

The Peaceable Kingdom (detail), c. 1837. Oil on canvas, 28 × 35 in. Collection Mercer Museum, Bucks County Historical Society

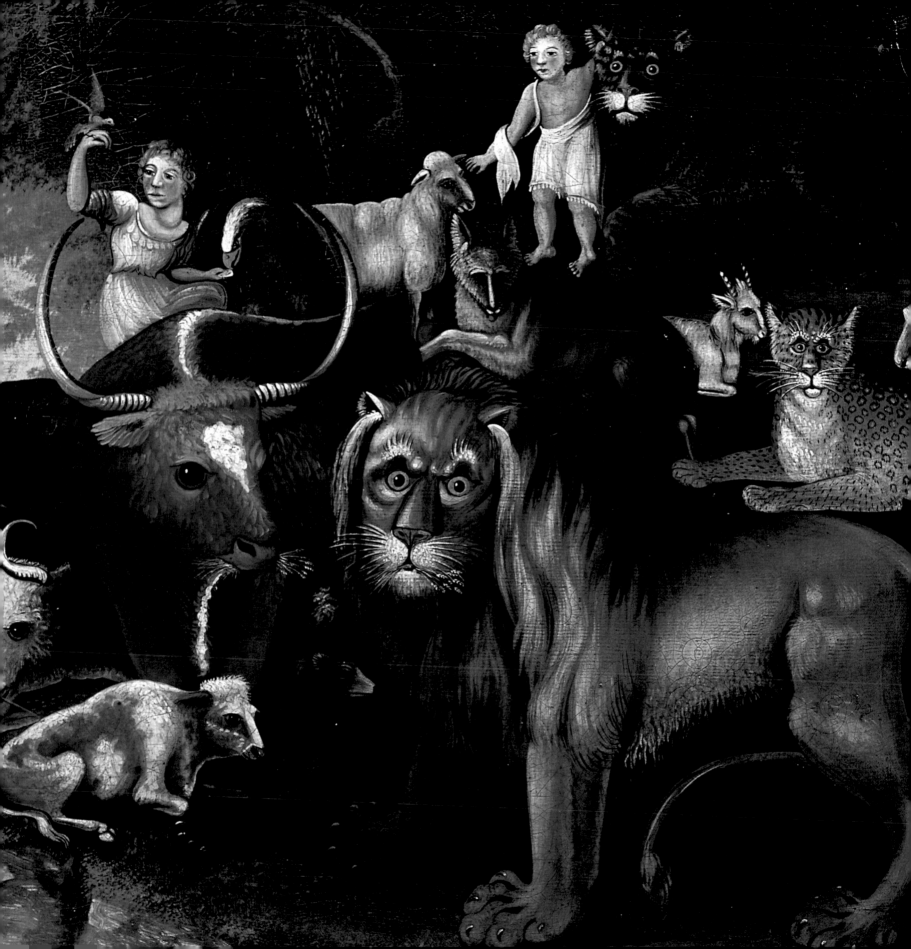

Edward posed for Thomas in the paint shop, at ease in his old "Winser chair," palette in one hand, brush in another, and a *Peaceable Kingdom* on an easel beside him. His Bible lay open to Isaiah. Thomas sought to catch the penetrating gaze of the sweetly sad eyes and the frailty of the spare frame of his sitter. The nose, broken in youth, suits the feisty veteran of much buffeting by life. The closely buttoned waistcoat covers a moral coat of armor. All in all, the deeply furrowed face is a far cry from that of the curly-haired boy of seven at the knee of Elizabeth Twining in *The Twining Farm*. The time was December 1836.

Thomas exacted a promise that the portrait be shown to no one. When the family discovered it by chance, they praised its fidelity. No one was more struck by the ability of Thomas than Edward Hicks Kennedy. He promptly wrote to an official of the Academy in Philadelphia to ask special permission to enter Thomas, who was not yet near fifteen, the required age. "Young Hicks is an artist of considerable promise, having lately emerged from the coach painting shop to the dignity of the easel. . . . He is young, modest, poor, but possesses genius." The youth would deem it "a great gratification" if Thomas Sully and other artists of "repute" would encourage the step.

Thomas Hicks did not linger in Newtown. But one suspects that he copied the Lang engraving after Sully, *Washington at the Delaware*—the one in a frame that bears an oakleaf-acorn design like that on a letter carried by Edward just after the death of his father in 1836. That was the very time. He may also, to repeat, have painted the *Penn's Treaty* that is at Rutgers University. In any case, Edward regretted his eagerness to be off. "Precious youth" was being "scattered, shattered, and peeled by the cunning craftiness" of the Orthodox, "those deluded voterys of Antichrist" in Philadelphia. Even the young of Newtown were skipping the "little solemn silent midweek meetings," to attend abolition and temperance rallies. Even so, they were in less danger than the youth of the South whom he hoped soon to rescue, if he could. He hoped, too, that they would not speak of him as the youth of Philadelphia were said to, they who would "rather be ruled by a hireling than such a man as Edward Hicks in a hireling spirit." But then, poor Elias had endured far worse.

*O*n a bitterly cold mid-January morning in 1837, Hicks left home with the Stabler portrait beside him in his gig, bound for Goose Creek Friends Meeting south of Leesburg, Virginia. A "preparatory

Thomas Hicks,
Portrait of Edward Hicks,
c. 1836.
Oil on canvas,
27¼ × 22⅛ in.
Abby Aldrich Rockefeller
Folk Art Center,
Williamsburg, Virginia

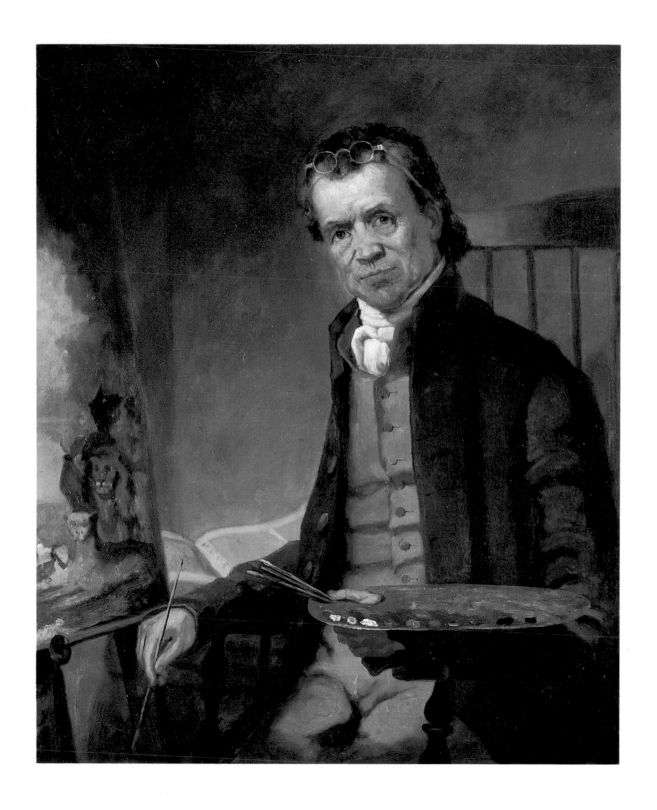

meeting" had approved the proposed visitation to see what could be done about the fondness of the young for racing and sport. Not distance, nor weather and its uncertainties, nor the bank crisis that faced the Van Buren administration stood in the way.

On the second day of February, Edward Hicks, snug at last as a guest of those Janneys whose forbears had left Newtown for Virginia in the early 1730s, preached at Goose Creek. His sermon, when printed from a copy made by a listener, would fill one hundred pages. "A Little Present for Friends and Friendly People in the Form of a Miscellaneous Discourse by a Poor Illiterate Mechanic" is the key to the meaning of the paintings of the *Peaceable Kingdom*.

"The devil is hatred," Hicks warned with his customary foreboding. If this did not come as news to the Virginians, his announcement that it was wrong to earn one's livelihood by usury or the learned professions, instead of by "humble industry," may have been disconcerting to at least a few Quaker moneylenders. His vivid, direct approach to the nature of good and evil by the allegorical method made his sermon at least as haunting and memorable as it was unsparing. He well knew that he was not the first to liken evil to the ferocious, and good to the meek. That he knew how the pagans—Hippocrates, Plato, and Aristotle—had alluded to animals and also the elements to describe man's virtues and failings is more than unlikely.

"The lamb, the kid, the cow, and the ox" stood for the good in mankind, and "the wolf, the leopard, the bear, and the lion," man's evil nature. Abel was lamblike, Cain like the wolf. The melancholic, sanguine, phlegmatic, and choleric were created by God from earth, air, water, and fire. Hicks called the wolf the melancholic emblem of usurers, the suicidal, the seekers after wealth, and the vainglorious—and its element was *earth*. The lamb and the "Inward Light" rescued George Fox from the *melancholic*, Hicks reminded his listeners.

The emblem of the *sanguine*, the leopard, was described as the "most beautiful of all the carnivorous animals of the cat kind"—and its element was *air*. Human leopards often robbed "innocent females of their virtues." The females often tore their friends to pieces. To Hicks, the fulminations of Thomas Paine were like the "screaming" of that beast.

The bear, the *phlegmatic*, is "cold, unfeeling, dull, inert, and beastly" until aroused, when it is unmatched for voracity. If hungry it will devour its victim; if not, it will bother nobody. Of their human counterparts, usurers and creditors seemed the worst.

The proud, arrogant lion, whose element is *fire*, embodies the *choleric*. Hicks assigned himself, St. Paul, Napoleon, Alexander, and the Orthodox leader Jonathan Evans to this animal category. He granted that if Evans was often too "malignant and bitter" against "infidels," he himself had the same weakness. But he did not doubt that there was yet time for Evans to change and "eat straw like the ox."

The ox? The beast of burden was at once powerful and docile, traits of those submissive to the will of God. "Innocence, liberality, and patience, like the lamb, the kid, the cow, and the ox" would win out over the "devouring, tearing, oppressing, and killing"—in the "peaceable kingdom."

Where did Hicks come by his knowledge of the elements and humors if not from the ancients? Probably from Burton's *Anatomy of Melancholy* rather than the nine definitions offered by Doctor Samuel Johnson, the celebrated English lexicographer. Edward Hicks would have taken to the thesis of Aristotle that art that offends morally threatens the good of man. He would have given short shrift to that of the fifth-century philosopher Empedocles, who considered the elements primal deities separated only by Love and Hatred in their domination of everything. Although the Greeks, like the other ancients, believed the universe to be made up of God, man, and nature, he reached no moral conclusions. What has all this to do with a Bucks County coachpainter of irresistible landscapes? *The Peaceable Kingdom* is the quintessential example of this axiom of Plato: "The impassioned contemplation of the beautiful is imagined as the beginning of a philosophy."

Romanophobe though Hicks was, he occasionally had a kind word for certain post-Biblical-age saints, besides Paul. He did not get around to St. Bonaventure, whose discourses on "divine illumination" through grace would have turned the painter's thoughts again to the "Inward Light" of Fox. Nor is he likely to have discovered that St. Francis of Assisi was the first to dramatize the Nativity by bringing live beasts to the creche that he and his friends built at Greccio. Artist and saint bore witness to the mystical unity among men and their fellow creatures.

The little stone meetinghouse in which Hicks tried to point the way to the "peaceable kingdom" still stands. The spot is now called Lincoln, Virginia. Friends built a larger place for worship across the road two years after his visit, his first and last to the South.

The Landing of Columbus

*I*n the *New-York Mirror* of January 7, 1837, Hicks found the inspiration for a painting, an engraving of "The Landing of Columbus" by M. I. Danforth, after an oil on canvas by John C. Chapman. He may or may not have finished it before he left for Goose Creek. All that appears certain, since its discovery in Purcellville, near Lincoln, is that he presented it as a bread and butter gift to his hosts the Janneys, perhaps following his return to Newtown. They were descendants of Amos Janney who had moved from Newtown to Opequon, Virginia, in about 1732. Hannah Yardley, wife of Amos, sat alone on a log for silent worship in the beginning. Then, until 1754, Friends met at the Belson house, in Providence, where they built a meetinghouse. In 1785, Goose Creek Meeting took over the old group of South Fork Meeting to "upgrade" its youth, according to the *American Quaker Genealogy* of Hinshaw. Edward Hicks was therefore braving a longstanding problem.

Engraved by M. I. Danforth for the New York Mirror. *Published January 7, 1837 After oil by John C. Chapman in the Capitol at Washington, D.C.* The Landing of Columbus. *New York Public Library*

The Landing of Columbus, *c. 1837.*
Oil on canvas, 17¾ × 23¾ in.
The National Gallery of Art, Washington,
gift of Edgar William and Bernice Chrysler Garbisch

*H*is success at Goose Creek Meeting emboldened Hicks to request permission to revisit the Friends of Ohio. Debts and the lack of ready money were obstacles, as always. Valentine and Abigail offered to join him but not to pay his way. He knew that he must not think of leaving town again without satisfying his nine-year-old indebtedness to Watson, Paxson, and Jones of Birmingham. He had met the interest payments with fair regularity, and, since they amounted to all but a little of the principal, he wished the rest might be forgiven. One day, when Watson brought a chain to the shop for a coat of paint, he saw his opportunity. When it was ready, he wrote Watson that inasmuch as he had painted a sign, free, for one of the others, they might accept paintings in lieu of money. If Paxson were to think a *Peaceable Kingdom*, and Jones a *Penn's Treaty*, too generous, they could send a little money, if they "pleased," toward his journey to Ohio.

The letter to Watson is of extraordinary interest for the light it sheds on the time it took Hicks to finish a painting: "I ought to have fifteen dollars for the paintings, to pay me 25 cents a day, but I don't care. I even take less for the sake of getting that Business settled, and realy I shall want all the monney I can rais, and more too, for I have an extensive and expensive Jurney before me and expect to start tomorrow." At "25 cents a day," these oils that brought "$25" required weeks of application between artisan jobs. (The 1817 letter of Comly proves that Hicks often painted by candlelight, a point that may help to explain the greater brightness of some canvases, particularly of those cleaned but never restored.) At this rate Hicks could have painted no more than six landscapes a year—if that—in any given year, a significant factor in an attempt to date the uncertain ones, lest a suggestion of the impossible might result.

On the same day that Hicks wrote to Watson of his good intentions before leaving for Ohio, the Carles, a sister of John Carle, and her daughter concluded a short visit. Isaac drove them to the Bristol ferry to see them off and also to welcome Valentine and Abigail. Next morning he drove his father and the cousins to Philadelphia for the train to Harrisburg. From there they were to go on to Pittsburgh by canal, and on down the Ohio to a point nearest their final destination, Columbiana, one more day beyond by hired carriage.

The Friends meeting for worship at Columbiana Hicks described as "Heavenly." From that place they went on to Lisbon and New Garden before returning to the Ohio for the trip down to Mount Pleasant, an Orthodox stronghold somewhat to be dreaded.

In a chronicle begun for that best of all traveling companions of the past, Benjamin Price, Hicks could safely say that Friends were "gaining ground," despite the disturbing number of Orthodox among them. The trouble was that too many were young and easily drawn away. Joseph Gurney, a noted English Quaker and philanthropist, had recently preached in Ohio and praised the teachings of Elias Hicks. West Grove Meeting was receptive to Edward, but he despised himself afterward for having been flattered by the effusive praise of an Orthodox physician. Better the "nails of Christ," for a "very poor creature" like himself, than praise.

Hicks continued his chronicle for Price as he traveled about among Friends of Plainfield, Wrightstown, Concord, and St. Clairsville. "It looks to me likely that this will be the last visit—from home—I shall ever get again," he wrote from great weariness. Who then would carry on his work and let him "'depart in peace'?" Elizabeth? He "cursed" himself for his selfish thought of surrender.

By the time he reached the canal boat in Pittsburgh he was so "unwell" that he wondered whether he dared ever travel so far again. In the midst of a meditative prayer for the strength to go on, and for his family, friends, and relations, he was "favored" with something like revelation. It was as if a river flowed through him from, he said, the throne of Heaven; as if a "special messenger" were announcing to him the passing of his beloved cousin Samuel Hicks. When he reached Lancaster he read in a Philadelphia newspaper that Samuel was dead. Edward had greatly esteemed this cousin, who had been among those that wished to help rescue him from "the mire of paint."

While Hicks was in Ohio, Thomas began his studies at the Academy. When the economic crisis forced the institution to shut down, he returned to Newtown. Undaunted, he applied to the National Academy of Design in New York City for admission in the autumn of 1838. Meanwhile, he set himself up in a loft below City Hall and began to prove once more that he was a portraitist of no mean talent.

However well Ohio may have received Edward Hicks, his return to Newtown marked the beginning of a period of almost unprecedented stress. There was no sign that his offer of paintings in lieu of cash to the Buckingham lenders would be acceptable. Lest cash be demanded, he preferred the uneasy silence for the time being. It was no comfort to find

that his late sister's son Edward Kennedy, who had given up medicine, was failing as a schoolmaster and heavily in debt. Kennedy had built the school on a lot bought from the estate of Isaac Hicks with a legacy left him by his father. As far as Hicks could tell, Abraham Chapman had not disposed of either of two *Kingdoms* that he had taken the "liberty" to send him before he went away. One he intended as a gift."as a small compensation for many favors," and the other as a work for sale—either to Chapman himself or anyone with a ready offer.

On March 12, 1838, he wrote to the Doylestown surveyor and justice Samuel Hart to ask what he intended to do about the paintings. If he had done nothing and did not seem interested in the gift, Hicks wished Hart to take them over and "keep them out of sight . . . in some upper room until some suitable person" made an offer. "However," he assured Hart rather lamely, "I don't care much about them. The object of my painting them was to raise money to bear my expenses in my late journey. It is all now done and settled. Therefore, they are of little consequence." The fact was that he still owed Hart money; he asked to "be indulged a little longer," until the carriages that he had hoped to sell before he went away were disposed of. Evidently they had been the reason for Hart's willingness to lend. Hicks made no secret of his dread that Hart might seek satisfaction by seizure of the vehicles, before long. He closed his painful requests with love to the Harts and also "dear friend Abraham Chapman . . . for I am like a good woman—if I love a man, I always love him." Samuel Hart accepted one of the paintings, Abraham Chapman the other. Both were the *Peaceable Kingdom* with the figure of Liberty. The latter remains in Doylestown, at the Mercer Museum.

The Peaceable Kingdom
With Liberty. c. 1837

A symbolic figure of Liberty takes her place in the *Peaceable Kingdom*s that follow on those oft-repeated, crowded versions of the mid-1830s. On bended knee she gazes at a dove perched on her finger, while an eagle drinks from a lamp of wisdom beside her. Her message, freedom, accompanies that of peace. Hosts of certificates, school merit awards, notes, and temperance pledges bore similar figures of Liberty and Columbia. The addition of Liberty was a concession to Samuel Johnson, who, however, had asked for much more.

The Peaceable Kingdom,
c. 1837.
Oil on canvas, 30⅛ × 34½ in.
New York State Historical Association,
Cooperstown, New York

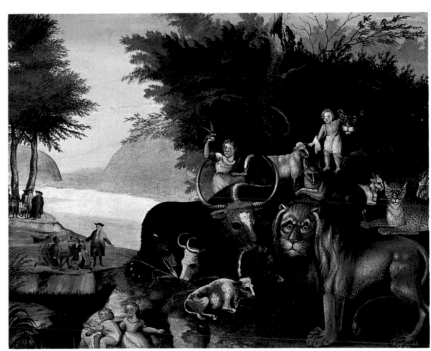

The Peaceable Kingdom,
c. 1837.
Oil on canvas, 28 × 35 in.
Collection Mercer Museum,
Bucks County Historical Society

In this group, the landscape, mellower and less rigid, is also more muted, somehow more redolent of the Quaker quietism that could be manifested more readily on canvas than in the sometimes overheated sermons that earlier had led to Hicks's disownment by two Friends Meetings.

The ox is yet more awesome and reminiscent of the Old Testament Bulls of Bashan, as well as the one of the prophecy of Isaiah. The familiar recumbent leopard has an air of more authority in this more symmetrical composition. The glowering lion of the repetitive earlier group is gone, and another formidable yet benign enough successor looks out of the canvas. Even if the shift from one lion model to another, by stages, did not rule out the possibility that the lion occasionally glowered at the Quaker schism, Hicks's own versified words would prove the contrary: "A little child was leading them in love/And not one savage beast was seen to frown." Would one who preached peace and love, as a minister, lapse into a contradiction in terms? A very limited choice of models could sometimes handicap.

The new "young lion" posed one of the more resistant research problems on account of its anomalous character. It has all the earmarks of a famous pair of three-month-old hybrid cubs of which, ostensibly, it is a composite. An itinerant exhibitor bred them in the royal zoo at Windsor Castle. Their parents were a "very gentle" tigress and a lion, both aged four. Born on October 17, 1824, they were the envy of the famous Cross Menagerie of London, which had had no such luck with cross-breeding.

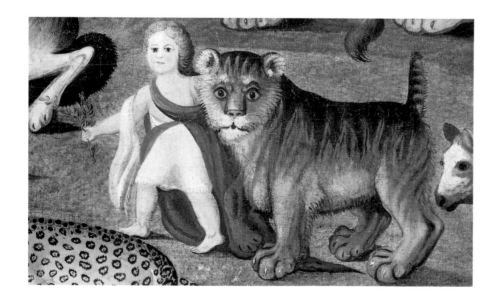

The Peaceable Kingdom
(detail), c. 1846.
Oil on canvas, 26 × 29⅜ in.
Private collection

The transverse stripes of pure-bred cubs soon disappear. Those of these hybrids remained distinctly "tigrine," especially "from the nose, over the head, along the back, and on the upper side of the tail." Also, like other parts, "the forehead was covered with obscure spots." The head was that of the father and the "superfices of the body like the Tigress," according to *The Animal Kingdom* (London, 1827). An engraving of the beautiful cubs appeared in 1825 and enjoyed wide currency in both America and England.

The child of the print *Happiness* returns, but considerably reduced in size to relieve that overcrowding by "the savage beasts."

A significant difference between this landscape, which once belonged to Watson of Langhorne, and the one acquired by Emmor Kimber is the absence of the Liberty figure in the latter. Therefore this *Kingdom* may have been the first to include the figure. Its suggested date, 1837, is the year when Watson proved himself once more a sterling friend.

The bear cub now appears with its parent, whose bulk and size create a new problem of space. The head and paws of the leopard are all that is shown of the beast here and in several *Kingdom*s to follow. Its origin, a print, is imitated in its entirety in an oil of 1844. Erosion serves the double purpose of a moral lesson and a means of dividing the composition. The ground beneath the Penn's Treaty scene is separated by a diagonal ended by a tree trunk. Edward Hicks early sensed, or learned, that painters have depended on the arch, triangle, and diagonal for centuries.

Cubs Bred Between a Lion and a Tigress: Three Months Old, *from Baron Cuvier's* The Animal Kingdom with Additional Descriptions of All the Species Hitherto Named and of Many Not before Noticed *(London: George B. Whittaker, 1827). University of Virginia, Science Library*

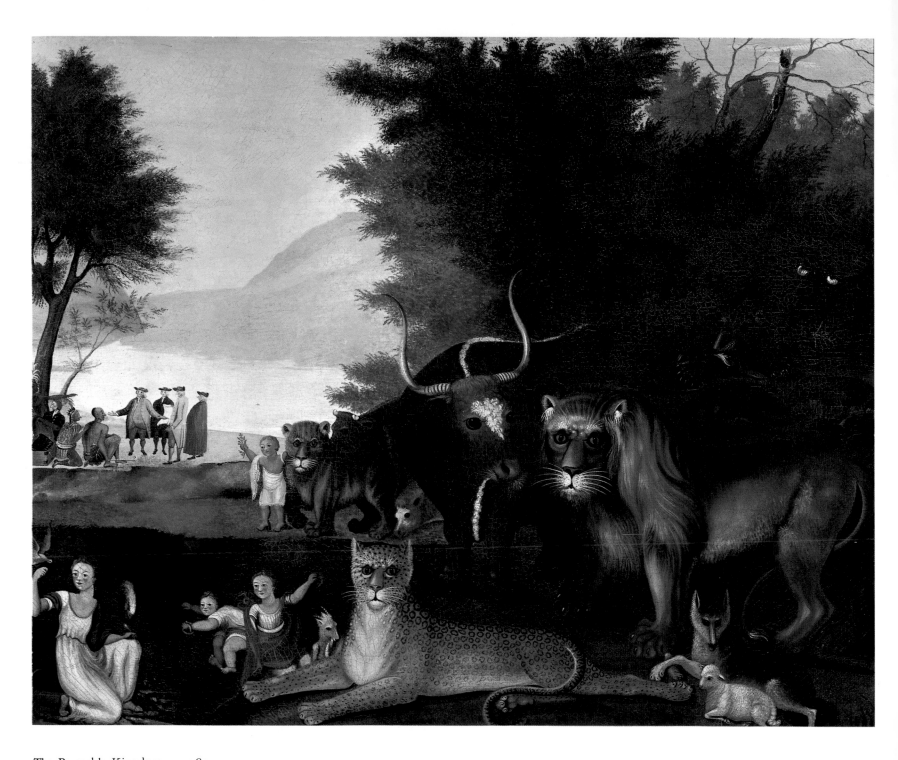

The Peaceable Kingdom, *c. 1837.*
Oil on canvas, 29 × 35¾ in.
Photo courtesy Christie, Manson, and Woods International, New York

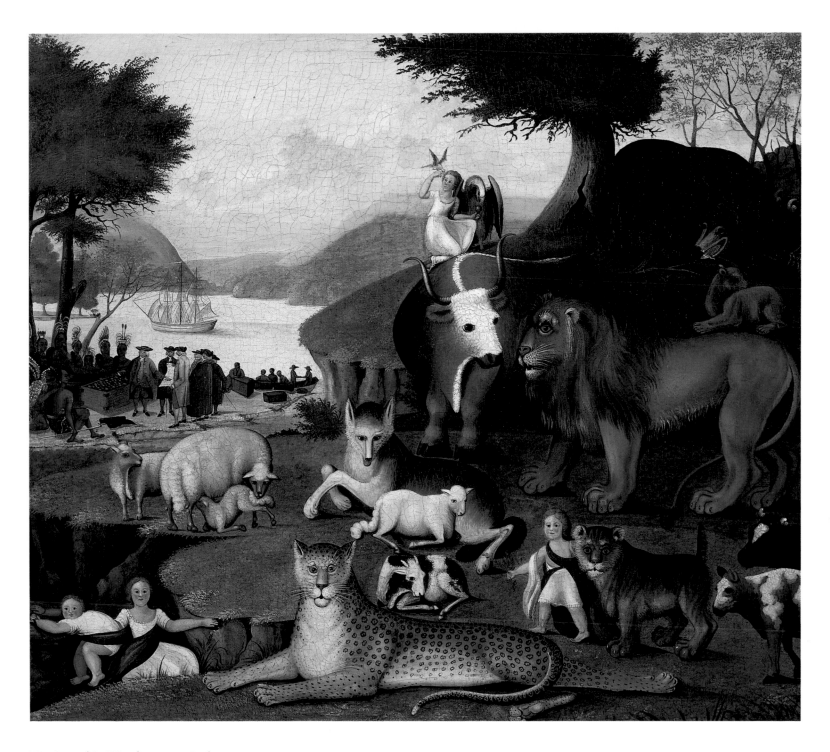

The Peaceable Kingdom, *c. 1846.*
Oil on canvas, 26 × 29 ⅜ in.
Private collection

Liberty, Meekness, Innocence

"My dear fellow citizens . . . shall we turn our liberty into licentiousness?" This the minister and painter had asked of his fellow Friends at Green Street Meeting in Philadelphia on the eve of the Separation, August 27, 1827.

He introduced Liberty into his *Peaceable Kingdom* a decade later. Her classical figure enhanced coins, medals, and official paper of all descriptions. She had symbolized power and sovereignty long before the United States of America chose the eagle for its national shield in 1782. William Barton of Philadelphia submitted a design with a female figure and dove, which was rejected by the commission. Her prototype was the British symbol—a woman with a wren, Preeminence—for empire. The cult of Liberty was introduced into America by the English dissenter Thomas Hollis.

Liberty, Meekness, Innocence antedates the Liberty figure of several *Kingdom*s, if the supposition that the small oil was painted to clarify her presence in the canvases can be relied upon. The Liberty, in both, cannot be unrelated. In each an eagle plunges its beak in the lamp of wisdom in fulfillment of Psalm CXIX:105: "Thy word is a lamp to my feet and a light to my path." Be that as it may, the Liberty continues to be taken for an angel by many, and to baffle, in the *Peaceable Kingdom* oils where she occurs. At least once she was taken for Hebe, goddess of youth, a pagan symbol.

The countenance of the Liberty in the *Kingdom* in the collection of Daniel Evans resembles that of the Liberty in this panel.

William Penn spoke of the lamb as a symbol of peace and love. According to tradition, a dove bore an olive branch to Noah.

To Edward Hicks his modest star as a painter appeared to have set as surely as that of Thomas was in the ascendant. The National Academy of Design in New York City had borrowed the portrait of Edward for exhibition besides two other oils by Thomas. The youth had moved to better studio rooms on City Hall Place.

When Abraham Chapman realized the grief that his temporizing had caused, he put matters to rights with the aid of Hart. After all, it was he more than any other member of the Society of Friends who, years earlier, had told Hicks in no uncertain terms not to turn away from

Liberty, Meekness,
and Innocence,
c. 1838–43.
Oil on panel,
14 × 9¾ in.
Private collection

painting. Hicks then got on with his variations on the theme of *Kingdom*s
with the figure of Liberty, which, by reason of their number, kept him at
his easel off and on until 1840. (She was to reappear for her swan song in
1846.)

The entire family, and perhaps Hicks most of all, grieved when
Edward Hicks Kennedy closed his school and left town in the summer of
1838. Indeed, the whole community was disappointed that he left many
debts behind him. John and Susan Carle thought sadly of their many
loans. Kennedy was gone before his brother Augustin, a pioneer teacher

in Jacksonville, Illinois, could deliver this warning: "What in the name of common sense has put you in the notion of coming to the West?" He forbade him to put his foolish "design in execution" without his consent and that of their brother Frederick, a successful farmer. "Why would anyone but a fool quit a medical career, his friends, relations, and family prestige for total uncertainty." He trusted that Elizabeth, whom he called "Aunt Betsy," would talk him out of it. He himself had all he could do to keep himself and his horse on forty dollars a month for "forty scholars." To quit "the parental village of Newtown—the Athens of the East, where the arts and sciences receive such unlimited patronage, and where *highly respectable Boarding Schools for young ladies* spring up in the corners of people's gardens like hotbed plants," was idiotic.

This mannered letter, like those of Edward Kennedy, call to mind the literary aspirations of their late colonial dilettante uncle William Hicks. Edward Hicks himself, as will presently be seen, also had the strain, within his uneducated limitations and within the Quaker crucible. Add to that the penchant of his great-uncle Edward Hicks, the Major, for landscape painting.

Not until the spring of 1839 did the question of the willingness of Thomas Paxson to forgive the principal of his loan in exchange for a *Peaceable Kingdom* again arise. John Watson let Hicks know that Paxson did not wish to forgive the balance due him. Hicks replied, "I will trie to pay it. Thy justice and the moderation of T.P. will so arang it as not to make me pay Intrest for money I have payd. I do sincerely thank thee for all thy kindness towards me."

But now the kindness and patience of Watson began to be tried in a more crucial way. At Buckingham Quarterly Meeting, Hicks challenged its minister Martha Smith, an activist for temperance and abolition. When he dared accuse her of "ranterism," the members turned against him four square. Hicks departed in disgrace.

Again he looked to Watson for a way out of the damage done: "As I cannot foresee the end and design of the storm that is gathering round me I wish to be prepared for the worst. I wish to have everything settled concerning my private character, so that it may remain untarnished if my public one is destroyed, or, as Jesse Leedom expresses it, '*my way closed up.*'" Having heard the rumblings, Leedom warned him to make peace or be "disowned" by the Quarterly Meeting.

Thomas Hicks,
Newtown from Scully's Hill,
1839.
Library of Newtown,
Newtown, Pennsylvania.
Photo by Alan Brady

This left him bewildered, coming as it did at a time when he longed as never before "to live more holy—more harmless—and more sepparate from sin . . . and from every root and fiber of jellocy, envy and hatred." Heaven preserve him, he mourned, from the "spiritual whoredom" common to "popular preachers." To remain a Friend would be "one of the greatest blessings"; but to be stripped of his ministry would be the "greatest of afflictions." The very thought riled him: "If I am to be deprived of that I shall be drove to the sad alternative of going and makeing an humble acknowledgement to the Orthodoxy, and be admited behind their door." To prevent such a step he believed that if his old friend Joseph Briggs would bring him together with Martha Smith, her husband, and her "particular friend" Thomas Paxson, all could end in "muttibility." They could live in peace for the rest of their days. "I am really sorry and much hurt that those whom I once considered my real friends should now be active in dragging me into a controversy as unnecessary as it is improper," he closed.

The death of Martha Smith ended the dispute. Her humility and moderation were to be revealed in letters printed in New York City a few years later. Hicks resumed his unwelcome insistence that "silly women" and "wrong enthusiasts" should remain silent. Lucretia Mott, as posterity well knows, did not.

While his tongue was incorrigible at the wrong times and places, Hicks's paintings of the *Peaceable Kingdom* sought a worthier expression of the depth of his feeling for its message. The figure of Liberty appeared in a succession of landscapes as a concession to the "ranters" and their campaign against slavery and every kind of religious and civil oppression.

Thomas Hicks vacationed in Newtown in the summer of 1839. He went up to Scully's Hill to sketch the village, which in 1684 had been laid out as a townstead of 640 acres. Contrary to popular belief, the gentleman with cane and knapsack in the charming landscape could not have been the sixteen-year-old artist Thomas. With his first portrait and Edward Hicks himself, briefly, as his guide, he undertook a copy commissioned by the Carles. Two years of formal training enabled him to paint the hands with more dexterity and to produce a smoother surface. Considering his troubles, Edward is not likely to have lost his furrows; the current academic credo was idealization of the subject. The truth of the lineaments may lie somewhere between the two renderings. John Cheesman, who in 1826 had acquired a *Kingdom* with vignettes, ordered a copy of the portrait for eventual presentation to his Friends Meeting.

Forty years ago it was rescued there from a coal bin, only to slip back into oblivion.

Six years had passed by since Samuel Johnson challenged Edward to paint in behalf of Abolition. Hicks had begun an answer to the long poem in verse of his own, but then hesitated to reply to him whom he called the ranking Quaker poet of his day. In this autumn of 1839 he requested another copy, which Johnson promptly wrote out under a letterhead engraved with *Kneeling Boy*, a print by Patrick Reason popular with abolitionists. Five days later, on October 3, 1839, Hicks dispatched eighty-eight couplets to the Paxson place in Birmingham. "Dear Brother," he began his plea for Johnson to disabuse himself of the idea that his poem of long ago had "made the path of duty plain." (That had been the sole purpose of the lofty composition.) Unmoved, Hicks declared Peace, and not Abolition, to be the message of both his tongue and his paintbrush. Again he turned his back on the Anti-Slavery Society founded in 1833. His belief from the beginning and forever was, purely and simply, that Quakers were not meant to espouse political causes.

The seventy-six-year-old Johnson could have wondered at the invitation to "join the Christian cause" of truth and leave slavery to the Lord. He would not have agreed that the chains of "self" were the ones to fear in a world of all manner of ills and evils. To be told that his "melodious solemn lyre" ought to praise the "glorious truth" of the Gospel, and let prayer serve all concerns, was hardly the answer Johnson had hoped for. Hicks denied that he was "the man to undertake a panoramic canvas of the progress of the cause of liberty":

> *Inferior folks with only monkey's art*
> *May imitate, but never life impart:*
> *Torture invention tax their little brains,*
> *And have at last their labour for their pains;*
> *While my dear friend with grave sarcastic scan,*
> *May say in Nathan's words, 'thou art the man.'*

He was denigrating his art as imitation, as mere invention, far from truth to real beauty. Certainly the Johnson desideratum would have taxed the skill of a Trumbull or West, or even a Delacroix. Hicks conceded that "much might be said" in paint on such Christian themes as Jacob's ladder, were there the opportunity:

> *But time's dealt out in particles to one*
> *Whose sands of life, on earth is nearly run—*

Who hopes to die at the bless'd Saviour's feet,
In self abasement and repentance meet;

Like his great-grandfather Joseph Rodman, he held fast to private conscience. The Quaker had directed that his "Negroes" be allowed to choose "their masters," and that his heirs not sell them against their will. Moreover, he had asked that his personal slave never be sold, but that he be kept in the family service as he deserved.

The name of Samuel Johnson does not appear in the *Memoirs*. Nor does that of Thomas Paxson. The diary of Hicks for 1844, year of the death of Johnson, does not mention the event among many deaths of Friends mourned in its pages. Only the log kept by Mathias Hutchinson in 1819 speaks of the hospitality of Samuel Johnson in Cooperstown, New York, when he and Briggs accompanied Hicks on the journey to Ontario.

*T*he long silence of Edward Hicks Kennedy was broken at last on December 21, 1839. From "Western Tennessee," where he had gone without his wife and child after a year of teaching in Muncie, Indiana, he wrote to Elizabeth. He longed for "reconciliation" with his cousin, whom he "loved, not as the world accounts love but with a purely disinterested, brotherly affection." He was homesick for Newtown. "How is Uncle Edward and Aunt Sarah, and your sisters and all? How is Uncle Edward's cough? One thing makes me feel a little sad, that is the little prospect I shall have of seeing him . . . within the ordinary range of years that he may live . . . and my day at Newtown is past."

He liked the "frankness and cordiality" of the South and its "generally well-educated and cultivated gentlemen," but preferred Pennsylvanians and Hoosiers. "There is one serious drawback . . . that is slavery." The six hundred blacks of the district were "well treated and not overworked," but their "ignorance and degradation" verged on the "brutal." A former advocate of Abolition, he could now watch planters "flog out" visiting abolitionists lest they arouse the blacks who outnumbered their owners six times over. A "bloody insurrection" like a recent one in Virginia was the fear, in the dependence on slavery by a "spoilt race of children." Kennedy closed with an admission of shame for having walked out on debts. He intended to repay "every cent," should any one at home have given him up as one who had lost "all sense of honor."

Elizabeth's swift reply, "a perfect treat," was "a quarter of a year" on the way to Kennedy. "Not every *gal* could string together so much

elegance and refined thought," minus the bits of gossip he pined for. She had said not one word about her sister Sally's "beaux," or whether her brother Isaac remained on the "'virgin'" stem. Kennedy had been to Indiana and back in the meantime, and was hoping to have his wife and child with him if he could escape his "$850" a year, at teaching, for newspaper publishing. Abolition was still much on his mind, and he was more convinced than ever that slaves were better off than if free. "Their condition is not so abject as we Northern people suppose. They are hardy, healthy and happy . . . and surrounded with abundance." Whipping was a rare form of punishment. As for the "multiplication of abolition societies and the speeches," they were fighting an "incurable evil" that the planters themselves often deprecated but could not change, now that slavery was "a system."

"How comes on our Newtown Anti-Slavery friends?" he asked, at a time when the population of that village of only 1,440 whites continued to militate against the injustice.

Again he asked, "How is Uncle Edward?" The mystery of Elizabeth's failure to marry continued to intrigue him. Tennessee and its bachelors would soon bring her spinsterhood, and that of his former sweetheart Phoebe Linton, to a halt, were they to come south. "But I'll tell you beforehand that you must both forego Quaker meetings," he dared to add, there being none. Her mother's "overweening solicitude and tenderness amounting to fear"—and also her "fastidiousness"—were a hindrance, in his unabashed opinion. Nevertheless, he predicted that Elizabeth would follow in the footsteps of Susan, who had "done well," despite her superiority "in mental endowments to her liege lord," John Carle. She might even find the right partner some day at Peck Slip, come to think of it.

"An enemy of learning," some Hicksite ministers and elders continued to say in whispers of Edward Hicks. There were members who spoke of him pityingly as "a fool" and ridiculed his "manner of life" as madness. This, at any rate, is how he himself saw matters. For the sake of "the dear visited children" whom he still hoped to influence, he took a stand, if a plaintive and feeble one. To the aging Rachel Hunt of Darby, much revered Friends minister and poet, he addressed some thoughts in November 1840: "I should love to see thee once more face to face but time is uncertain and eternity is at hand," he grieved, pleading for prayers and sympathy. His "dear Mother" Rachel saw, he knew, how fervently he, a "poor creature" and "child of God," longed to bring

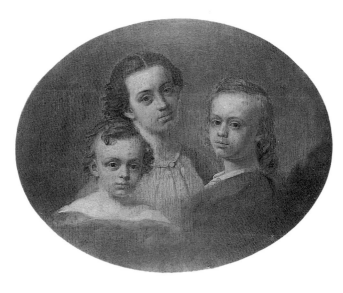

strength and nourishment to the young whom "the serpent" of pride might otherwise undo. (In his weariness he wrote the word "cockade" for cockatrice.)

For his wife Sarah the days were also less than hopeful. Her eighty-five-year-old father died on June 13, 1841, after a lingering illness. Because of his "great loss by fire" he willed his Court Street house to his son Joseph, and another to his daughter Mary, who had looked after him. He no longer had it in his "power to give the others some further token" of his love and affection. "But inasmuch as they are comfortably settled in the world, and I have but little to leave, I thought it right to leave it as I have," he consoled himself, adding that all six children were "equally dear."

An encouraging letter from Chantilly, Virginia, helped drive away the clouds. A loyal Hicksite named Lee wrote to say how "gratified" he was with the fine painting Hicks had sent to him. The "untaught pencil" had done full justice to "well chosen" themes, "the peaceable establishment of the Kingdom" and Penn's Treaty. Lee hailed the "historical paintings" as "an open book from which all read and imbibe the right sort of national feeling."

A visit from Phebe Ann, near eight, did her disheartened grandparents much good that summer, four months after the birth of her brother Silas. So did the arrival of Thomas Hicks in July for a holiday of painting. Amid the "decay of things" in his studio there were plenty of volumes to choose from for such a sojourn—Shakespeare, Dr. Samuel Johnson, Thomas Hood, and their contemporaries. Like Edward Hicks Kennedy before him, he had a passing, boyish infatuation for his cousin Elizabeth Hicks, who had posed for him more than once. He still teased her about the time she had feared to be alone with him in his loft after what she mistook for timid advances. But he had finished a lovely portrait that the Carles chose to hang in their parlor. While he ran on inanely about the "mask of friendship," she teased him about a "fickleness" that he himself excused as "artlessness." He was as handsome at eighteen as she was beautiful at thirty.

He could not, and did not, wait to write to Elizabeth after his return to the city. Like Kennedy, he liked to philosophize and describe. He would have given "three moons" of his future life to have actually shared with her in person what he was about to share on paper. With Carle and two of their friends he had rented a small boat and rowed out from the Battery to Bedloe's Island in the moonlight, then returned with the tide: "The effect was grand. Castle Garden was brilliantly illuminated, and the Battery opposed the dark mass of bricks and mortar

behind it, with its hundreds of lights." The "thousand lamps" of Jersey City on the left, and of Brooklyn on the right, were reflected on the harbor. As they drew near the man-o'-war *North Carolina*, one of her fourteen-pound cannons boomed out and reverberated across the bay. The roar was followed by a burst of fife and kettle drums. Afterward, the silence was broken only by Thomas Moore's tuneful "Ard By Daughter." The four rowed on to Whitehall Slip for a cherry cobbler before parting. Despite the fatal attraction that Elizabeth held for him, Thomas continued to call her "Dear Aunty."

A letter of February 1842 may have been preceded by others not kept. He indicated that he was seeing less of the "self-willed" Susan those winter days when the ills of her household made it less ingratiating. He pictured Elizabeth as sitting quietly at home on a winter's day. It was a sight that he would not have hesitated to paint, even without her, were it not "most too quiet and happy" for his "restless spirit." Then he added, "I'll try in vain—thine." Then, with a characteristically sudden change of mood, meant to show he had grown up at nineteen, he closed abruptly: "This probably concludes the *correspondence general* I have kept up for some time. If it has been a relief and gratification to thee, I am too well repaid."

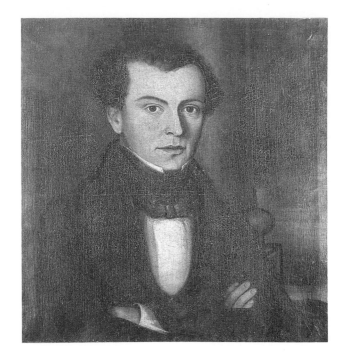

His portrait of Edward Hicks once more left the Carle parlor for exhibition at the National Academy of Design.

One day while Thomas awaited the arrival of a "sitter" he received a surprise visitor, an elderly stranger whose "vast aquiline nose" resembled that of Elias Hicks. Indeed, Elias Hicks was his name. When he explained that he wished to see Thomas's father, the painter well understood. "I knew from instinct that he referred to thee," Thomas informed Edward Hicks by letter. "I answered that my father was dead and that you and he were cousins." The "gentleman of the old school," whose portrait—by Thomas Hicks—eventually went to the Chamber of Commerce of New York City, was a retired businessman. He was short-statured, gray-eyed, and dressed in fine black broadcloth and cravat, "capped with a *chestnut sorrel* wig." He had seen Gilbert Hicks when the Tory fugitive of Newtown was the guest of his parents. Now that the visitor had time to dabble in genealogy, he hoped to be put in touch with one Edward Hicks of Newtown, a grandson of Gilbert.

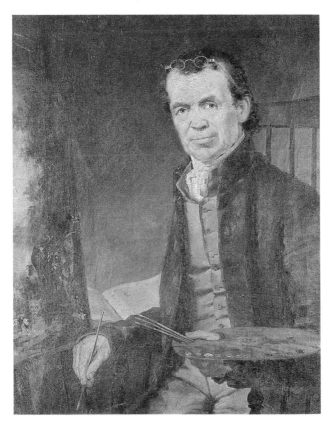

"These things to me have but little interest," wrote Thomas as he passed the word along. "The sanguinary tie is itself, to me, a small matter: he is my brother whose sympathies, affections, hopes and faith accord with mine. . . . Humanity is, or should be, our family." It was rather the "innate greatness of the human soul" that he himself cared for.

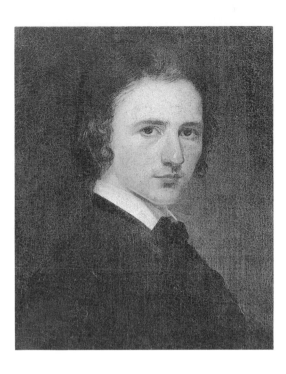

He proved himself a good judge of it in years to come, with his likenesses of Lincoln (painted from a daguerreotype), Longfellow, Seward, Margaret Fuller, Harriet Beecher Stowe, and other notables.

The visitor returned with a "genealogical sketch" for Thomas Hicks to present to Edward, who was becoming more and more interested in family history. Thomas could not say that he was overjoyed to meet him. "I have strange feelings when I look upon this man. He is far along in the role of life—even tottering. I recognize in him that restlessness, that utter inquietude peculiar to the Hickses. Even when for a moment the body is perfectly still, the incessant movement of the eye indicates a mind which knows no calm—a perturbed spirit." This applied as well to Edward Hicks. Such "commotion of soul in aged persons" was incongruous to Thomas. "When I contemplate it in those whose next step brings them to the grave's brink, usurping the place of dignity, or indicative of an unshaken faith, and of resignation to the will of God, I feel keenly the vagueness and uncertainty of the soul's destiny." Surely that look of anxiety was, he believed, compatible with youth only. Thomas Hicks was much given to such ruminations and to the writing of rather turgid paeans to the eternal and nature. The Elias Hicks who sat for him, a kinsman of the more noted man of that name, makes brief appearances in the famous diary of his New York neighbor, William Dunlap.

Memoirs

For the sake of young Friends and for his own children, Edward Hicks began his *Memoirs* on April 4, 1843, after having discarded a draft begun some weeks before: "I am, this day, sixty-three years of age, and I have thought it right to attempt, at least, to write a short narrative of my life by way of testimony to the mercy and goodness of a gracious God and Savior. . . . I was born in the village of Attleborough [Four Lanes End, now Langhorne], Middletown township, Bucks County, Pennsylvania. . . . My parents were Isaac and Catherine Hicks."

He knew only the little that his father had told him about his family. There were four colonial generations to account for and concerning whom he had only lately been seeking to learn more. There was far more to be learned than he ever found.

"My grandfather Colonel Edward Hicks was a first cousin to [Gilbert Hicks]." Edward, who was not a colonel, was actually the brother of Gilbert, a Bucks County official who was sixteen years his junior. Edward did not have "twelve children," and he and his wife were not "first cousins." Mary Hicks, who married Samuel Seabury before he became the first Episcopal bishop in America, was indeed the aunt of the painter. But the passage about his forbears should be relieved of its many misapprehensions.

The Declaration
of Independence
(detail), 1844.
Oil on canvas,
26 × 30 in.
Photo courtesy Sotheby,
Parke, Bernet, Inc.

The marriage of Edward the merchant to Violetta Ricketts, daughter of a wealthy New Yorker who owned a plantation in the West Indies, did not change his manifest destiny—failure. Just how deeply his "pride, extravagance and want of common sense" disappointed his father-in-law the last will of William Ricketts fully indicates. It promised to pay Edward (a co-executor), Violetta, and "five clerics" the cost of "mourning rings, black hat bands, and black gloves," to be worn when the coffin disappeared into the south wall of Trinity Church near Bowling Green. To his son William he left his Jamaica plantation and much more;

Joseph B. Smith,
John Street, c. 1768,
First half of nineteenth century.
Oil on panel, 32 × 61 in.
Museum of the City of New York.
Courtesy Miss Ethel M. Russell.
Street of the Ricketts family,
great-grandparents of Edward Hicks.
The central building is the
first Methodist Episcopal church
erected in America, 1768.

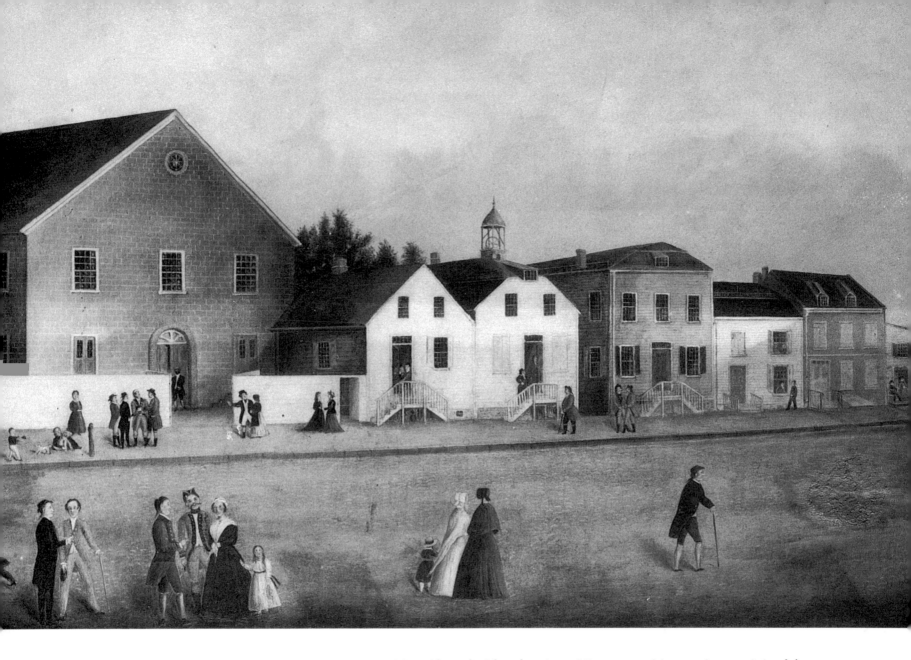

to his wife and elder daughter Mary went his two houses joined by a common garden on Nassau and Jay streets. To his younger daughter he bequeathed a Staten Island plantation and its slaves. Neither was in such need as Violetta, especially Mary, who was the wife of Stephen Van Cortlandt, a descendant of Stephanus, lord of Van Cortlandt Manor, and kinsman of the Schuylers of Livingston Manor. But Violetta was not mentioned at all; her father willed her two children fifty hogsheads of his Jamaican sugar as if to spite her and Edward for having squandered her dowry.

They moved to Philadelphia and more failure, the end of which Violetta was not to see. Her epitaph appears earlier in the present book, along with an account of the rise of Edward's brother Gilbert in Bucks County.

Having entrusted his children to his sister Mary Hicks, who very soon became Mrs. John Searle, Edward Hicks the ruined merchant repaired to Staten Island, and with good reason. Staten Island had become a fiefdom of sorts for two of Violetta's cousins, allied like Violetta herself to the Arundel gentry of Maryland. The Franklin Square residence of one—an official and civic leader—was like a capitol, known for the splendor of its banquets. With part of the money left by their mother to his children the reckless widower invested with a partner in two merchant ships, the *Peggy* and the *Hercules*. His cousins helped him obtain the official position of joint inspector of vessels.

His sons William and Edward did well at school in Burlington. A classmate recalled them in his old age—for the benefit of the painter—as "the prettiest boys he ever saw . . . and the best scholars in the school." Their father did not hesitate to surrender William's legacy to the cause of a year at the Middle Temple in London for the study of law. Edward was not so lucky. The artistic bent that worried his father landed him in the Staten Island militia.

In London, William became fast friends with Richard Penn, of the distinguished family of Pennsylvania proprietors, and the equally destined John Dickinson. All three, but especially William Hicks, had literary tastes. Indeed, William's versifying and flair for the poets exceeded his interest in the law, and, for that matter, commerce. On his return to America he became his father's partner while keeping his eye on Philadelphia, the home of Penn and Dickinson. He made his dutiful visits to Burlington an excuse to go there and mingle with society.

An Anglican missioner, Samuel Seabury, had asked permission to marry Mary. Her brother William and her father Edward Hicks the merchant went to Burlington to hasten the marriage. William took an instant dislike to the portly Yale graduate and descendant of John Alden the pilgrim, who, for all of his qualities, had no means. A dowry was out of the question until Mary, a minor, could inherit money already spent by her father. Edward wished to put up enough to secure a farm for Seabury near Jamaica, Long Island (Seabury's first parish), present him with a few cheap sticks of furniture, and see them married without more ado.

William wanted an advantageous marriage for himself. He began to woo Francina Jekyll, in print, under the pseudonym of "Lovelace." His

Engraving after J. Collins,
Portrait of George Dillwyn
(1738–1820).
Society of Friends, London

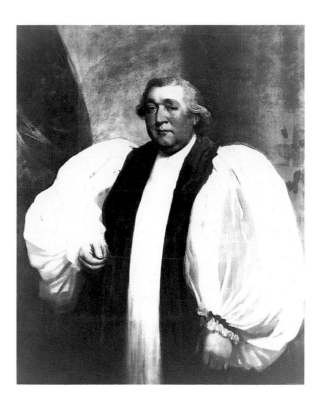

Artist unknown,
Portrait of Rt. Reverend
Samuel Seabury (1729–1796).
*Collection General Theological
Seminary, New York City.*
*Photo courtesy Frick
Art Reference Library*

poem, "Upon Seeing the Portrait of Miss xx—xx By Mr. West," started much guessing among the literati of Philadelphia when it appeared in the new, short-lived *American Magazine and Monthly Chronicle for the British Colonies.* (Benjamin West was then a mere beginner.) Some thought that Francina's cousin, Joseph Shippen III, was the poet; there were many guesses which, as it happens, have persisted into this century. Some still ask, "Who was 'Mr. Hicks?'" With only that name on it, a copy of the magazine, sent by William to a London friend, gathers dust in the library of the British Museum. Christ Church, in Philadelphia, was the scene of the marriage in July 1758.

The dowry of Francina was one of the fine houses owned by her mother, the former Margaret Shippen, and included a gift of furniture and money enough to live in the style to which Francina was accustomed. Her father, John Jekyll, former Boston collector of customs, had inherited two fortunes, one from his first wife, another from Sir John Jekyll of Yorkshire. His widow Margaret had since come into both. Francina bore William five children in rapid succession, and evidently agreed to his keeping "Ned," his child of an Irish maidservant. She must have grieved that the bantling lived, when her firstborn had survived only long enough to receive the name of Elizea Margarita Vanderhuyden, ancestor of the Shippens and certain Randolphs of Virginia. Confident of inheriting some of the estate of Margaret Shippen—more than two thousand acres in and around Philadelphia, the lighthearted William and Francina lived as they pleased. It was therefore with mixed astonishment and gloom that she learned, on her mother's death, what had been bequeathed her: "a mourning ring to the value of one guinea." The two stepchildren of Margaret were the sole heirs.

Charles Hicks, the youngest son of Violetta and Edward Hicks, followed his brother Edward into the Staten Island militia after the latter moved on to Long Island with rank. Charles was none too willing to share the house that he had bought with money left him by his uncle Colonel William Ricketts, rich lottery official of Elizabethtown. What he thought of his uncle's obsequies in Trinity churchyard is not unimaginable. The exhumation of sixteen-year-old Polly Ricketts, to the end that she might be placed in his "decent coffin of mahogany" and buried with her father, was macabre. On her death the Colonel had published a long eulogy in verse in a New York daily journal. (Their grave was blown up during a skirmish led by the redcoats.)

The Seaburys would wait no longer for the legacy and ferried to Staten Island to demand it. Old Edward complained of "harsh treatment" and "neglect" by Charles, and begged his visitors to take him in. They politely refused and fled home to their six children.

Hicks turned up on their doorstep with his four slaves, soon followed by his chattels. The Seaburys bore with him as long as they could, then the cleric seized the goods as "a pawn." Hicks accused him of robbing his "younger children" of their share. One day when Seabury was away, William arrived with his aged cousin, the lawyer Thomas Hicks of Little Neck, and made Mary witness his settlement of eight hundred pounds sterling on young Edward and Charles. Mary was left out. William took the slave Ben with him as he departed. Seabury, shocked on his return, ordered old Hicks "to quit the house."

The worst was yet to come. Charles had the minister jailed for unlawful seizure and falsehood. In his cell, Seabury wrote a denial of the charges for publication, with emphasis on the "mean and dishonourable" behavior of old Edward. In the end the court gave Mary the chattels and what was owing, but compelled her to refund the cost of her wedding, the loan, the poor furniture, and even her tuition and keep in Burlington, not forgetting the slave her father had given her. His public offer of one thousand pounds sterling, for proof of the accusations made by Seabury (whose "delicate morals" he impugned, and whom he once more denouced as "a disgrace to his profession") went begging.

No more is heard of the failed merchant Edward Hicks until thirteen years later, when his cousin Mayor Whitehead Hicks of New York City honors an old statement, presented by a long-suffering blacksmith for horseshoes.

*T*he political unrest had a predictable effect on William Hicks. For him the choosing of sides posed no serious problem, provided his side won. If the Crown won out he was probably safe even in such desperate straits as his. The stand of his friend John Dickinson in the Stamp Act Congress had not signaled opposition to the Penn proprietors of Pennsylvania. Not even his advocacy of a Declaration of Rights alienated him from William Hicks and Governor Richard Penn.

To leave no doubt as to where he stood, William wrote a diatribe, in April 1767, against the followers of Franklin and signed himself "Publicus." It drew one reply that so riled Bradford, the Royalist editor of the *Philadelphia Journal*, that he invited Hicks to join him at the Coffee

House, where the writer with the poison pen could be found and punished. Not Hicks, but William Bradford, threw the offender in the gutter while a crowd looked on. That ended the career of William Hicks as a pamphleteer, but his fidelity did not go unrewarded. Governor Penn granted him four Crown commissions. As Prothonotary of Bucks County, he would be at the Courthouse in Newtown now and then, and trading family news at the Bird-in-Hand Tavern with his Uncle Gilbert.

His next drive to the county seat was for the wedding of Gilbert's daughter Elizabeth to Augustine Willets in a Quaker ceremony at a nearby Friends Meeting. Her mother Mary Rodman's birthright had not, after all, been in vain; the bride's Anglican father had long since adopted Mary's "thee" and "thou." William had brought his sister Catherine along. She and her first cousin Isaac, son of Gilbert, fell in love. When they met again at the wedding of her sister Anne to Benjamin Morgan of Bound Brook, New Jersey, their infatuation went unnoticed by both William and Gilbert. Francina might have perceived it had she not been too near confinement to attend. Indeed, she died in October 1770 in childbirth, leaving an infant son whom William named Jacob Johnson after a landed cousin on the island of Jamaica. He chose a coffin of walnut with silver handles for Francina instead of the usual pine.

Within weeks he himself lay near death of an illness that not even the noted brother physicians Bond could explain. Thomas Bond, the first American to perform a human dissection, called in Phineas, founder of the Pennsylvania Hospital; both were at a loss. A last will and testament had to be drafted before long. William importuned the governor to see that the four Crown commissions provided for his "very young ones," and begged him to remember a promise to take his namesake Richard under his protection in case of need. The Dickinson brothers, co-executors, were to see that both his eight-year-old Catherine and his sister Catherine suffered no "want and distress." Portraits of Francina and Violetta were for his daughter, and her fine dresses for his sister. Save for his own carnelian ring, apparently there were no jewels that had not yet been sold or pawned. His silver heirloom bowl, dress sword, and hunting knife he willed to his little boys. To his venerable cousin of Little Neck, Thomas Hicks, lawyer, he bequeathed his library. They had more than the love of literature in common. Thomas had a natural daughter, Mary, who lived with him. For his own misbegotten "Ned," William asked a "decent education" toward which he asked that fifty pounds sterling be contributed. He asked, too, that when "Ned" grew old enough, he be suitably apprenticed.

There is, the saying goes, a time to die. William rallied, and, as soon as he was able, he traveled to Burlington for a heart-to-heart talk with Catherine—about Isaac. He had been hearing rumors. His Aunt Mary put him to bed at once. In the morning he looked so weepily reproachful, as Catherine embraced him, that it made her love him "even more than ever," as she let Isaac know. The fact was that she had gone ahead and been married to Isaac in Newtown on November 17, 1771, unbeknownst to Gilbert (but as the Reverend Samuel Jones, Presbyterian minister, well knew). Isaac had to face the music next day as clerk in his father's office on Court Row. Catherine hurried home to Burlington where, now, she had to face the consequences. William hinted that he might drop her from his will, in which he had declared her more a child of his than a sister. Only if Isaac proved his worth and showed more than "goodness" of heart could he forgive him.

Catherine wrote Isaac that William would surely not carry out such a threat, but that, if he did, so be it. In her next she declared that she would rather "live in low circumstances" with Isaac than in the "greatest affluence" with another. (These letters her son Edward, the painter, carried in his pocket after his father's death.)

Gilbert thought both his son and niece guilty of folly. Catherine he ignored.

In a childish hand that belied her twenty-six years she let Isaac know: "I just begun to be very gloomy about you. I exist only in your dear company; I never knew till now how Esential you was to my Happiness. You my Soul, know how well I love you but much as my Love is I thought I could be happy a few Days without you; but I find I am mistaken. I long to see you and lay in your Dear Arms. I miss you much in the Day but a vast deal more at night. I can't sleep at all!" Still, she was "out every night" with her cousins the Searles and "amazingly" well.

Her sister Anne and Anne's husband Morgan arrived in January to call for the infant Jacob and take him home. From Philadelphia they sleighed with him to Newtown, where they caught the stage for Bound Brook.

William was well enough again by spring to drive to Newtown, attend to some court business, and buy leather and cider from Joseph Worstall, the future father-in-law of Hicks the painter. But he was unable to be present at the wedding of his bon vivant friend the governor. On May 28, 1772, the *Pennsylvania Gazette* announced the death of William Hicks.

John Dickinson raised two thousand pounds sterling from public funds for the orphans. He granted the commissions of prothonotary, registrar of the orphans court, and clerk of the peace for Bucks County to Isaac. In exchange for this favor he asked Isaac to pay Mary Hicks Searle two hundred pounds sterling a year for looking after the orphans. She hired a tutor for Dickey and "little Kitty" but—as with William and Edward years before—she enrolled the eldest, Giles and Billy, in the Academy.

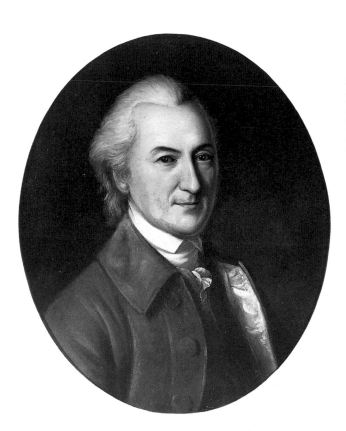

Charles Willson Peale,
Portrait of John Dickinson,
*1782. National
Historical Park Collection*

Catherine gave birth to Gilbert Edward Hicks in Four Lanes End on May 11, 1773, an event that saved her from accepting Giles who sometimes beat Ned and called him "an Irish bastard." To have allowed Dickey, who came down with small pox, to visit might have been fatal. She and Isaac heard less of all this than poor Dickinson, to whom Mary Hicks Searle constantly appealed. Both boys, and the slaves left by William Hicks, needed shoes and there were bills to be paid.

It was ironic that John Dickinson should have had to listen and to act. By this time he had become a national celebrity, not only on account of his *Letters from a Farmer in Pennsylvania*, but for his new "Liberty Song," which took the public by storm. Soon, when the muskets began to sound, people would call him the "penman of the Revolution."

Guns were not yet booming when the turmoil that presaged revolution caused dissension even among the Penn proprietors and their shrinking numbers. John Penn took over the governorship. Richard went to London to petition the Crown for more moderation. He never returned. He perhaps would not have dared.

The insurgents of Bucks County were fast becoming a serious threat to Gilbert and Isaac. The ledger of Isaac shows that he had again taken to drink for a panacea, even on the birth of William Richard on November 17, 1774.

Dickinson was not the only pamphleteer. Samuel Seabury published his notoriously Loyalist letters signed "Westchester Farmer" which seventeen-year-old Alexander Hamilton denounced for their profanity and their cry for mere parliamentary reform. Seabury taunted Hamilton for "fibbing," a quality "rather meaner than rapping out a little now and then." It was "rapping" that landed the irrepressible Seabury in jail in New Haven until he was paroled on a plea for the support of his family. He had worked as a scrivener and as a doctor of sorts in his parish. The Continentals suddenly advanced on Westchester. They seized his manse, turned his church and barns into infirmaries. He chose a moonless night

in which to row alone to Long Island and safety. Mary and the children watched the trampling of corn and buckwheat, the burning of grain, hay, and even church pews, for fuel. The British division that came to the rescue was no better, but it enabled Seabury to bring his family to occupied Manhattan.

An ominous straw in the wind for Dickinson, as well as for the orphans, was the opposition to his proposal that the Continental Congress let Pennsylvania and Virginia go their way. Without them, there could be a "pacific system" in his opinion. Arthur Lee of Virginia alone agreed. John Adams took bitter exception. He belittled the courtly arrival of Dickinson at the Congress behind two high-stepping teams.

Dickinson had no more than withdrawn to Wilmington with his family when Mary Hicks Searle sent Giles and Dickey to his care. She was too ill to keep them. He enrolled both in the local Academy and enlisted as a private in the militia, a rare step for a Quaker.

Gilbert Hicks had kept out of the imbroglio of the orphans after he helped secure Isaac's commissions. He had concerns enough of his own. Because of his earlier appeals for better prisons and food for escaped slaves the governor had ruled that Gilbert hear all trials concerning these issues. But for how long would he be able to serve? Reelection of Tory officials was about to be forbidden. His attempt two years earlier to steer a safe middle course might now prove his undoing. No one would forget that he had called on "every American" to remain a loyal British subject and be assured protection from "injury and distress." It was he who might soon need protection.

Catherine, expectant, was terrified by the cannon fire that reverberated from down the Delaware. The Continentals were ready to march on Trenton. Edward Henry Hicks was born in June. He died two months later, less than a week before the signing of the Declaration of Independence—a declaration of war. Dickinson did not sign that historic rejection of compromise and accommodation with the British. Isaac ceased to turn up at the courthouse and took to heavy drinking in his anxiety.

In October, Gilbert was put to the test. He was obliged to summon the townsfolk to the courthouse and listen while, from its steps, he read General Howe's proclamation of loyalty to the Crown. A shout of "Hang the traitor!" soon interrupted him. Within minutes he was galloping on

horseback toward Four Lanes End. He made his slave Ishmael don a dress uniform and white wig, while he himself rode off to a farm where he found shelter for the night on his way to safety in Philadelphia, there to travel to occupied New York City and cousins on Long Island.

Meanwhile, the slave and his mount led the pursuers on a wild chase. A day or so after the house was searched, wagons came to cart much of the furniture away for a future auction. The recent death of their second son left Isaac, Catherine, and Gilbert Edward, not yet three, alone with the little black girl, Jane, whose parents, Ishmael and Hagar, had to flee the wrath of the Continentals for good. The four were confined to one room of the house. Isaac had to raise "4,000 pounds sterling" as bond, while his nonbelligerent brother-in-law Willets paid only five hundred.

The names of a dozen "traitors," including Gilbert's, were posted throughout the county. Their estates were offered at auction in Newtown. Of all this Gilbert knew nothing as he signed a beautiful beribboned last will, presently safehanded to Isaac, bequeathing the already fugitive slaves to his son Joseph; and furniture, much of it about to change hands, to his unwed daughter Sally.

Four Lanes End became still less of a haven for Loyalists after the Battle of Brandywine. The Marquis de Lafayette chose the Richardson house for himself and his troops, and Gilbert's house, opposite, for the wounded and dying. He himself lay on a table while his leg wounds were bound, a table that survives. The floors of both fine residences were quickly filled with straw beds. One hundred and sixty died and were buried in a common plot that winter. The mound was bared by mongrels during the spring thaws; town volunteers with shovels covered the wooden boxes.

The seizure of power from the British did not assure Newtown of peace from raiders. A party made off with 2,000 yards of cloth needed for Washington's ragged army after seizing the father of six children, but not until they had also captured a young sniper.

In all the turmoil Catherine was again with child. Eliza Violetta Hicks was born on March 17, 1778. Six months later, in the heat of August, the family phaeton, furniture, china, remaining twelve acres, and Jane the slave girl were inventoried as worth "224 pounds sterling" in Newtown. At the "estates" sale, the house went to Isaac, with the help of an absentee ally, for "4,030 pounds"; but without the right of full occupancy

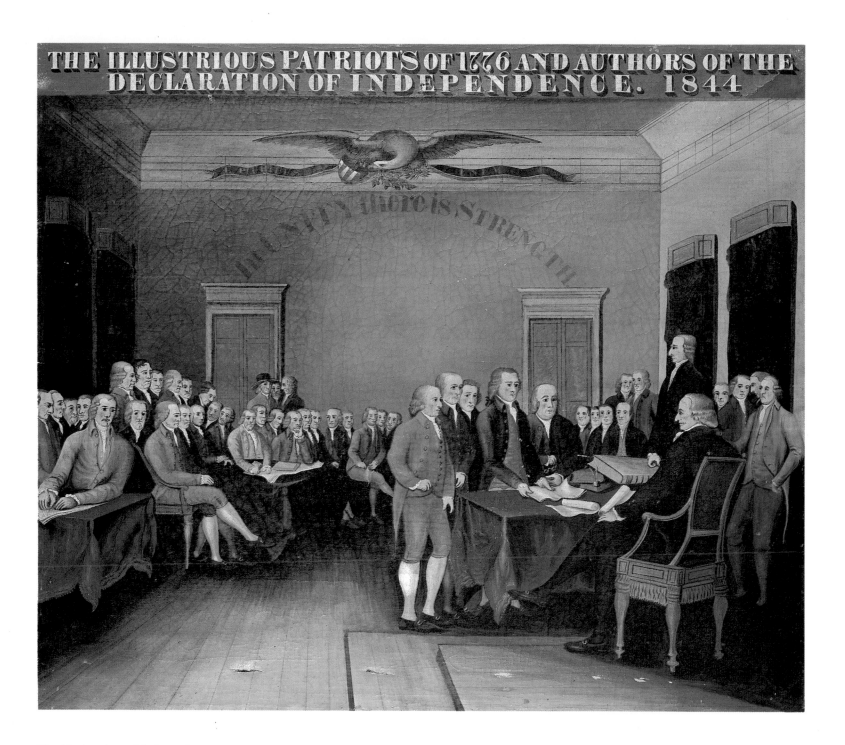

The Declaration of Independence,
1844. Oil on canvas, 26 × 30 in.
Photo courtesy Sotheby, Parke, Bernet, Inc.

during hostilities. For twenty years John De Normandie, a Swiss-American doctor of Bristol, had, as noted earlier, been the partner of Gilbert in Newtown and Bristol real estate. This gained the day. Moreover, the de jure partnership barred the sale of any of the land for the building of a new village, Washington, by a New York speculator, William Goforth. Isaac also retrieved Jane, as well as most of the treasures brought by Mary Rodman from Long Island to Bensalem years earlier.

Dickinson, meanwhile, had risen from his lowly rank and enlisted Giles Hicks in the 10th Pennsylvania Regiment. The death of Mary Hicks Searle in the spring of 1779 left Billy and "Ned" homeless. Dickinson apprenticed Billy to shoemaker Mordecai Moore and sent Ned to Four Lanes End. The crowding, and the boy's insolence to Catherine, forced Isaac to turn him over to a neighbor while he, in desperation, protested to Dickinson. He argued that his withdrawal to the West Indies was likely; and, before waiting for a reply, he put both boys on a stagecoach with a note: "Dickey, poor fellow, I should have sent clothed better had not my tailor disappointed me. . . . I have done everything in my power for him and am sorry to send him in such ragged condition."

Isaac's flight to the West Indies was not to be. Instead, he joined the 6th Regiment of Captain White's local Continentals, who granted him permission to remain on call until Catherine's confinement. His failure to respond to a call led to swift banishment. He was handed a pass to New York City and told to keep out of Bucks County. Catherine, it will be remembered, made her way to Burlington cousins with Jane and the children.

Before Isaac and Catherine were sent on their separate ways by fate, they received a surprise visit from Giles Hicks. He had just been seized and released by the enemy for the second and last time, then mustered out with Dickinson's more than willing help. Earlier, British dragoons had paroled him to his guardian who, only a little before, had managed to have Giles made a captain to silence his complaints of wages "beneath the dignity of an officer." Dickinson was relieved to hear from London, where Giles's uncle Edward Hicks had joined his wife after four years of exile in Nova Scotia. The major—by this time lieutenant-colonel—and his wife had inherited a plantation on Tobago. He wished Giles to be sent to the island to learn management, in which he himself was not interested. Giles, making the trip for the second time, was seized off the coast of Maryland by the French fleet. His claim that he could prove he knew "his excellency General Washington" and John Dickinson effected his release for a visit with "an aunt" on shore. He hastened to Philadelphia, collected the

portraits of Violetta and Francina, his father's sword, the heirloom silver bowl, and then caught the stage for Four Lanes End. In great haste to be off again for Tobago, he entrusted the treasures to Catherine. (Half a century ago there were rumors—still unconfirmed—that the portraits were somewhere in the vicinity of Greenwich, Connecticut.)

From Tobago, Giles ordered Dickinson to have "Billy bred to the law" according to his father's wishes. But Dickinson had already taken the measure of young William Hicks and turned him over to the Philadelphia printers Dunlap and Claypool, whose shop he promptly fled. When his guardian's search for him ended two years later, he again slipped out of an apprenticeship, this one with that famous printer of the Declaration of Independence and Bibles, Mathew Carey. Dickinson, understandably, demanded his quit claim.

Ned had turned out little better. He died and was buried at Christ Church, whose "clerk, grave digger, bell ringer and watchman" Dickinson paid for. It was then that the news of the death of Giles on Tobago arrived by way of London, with a request from his uncle the lieutenant-colonel that whatever jewels "of value" the youth may have owned be sent to him. John Barclay, husband of Mary Searle of Burlington, and administrator of the estate of Giles, handed his resignation to Dickinson in disgust. There were not even any trinkets worthy of mention.

Richard Penn Hicks—"Dicky"—had been unable to dislodge the natural daughter of the centenarian Colonel Thomas Hicks who had left him his forty-acre estate at Little Neck. Upon her sudden death, he visited the place and found its once rich land denuded, desolate. He decided to leave it in care of its feeble, penniless custodian and join the militia, according to the increasingly weary advice of Dickinson. He married, fell ill of consumption, and within a year or two was buried with his infant child at Christ Church.

The prospects for his sister Catherine were bright enough when she was married at Old Swedes' Church in Philadelphia to Stephen Ceranio, a merchant of Saint-Domingue. But she died a month later. Ceranio presented his demand to Dickinson for "300 pounds" and departed.

Jacob Johnson Hicks, the youngest, had finally been taken in by the Dickinsons in Wilmington. But he did so poorly at the Academy that Dickinson sent him up to Philadelphia to attend lectures by Benjamin Rush, William Bartram, and other savants. His indifference to higher learning left only the chance to run the Tobago plantation, a white hope for him. He tried it but soon returned to Dickinson, who gave him his quit claim and the chance to buy a small farm. He died soon afterward.

His will bequeathed Eliza Violetta Hicks fifty pounds, but it did not mention her needy brother Edward, bound for Four Lanes End and an apprenticeship.

There is no sign that Edward, at twelve, had the talent that had manifested itself in his uncle, Lieutenant-Colonel Edward Hicks, who was living in London. This officer of the 70th Regiment of Foot, billeted in Nova Scotia during the Revolution, emerges for the first time as kinsman and artist. In 1781, he painted views of the fort and his surroundings, brought them with him to London, and had them aquatinted on steel. In 1782, year of his arrival, the Museum Book Shop published them for sale. But that there was an artistic strain in the family, passed down through Edward to the portraitist Thomas Hicks, is abundantly clear. The original water-color studies by officer Hicks are in a private collection in Canada; pen-and-ink copies by T. B. Akin are in the Provincial Museum, Halifax. *Northwest Aspect of the Citadel {Halifax}* is in the Stokes Collection of the New York Public Library.

Lt. Col. Edward Hicks,
Northwest Aspect of
the Citadel {Halifax},
1781 (date depicted). Aquatint.
I. N. Phelps Stokes Collection,
New York Public Library.
Astor, Lenox and Tilden Foundations

Sing Praises

Little Silas Carle had been in Newtown since before Christmas. For his amusement Hicks painted and lettered blocks for an alphabet set. It met with so much approval that he prepared and neatly boxed several for sale in Attleborough and Philadelphia. While awaiting an order for more, he stored his letter stencils in one of his Bibles. Buyers were more interested in toys.

In April, the *Journal* of Newtown carried his paid notice to the county that he would letter highway directors "at forty-five cents each" and put "hands" on them as well. For orders of forty or fifty, already "cut, painted, and brought to the shop" for lettering and hands, he would guarantee delivery, at sixty cents each, up to fifty miles. The paper also put in a good word for the alphabet blocks with the opinion that they were more instructive than "whirligigs, tops, miniature men and dogs, &c."

The offer to deliver came a cropper at the very start. The mare Belle, faithful companion on many a long journey, departed the world of missions and deliveries. In an immaculate hand, Phebe Ann assured her grandfather of her sorrow. She would never forget the pleasant drives that he, she, and Belle had enjoyed together. Her letters, usually addressed to Elizabeth but meant for the family, reported that she could read the *New Testament* that her father had given her. In spelling and geography she

The Peaceable Kingdom
(detail), c. 1844.
Oil on canvas,
24 × 31 ¾ in.
Photo courtesy Sotheby,
Parke, Bernet, Inc.

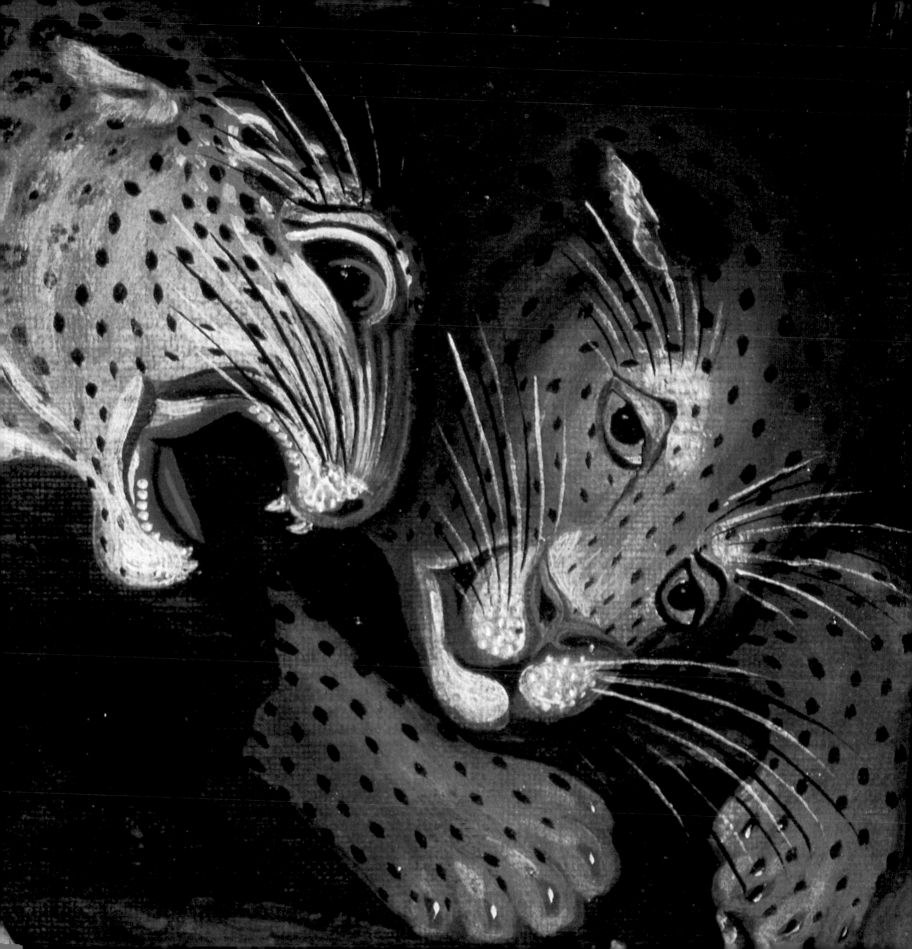

stood at the head of her class. She regaled the family with an account of Barnum's Museum, its Tom Thumb who weighed only as much as a baby, and the new water faucets that piped fresh water from the Croton reservoir to the kitchen.

A sudden outbreak of autumn fever in August ended the long stay of "little Silas" in Newtown. When his grandmother bundled him up at the first sign and rushed him home to Peck Slip and the attention of Dr. Seaman, she acted none too soon. By mid-September Edward was pleading for her return: "Thee has left a void, my dear, in our little circle." His nights were filled with loneliness and spells of coughing, and his days with reports of illness and dying all around him. He continued to rise early, "if able," mend the fire and "put on the kittle" for tea. At the moment of writing he was without both Elizabeth and Mary whom he had sent to the Leedom farm to help care for the dying Polly Leedom, mother-in-law of Mary Twining Leedom. He had been up and about at daylight to "gear the horse to the wagon" and send Isaac over to see them. His helper Thomas Gilpin had sent word that he was too ill. Edward was about to do the chores.

Silas Carle died on the twenty-first day of September. A week later his grandmother Hicks returned with Phebe Ann to Newtown. By the time Isaac brought the child back to Peck Slip the bond between her and Edward Hicks was one of mutual adoration. She wrote thanks for everyone's kindness and for the "gingercakes, bread, and biscuits" that she had brought to treat the family. Her father added a line to chide Elizabeth for choosing to help Sally, a prospective bride, instead of his Susan.

The year had been an eventful one for the nation. By treaty, President William Henry Harrison had annexed the Republic of Texas, a state on the way to becoming the most populous in the Union.

During the winter of 1844 Edward Hicks wrote a tract on primitive Christianity, *A Word of Exhortation to Young Friends*. To it he turned with a will—indeed, almost with a vengeance. "What will be the state of gentle Christendom in the year 2000 it is not for me to say; but, if the abomination of desolation . . . what may not we Christians expect, when a Saviour shall, for the last time, weep over us?" Here was a chilling prophecy as well as a question. In this tract, intended for free distribution among "the young of all parties in the Society of Friends," Hicks flailed in all directions, even at himself. Paine, Voltaire, and Spinoza he regarded as no better than the brutal Crusaders, or the Puritans who massacred and

burned Indians, or Genghis Khan and Tamerlane and their hordes. He condemned his own proneness to "fanatical melancholy," and his having left wife and children in order to travel and then take his ease in "rich Friends' rocking chairs, cracking jokes, telling anecdotes, back-biting. . . ." Only the way of the fishermen of Galilee could open the gates to salvation, through the "nothingness of self," away from politics and "superfluities." He denounced the worldly sons of his idol Penn as if he did not know—or at any rate did not care—that they had done his own father, grandfather, and sycophantic uncle William huge favors.

Newtown Meeting was the scene of the marriage of Sally Hicks and Isaac Parry the younger in the spring of 1844. The merchant Richard Price sent his congratulations. He also informed Edward that the alphabet blocks had had no sale. He had turned his stock over to another Quaker storekeeper who would see what he could do. Center city, Philadelphia, was a place for only wary shoppers at this time of the worst of all American religious riots. Two Catholic churches were burned, and many fugitives from the Irish potato famine perished.

Edward Hicks Carle was born on June 1, but his arrival posed no threat to the unwonted place of Phebe Ann in her grandfather's affections. Her letters had become an important news source. She reported that Thomas Hicks was about to leave for a year in Europe.

During the dog days of August, Edward Hicks busied himself with a painting ordered by Joseph Watson, a bridegroom, for his new house in Langhorne. He had Isaac deliver it with a letter:

Dear Joseph,

I send thee by my son one of the best paintings I ever done (and it may be my last). The price as agreed upon (twenty dollars, with the additional sum of one dollar 75 cents which I give Edward Trego for the fraim). I thought it a great deal cheaper than thee would be likely to get a fraim with ten coats of varnish anywhere else. Thee can pay the money to Isaac who can give thee a receipt if necessary but—I have no account against thee. With gratitude and thankfulness for thy kind patronage of the poor painter and a grateful remembrance of many favours from thy kind parents, I bid thee, dear child an affectionate farewell

<div align="center">

EDW. HICKS

</div>

Yet in his *Memoirs* a few months before he had assailed painting as "a link in the chain of anti-Christian foibles next to music and dancing." It was part and parcel with the folly of "fashionable learning." But the side that fought down the imaginary dragon knew better.

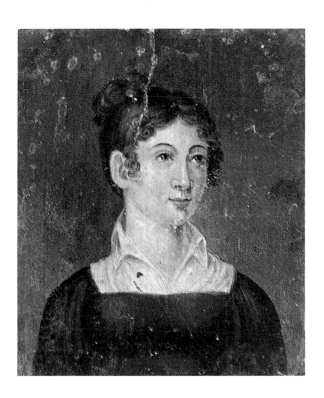

Thomas Hicks,
Sarah "Sally" Hicks,
c. 1840.
Hicks Family Collection.
Photo by Alan Brady

The Peaceable Kingdom
of the Risen Leopard

The central figure of a landscape painted for Joseph Watson, and sent to him with a letter, is a majestic leopard on all fours. It is one of four known *Kingdom*s of its exquisite genre.

Fortunate in his choice of models for the bear, lion, and ox as well, Hicks did more than full justice and far surpassed the quite ordinary woodcut illustrations from whence they came. His mastery grew even as his physical strength waned. The result is transcendent.

The examples in Williamsburg and Dallas, much alike, emboldened Hicks to outdo himself in the canvases that followed. The third, in a private collection, is a stunning proliferation of both old and new models, including a Liberty figure, and also the babe from Raphael. Its broken branch, traceable to Penn for whom it symbolized moral decay, becomes central rather than lateral. The final version, perhaps the most haunting, has for its "little child" a boy in a white guimpe and jumper suit with red sash. The girl at the lower left bears comparison with a daguerreotype of the oval-faced Phebe Ann, her grandfather-the-painter's favorite. The detail of Penn's Treaty is more animated and ranging than heretofore.

The source of the leopard, bear, and lion is a book published by Samuel Griswold Goodrich (1783–1860) under the pseudonym of Peter Parley, the most celebrated name "in the history of American children's literature." He chose the guise of a moralizing, white-headed, gouty Boston Quaker, dressed in knee breeches and broad-brimmed hat, and leaning on a cane, while proclaiming: "I have seen a great many things and had a great many adventures and I love to talk about them." Peter Parley took his name from *parler*, the French for *to talk*. To draw American children away from the British fairy tale and Mother Goose monopoly, he began with *The Tales of Peter Parley About America* (1827). His books, read worldwide, were pirated as freely as he himself had pirated much of the stuff of his success.

For the booklet on quadrupeds the illustrator made use of the leopards in a Bible engraving after Potter, or one of his imitators. Hicks had already made occasional use of the head of a leopard that served his scriptural purpose: ". . . the soul . . . from a horrible pit emerges to sing praises. . . ."

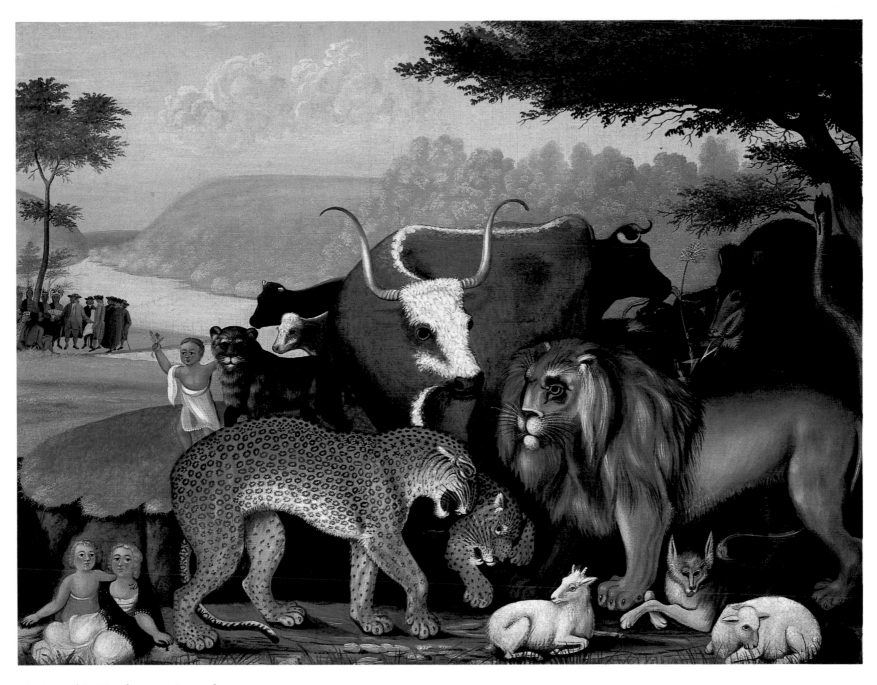

The Peaceable Kingdom *c. 1844–46.*
Oil on canvas, 23⅞ × 31¼ in.
Dallas Museum of Fine Art, the Art Museum League Fund

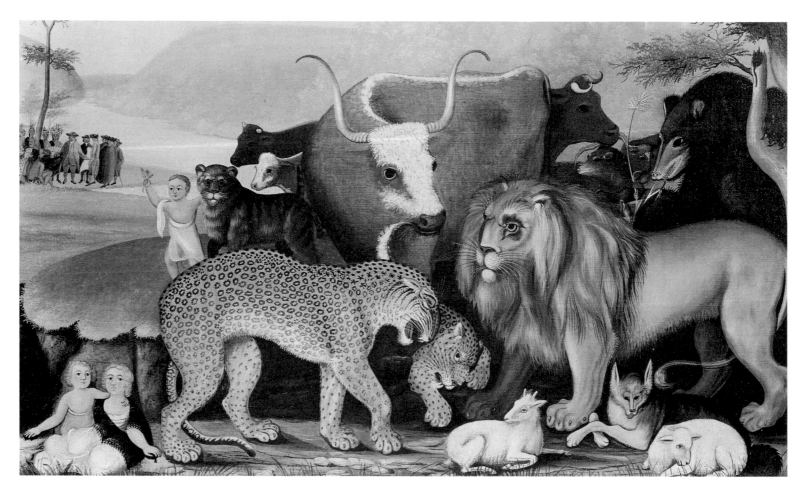

The lion matches figure 36 of Chapter 8 in *The Introduction to the Academical Reader*, published by John J. Harrod (Baltimore, 1830). The figure is signed "Horton," for John S. Horton, active in Baltimore (1837–47) and New York (1846–53). He sometimes signed his woodcuts "H." Peter Parley and others repeated the lion.

Before Christmas Edward Hicks preached at Bristol Meeting in a manner that dismayed Samuel Swain, frequent mediator of inner strife. In a letter of mixed thanks, his critic mildly rebuked him for his stubborn refusal to leave well enough alone and not fault the Abolitionists for their unwillingness to see "slavery of the body" as a "secondary consideration." Swain said that he seemed to forget that the Lord had brought "slaves out of bondage." He warned that those who forgave slaveholders ought to be sentenced to the "indignities of slavery for a year." Edward ought, he wrote, to reconsider and help storm the "prison doors," or else, like Thomas Jefferson, "tremble" for his country.

The year had brought forth more than the *Peaceable Kingdom* that Hicks liked the best of any thus far. With what must have been no little frustration, he had undertaken a copy of the *Declaration of Independence*.

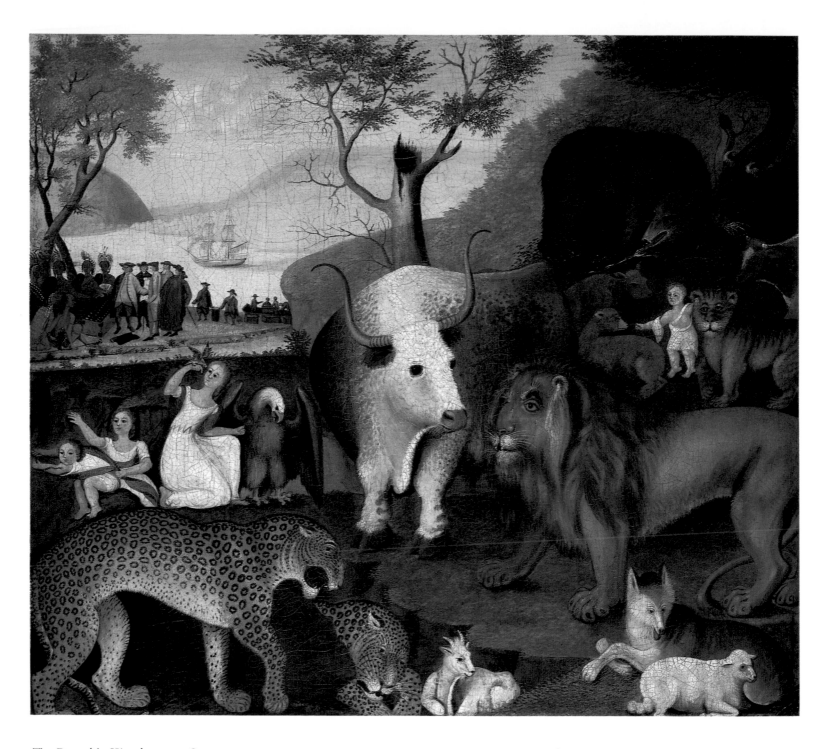

The Peaceable Kingdom, *c. 1844.*
Oil on canvas, 24 × 31¼ *in.*
Private collection.
Photo by Otto Nelson

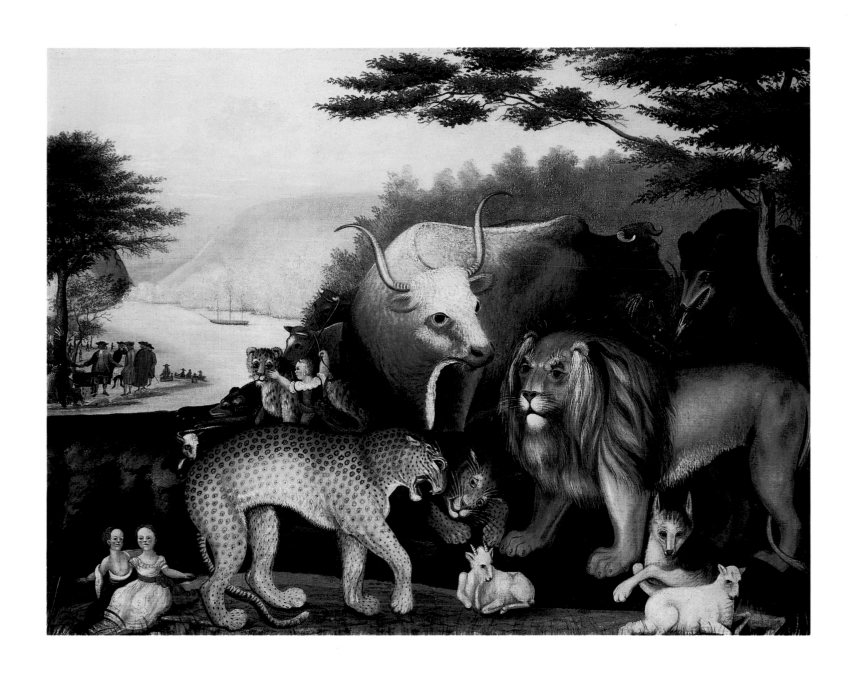

The Peaceable Kingdom, *c. 1844.*
Oil on canvas, 24 × 31 ¾ in.
Photo courtesy Sotheby, Parke, Bernet, Inc.

The Declaration of Independence

*B*oth Hicks and his son Isaac signed their separate copies of *Lives of the Signers of the Declaration of Independence* by Charles Augustus Goodrich (New York, 1829). Beside the likenesses of the signers, Edward noted their ages at the time of the Declaration. Beside that of Franklin he wrote, "self-taught." The frontispiece of this book is an engraved copy, by Illman & Pilbrow, of the famous one by Asher Brown Durand after one of the two versions painted by John Trumbull. Hicks may or may not have known its unusual history. Trumbull had brought the accomplished Neale from London to print the engraving that had engaged Durand for three years. The public demand was such that Durand became the richest and most respected American exponent of his craft. Trumbull had presented the first impression of the print to General de Lafayette during the hero's triumphal tour of 1824. One of the celebrated paintings hangs in the Wadsworth Atheneum in Hartford.

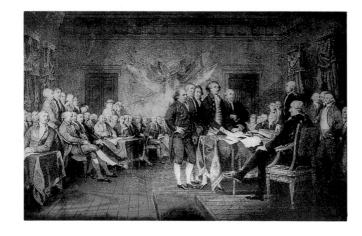

Engraved by Illman and Pilbrow after engraving by Asher Brown Durand after oil by John Trumbull, The Declaration of Independence, *1829. New York Public Library*

Hicks made a brave but sorry attempt at portraiture in the version that is owned by the Chrysler Museum, Norfolk. It is the same size as the dated, more embellished version illustrated. In all three known versions it is the rich somber tones, in keeping with the solemn scene, that breathe life into what might otherwise be a stiff aggregation of waxworks figures. Hicks painted the version dated 1844 on its face for Isaac. Eleanore Price Mather declares the first owner of the simplest version to have been Horace Burton of Bristol Friends Meeting.

Hicks returned from Philadelphia Yearly Meeting in May 1845 determined to begin printing his *Memoirs* and *A Word of Exhortation to Young Friends*. But first he wished to make some additions and changes. To the treatise for youth he added that for "anger, clamor and evil speaking" he had paid dearly. "Suffering in silence" with meekness and patience might have prevented the schism.

Richard Price rejected a hint from Edward to see the *Memoirs* through publication. He frankly doubted that "a rich harvest would be gained," failing to see that the purpose of Hicks was to carry on from the grave through the printed page. Comly, Watson, Ferris, and others looked the manuscript over and thought it too inflammatory, even if initials instead of full names were to be used. Rather halfheartedly, Price discussed printers. He recommended that Oliver Hough, a Quaker printer and scrivener, be considered. Hough was the son-in-law of Edward's friend Joseph Briggs. When approached, he agreed to print a

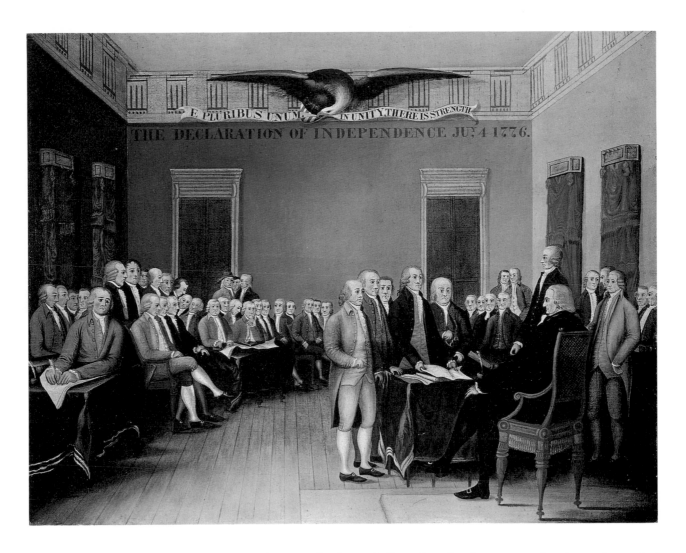

The Declaration of
Independence, c. 1840–45,
Oil on canvas, 24 × 31¾ in.
Abby Aldrich Rockefeller
Folk Art Center,
Williamsburg, Virginia

thousand copies for forty dollars, less for the money that he truly needed than from a sense of duty. Henry Willet Hicks of New York City, heir of the late master of Andalusia, agreed to handle the disbursements.

The death of Andrew Jackson in June inspired the painter to attempt a portrait to be copied from a print, as soon as an order of canvas arrived from New York via a Philadelphia merchant. Rather than delay, he cut a piece of carriage curtain cloth on which to begin a salvo to the late president. Cyrus Hillborn, brother of Amos Hillborn, who had ordered the canvas (which, presently, Hicks was to put to unexcelled use) had asked him to paint the family farm and homestead northwest of Newtown. He intended to begin in late August before he opened the shop again after the "dog days."

Portrait of Andrew Jackson

Edward Hicks had his military heroes and patriots. Although neither he nor his fellows ever fired a shot or saw a battlefield, he looked back on his marching days in the local militia with mixed regret and pride. For Jackson he had a fellow feeling based on more than the Whig sympathies of the Hicksites. Both men were born in poverty, sparsely educated, partisans of the average man, and foes of monopolistic wealth. Both had their opinion of the British. Jackson had fought them in youth and defeated them in New Orleans in manhood. He took no part in the Abolition movement.

From a small engraving by the English immigrant Thomas Illman, Hicks sketched a head lifesize on a ground coat applied to carriage curtain cloth, perhaps intending to repeat it on canvas expected from the city. Illman himself had copied a drawing by Henry Hoppner Meyer. With the aid of a second print Hicks improvised on the official seal; he added rays of glory to the background, and reversed the barbs and olive branches exactly as he saw them in the print. The latter should have, but did not, number thirteen each. He omitted the drapery and "E pluribus unum" but retained the tassels.

The portrait could not have been painted in the 1830s. In 1841 an act of Congress ordered that the European eagle be replaced by the bald eagle for the great seal. The print to which Hicks referred for the background manifestly antedated the act. (This raises questions concerning both the long accepted attribution and dating of the sign for the tavern of William Wood, Fallsington, Pennsylvania.)

Hicks rolled up the portrait and placed it in a corner, where it lay until after his death. Wisely, he turned from this his only authenticated, known attempt at portraiture, for the first of his farmscapes.

Engraving by Thomas Illman
after portrait sketch by Henry Hoppner Meyer
after oil portrait by Ralph E. W. Earl,
Andrew Jackson,
Photo courtesy Historical
Society of Pennsylvania

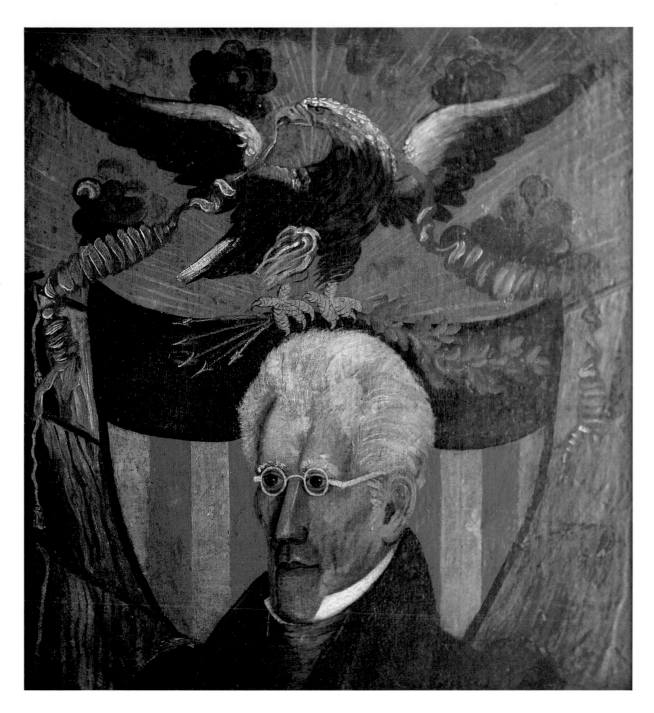

President Andrew Jackson, *c. 1845.*
Oil on carriage curtain cloth, later mounted on Masonite panel,
21½ × 20 in. Hicks Family Collection.
Photo by Alan Brady

The Residence of Thomas Hillborn

*E*dward Hicks, the minister, intransigent in matters of faith and civic concerns, became increasingly pliant as to painting. No one sensed more surely than he himself that, with a little urging, he was ready to move in new directions with his brushes. The son of an old friend asked him to undertake a view of the family farmstead on the Wrightstown Road north of town. Cyrus Hillborn, a Philadelphia merchant from whom Hicks bought coach paint and varnish, agreed that it should be painted in part from memory as it appeared in 1821, two years before the death of Thomas Hillborn. Thomas was descended from that first Thomas, an Englishman who came to Pennsylvania from New Jersey in 1702. Hicks shows him driving a plow while his five sons and hired hands move about the place, and while Mrs. Hillborn and a daughter-in-law look on. It is inscribed on the top rail of the stretcher: "Purchased by his son, Cyrus Hillborn in 1845 when/This Picture was painted, by Edward Hicks in his 66th year." The landscape remained in the family until late years, but came to Colonial Williamsburg from Wissonoming.

The date 1792 is still visible on a corner of the house.

The picture marks the belated willingness of Hicks to come to grips with the real and familiar. His compass was imagination, recollection, sentiment. He ceased to depend entirely on prints for his compositions, while turning to them as usual when they served. Growing local recognition had encouraged this new boldness and confidence. He could not but have been gratified by this salute by *The Democrat* of Doylestown on October 12, 1845, to a sign for the general store of Brown Eyre & Company: "It presented the variety of stoves and implements of husbandry . . . truly and beautifully, and also a rural scene . . . farm buildings, groves, landscape . . . operations of the farmer, handsomely arranged and true to nature." A few months later, in 1846, Hicks recorded payment of fifteen dollars by that establishment for trimming a new style of wagon called "The Great Western." Neither of these examples of the skill of Hicks has survived. Nor did a certain sign that Sherman Day described. It portrayed a tipsy driver atop a fine stagecoach and four. The driver, a friend of Edward's, protested when he saw how he had been perceived. But Hicks would only say wryly, "Doesn't thee get a little so sometimes?" As soon as Jacob Sutherland promised to mend his ways he was painted sitting upright with reins well in hand.

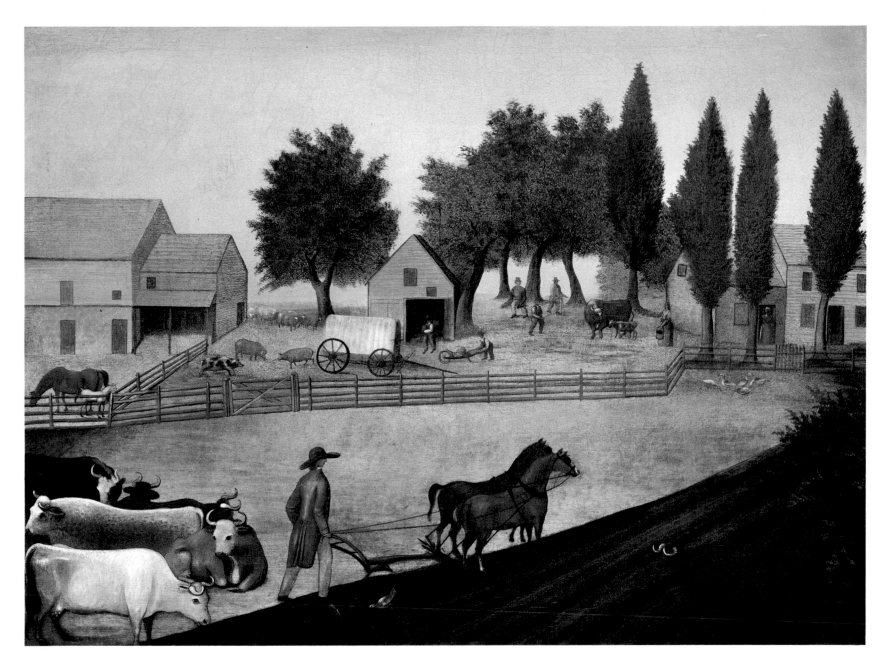

The Residence of Thomas Hillborn,
1845. Oil on canvas, 23⅝ × 31⅞ in.
Abby Aldrich Rockefeller
Folk Art Center,
Williamsburg, Virginia

The Peaceable Kingdom
1845

The Natural Bridge of Virginia makes four appearances in the ever-changing mise-en-scene of the timeless peace message. Its role is more than symbolic. Its poetic aura, subtle lights, and intense autumnal hues belong to the romantic age to which the *Peaceable Kingdom*s are tangential.

The "little child" leads the "tiglon" cub and also a lightly tethered calf. Wolf and lamb return to the rapport pictured by the artist Westall. As for the lion, symbol of melancholy and choler, it follows the design of Northcote; but its lineaments are curiously like those of the painter as his cousin Thomas Hicks portayed him.

The crevasse is again the habitat of serpents and the perilous resort of the two children of past landscapes. One babe (no longer the draped infant from Raphael), rises and balances precariously.

The stretcher bears the date 1845.

The Peaceable Kingdom,
c. 1845.
Oil on canvas,
24¼ × 31 in.
Yale University Art Gallery,
bequest of Robert W. Carle,
B.A., 1897

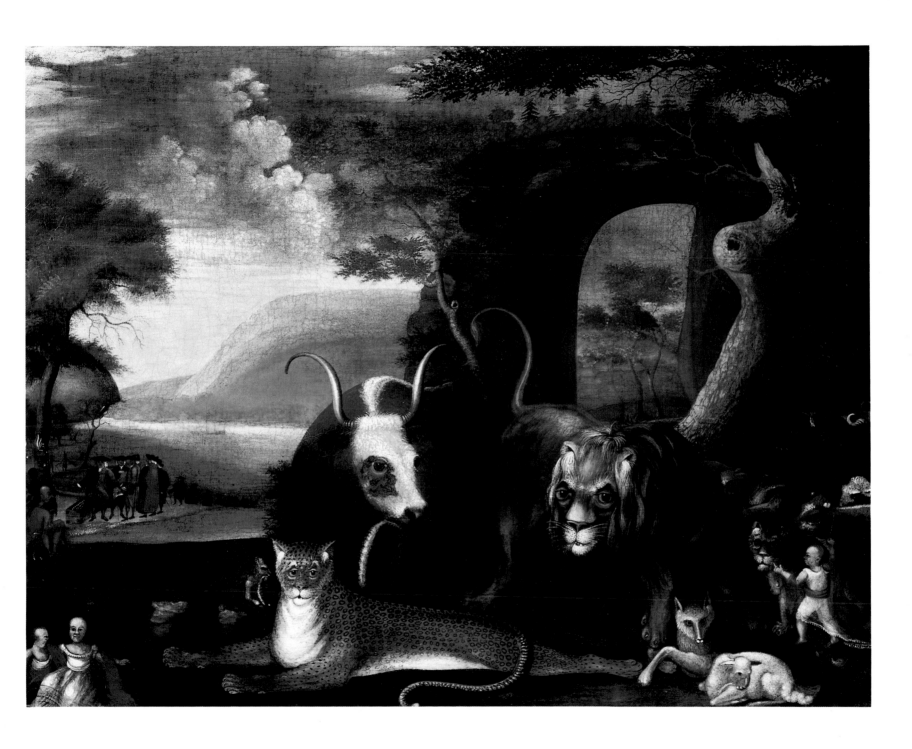

The Peaceable Kingdom
1845–46

Now there comes a new ease in Hicks's approach to the horizontal, his command of perspective. Intensified humility, a marked sweetness, an atmosphere subdued beyond that of its predecessors characterize this endearing landscape. It might almost be seen as an apology for a recent, shocking display of anger at Makefield. The reclining leopard guards the "little child" in contemporary frock in the soothing company of calf, fox, lamb, and kid. The striped "tiglon" that the child leads is less the "young lion" than are the three purebred lion cubs. The circle of animals is a safe distance from the large bear, ox, and cats below. The crevasse all but disappears, so that firm ground is provided for the lioness and cubs watched over by the lion. The winsome girl and infant boy, on a rise apart, are unintimidated by the dens of asp and cockatrice. Trees and foliage, receding toward a most praiseworthy background, are painted with more than the usual refinement.

The adaptation of models is extraordinarily adroit. The bear, lion, lioness, and cubs (like the risen leopard of earlier *Kingdom*s) are replicas of rather shoddily printed illustrations in Samuel Griswold Goodrich's *Book of Quadrupeds for Youth*, published in New York in 1832. Hicks skillfully infuses the creatures with life through his handling of color. Judging from these couplets on the back of a now extinct *Kingdom*, recalled by a descendant of the original owner and quoted here from Eleanore Price Mather, Hicks appreciated his drama: "The great male lion, terrible for blood/Walks out to view the vast extended flood/. . . Perchance too near the female den did creep/though grim her look, her teeth in dread array/ Her peaceful young one's oe'er her body play."

The stretcher is inscribed: "Painted by Edward Hicks in the 66th year of his age."

Left: Samuel G. Goodrich, The Lioness and Cubs. *Woodcut from* Book of Quadrupeds for Youth *(New York: 1832). Free Library of Philadelphia*

Center: Alexander Anderson, The Bear. *Woodcut. Print Room, New York Public Library*

Right: Alexander Anderson, The Lion. *Woodcut. Print Room, New York Public Library*

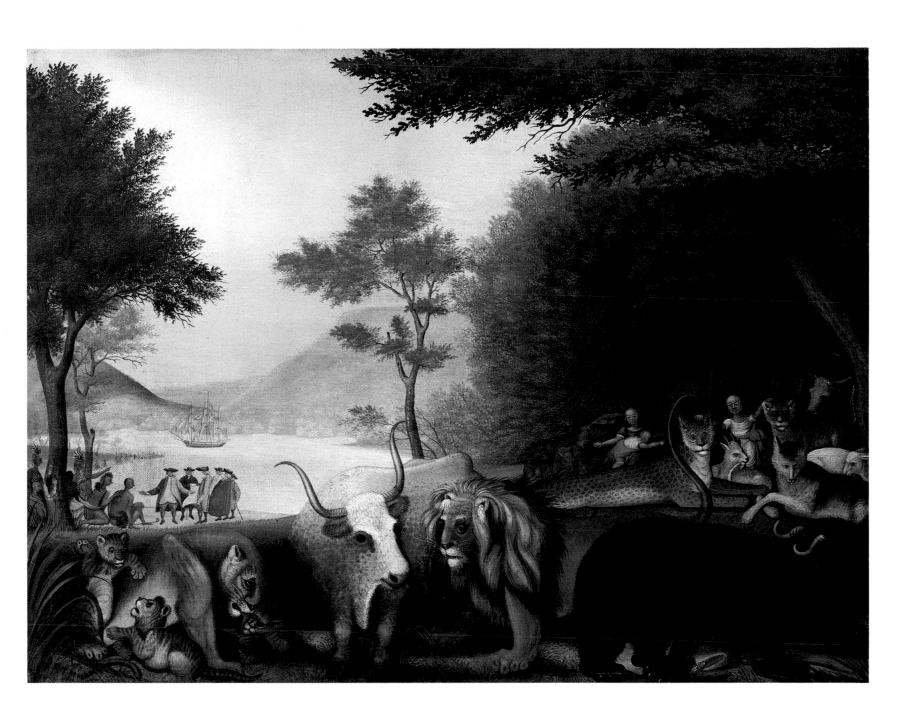

The Peaceable Kingdom, 1845–46.
Oil on canvas, 24 × 31 ¾ in.
The Phillips Collection, Washington, D.C.

Drawing of a Cabin in a Clearing

c. 1845

For more than a century this unfinished drawing of a log cabin in a clearing lay folded in a Hicks family Bible signed as the property of Isaac Hicks. When Isaac died in 1836, his son Edward claimed and signed it, and, evidently, placed his unfinished sketch inside it, but not until years later. There is reason to propose 1845 as its possible date. By then Hicks was painting empirical—and, especially, patriotic—themes as well as allegory. After the election of the first "log cabin" president, William Henry Harrison, vistas such as the one Hicks began but abandoned became popular. Mrs. Trollope, for her widely read *Domestic Manners of the Americans*, chose one with cabin, stumps, and snakerail fences, a common sight in Bucks County and almost everywhere.

Opposite:
Log Cabin in a Clearing,
c. 1845.
Pencil drawing on paper,
8¼ × 7¾ in.
Collection Mark Osterman.
Trial restoration on photocopy

Left:
Log Cabin in a Clearing
(detail), c. 1845.
Pencil drawing on paper,
8¼ × 7¾ in.
Infrared photo by
Mark Osterman

Because the drawing is a graphic example of how Hicks began work on a landscape, it is a discovery of prime importance. Whether he had always worked from a preliminary sketch of sorts, before transferring it to the ground coat of a canvas, it would be useful to know. The sharply outlined buildings resemble those of the farmscapes. The ovoid head of the Indian is like those of the *Penn's Treaty* oils. The delicate but too flat and one-dimensional horse and Indian in flight—like those of Titian Ramsay Peale and others—could only have come from a printed source.

This is one of but three surviving pencil sketches. The others are the drawing of a lamb on the back of a letter, and the details for a *Peaceable Kingdom* found loose within a Plymouth Meeting Bible. In her catalogue raisonné, Eleanore Price Mather dates the latter about 1837. The drawings support the likelihood that Hicks began with his pencil.

Log Cabin in a Clearing (detail), c. 1845. Pencil drawing on paper, 8¼ × 7¾ in. Infrared photo by Mark Osterman

Log Cabin in a Clearing
(*detail*), *c. 1845*
Pencil drawing on paper,
8¼ × 7¾ in.
Infrared photo by
Mark Osterman

*P*hebe Ann had her wish, much to her grandfather's delight. She was allowed to attend school in Newtown for the autumn term. She sat close to him while he told Isaac, who was in New York for yearly Meeting, to come home without delay. The hogs were fat and ready for butchering. To keep four stoves working for "sausage and mince pie and all that kind of thing" for Thanksgiving called for all hands. But he said to "put Susan and Sally and little Ned in the cars for Trenton" before driving home.

The Carles could not come. Phebe Ann left for home with her Grandmother Hicks after the holiday. On arrival they found Susan near collapse and Ned in "fits of fever." Phebe Ann wrote that her grandmother would not be returning until the danger was past. A few hours later she added to the page: "Bub lays quiet at present. The doctor stayed a part of the night with him. We have very little hope."

Edward Hicks could not bear the thought of more deaths in the family. His worries, just then, were needless. Ned recovered.

*O*ne winter's day, in 1846, after having begun "a little diary . . . of passing events" to add to his *Memoirs*, Hicks wrote: "At the close of yesterday I was favoured with the presence of my blessed Saviour as a quickening spirit, preparing my soul to offer a living aspiration—thanksgiving and praise for my many blessings, both spiritual and temporal." He was caught up in ecstasy while praying for "all the precious visited children in the world, especially the sick, the sorrowful, the brokenhearted. . . ."

Through the February drifts he made his way on foot for nearly a mile to the old Presbyterian church. He walked wearily down the aisle to the open coffin of little Hannah Willard. Her waxen features seemed to change into those of her playmate Phebe Ann, whose critical illness had caused Isaac and Elizabeth to brave the cold and go to her. He retreated to the rear, unable to quiet his sobbing.

He had already confessed to a premonition in his diary. Two days later he wrote that his "precious child" had died of "brain congestion." Neighbors passed the word along until it reached Horsham. Sally Hicks and her husband barely made it in their sleigh to Newtown through the drifts. When Emmor Kimber heard, he "wept aloud"; John Comly was visibly affected, knowing how much Phebe Ann had come to mean to his dear old friend.

Isaac returned the morning after the funeral, which began at Peck Slip and ended in Westbury beside an open grave next to that of "little Silas." The line of carriages had been long as it crossed the East River and made its way eastward' in snow.

Ten days passed without a word from Elizabeth. Edward Hicks drove "all the way through the mud to the Parrys'" to ask if Sally had heard from her. "He came home quite down," Isaac wrote pleadingly to Elizabeth. "It's in thy power, dear Sister, to relieve us of much anxiety—but I am afraid thee is sick." Whether or not she was, her father fell ill after the futile ride to Horsham. As soon as he was able, he sent a letter that begged Elizabeth to come home. His "inflammation of the brest" had responded to "meddision," but only enough to enable him to leave his bed each day for an hour or so. "If my dear child can possably leave her dear afflicted sister . . . come." He feared that he might soon be joining the "angelic spirit" of "one of the most perfect angels," Phebe Ann. He was ready to be "transplanted in the garden of the Paradise of *God*," and praying to go "when the time came." If she were near, he would not be so inclined to fear that his preaching and writing were only "quibbling" and "scribbling." Isaac would meet her at the "Depo in Trenton."

Elizabeth could not leave Susan—not until little Ned, who had caught cold the day of the funeral, was out of danger. She had decided not to worry her parents with the news. When she explained, her father told her to come and bring Susan and the children, but to come.

"Diligent in business," he noted in his dairy, not once but again and again in the days that followed. An "almost broken heart" had made him resort to the "balsamic ointment" of painting.

"Distressing nights" became more frequent. A "peculiarly solemn" hallucination kept returning. He dreamt that a torrent of words against Orthodox preaching and teaching poured from his lips, while he craved to be silent. One night he sat bolt upright, startled out of his sleep. He lit a candle and took up the writings of William Penn on love and unity as if afraid of madness. He knew that the cure lay in the will to be silent, in taking to "the closet of the heart" and closing "the door" in the spirit of quietism, the answer to earthly cares.

The ecstasies did not cease. There was one of such intensity as he had not experienced before, and which, briefly, restored his peace of soul. His evocations of the *Peaceable Kingdom* during this year of the true mystic that Edward Hicks had become—and those yet to come—reflect these "favors," as he called the moments of ecstasy.

A succession of funerals and the necessity of his dwelling on "death and eternity" in eulogies regularly drew him out of his otherwise accepted silence. On a day when he opened his Bible in search of an excuse to stay away from the funeral of a Friend who had ridiculed his ministry, his finger led to a verse that sped him to the service. "Great weakness of body and mind" did not keep him from attending. Later in the day, at his easel, he again felt the comforting "angel" near, despite his "unworthiness." One looks at his landscapes of this year and finds his words easy to accept.

And yet, while he was at work on his *Noah's Ark* in April, he belittled what is generally hailed as a "primitive" masterpiece. He dismissed it as a means to a living, the performance of duty "to provide things honest in the sight of all men." Even if nobody understood, He who "careth even for the sparrow" did.

On June 3, these unusual thoughts appeared in his diary: "There are certainly many excellent pieces among the tracts by Orthodox Friends. I could have wished they had not tried to imitate the priests . . . nor had what, I fear, is so much selfish design in the selection of their matter. However, I may be too jealous, and therefore judge them wrongly. I will leave it to Him who knows the secrets of our hearts."

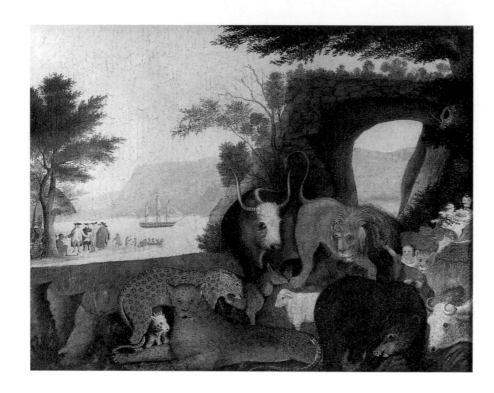

The Peaceable Kingdom,
1846–47.
Oil on canvas,
23¹¹⁄₁₆ × 31 in.
Denver Museum of Art,
gift of Charles Bayly, Jr.

The Peaceable Kingdom
of the "Great Lion." 1846–47

How to account for the restive, uneasy air of the atypical *Peaceable Kingdom* at the Denver Art Museum? Are problems of space and a visible struggle to master the elements of the crowded composition to blame? Did the bringing together of the new pouncing lion with both the risen and recumbent leopards represent, for once, more preoccupation with the medium than with the message? The kid assumes a new position. The child tugs, or would tug, at the mane of the Northcote lion. The wolf is unexpectedly on all fours, confronted by the lamb in what seems an uncertain truce. Never has the crevasse been more awesome or so black, or more truly "the horrible pit." Far above, to the right, the children are nearly lost to sight but well out of the company of the beasts.

The back of the framed picture is inscribed: "Painted by Edward Hicks in his 67 year."

The Peaceable Kingdom
of the "Great Lion." 1846–47

Perhaps no *Peaceable Kingdom* before it better illustrates the unique position of Edward Hicks in the history of American landscape painting. Through innocent derivation and intense identification with the prophecy, Hicks worked magic as compared with contemporary untrained painters. Thomas Chambers and his brush romped through his scenes. For Joseph Headley (or Hidley), distant villages in steep and deep perspective were the problem rather than trees and foliage. Erastus Salisbury Field undertook huge copies of fabulous Bible scenes conjured by the painter John Martin.

In his "67th year" Hicks brushed his name and age on the back of this canvas. Until late years it hung in a closet of the Vineland Historical Society in New Jersey, the gift of the Scull family. It is now owned by Sidney Janis.

The Peaceable Kingdom
of the "Great Lion." c. 1846–47

By this time, well aware of the use of volumetric bulk as an expression of power, Hicks achieves an ox more truly representational than any other in his *Kingdom*s. Even among formidable animal companions it is the focus of attention. The human principals are almost incidental, as if mere observers of the procession. Here, as in an area of the Leedom farm landscape painted a year later, the coat of colors is so thin as to allow the penciled coastline to show through the Penn's Treaty figures. Perhaps Edward's sight, like his hearing, had begun to lose its keenness. For years he had painted, at times, late at night by candlelight.

Not the first work by Hicks to be seen in Europe, this exquisite canvas was exhibited in Frankfurt, Germany, in 1953, on loan from the Albright-Knox Art Gallery, Buffalo, New York.

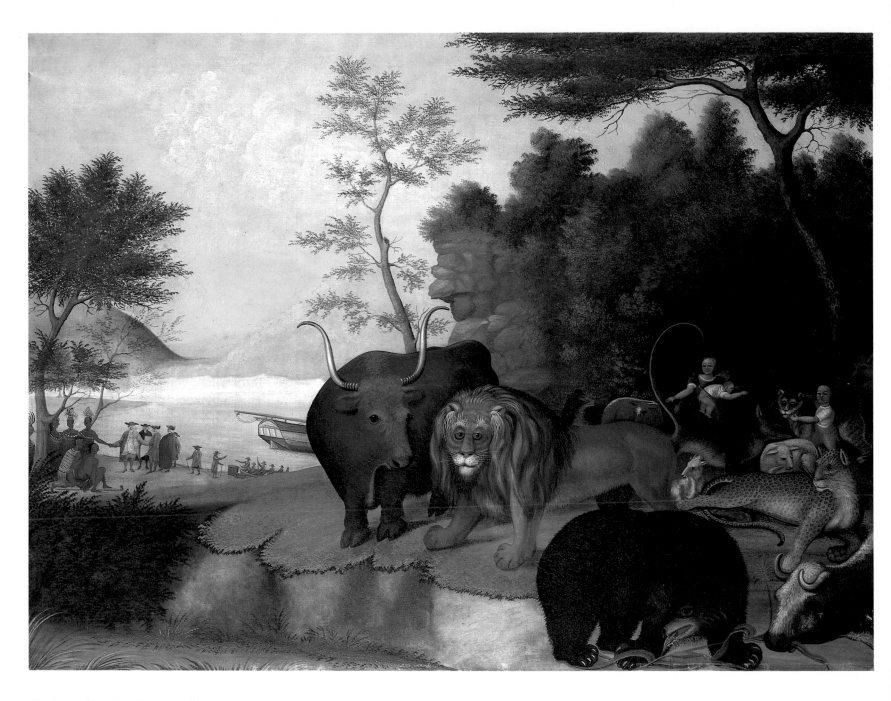

The Peaceable Kingdom, 1846–47.
Oil on canvas, 24 × 32 in.
Photo courtesy Sidney Janis Gallery

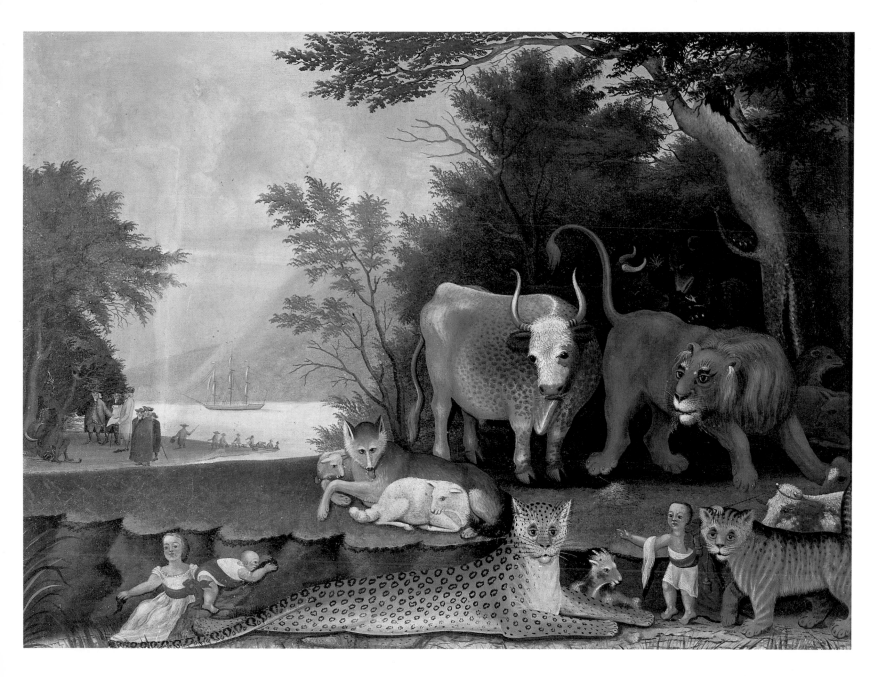

The Peaceable Kingdom, *c. 1846–47.*
Oil on canvas, 23⅞ × 31⅞ in.
Albright-Knox Gallery, Buffalo, New York, James G. Forsyth Fund

The Peaceable Kingdom
of the "Great Lion." 1846–47

*L*ong in the collection of Robert Carlen, this version of the favorite theme is a precious legacy.

The composition is entirely divested of that much earlier compulsive adherence to the design of Westall, and also to the confining diagonal. It is far less bound by the elements of the message; the supremacy of the lion becomes the main thrust. So ably is the master of the pride of lions represented that the utter banality of its source is unimaginable. The English painter James Northcote (1746–1831) had engraved a *Daniel in the Lions' Den* for an English Bible. With other plates it was copied by Alexander Anderson for American Bibles. Northcote himself, a designer and publisher of books and prints for popular sale, had his artisan William Harvey copy the figure of one of the lions—this time attacking a wolf—in a wood engraving. It was for Northcote's Aesopian *Fables*, which ran through several cheap paperback editions, and it illustrated "The Lion and the Wolf." Northcote was much given to all such borrowing and expediency. Art historian Julius Held perceives Flemish artists under the spell of Rubens in such lions.

The lioness and cubs group is also thought to have been painted originally by one of Northcote's contemporaries, such as Sir Joshua Reynolds or Richard Earlom. Although Hicks redeemed this image and that of the male lion from books on natural history, he creates the impression that lion and family had never been apart.

The long back of the ox, which succeeds the familiar long-horned model in the foreground, is a proscenium for the enchanting drama above.

Animation—truly suspended—and a new mobility lend an air of spontaneity that almost belies a reliance on prints. Perhaps they were not always necessary, as Hicks progressed in his draughtsmanship. In any case, his use of models, where they can be identified, in no way diminishes the beauty, mystery, and ineffability of the scene, much less its moving effect on the beholder.

To repeat, such copying and adaptation are age-old. Painters of the present day continue the practice. Photographs have been used by artists since the mid-nineteenth century as models for sketching and painting living forms. Albrecht Dürer drew an awesome juggernaut of a rhinoceros from written description and hearsay. Hicks was only somewhat better off

when he had to depend, from phase to phase, on random, often insipid and ordinary engraved material. That he had much idea of the tradition of animals in art is doubtful. He lived and died none the worse for not knowing that a new standard for realism began in the sixteenth century with Conrad Gessner. But he did know Aesop, whose nineteenth fable, "The Birds, Beasts, and Bat," he mentioned in his *Memoirs*.

Color, admirably chosen and knowingly disposed, conveys, in the hands of an untrained painter, a solemnity of mood that is close to the infinite and eternal. Sublimity and reality are one, in the presence of remarkable tension and energy. Nowhere, among the evocations by Hicks, is there a more beautiful expression of the prophecy.

"Painted by Edward Hicks in the 67th Year of his Age." By that the painter evidently meant after his sixty-sixth birthday.

James Northcote, The Lion and the Wolf.
Illustration from Fables,
written and illustrated by James Northcote, R.A.
(London: 1828, 1833; New York: 1857).
Courtesy University of Virginia,
Alderman Library

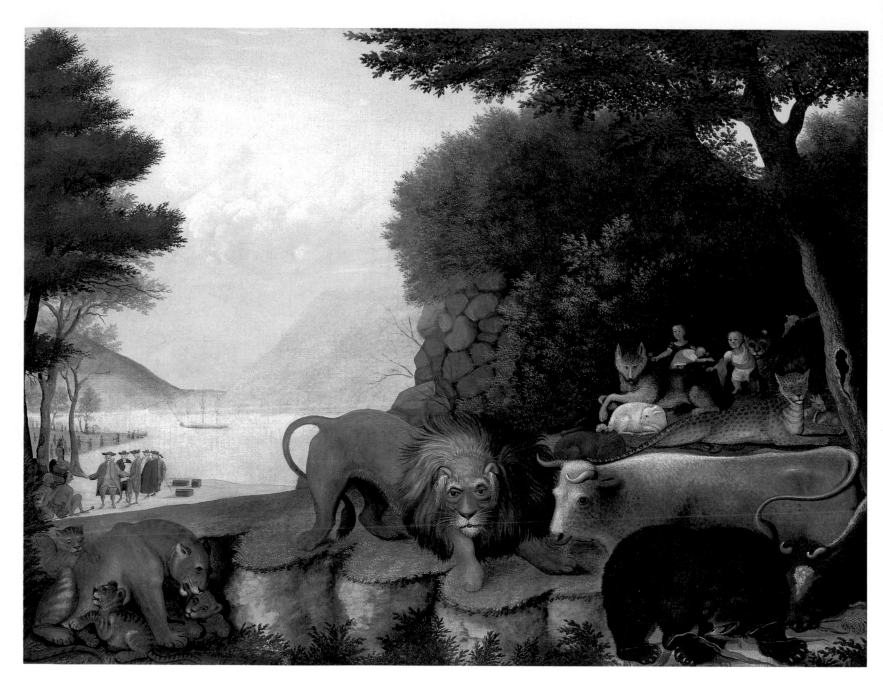

The Peaceable Kingdom, 1846–47.
Oil on canvas, 25 × 32½ in.
Collection Mr. and Mrs. Robert Carlen,
on loan to Diplomatic Reception Rooms,
U.S. Department of State

Noah's Ark

1846

A letter of April 18, 1846, from Sally to her sister Elizabeth Hicks, reported that their father was at work on a *Noah's Ark*. Either before that or later he painted one from a print for the Ferry Inn near Mc-Conkey's Ferry. Its fate is unknown.

On that day in April the painter wrote in his diary: "Diligent in business, and if not fervent in spirit, seriously thoughtful about death and eternity. Oh! how awful the consideration; I have nothing to depend upon but the mercy and forgiveness of God, for I have no works of righteousness of my own; I am nothing but a poor worthless insignificant painter." Two days later he added: ". . . working with my hands to provide things honest in the sight of all men, ministering to my own necessities and them that are with me, which always produces peace of mind to an humble, honest Christian." These were days of almost endless funerals and processions from Newtown meeting.

On May 8 he wrote:

Steadily engaged in my shop. My business, though too trifling and insignificant for a Christian to follow, affords me an honorable and I hope an honest living. Having to work with my own hands, for all the money I get, appears to me to be more in accordance with primitive Christianity, than living on the work of other people's hands; especially on rent and usury. But my view on this subject appears too much out of fashion to be united with, even by Friends. . . . "Do good and lend, hoping for nothing again, and great shall be thy reward in Heaven."

S. G. Goodrich,
Arabian Horse,
From Peter Parley's
Tales of Animals
(Boston, 1830).
Rare Books, Free Library
of Philadelphia

A month later Hicks boarded the stagecoach bound for Haddonfield Quarterly Meeting at Medford, New Jersey. He paused at Burlington to call on "Joseph Parrish, son of dear deceased friend Doctor Parrish, who is a practicing physician in that place."

The Nathaniel Currier lithograph of *Noah's Ark* suffers amazingly by comparison with the oil by Hicks, based upon it. Nowhere does he better prove his ability to transcend his model and enhance it with figures from other prints. The lion is like the one on page 35 of *The Symbolical Bible for the Amusement and Instruction of Children* (New York, N. B. Holmes, 1831). The page is entitled, "Isaiah, XI, 6." It turns up in other paper juveniles, especially "hieroglyphical" Bibles. It shares the book with the frolicking dog that matches the one in *The Twining Farm*.

Noah received his due in the *Memoirs*: "Noah and his family, in whom the most of the innocent nature reigned, was saved to repeople the earth, and notwithstanding his own uprightness, the same evil genius made its appearance in his family." His descendant Esau had the nature of "the wolf, the leopard, the bear, and the lion, where cursed self reigns with all its cruel, bloodthirsty violence." Jacob was lamblike.

Above: Page from
The Symbolical Bible
for the Amusement
and Instruction of
Children *(New York:
N. B. Holmes, 1831).
Free Library
of Philadelphia*

*Left: Nathaniel Currier,
Noah's Ark, 1844. Lithograph*

*Opposite:
Noah's Ark,
1846.
Oil on canvas,
26½ × 30½ in.
Philadelphia Museum of Art,
bequest of Lisa Norris Elkins*

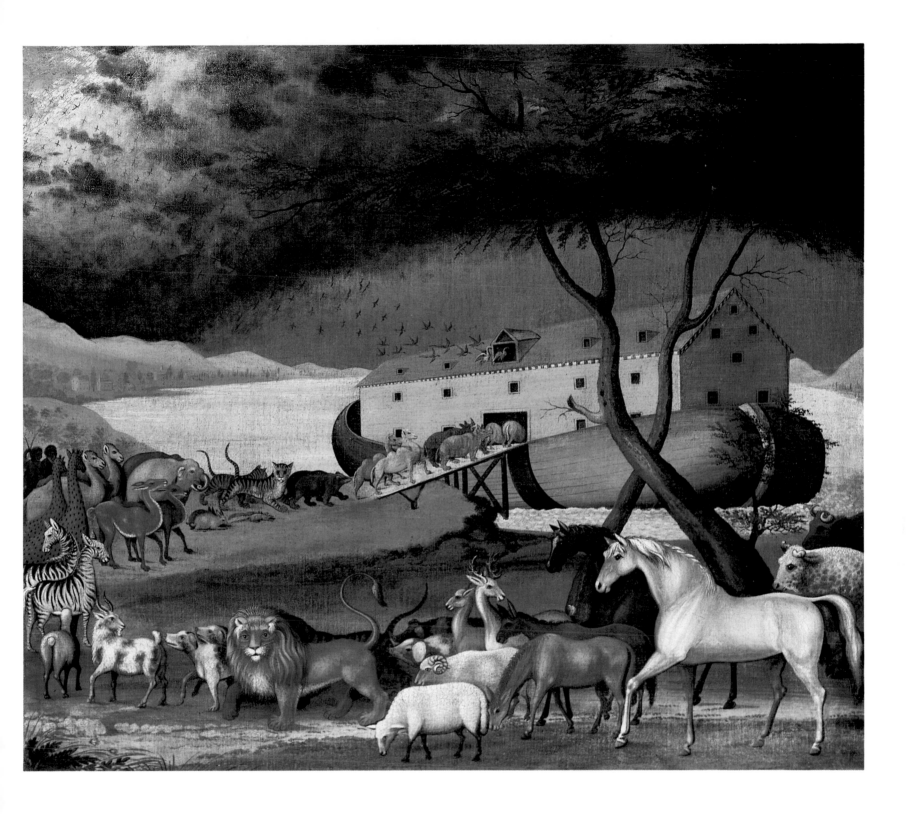

Ecstasy

On the day of the funeral of Elizabeth Buckman, a very dear friend, "a singular thing occurred." Hicks had decided to wait until the procession neared his house before he joined it. When he became so lost in his painting that he did not hear the wheels until after they had passed, he wondered as he rushed, late, to the meetinghouse. He took it for a sign that the Lord wished to break his "habit of preaching."

In the month of May he heard footsteps on the path to his shop. He looked down from his upper window and saw a childhood sweetheart, Margaret Richardson, and her husband, from Wilmington, approaching. "She was a young woman that I loved, and with whom I spent many happy hours, innocently." After they had gone his thoughts turned rather to Sarah and their more than forty years together. Were one of her increasingly frequent illnesses to take her, he too would die.

At Makefield Quarterly Meeting only days later, he was too full of life for his own good. He condemned an Abolitionist among the worshipers so mercilessly that all heads hung in shame. One left his place to sulk beside the stove. Disgraced, Edward dared not attend Yearly Meeting in Philadelphia a week or so later. "Praying and weeping" over his isolation, he remained in his shop, trying to convince himself that he was spared much "idle talking and laughing." There was, in fact, not laughing but the usual sharp disunity, news of which left him weak and made

The Residence of
David Twining, 1785
(detail), c. 1846.
Oil on canvas,
26 × 29½ in.
Museum of Art, Carnegie
Institute, Pittsburgh,
Howard N. Eavenson
Memorial Fund for the
Howard N. Eavenson
Americana Collection

him put away his brushes. At odds with too many, he may have been at work on a painting depicting two matchless examples of brotherly love: David and Jonathan, and the Good Samaritan, painted in 1846.

David and Jonathan at the Stone Ezel
1846–47

*B*eside the Ezel, David and Jonathan embrace, as in the first Book of Samuel, chapter 20, and Jonathan bids David, his beloved friend, "Go in peace." King Saul, father of Jonathan, had sworn to kill David. The two friends had therefore made a covenant that if an arrow from the quiver of the youth who is seen disappearing toward the city should fall nearer the Ezel stone than near David, he must flee. "The Lord be between me and thee, and between my seed and thy seed forever," Jonathan intones. Might they not, in their regalia, almost join the Indians of one of the *Penn's Treaty* oils as Hicks conceived it? In any case, the painting is a votive of brotherly love meant to unite sharply divided Friends. Like the *Peaceable Kingdom* that not so long ago turned up in Vineland, New Jersey, it is inscribed, ". . . painted in the 67th year." From somewhere in Bucks County the painting traveled to the shop of a dealer, where it remained until 1980.

What has remained unknown until now is that this vision of peace was actually derived, in part, from an engraving in the Hicks family Bible that is signed by both Isaac and Edward Hicks. The detail of the Good Samaritan (Luke, x, 1:37)—engraved by C. Tiebout from an etching by James Akin after an oil by William Hogarth—was the source. Akin was better known for his satirical subjects. Isaac Hicks bought the Bible—published in Philadelphia in 1801—on February 23, 1802, and entered the date. The Bible remained in the Hicks family until the 1970s, when the rare pencil sketch of a log cabin in a clearing was found folded inside it. Hicks had eased the print out, pressed it into service, then returned it to its place.

Whether Hicks had drawn a circle around himself or become, for the time being, a pariah, his isolation served posterity in 1846. But he was not ready to be shelved, even if his business suffered. He broke out of his aloofness to drive to Warminster Meeting, by way of Whitemarsh, to see Sarah's sister Susan Worstall Phipps. The call was one of the "most heavenly occasions." On a wall hung a *Peaceable Kingdom* memorial to

David and Jonathan at the Stone Ezel, *Winter 1846–47.*
Oil on canvas, 24 × 32 in.
Photo courtesy Sotheby, Parke, Bernet, Inc.

Elias. Driving along he came upon a destitute couple and drove them to Warminster. On the way home, after a "precious" meeting, he picked up an old fellow soldier. The hapless wife-deserter and vagrant was tramping along from Philadelphia to Newtown.

The June heat wilted the "poor old feeble man" and his "worn-out constitution." One evening while cleaning his brushes he felt "departure from this world" drawing near. Then the "holy presence" filled him with deep serenity, banishing his dark imaginings.

At a First Day meeting he scolded Friends for slumping in their seats on account of the humidity. It was no way for him to petition permission to visit meetings beyond Philadelphia. Although the women gave their consent, the men "cavilled" and said to ask Comly. Hicks did so and kept close watch on the post at the Brick Hotel for the reply. He told the lad who tended bar to watch out for the temptations of the tavern and not learn the lesson that he himself had.

The letter of approval came, and Hicks departed with his old standby Joseph Briggs on a twelve-day circuit. After delivering the *Noah's Ark* in Burlington, they drove on to London Grove. There Comly whispered in his increasingly deaf ear that he had better entrust his *Memoirs* and treatises to him and other friends for posthumous publication, lest these stir up more foibles. Hicks was stunned.

At Williston his old traveling companion, Benjamin Price, spoke like a dedicated abolitionist and in the educated manner of a Friends school principal. He made Hicks feel like the "illiterate minister" of Newtown. At five more meetings his sermons for union went unheeded. At Brandywine he fled the "ranting" on foot, for his lodgings a mile away. Finally, at Cherry Street Meeting in Philadelphia, he remained seated and silent.

The strain of holding his tongue told on him by the time he reached home. He felt "neither sick enough to lay by, nor well enough to work."

In August he drove to Byberry to ask Comly to relent. But his still loving friend gave no ground. On his return the news of the latest illness of Susan Carle hurt most as a reminder of the loss of Phebe Ann. Scarcely a day had passed without tears for one whom, admittedly, he loved "almost more than life."

The arrival of Valentine and Abigail was the last straw. The mercury was soaring. Beds were too few. Callers were too many. Edward would

rather have sweltered in his shop, where before long he took refuge, than listen to the gossips, one of whom preferred Franklin to the Bible. His diary confesses: "I certainly have some doubts of the propriety of Friends spending their precious time unprofitably in visits merely for pleasure, and am almost ready to conclude that it increases weakness, idleness and pride among us."

The heat hung on until September. There was so little business that he fired his helper and spent the days at his easel.

At quarterly meeting in Fallsington the pendulum swung from his vow of silence to a choleric outburst. He saw, too late, that he had gone too far with his diatribes against "scholastic learning," phrenology, animal magnetism, medical quackery, mulberry tree speculation, vain wealth, "oppressors" of tradition, "silly talkative women," and the rest.

Alone and contrite again in his shop he was "preciously visited" by the comforting "angel of God's presence." He took the "favor" as "preparation" of his soul for prayers for the "sick, sorrowful, brokenhearted," with whom, surely, he had much in common.

The ambivalent loving and loathing, tolerance and bigotry, were far from purged. He was soon castigating the "deluded votaries of anti-Christ . . . Catholics, Episcopalians, and English Orthodox."

Two young "collegians" came to ask him to explain the precept, "love thine enemies." He was willing to grant that "the right way to kill the devil is *not* to love him to death." A "lovely" Jewish youth drove up from Philadelphia to ask why he objected to large donations to a certain college. Hicks dismissed it as "foolish."

By November he was a ghost of himself. At Philadelphia Yearly Meeting he left all of the contumely to others and kept his own counsel.

One Indian summer day he wrote in his diary, "Oh! my poverty, my poverty. If I should die in this state what will become of me! And really I feel so weak, short-breath'd, and miserable, I may soon die like my father, in the old arm chair in the shop." Spent as he was, he was painting more from the spirit than the body and his poor "zig-zag nature."

"Did more work and better than I ever did, in the same time, for which I am thankful to my Heavenly Father, for the ability to work, and the poverty that drives me to it."

The Twining Farm
1845–47

The Twining family farm was a mile southwest of the village of Newtown. More than fifty years after Edward Hicks had left his guardian, Mrs. Twining, for an apprenticeship below in Attleborough, he painted the place from memory. He finished four versions, adding more and more details after the first effort had set the stage—with the essentials—for much livelier renditions. The first, painted for a Twining, remained in the family for generations, and in a frame said to have been made from a rafter of the barn. Of the four, it alone has its title on the canvas, and the year of the remembered scene as 1785, instead of 1787. The latter two dispense with: "when the painter was five years old." Why the change? Because the boy looked the part of seven, old enough to remember more and to listen to Elizabeth Twining, whom the painter wished to show with an open Bible. The year 1785 was too early.

Like *The Hillborn Farm* before it, the first Twining farmscapes were brave departures from allegory, and from inspirational and patriotic themes materialized by Hicks from prints. But in his delineation of scenes familiar to him he remained dependent on printed models, many of which he had already shown in earlier landscapes, as may be seen. Even the horses and men in his Sullyesque bridge sign of Washington served him, when he showed Jesse Leedom with his fiancée Mary Twining and their mounts. Jesse, who married Mary in April 1788, puts the wrong foot in his stirrup.

The second and third versions, far more animated, are a veritable celebration of maternity. Unlike the first, they show sixty-seven-year-old David Twining with his face to the viewer. His wife Elizabeth looks much older than her fifty-two years. The young white pine was painted from life, and, as late as 1921, it was still standing and by then "magnificient." The Twinings had a black freeman, Caesar, shown at the plow.

There was more to David Twining than meets the eye. His father Stephen was an English immigrant of the late seventeenth century whose sons settled in Bucks County. One of them, Benjamin, built a stone house in Newtown near 1757, then sold it to a local justice, John Harris, whose widow lived there when Washington used it as his headquarters at the time of the Battle of Trenton. Benjamin's son David was master of the

The Residence of David Twining, *1785*, c. *1846*. Oil on canvas, 26 × 29 ½ in. Museum of Art, Carnegie Institute, Pittsburgh, Howard N. Eavenson Memorial Fund for the Howard N. Eavenson Americana Collection

the Residence of David Twining in 1785
when the painter was six years old.

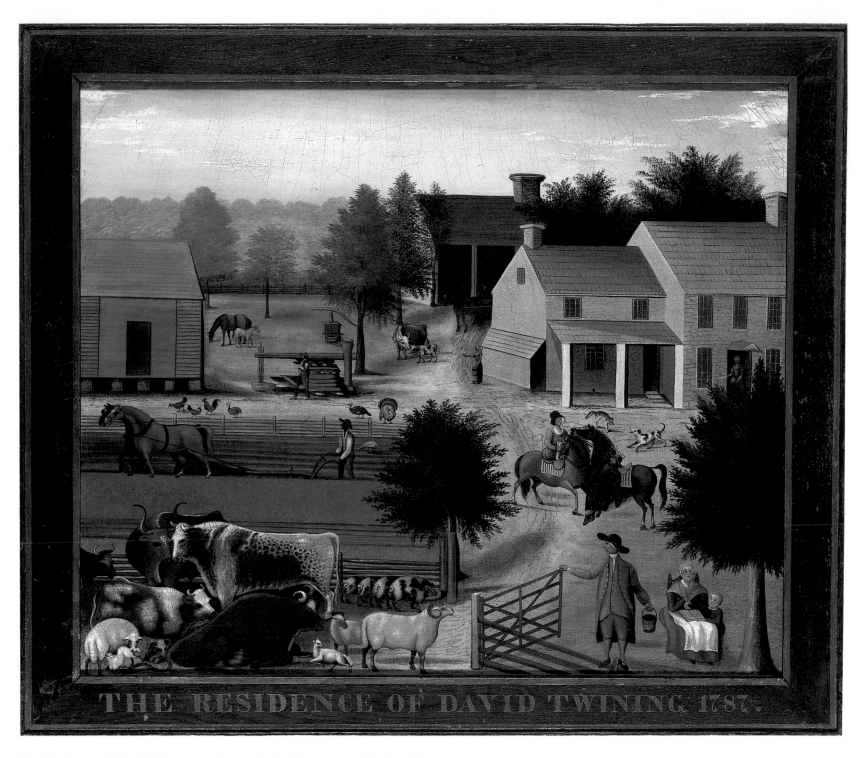

The Residence of David Twining, 1787, c. 1846. Oil on canvas, 26½ × 31½ in.
Abby Aldrich Rockefeller Folk Art Center, Williamsburg, Virginia

The Residence of David Twining, 1785, c. 1846–47. Oil on canvas, 26 × 29¾ in.
Photo courtesy Sotheby, Parke, Bernet, Inc.

Twining Farm, where Hicks lived from infancy to early adolescence. By the time of his infant charge's arrival, as noted earlier, David was a prominent figure of Newtown and environs. After helping to found the Newtown Library Company in 1760, he bought many of its first thirty-five volumes in Philadelphia and for some years kept them in his farmhouse. For the library's first quarter century he served as treasurer. He died in 1791. His last will merits consideration because it concerns the farm, and even certain details in the picture. Visible are the "tight-bodied" coat that he left to his brother Stephen, and the silver buckles inherited by his nephew Jacob. To daughters Sarah, Elizabeth, and Mary he bequeathed a thousand acres in Newtown and Westmoreland townships; and to their sister Beulah, two hundred acres of Leedom land, a roan mare, and "200 pounds sterling." The feather bed that had been hers all along he left to his widow, and their furniture, china cups, sterling, pewter, brass kettle, and iron pot. She was to have her choice of a horse to be saddled and kept for her by Beulah; and a cow to be milked for her; and good wood for fires in a room to be her own on the ground floor in the rear of the farmhouse. Should she marry, she would have to give back her inheritance. To their grandson David Leedom, the dedicated Friend left cash enough for the purchase of "a large Bible."

Mary, in the sidesaddle, was the favorite of Hicks. But Beulah, the youngest and childless, remained the most motherly and vigilant until her death in 1826. She surprised him by making no mention of him in her will, after his having urged her not to, as he admits with some bitterness in his *Memoirs*. When Edward told her that he did not wish to have the "ravening wolfish spirit" of an heir, Beulah, unfortunately, took him at his word. She stands in the doorway of the house in *The Twining Farm*, still a "fixed star in the firmament of God's power," and not yet a comet thrown out of orbit before it "dazzles, then sinks." In one of the dormers, above, she had later devoured "pernicious novels" by moonlight. She married the physician and Presbyterian Samuel Torbert, "out of meeting." He contested the divorce which she finally won in the Supreme Court of Connecticut. Upon her return to her widowed mother, she took charge of the farm and rejoined welcoming Friends.

As for the little dog in the scene, he is like the one on page 23 of a penny "hieroglyphical Bible" of 1831, from N. B. Holmes, a New York printer. It is entitled, *The Symbolical Bible for the Amusement and Instruction of Children*. A dozen pages later there comes the lion adopted for *Noah's Ark*.

And the Philistine said unto David, am I a

that thou comest to me with staves?

Pastoral Landscape
c. 1846

The familiar colors and terrain of Bucks County do not erase Hicks's debt to Paulus Potter and one of his many seventeenth-century landscapes of the Dutch lowlands, *Three Oxen in Meadows*. Weisbrod engraved it, under the title *A Bull and Two Cows*, for the second volume of *Galerie des Peintres* by J. P. Le Brun (Paris, 1792). The painting by Potter is remarkable for having been achieved on a canvas less than twelve by twelve inches. The version by Hicks, oil on a panel of yellow poplar, measures nearly seventeen inches by a little over twenty. The Potter canvas belongs to Her Majesty Queen Elizabeth II.

Hicks's painting, in Colonial Williamsburg, adheres quite closely to the Weisbrod print. At least two other pastorals by Hicks bring in figures from other printed sources. The profile figure of a steer, in one of the variants, reappears in one of the versions of the *Grave of William Penn* and one rendering of *The Twining Farm*. Charles Leedom, a friend, commissioned the Williamsburg landscape.

Above: Weisbrod after oil by Paulus Potter,
A Bull and Two Cows,
Etching in 2nd volume of Galerie des Peintres *by J. P. LeBrun (Paris, 1792). Courtesy University of Virginia, Alderman Library*

Left: Pastoral Landscape,
c. 1846.
Oil on yellow poplar panel,
16¾ × 20 in.
Abby Aldrich Rockefeller Folk Art Center, Williamsburg, Virginia

Opposite:
Landscape with Cattle,
c. 1846.
Oil on wood panel,
17⅝ × 20⅝ in.
Private collection

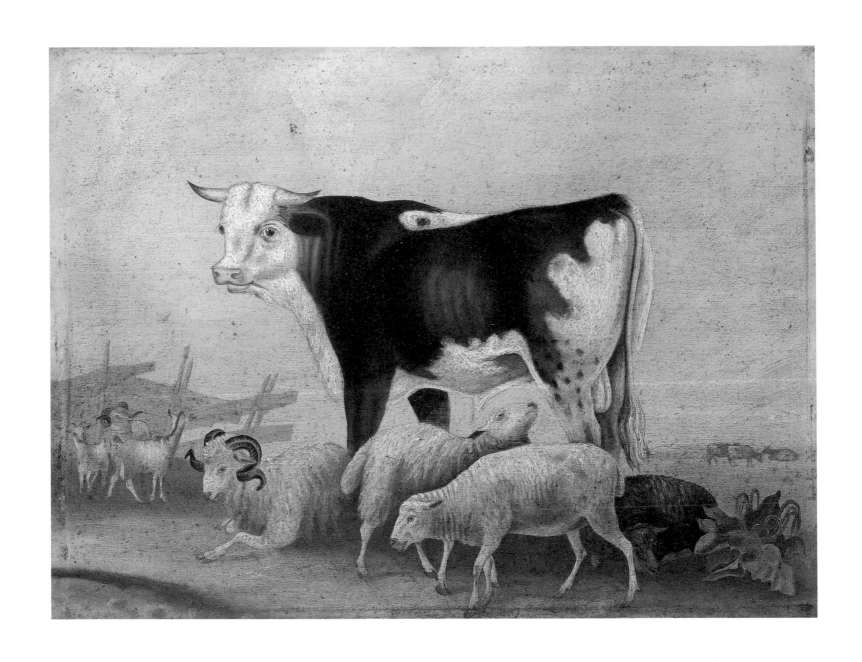

James Cornell's Prize Bull, *1846.*
Oil on panel, 12 × 16⅛ in.
Abby Aldrich Rockefeller Folk Art Center, Williamsburg, Virginia

Prize Bull
1846

Above: Pastoral Landscape, *c. 1846. Oil on wood panel, 16 × 21 in. Photo courtesy Sotheby, Parke, Bernet, Inc.*

Left: Steer, *stock model. Hicks Family Collection*

Engraving by P. Maverick after drawing by Alexander Robertson, Near Berthier on the St. Lawrence. Portfolio, *1809–10*

*J*ames Cornell, founder and officer of the Bucks County Agricultural Society and known for his advanced breeding of livestock, commissioned *Prize Bull*. On the back of the small wood panel is this receipt: "James Cornell to Edward Hicks. De To painting his prize bull. $15.00 Rec. 5th mo 16th 1846 the above in full of all demands by me. E. Hicks."

Some years ago the art historian Julius Held wrote that Paulus Potter (1625–54) inspired the pastoral landscapes of Hicks. The family attic of Eleanore Price Mather yielded another discovery that solves the mystery of the lateral figures in the Hicks landscape. The model was a painting of grazing sheep by Potter, lithographed separately by Gustave Canton. A forebear of Mrs. Mather had acquired the figures while studying painting. They appear in her catalogue raisonné (no. 58). Apparently such printed figures were collectibles among Quaker farmers as well, especially those friendly to the aspirations of Edward Hicks.

In a pastoral landscape shown at the Coe Kerr Gallery, New York City, there are cattle derived by Hicks from two sources. An animal on the left he copied from a cutout that remains in the Hicks family collection. The one on the right is the reclining beast seen in, for example, another pastoral, a farmscape and *The Grave of William Penn*. In the *Portfolio* issues that published "The Foresters" by Alexander Wilson, there is an illustration from a drawing by Alexander Robertson, engraved by "P. Maverick, NY." It must have caught the eye of Hicks, whose landscape background is an unmistakable improvisation on the print, *Near Berthier on the St. Lawrence*.

*O*n Christmas Day, 1846, while painting and pondering the emptiness of wealth and honors, Edward Hicks was drawn out of himself into a state of "living prayer."

A Little Present for Friends arrived that evening from Oliver Hough. He opened it, read for a while, and thought it not bad for a "poor illiterate mechanic."

Before Sundown

Leedom Farm *(detail)*,
1849.
Oil on canvas,
40 × 49 in.
Abby Aldrich Rockefeller
Folk Art Center,
Williamsburg, Virginia

*H*ardly able to make the fire and get the meetinghouse ready . . . and then hardly able to attend," Edward Hicks grieved in January 1847. "Of such a character as to be of no real use to anybody." On First Day he delivered a "lifeless communication" like the "poor ignorant, negatively wicked old man in his dotage" that he thought himself. When would he learn not to have "too high a conceit of himself" and be silent, especially while low-spirited. He despaired of knowing as he went "crying" to bed that night with longing "to live one more day like a Christian." Not for some days had he braved the drafty shop to take refuge in painting.

It was in such a frame of mind that he was told of an ugly rumor. His Orthodox enemies were saying that he had no scruples about accepting "presents and favors" for his sermons and an "extraordinary price" for his paintings. Into the diary meant to be made public he wrote: "I admit that I receive ten dollars a year . . . for taking care of the meetinghouse, making fires, sweeping &c." That was better than usury, he believed. He disliked to bear "unpleasant testimony" against a Friend who had extracted compound interest on a loan of $150. "Lazy proud hirelings" had scoffed at his beliefs when peace was all that he had asked for. If more Friends were like Jesse and Mary Twining Leedom, who had helped him but not for gain, how much better it would be!

One Quaker moneylender who had read his treatise and its strictures on usury arrived with his daughter at the Hicks doorstep to demand that Edward take it back. In a daze he bade them step in. After they left he took stock of himself. Had he lost his power of persuasion? Was he an utter failure? Had he nothing left but a "comfortable home" and twelve acres east, and "a trifling trade," now carried on mostly by hired "hands?"

On his sixty-seventh birthday he thought to close his "writing concern" and share no more of his "visions and prophecies." He would speak in meeting only if moved by the Holy Spirit, pay every debt both new and old, and by the end of April be solvent for the first time in at least thirty years. All would be settled except the fate of his *Memoirs*. He would also paint *The Grave of William Penn* with all the love and reverence in his power before too late, and with certain Friends in mind as worthy recipients. If they wished to pay him, well and good. Another transcendent *Peaceable Kingdom* lay ahead.

Oliver Hough revised the grammar, spelling, and punctuation of the *Memoirs* whenever time permitted. Hicks continued to add to the manuscript. He flatly refused to submit it for the approval of a committee, and insisted on full responsibility for a book that he was determined to present free to Friends as his own work and thought entirely. With Comly, whom he still thought should have had the honor of his name as leader of the followers of Elias—to make them "Comlyites"—he was not at all angry. The penchant of Elias for Unitarian ideas not strictly fundamental had troubled Edward shortly before and since his death.

The Grave of William Penn, 1847. Oil on canvas, 24 × 30 in. Abby Aldrich Rockefeller Folk Art Center, Williamsburg, Virginia

The Grave of William Penn
1847

The Grave of William Penn is the most formal and visible homage paid by Hicks to his ideal Christian, whom he had hailed in sermons and in the Peace Treaty detail in most of his many *Kingdom*s. With the encomiums in the *Memoirs*, the unceasing tributes would be complete.

The several versions of this subject are the echo of a letter of Hicks, in April 1847, to his "Beloved friend Richard Price," the Philadelphia merchant and fellow Hicksite. Indeed, Price and his wife Lydia Longstreth had been disowned by Philadelphia Monthly Meeting for their sympathies, not shared by his nonetheless forgiving father, Richard.

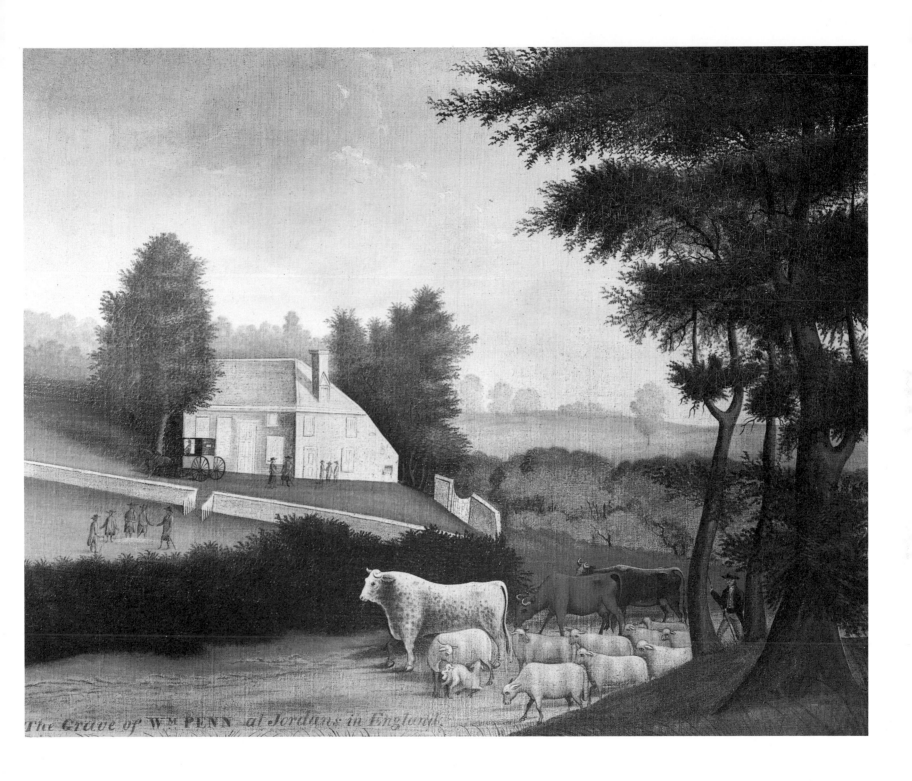

The Grave of Wᵐ PENN at Jordans in England.

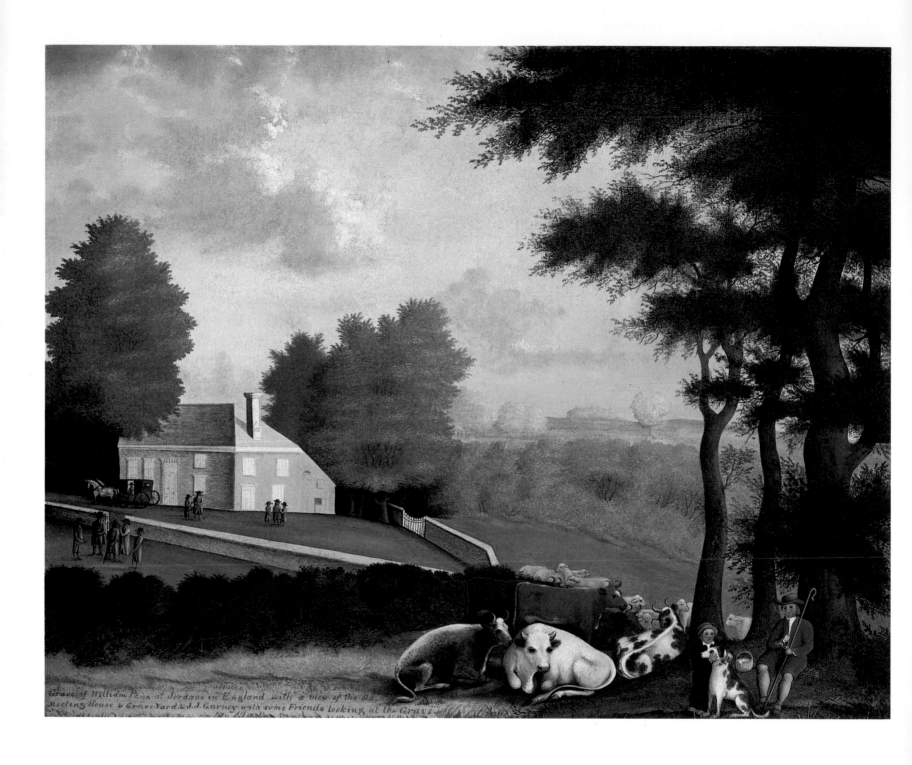

Grave of William Penn at Jordans in England with a view of the old
Meeting House & Grave Yard & J. J. Gurney with some Friends looking at the Grave

Hicks was writing thanks for two bottles of tonic wine, much appreciated on account of his increasing frailty:

I do not refer to the painting business because I want purchasers for my work, for I have more bespoke already than I shall ever get done perhaps. But just mention to thy father-in-law, as he has a taste for farming and cattle, that there is a flock on the place I allude to with the likeness of a famous English Bull. In fact the English engraving is a picture of the handsomest English landscape I ever saw, and to enhance its value Joseph John Gurney's [in it] with his chariot. Friends is represented near the meeting house and in the graveyard.

Hicks did not know then, or perhaps ever, that the oil itself, by the Dutch painter H. F. de Cort, had been presented to the Historical Society of Pennsylvania by Granville Penn in 1834. He had seen a lithograph by Paul Gauci, rather than an engraving, entitled *Grave of William Penn, in the Quaker Burial Ground at Jordans in Buckinghamshire.* The spot is near Beaconsfield and Chalfont, St. Giles. The gentlemen are not the noted Quaker, Gurney, and Friends but the French philosophical historian Montesquieu and party. Penn died on May 30, 1718.

Joshua Longstreth acquired a copy that bears no explanatory lettering. For years it hung in Long House, residence of the Bryn Mawr novelist Owen Wister.

The version in the Garbisch Collection at the National Gallery of Art bears a long inscription on its face. The absence of ram, lamb, and ewe, and the independent handling of the foreground suggest that it is, if not the first, an early example of the group. The shepherd, the boy and the dog, and the picnic hamper, supplied by Hicks with the aid of printed models, lend a note of bucolic cheer to the melancholy scene. His shifting of the sheep to the meadow makes room for the fat cattle, also from prints.

The title reads: "Grave of William Penn in England with a view of the old Meeting House & Grave-yard & J. J. Gurney with some Friends looking at the Grave."

The version in the folk art collection at Williamsburg is briefer: "The Grave of William Penn at Jordans in England." Its bull, patently a prizewinner, and doubtless from the print that Hicks had praised, upstages the two central animal figures of the oil by De Cort, whom it would surely have astonished. The famous bull of the Pendleton lithograph entitled *Wye-Comet,* which was based on a painting by an

obscure artist named F. Roten, could have been the model. Pendleton was the first commercial lithographer in America; in 1819, Bass Otis introduced the method invented by Alois Senefelder, a Swiss. Inasmuch as Pendleton here signed *his* name only, the lithograph was made in Boston in 1824, when he was on his own there for a year. The print made its way to the Philadelphia Agricultural Society. Much the worse for wear, it may be seen at the American Philosophical Society. The bull appears in three other versions, all of which include the lamb and ewe from, presumably, Thomas Bewick. The paintings were presentations for Friends, signed by Edward Hicks, who for the heavens threw a late afternoon blending of blue, rose, and gold like that of the skies of Newtown.

These landscapes were forerunners of the striking farmscapes. Hicks was not alone in his desire to pay homage to maternity. From ancient times artists have used the suckling lamb as a symbol. The Chinese

Opposite:
The Grave of William Penn, *1847.*
Oil on canvas,
23½ × 29 in.
Collection the Newark Museum,
gift of Mr. and Mrs.
Bernard M. Douglas, 1956

Paul Gauci, printed by
Graf & Soret, after oil
by H. F. de Cort,
Grave of Penn in the Quaker's Burial Ground at Jordans in Buckinghamshire.
Lithograph. Historical
Society of Pennsylvania

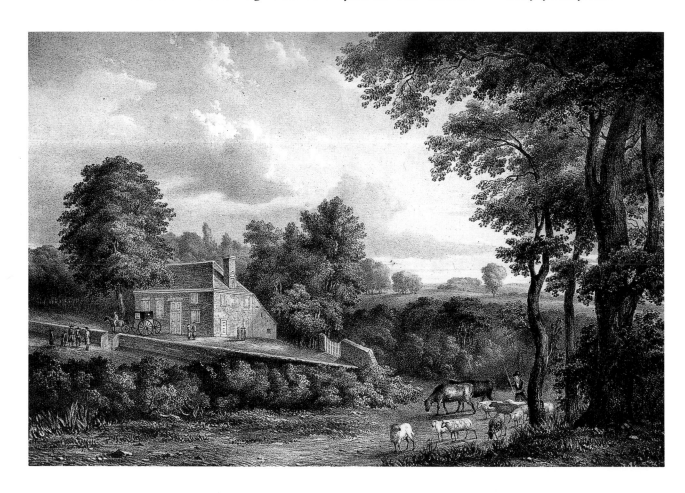

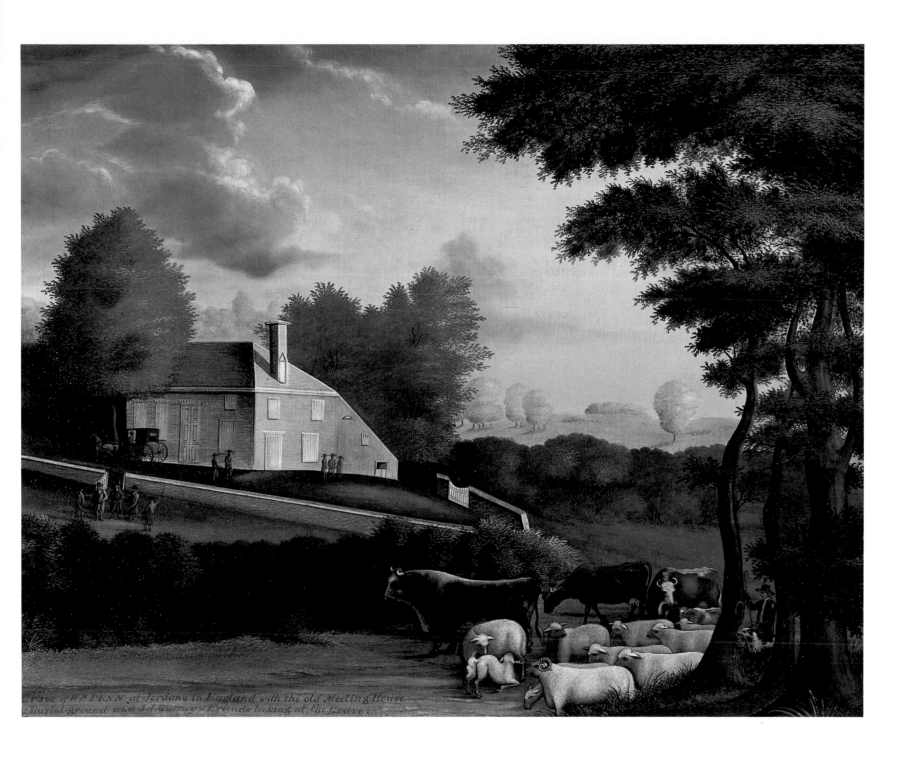

Grave of W.ᵐ PENN at Jordans in England, with the old Meeting House
& Burial-ground and J.J. Gurney & Friends looking at the Grave

pictograph for the word *good* is a schematic symbol of mother and child. In his *De Natura Rerum*, based on "old readings" from the ancient Greeks and Byzantium, Archbishop Isadore of Seville called the earth *Mother*. To illustrate Psalm LXII, the *Utrecht Psalter* of 830 A.D. used Genesis, 1:24 and its "bring forth," beside a mare and foal. Edward Hicks never ceased to mourn his mother Catherine. One of his last aspirations was to die a "babe" and cry "Abba!"

The time had come to draft an introduction for the *Memoirs*. What Hicks wrote was more like a valedictory. He apologized to all whom he had offended by his candor; to Makefield Quarterly Meeting, which had disowned him; and, finally, to all who deplored his having lived in part by landscape painting:

My constitutional nature has presented formidable obstacles to the attainment of that truly desirable character, a consistent and exemplary member of the Religious Society of Friends; one of which is an excessive fondness for painting, a trade to which I was brought up, being connected with coach making, and followed the greatest part of my life; having been unsuccessful in every attempt to make an honest and honorable living by a more consistent business; and now in the decline of life, near my seventieth year, with a body reduced to a mere skeleton, racked by a tremendous cough, with scarcely breath and strength at times to breathe or walk, I should be a burthen on my family or friends were it not for my knowledge of painting, by which I am still enabled to minister to my own necessities and them that are with me, through the kind patronage of a few noble, generous Friends, and friendly people, who, in my case, practically answer that query in our Christian discipline, 'Are poor Friends' necessities duly inspected, and are they relieved and assisted in such business as they are capable of?

He admitted having gone ahead without the benefit of the Society's blessing and with limited understanding of the consequences. If by speaking "to the utmost of truth . . . and almost beyond," he was willingly bearing his "sins and foibles" for his enemies to make the most of it, so be it. He had not meant to sow disunity, and prayed Makefield's members to let him be "an object of their care, their sympathy and prayers." He did so with an intimation of having "little expectation of ever mingling with Friends in meeting any more."

Comly had nothing to fear. Oliver Hough had found the editing a slow and demanding effort. Hicks recopied each of the correction sheets in longhand for printing, a slow process under such an arrangement.

*T*he writing "concerns" were all but laid to rest. The taxing mission journeys were over. All indebtedness was a thing of the past. With so much and such unexampled freedom from care the time had come for silent worship, for painting with fast ebbing strength, and perhaps for dying.

A sign that he painted for the Willow Grove hotel caused the *Democrat*, newspaper of Doylestown, to praise it as "the beautiful work of art" by "Edward Hicks, an aged and much beloved minister in the Society of Friends." The reporter pronounced it "the best of any between Willow Grove and Philadelphia—or Easton, far north, for that matter." He predicted that "thousands" would stop by to admire it. Its subject like its fate is a mystery.

The decision to give up ministry so distressed Mary Lippincott of Moorestown, New Jersey, that in February she pleaded: "My beloved Friend . . . pleasant is the remembrance of thee and of the favoured sessions we have had, when we have gone up to the 'house of the Lord' together. Dear Edward, don't give up; don't despair! . . . Well do I remember the voice of encouragement from thy lips, nearly thirty years ago (the first time I ever heard thee). . . ." Since then his words had "hundreds of times arisen, fresh as when uttered."

No one doubted that Edward Hicks had preached his last sermon, except for the lessons from Isaiah on canvas. Indeed, he had still more to say, with his brushes, about the beloved farm country around him. James Cornell, for one, seized upon his willingness to accept a commission or two. In October 1848, Hicks undertook a tribute to the prize-winning livestock of the Cornell farm. It is a luminous celebration of rural Bucks County in autumn. No American untrained painter has ever caught sunlight, atmosphere, and color as he did in this evocation of what he called the truly "Christian way." He and Isaac had kept abreast of the changing agricultural tradition of eastern Pennsylvania. The *Columbian Magazine* of Philadelphia had published an ideal plan for "a well-ordered farmyard . . . the foundation of all good husbandry," as early as 1786. Not only the American Philosophical Society members of that city but its rural counterparts were in continuous correspondence with Royal Society of London members about methods and implements. Cornell was well known and evidently owned books that Hicks perused for models instead of sketching from life. The proof is in these pages.

The Cornell Farm
1848

*T*he brilliant autumnal painting of the Cornell farm carries these words across its lower border: "An Indian summer view of the Farm Stock of James C. Cornell of Northampton Bucks County Pennsylvania. That took the Premiums in the Agricultural Society October the 12, 1848."

If, as is known, Cornell ordered the painting of the bull calf in 1846, there is all the more reason to assume that this demanding picture was also a commission. Although not a Quaker, he must, by his reputation throughout the eastern United States for his ability in farm management, have enjoyed the admiration of the artist. He must also have seen the paintings of the Hillborn and Twining farms and made the most of Hicks's ebbing strength before too late, and on a special occasion, painstakingly noted by the artist as above.

The original tract, west of Newtown, was approximately 2,000 acres divided by the East Holland Road, which ran through it to Neshaminy Creek. The family Bible, dated 1660 and preserved in Doylestown, bears many Dutch and French Huguenot ancestral names. The Cornells came to Pennsylvania from Long Island in the eighteenth century.

It could have come as no surprise when members of the family appeared in the *Democrat* of Doylestown as winners. Both James and his brother Adrian were founders of the Bucks County Agricultural Society. Part owner of the Newtown bank, James Cornell could well afford to breed fancy livestock. His white brood mare and colt won first prize, his dairy cow second, and his sheep, ewes, poultry, and litters of Bedford and Berkshire pigs took cash awards. His "milch cows of native stock" were "best of show." The livestock of his brothers David and Martin also scored.

On the day of the livestock show, the annual plowing contest, held in front of the Brick Hotel, drew a crowd that cheered the six competing teams. No farmscape was complete without a plowman. Closely following the design of Bucks county engraver William H. Ellis on the certificate of the county's Agricultural Society, Hicks used one black and one white horse (though this exigency of prints was not essential to painting). The much older Philadelphia Society for Promoting Agriculture had instead chosen oxen for its seal, and the motto "Venerate the Plow" from the poem "The Seasons," by James Thomson.

Cornell Farm,
1848.
Oil on canvas,
36¾ × 49 in.
National Gallery of Art,
Washington, gift of
Edgar William and Bernice
Chrysler Garbisch, 1964

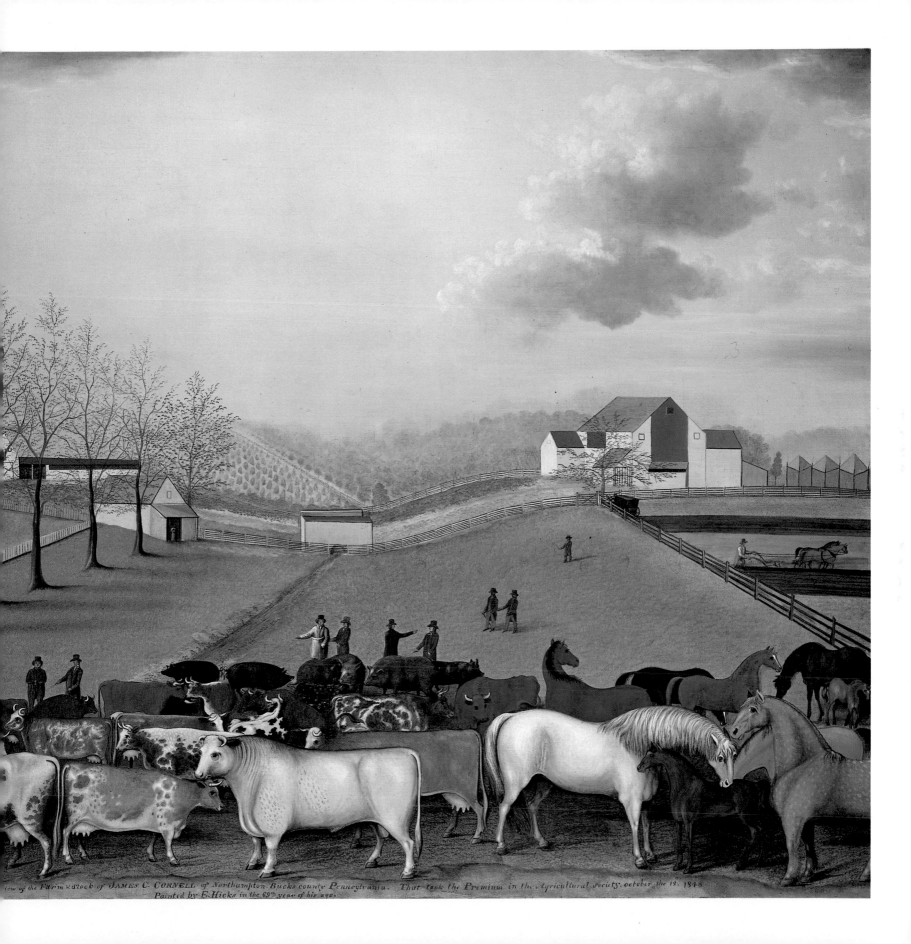

iew of the Farm & Stock of JAMES C. CORNELL, of Northampton Bucks county Pennsylvania. That took the Premium in the Agricultural Society, october the 12, 1846.
Painted by E. Hicks in the 69th year of his age.

Hicks began work with pencil and paper. This suggests that he sketched the main points of his composition. He drew the skyline, fixed on the location of buildings and fences, and decided how to place and arrange the judges and livestock—ten men and forty-five animals. Distance obviated the necessity of anything close to true representation of the human faces and figures. From prints and books he had a stock of models, chosen to suit the occasion. The Ayreshires had served in earlier paintings. Cornell himself had doubtless eagerly acquired the recently published volume by David Low, *On the Domesticated Animals of the British Islands* (London, 1845). Three of its animal figures found their way into the Hicks composition. The landscape on canvas may be a reasonable approximation of the scene, within the limitations of an artist dependent on prints for animal figures. Here the "short-horned bull" is not seen for the last time.

With *The Cornell Farm*, and *The Leedom Farm* that follows, Edward Hicks created landscapes of extraordinary power, and of a beauty unlikely ever to be surpassed by artists of his attainments.

For the dentist Morris Linton, neighbor and son of a fellow "regimental dandy," the late James Linton, Hicks painted his last and most august *Washington Crossed Here*. This time the canvas bore no lettering on its face, possibly because there remained much else to do. There were sentimental reasons, too, for painting the Leedom farm for the children of the late Mary and Jesse. It was now or never. A short drive to the farm with pencil and paper to mark off house, fences, barnyard, outbuildings, and skyline was a start. The barnyard could be populated in the shop from a supply of livestock and poultry figures. Add schematic figures of his late, faithful friends and their children, throw a suitable sky over all after finishing the earth and the rest, and the landscape would be ready for varnish.

Hicks was too ill by the month of June to put the final touches to a *Peaceable Kingdom* for Elizabeth. He had finished, and most beautifully, a similar one a few months earlier. The theme was the familiar one of hope and love, sublimation, youth and age, good and evil, birth and death. But there was a new measure of detachment, of trust in eternity. Distances were less cut off by the foreground, animals less encapsulated—in fact freed more discernibly than ever from their pyramidal diagonal, to follow their enchanting leader single file.

At regular intervals for weeks there were importunings for Elizabeth to come home from Peck Slip where she had been helping Susan through one more of "little Ned's" illnesses. To try to placate her father she wrote

Artist unknown,
Horse. *From David Low,*
On the Domesticated Animals
of the British Isles
(London, 1845). American
Philosophical Society, Library

letters of assurance that his ministry would have its reward, and that Friends sent "their loves." He was not to doubt but that his "pure Christian faith" had become a "shield for his children," whom it better served than would the "dagger" of riches. He remained inconsolable, pleaded that her mother was up "by sunrise," wan, and in need of her. Toward Ned he felt numb. Ever "since the death of precious Phebe Ann," whose name he still could not write without weeping, he was unable to grieve over other children. "I cannot feel the like for any other." It was not for one or the other but for the family and its safe conduct to Heaven that he prayed continually, and especially while "favored." Whatever his faults, he mused that his "immoral conduct" in youth would hardly "leave a stain" if it was "exposed on the housetops," and compared with the wickedness of the world.

As soon as Ned recovered, Elizabeth returned. By then the doctor thought her father might live until autumn. He continued to go out to his shop each morning for a while. On July 13 he wrote in his diary for the final time:

I feel as if I ought to try to write a few lines more before I die, which some of the Doctors think will be this summer. Indeed, I feel scarcely able to walk up and down stairs, such is the weakness of my body, though I humbly hope I am favored with sound mind and memory, and want simply to say, in as few words as possible, something by way of encouragement to such precious visited minds as may come after me and read this.

Dear, precious children, believe me, an establishment in the ever blessed truth . . . is infinitely—infinitely superior to everything of this world. Press after it, lay fast hold of it.

Any thought of trying to lengthen his days was, to him, foolish "self-righteousness." For "nearly fifty years" the "fear of falling" from heavenly grace had been the dread "companion" of his mind, especially in the days of youthful "temptation and tremendous tossings." But in these last days he felt "incontestable evidence" that "truth . . . and that *faith* that works by love"—and for "all the dear children the world over"—had won out. Surely his soul must "triumph over death, hell and the grave":

I write this seriously, and awfully, and thoughtfully, being under no excitement from preparations of opium, or other medicine. But in a short time I shall not be able to say so, for unless I can get relief some other way, I shall have to have recourse to some kind of an anodyne; and in that case, whatever expressions I may use will be more or less coherent, in proportion to the irritability of the nervous system, the exquisite connection of soul and body.

Artist unknown,
Cow. *From David Low,*
On the Domesticated Animals
of the British Isles
(London, 1845). American
Philosophical Society, Library

Then, more passionately than in that discarded beginning of his *Memoirs*, he echoed St. Paul:

> *I view myself not only the chief of sinners, but a wretched sinner, a fool, a worm of the dust, a nothing . . . But I am writing too much and saying too little, and had better mind my own business . . . a simple childlike testimony . . . which will subject me to be pitied by the wise and prudent of the world as a fool, or ridiculed as an enthusiast, my doctrine considered madness. Yet I would not part with this childlike belief for ten thousand times ten thousand worlds. . . .*

His wish was for a "passport from this world to the Heaven of Heavens."

The Leedom Farm
1849

*I*maginable praise of his farmscapes led Edward Hicks to attempt to bring off what proved a stunning achievement for an untrained painter, let alone for a dying man. Not long after his sixty-ninth birthday, he finished the *Leedom Farm* and inscribed the canvas: "A May morning view of the Farm and Stock of David Leedom of Newtown Bucks County—Pennsylvania with a representation of Himself. Wife. Father. Mother. Brothers and nephew. Painted by Edw. Hicks in the 70th year of his age."

Its blue skies are tinged with rose in the way of Newtown's mornings and evenings. Billowing clouds enliven the crowded but endearing scene below. The domestic and farmyard activity is less formal, and much more intimate, than the competitive atmosphere of the no less magnificent *Cornell Farm*. Nothing is on exhibition. There, west of town on the Addisville Road, all are at ease and as Hicks saw them in his mind's eye. His intention, a tribute to diligent and successful friends and farmers, accounts for minutiae shown with affection, down to the last hissing goose of the irresistible aggregation. He was saluting farming—his ideal—and he knew whereof he painted, although he may not have known that he was doing so in the tradition of popular and monastic artists since the Middle Ages. (Not that such tributes were always drawn or painted. In the Vendée district of France the coffin of a farmer of worth was drawn to his burial place by his best team of white oxen, followed by all the others in his possession, in a humble show of a life well spent.)

The schematically drawn figures of Jesse Leedom and Mary Twining are of faithful friends already dead. Their son David, heir to their 167

Leedom Farm, 1849.
Oil on canvas, 40 × 49 in.
Abby Aldrich Rockefeller Folk Art Center,
Williamsburg, Virginia

acres, his late grandmother Polly Leedom, and others of the family have the air of looking out toward the road, where Hicks drew lines still visible. This time the plow rests and its team stands idle in the barnyard; their driver leans on the five-rail fence. There are more than sixty animal and poultry figures in the carefully balanced semblance of reality. The tethered horses could have been sketched from life. One is like a horse in Peter Parley's *Tales of Quadrupeds* (1832). Other forms have their origin in stock models seen, in some instances, before. The great reclining ox, which makes its initial appearance here, will be drawn again to advantage in the final *Kingdom*.

S. G. Goodrich,
Arabian Horse.
From Peter Parley's
Tales of Animals
(Boston, 1830).
Rare Books, Free Library
of Philadelphia

The row of trees in the right middle ground appears to be there for expediency. In reality, as a final sale list proves, it is the edge of twenty-one acres of woodland. In the fieldstone house there were a large hallway, two parlors, a large dining room at the east, another at the west, and bedrooms above. A two-story stone kitchen, with a milk vault beside it near the well, was attached to a wall as shown in the painting. Near the stone barn stood stables for twenty-five horses, and varied shedding; the hog pen; the corn crib for a thousand bushels; the smoke house; and the ice house. There were two apple orchards, pear and plum trees, grapevine, kitchen garden, and spring. The weather vane, an Indian archer, was the traditional Quaker sign of good will toward the red man.

Finger prints on the "pied-brown cow," discovered by the conservator Russell Quandt, show that Hicks sometimes used thumb or fingers to work in his paints. His observations shed still more light on the methods of the artist:

The Leedom Farm exemplifies the procedure probably used most frequently by Hicks. The outlines of buildings, fences, grass, and landscapes are drawn first on the ground layer. The land area is then given a brown-colored wash. Next, the sky, roofs, chimneys, siding, and fences are painted the appropriate colors, and most of the details such as eaves, cornices, and openings are completed. A medium-toned green is applied to the middle distance and the grass of the foreground. Finally, human figures, animals and trees were put in. Evidence that these were added last, on top of already completed architectural details, is provided by the ghost images of fence rails which cross torsos of the principal figures in the middle ground. Their bare outlines might have been sketched in the preliminary drawing, but their details were superimposed on finished passages of a different nature. Hicks's last touches to the painting consisted of adding highlights to the grass in the foreground and trees in the middle distance.

The result, by any standards, is a tour de force of pure enchantment.

Opposite:
Leedom Farm,
(detail), 1849.
Oil on canvas,
40 × 49 in.
Abby Aldrich Rockefeller
Folk Art Center,
Williamsburg, Virginia

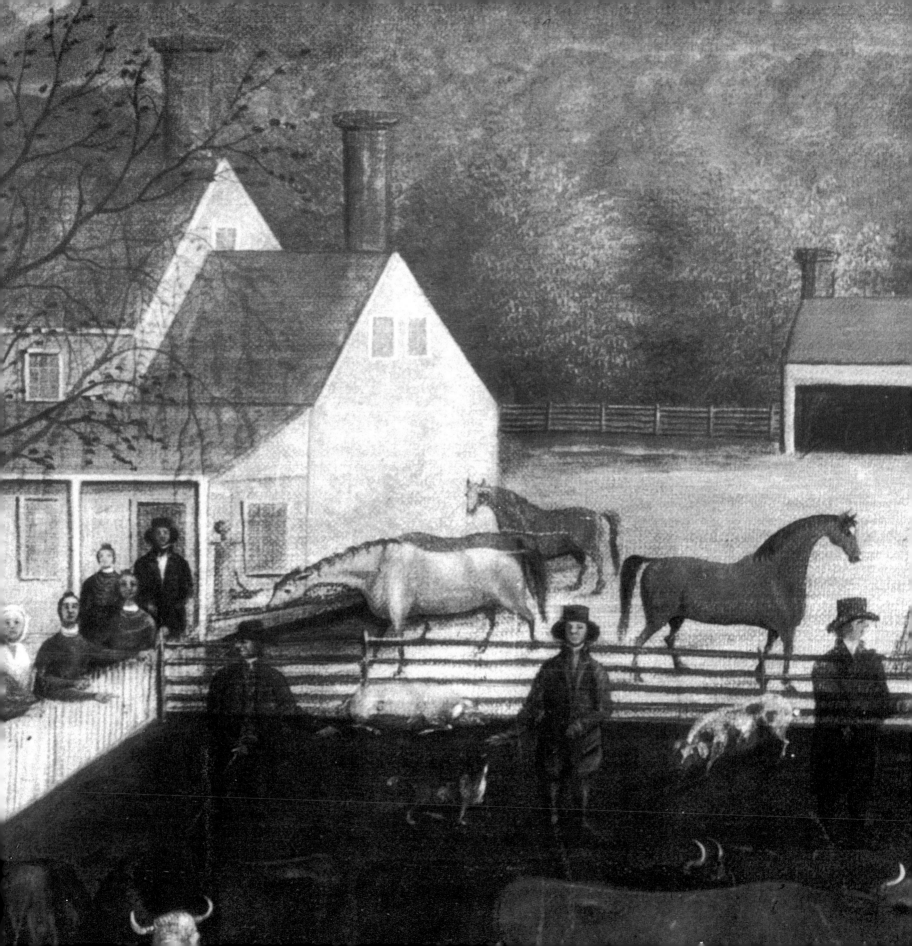

The Peaceable Kingdom
1849

*L*ate in 1848, or in the new year, the artist began what was to be the second to the last affirmation of all that he hoped lay ahead.

Awareness of nature and its beauty was part of his English heritage. He also recognized its lessons and made the most of them. The barren mound near the stream contrasts poignantly with the twin trees near by, and with their autumnal transparency. Two bleak stumps and a dead branch below are even more eloquent than the great broken tree trunk of much earlier *Kingdom*s. The atmosphere is prophetic, tenderly melancholy, full of hints of the finite and inevitable as time slips by. One senses a profound resignation. Penn carries on, but afar.

With such a landscape, Hicks had set the mood for his introduction of a long line of the players of the roles in his scriptural drama. This time the "little child," from a new source, deserts her customary position and makes her way smilingly off the stage of life. She holds neither olive nor grape branch, because Hicks was guided by an engraving in which she carried a modish drawstring reticule. Some of the mild-mannered animals follow in her train, while others pause to rest, for the felicity of the composition and also for truth to the prophecy. Again, the recumbent leopard "in perfect stillness lies." Lest use of the great horned ox throw the processional effect off balance, a less conspicuous substitute chews beside the lion.

The lion, also "new," has a fascinating history. By facing out, toward eternity, he serves the painter's intent and also his lifelong problem with delineating eyes. Although the direct source was the illustration from *Peter Parley's Tales of Animals* (1832), the lion stemmed from a painting by

The Lion.
From Peter Parley's
Tales of Animals
*(Boston, 1832).
Rare Books, Free Library
of Philadelphia*

The Peaceable Kingdom,
*1848–49.
Oil on canvas,
24 × 30¼ in.
Private collection.
Photo courtesy
Galerie St. Etienne*

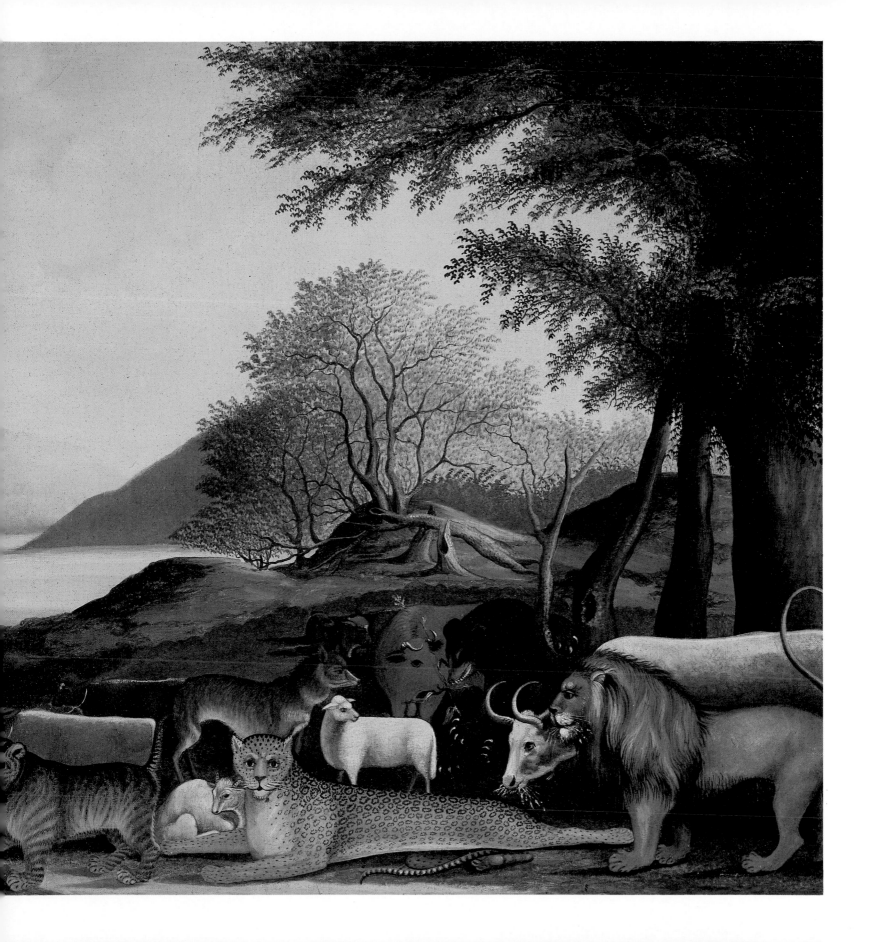

Nicholas Maréchal. He was the official artist of the Museum d'Histoire Naturelle, Paris, and the adjacent Jardin des Plantes where the beast was caged. The museum appointed Miger to engrave it on steel for a lavish volume by the Baron Cuvier and his colleague the Comte de Lacépède: *La Ménagerie du Muséum National d'Histoire, ou Description et Histoire des Animaux qui y vivent ou qui y on vécu* (Paris, 1801). American illustrators helped themselves to it, copying one another rather than Miger. A journeyman, "N..Camp," lithographed a copy of Miger by the Philadelphia artist Reuben S. Gilbert for the firm of Augustus Köllner of that city. As late as 1850, the lion was appropriated by Augustus A. Gould for a juvenile on natural history.

Edward Hicks was not alone in putting the talents of illustrators to use. Sometimes the lion chosen for this canvas appears in nineteenth-century books with another who gazes from behind it and is only partly visible against a desert landscape.

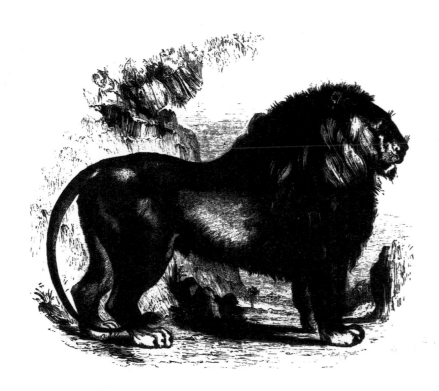

Gilbert after Miger
after Maréchal,
The Lion. *Lithograph.*
Free Library of Philadelphia

Washington Crossed Here
1849

*K*nowing death to be not far off, and anxious to accomplish last things, the artist undertook a final rendering of Washington beside the Delaware. It proved to be his most forceful. For the friend and neighbor for whom it was intended he inscribed these words on the back of the canvas: "Painted by Edw. Hicks in his 69th year of his [age]—for Doctor M. Linton of Newtown, son of his old friend & fellow soldier, James Linton. General Washington with his army crossing the Delaware at McConkey Ferry the night before he took the Hessians, Dec.r 25, 1776." This time he avoided his earlier error as to the day.

His feelings concerning Washington, product of "humble industry" and taught only "to read, and to write, and to cipher," remained unchanged.

Quite by coincidence, the year of the flood that downed the two signs—1841—was also the year when the Sully oil stepped from relative obscurity into the limelight. Its purchaser, John Doggett of Boston, sold it to Moses Kimball, new owner of the venerable commercial Boston Museum & Gallery of Fine Arts. Showman rather than aesthete, Kimball lured patrons opposed to the theater but in need of the amusement provided by his live performers, a simulated Niagara with "real" water, and a waxworks. In time, the painting was presented to the city's current Museum of Fine Arts.

The Peaceable Kingdom
1849

*T*his, the last powerful affirmation and most elegiac expression of the prophecy of Isaiah, was for Elizabeth, who, herself, had become a minister. Assumed by later generations to have been unfinished, when in fact it had merely suffered from heat and light, it has at last been returned to its original state by expert cleaning. Even when handicapped by grime, its rare character and identity were clearly perceptible. In the juxtaposition of the symbols of life and death the mound has a more foreboding look. Not all of the dumb retinue fall in line as willingly behind the lighthearted "little child" as in the preceding, similar *Kingdom*. The ox, greater and full of lassitude, appears in no hurry to forsake

Washington Crossing the Delaware,
1848. Oil on canvas,
36¹/₈ × 47³/₈ in.
Abby Aldrich Rockefeller
Folk Art Center,
Williamsburg, Virginia

The Peaceable Kingdom, *1849.*
Oil on canvas, 24 × 30 in.
Nelson-Atkins Museum, Kansas City, Missouri,
lent by the great, great grandson of the artist

its repose and follow; it is the animal figure that one is more likely to remember on looking back, although the restless Northcote lion, distracted, bids for attention by breaking ranks. In the familiar Treaty scene, yonder, Penn gets on with his timeless parley, as oblivious of the striking procession below as it is of him.

Allegory is likened to a phantom of the mind, euphoric illusion. To Edward Hicks, a man of private visions, it was truth.

*T*hat sterling Friend James Walton, who with John Comly had drawn Edward Hicks into the Society of Friends, came with a companion to call on him in his shop. "I feel like a man who has had a task given him to perform in the morning, and who has got it all finished a *little before sun down*," he told his visitors. He was "now taking a little rest from the labors of the day." Walton left with keen regret that he had not ordered a set of alphabet blocks for his youngest child before too late.

John Watson came by. He was struck by the "sweet disposition of mind" that he found and by the vigor of the handshake. "A change may take place and I may yet live some years," Hicks mused. Either way, he would "continue steadfast."

Thomas Hicks was on the high seas and eagerly looking forward to seeing all the relations and recounting his many adventures. Just a year earlier he had hidden two insurgents in his studio rooms during the revolution in Paris, before their escape. He was nothing so far from suave as the Thomas who had hurried off from New York without a passport, and who had to be rescued on board ship by a letter of introduction provided by a passenger. That friend in need was Colonel Polk, none other than the brother of the president. Now Thomas wore heavy sideburns and whiskers and looked much hardier. But none of these changes was Edward Hicks to see.

With Isaac seated beside him, ready to help, he wrote out a brief will and testament in a neat and even hand. He signed and dated it August 3, 1849, then added his butterfly flourish below. Were his wife, to whom he left all, to die, his property would be shared by all his children, even Susan and Sally, both "well provided for by their husbands." He knew there would be little to share. Isaac was to look after "dear afflicted Mary." He was also to borrow three hundred dollars, if necessary, for a dowry for Elizabeth, if she married. He was to continue with the shop work and the farming as before. He had sold his house

without ever having lived there; his father assumed that he would continue living at home. As for the paintings and other property in the shop, they were to be appraised and sold.

The painter had been saying all along that he would "go suddenly, without much pain or suffering." At noon on August 22, 1849, he came in from the shop as usual for dinner. A solicitous letter awaited him from Henry Willet Hicks, who wished to come down and discuss final plans for publication of the *Memoirs*. Hicks read it and told the family to inform Henry that all the work was finished and done, and that if he hurried he might reach Newtown in time for his funeral. The family was dismayed. Hicks took little notice, but instead rejoiced aloud that his cares were over, and that peace and joy were all around him. Back he went to his shop to work until supper time.

That evening he announced that he had closed the shop, except for what Isaac would have to finish. In the morning he did not leave his bed for the midweek meeting with Friends. Sarah, the children, and the family guest Caroline Hicks Seaman gathered around the bedside. It was a canopied bed that Gilbert Hicks and Mary Rodman had brought from Flushing to Bensalem. To each one the painter murmured a brief farewell. In the afternoon, happy and tranquil, he whispered, "Oh 'tis a glorious boon to die, That favor can't be prized too high."

The death notice of the usual line or two drew the largest turnout in Bucks County history, a crowd of three or four thousand mourners. Rigs clogged all the roads into Newtown. The meetinghouse, grounds, and street were filled. Mary Lippincott spoke with emotion. Joseph Foulke testified to the rare worthiness of his friend and fellow minister.

*U*nder a giant sycamore whose bare, gnarled roots grope uneasily about, close by the burial ground gate, is the small plain stone. Beside Edward is Sarah, who died in 1855. At his head is Tacie Anne, fifteen months, infant of Isaac and his wife Hannah Penrose. Around the tree trunk room was made nearly forty years after the death of Edward for bachelor Mahlon Buckman, luckless suitor of Susan. He had outlived both Susan and John, whom he had brought together. They had borne with the frequent extended visits of this friend, who endeared himself to their children. Near, yet alone and apart, lies Sarah Speakman, spinster who disappointed Isaac.

The *Memoirs of the Life and Religious Labors of Edward Hicks, late of*

Newtown, Bucks County, Pennsylvania, Written by Himself, was printed at 7 Carter's Alley, Philadelphia, Pennsylvania, in 1851. He would have been consoled by the "Testimony" that precedes his "Introduction." Friends of Makefield Monthly Meeting summed up his life and hailed his ministry, then closed: "Mark the perfect man, and behold the upright, For the end of that man is peace."

*T*he paint shop fell to the wreckers in 1873. There is no trace of the chrysalis of a vision captured in rare mutations.

The wonder of the vision grows, its power increases.

Notes and Sources

Abbreviations

Childhood and Youth

Page

16 " . . . 'truly above rubies.' " Hicks, *Memoirs of the Life & Religious Labors of Edward Hicks, Late of Newtown, Bucks County, Pennsylvania* (Biblio. 49, hereafter cited as *Memoirs*). A brief unpublished draft of the first beginning of *Memoirs* is at the Friends Historical Library (S).

16 David Twining (1722–1791) and his wife Elizabeth Lewis (1737–1806). Twining, *The Twining Family* (Biblio. 92). See also Biblio. 25, 31, 35, 67, 106, 137.

18 "Gilbert, ten, became the lodger and pupil. . . . " James Boyd (1769–1814) was first principal of the Free School of Bucks County, established in Newtown in 1794. *Minutes of the Newtown Presbyterian Church,* Newtown, 1984. Years later Edward Hicks was to debate him in the local prints.

19 " 'David Twining in account. . . . ' " For the boarding and teaching of his children, Isaac Hicks paid £ 12 per annum to David Twining for Edward (June 1783–spring 1791), £ 25 per annum to James Boyd for Gilbert (May 17–October 25, 1786) and to J. De Normandie for Gilbert's "tuition as a physician" (November 25, 1786–October 26, 1791), and £ 20 per annum to Catherine Heaton for Eliza Violetta (May 1783–May 1789). Accounts Ledger of Isaac Hicks (BC and the American Philosophical Society, New York).

19 Partnership of James De Normandie and Judge Gilbert Hicks. Michael Jenks papers (BC).

19 "Only lately Isaac Hicks had written. . . . " Letter from Isaac Hicks to Thomas Ricke (P, Autograph Collection).

20 "Indeed he had become happy. . . . " Isaac Hicks married Mary Young (née Gilbert, August 3, 1757), widow of Edward Young, at Christ Church, Philadelphia, on October 20, 1792.

20 "Moreover, William White. . . . " Seabury papers, General Theological Seminary Library, New York.

20 "Just outside the south portal. . . ." Clark, *A Record of the Inscriptions . . . in the Burial Grounds of Christ Church* (Biblio. 18).

20 " . . . 'lackey, shoeblack. . . .' " *Memoirs*.

20–22 Short quotations from *Memoirs*.

22 " . . . 'a light airy disposition. . . . sobriety and seriousness.' " Comly, *Journal* (Biblio. 19).

22 "He borrowed serious books. . . . " Library Company, Newtown, Pennsylvania.

23–26 Short quotations from *Memoirs*.

26 "She died. . . . " Mary Young Hicks died intestate. Letter of Administration #3913, February 28, 1812, Wills, Doylestown, Pennsylvania. Witnesses were William Watts and James Raguet. Edward Hicks painted signs for Watts and Raguet in 1818. See Appendices, The Accounts Ledger of Edward Hicks.

27 " . . . 'for painting the Pennsylvania coat of arms. . . . ' " See Appendices, Accounts Ledger.

29 "Hicks's shop ledger. . . . " Accounts Ledger of Edward Hicks (BC).

30 " 'Coach, Sign, and Ornamental painting. . . . ' " *Star of Freedom*, May 21–June 25, 1817. See also Barnsley, "Presses and Printers of Newtown Before 1868" (Biblio. 101).

30 " . . . a retired, wealthy, merchant cousin. . . . (Isaac Hicks by name). . . . " Barrett, *The Old Merchants of New York City* (Biblio. 6) and Ely, *A Genealogical and Personal History of Bucks County, Pennsylvania* (Biblio. 34).

30–33 "In the first of seven letters. . . . for the sake of his higher calling." Comly letters: June 15, August 12, October 23, and November 17, 1817; February 11, March 10, and May 23, 1818 (s).

31 Edward Hicks's financial crisis of 1817. Forbush, "Love and Charity Greatly Abound" (Biblio. 114).

31 "His sister had drowned. . . . " *Memoirs*. See also Futhey and Cope, *History of Chester County. . . .* (Biblio. 41).

33 "It was at about this time. . . . " The Bird in Hand Tavern, built in 1690, is reputedly the oldest surviving frame building in Pennsylvania.

The Mire of Paint

34–36 "He decorated clock dials. . . . the ledger does not say." Accounts Ledger of Edward Hicks (BC).

37 Short quotations from *Memoirs*.

37–40 "Young, studious Mathias Hutchinson. . . . closed the log of the two-thousand-mile journey." Ryan, "Mathias Hutchinson. . . . A Journey (1819–20)" (Biblio. 143).

38 "Joseph Wilson, a brother. . . . " *Portfolio* 2, series 3, 1809.

40 "A letter which did catch up with him. . . . " Beulah Twining Torbert to Edward Hicks, in letter from Mary Hicks to Edward Hicks, October 16, 1819 (H).

40 " . . . 'take good care of the calf. . . . ' " Letters of Edward and Elias Hicks (s).

41 "Hicks lived so near the meetinghouse. . . . " Newtown Preparative Meeting Minutes, August 22, 1820.

41 "The family settled in quarters. . . . " Accounts Ledger of Edward Hicks (BC).

42 "One Friend later pronounced. . . . " Letter from Townsend Sharpless to Mary Jones, January 17, 1822 (s).

42 "Sarah and Samuel Hicks wrote to express. . . . " Letter from Sarah and Samuel Hicks to Edward Hicks, February 28, 1822 (H).

42 "Elias Hicks saw the loss. . . . " Letter from Elias Hicks to Edward Hicks, April 9, 1822 (H).

42–43 Short quotations from *Memoirs*.

43 "In Catawissa, whose name. . . . " *Historical and Biographical Annals of Columbia and Montour Counties, Pennsylvania* (Biblio. 52).

44 " . . . an oil done by David Martin." Sellers, *Benjamin Franklin Portraits* (Biblio. 79). The example in the Pennsylvania Academy of Fine Arts is considered one of the earliest. Another hangs in the White House in Washington, D.C.

46 " 'I think it proper. . . . was a present. . . . ' " Accounts Ledger of Edward Hicks (BC).

46 " . . . the family Bible. . . . " This Bible is no longer in the family, but privately owned.

48 Henry Schenck Tanner was born and died in New York City (1786–1858). From 1816 to 1824 his brother Benjamin (1775–1848) was a member of the Philadelphia firm of Tanner, Vallance, Kearny & Company. In 1815 Henry invented a counterfeiting-proof process for banknote engraving incorporating white lines and black ground. He received the rare honor of an invitation to membership from the Geographical Society of London and Paris. Obituary, *New York Evening Post,* May 18, 1858.

48 "The discovery of the cartouche. . . . " Ayres, "Edward Hicks and His Sources" (Biblio. 100).

48 " . . . 'the purity of the beginning.' " Richardson, *Iconology. . . . Emblematic Figures* (Biblio. 72).

48 "The frontispiece of *A Brief Memoir*. . . . " Wakefield, *A Brief Memoir . . . ,* Rare Books, Library Company, Philadelphia.

54 "The antiquarian Eberlein ridiculed. . . . " Eberlein, *Practical Book of Early American Arts and Crafts* (Biblio 33).

55 " . . . Edouard Manet was to create a masterpiece. . . . its composition from a print." Liedtke, "In Detail: Manet's *Le Déjeuner sur l'Herbe*" (Biblio. 129).

56 "John Peter Salley wrote. . . . " Public Record Office, London, England, c.o.5/1327.

56 "A *Niagara* sign painted by Hicks. . . . " Accounts Ledger of Edward Hicks (BC).

59 Inscription to Sarah Titus Hicks, April 1, 1826 (H).

59 " 'Dear Coz Edward. . . . ' " Letter from Silas Hicks to Edward Hicks, May 1, 1826 (H).

59 "He declared that he would not. . . . " Letter from John C. Cheesman to Edward Hicks, April 28, 1826 (H).

61 " 'Oil varnishes, they know from experience. . . . ' " Letter from Sheldon and Caroline Keck to Alice Ford.

Schism

62–64 Short quotations from *Memoirs.*

64 "That intransigent leader. . . . " Evans, *Jonathan Evans and His Time, 1759–1839* (Biblio. 35).

64 "In one of two sermons. . . . " Hicks, "Sermon. . . . " (Biblio. 120).

65 "Phineas Jenks and other. . . . " *Bucks County Papers* 2, p. 104.

65 " . . . 'certain disownment.' " Minutes of Buckingham Quarterly Meeting, 1827.

65 Short quotations from *Memoirs.*

66 "Rejoicing . . . he managed to pay his father-in-law. . . . ' " Accounts Ledger of Edward Hicks (BC).

66 "They accused him of having excited. . . . " Letter from Mary and Elizabeth Allinson to Edward Hicks, January 7, 1828, and his reply, August 14, 1828 (H).

67 " 'I feel too poor. . . . ' " Letters from Edward Hicks to Halladay Jackson, February 29 and August 14, 1828, Winterthur Museum library, Delaware.

67 "He swallowed his pride. . . . " Letter from Edward Hicks to John Watson, December 7, 1828, Galerie St. Etienne, New York.

67 " 'Testimony of Disownment . . . unsound Doctrines." Signed by Moses Comfort, Jr., Clerk, with "the Indorsement of John Kirkbride, stating he offered this copy to Hicks in the presence of William Satterwaite." See Biblio. 71.

68 "One of his poems. . . . " Johnson, *The Triple Wreath, Poems . . .* (Biblio. 55).

68–72 " 'Should nations . . . the sons of men?' " Johnson, *The Triple Wreath, Poems . . .* (Biblio. 55).

72 "Finally, the observations. . . . " Quandt, "Technical Examination of Eighteenth Century Painting (Biblio. 70)."

72 "His millhouse, currying shop. . . . " Last will of Joseph Worstall, *Wills* 7528, Records Office, Doylestown. See also Biblio. 7.

74 " 'It is a time when. . . . ' " Letter from Edward Hicks to Samuel Hart, December 1829 (H).

74–76 "Written by candlelight. . . . he closed." Letters from Edward Hicks to his family, January 1, 24, February 26; 1830 (H).

76 " 'This, Edward. . . . for thee.' " Beulah Twining in letter from Mary Hicks to Edward Hicks, January 7, 1830 (H).

New Horizons, New Landscapes

William Penn and George Washington

118 "To commemorate the settlement of Pennsylvania. . . ." Alberts, *Benjamin West* (Biblio. 1)

118 "Penn received a beaded. . . ." According to J. William Frost, the wampum belt had "no documentary history before the 19th century." Frost, *Memoirs* 6 (1858), pp. 205–82 (P). Also included in the Historical Society's collection is the blue sash worn by Penn in the *Peaceable Kingdom* of the Philadelphia Museum of Art.

118 "Watson's *Annals*. . . ." Biblio. 95.

122 "'That awful messenger that rides. . . .'" Letter from Edward Hicks to Elizabeth Hicks, winter 1836 (H).

122 "In the spring. . . ." Accounts Ledger of Edward Hicks (BC).

124 "Cunningham's *Lives of the British Painters*." Biblio. 22.

124 Thomas Hicks, painter. See Biblio. 4, 44, 91, 122.

124 "Before Thomas reached fourteen. . . ." Accounts Ledger of Isaac Hicks (BC).

125 "'If I can get rid of them. . . .'" Letter from Edward Hicks to Louis Jones, June 14, 1836, Carle collection.

126 "Edward delegated the unenviable task. . . ." Will 3010, Records Office, Doylestown.

126 "'He died. . . . distressing manner.'" Warner, *Queen Victoria's Sketchbook* (Biblio. 94).

Missions

130 "Stabler had preached about the 'tree of life. . . .'" Stabler, *Edward Stabler* (Biblio. 85).

132 "Edward posed for Thomas. . . ." First portrait of Edward Hicks, Colonial Williamsburg, Virginia. See also Biblio. 4.

132 "'Young Hicks is an artist of considerable promise. . . .'" Letter from Edward Hicks Kennedy to T. W. Harris, June 30, 1837, Archives of the Pennsylvania Academy of the Fine Arts, Philadelphia.

132 "'Precious youth' was being 'scattered. . . .'" Letter from Edward Hicks to Richard Price, December 12, 1836 (H).

132 ". . . bound for Goose Creek Friends Meeting. . . ." The Meeting was "allowed" by Fairfax Monthly Meeting and set up on August 30, 1754, near South Fork of Goose Creek, site of the present village of Lincoln, Loudon County. Goose Creek became a Preparatory Meeting in 1757 and a Monthly Meeting in 1785, when it took over South Fork Meeting, both of which worried Fairfax Meeting, owing to its gambling, racing, and wild youth, many of whom were disowned. Hinshaw, *Encyclopaedia of American Quaker Genealogy* (Biblio. 51), volume 6, pp. 404, 464, 515.

134–35 "'The devil is hatred. . . . peaceable kingdom.'" *Memoirs*.

138 "when it was ready, he wrote. . . . 'to start tomorrow.'" Letter from Edward Hicks to John Watson, August 14, 1837, Galerie St. Etienne.

139 "In a chronicle begun. . . . cousin Samuel Hicks.'" Letter from Edward Hicks to Benjamin Price, September 3, 1837 (S).

140 "Kennedy had built the school. . . ." In 1844, one Evans turned the house from school into tavern.

140 ". . . 'keep them out of sight. . . . I always love him.'" Letter from Edward Hicks to Samuel Hart, March 12, 1838, Hart Collection (BC).

140 "A symbolic figure of Liberty. . . ." Sommer, "Thomas Hollis" (Biblio. 84). See also Biblio. 113.

140 "The addition of Liberty. . . ." See typescript of poem by Samuel Johnson, "To Edward Hicks in His Proposition to Execute a Painting Commemorative of the Progress of Religious Liberty," October 3, 1839 (S). For Hicks on Abolition, see National Anti-Slavery Standard, April 16, 1846 (S).

142 "It has all the earmarks. . . ." For a tailpiece by woodcut of the tiglon cubs of the King's Menagerie at Sand-Pit Gate near Windsor Castle, see James Rennie, *The Menageries: Quadrupeds, Described and Drawn from Living Subjects*, Volume 1, p. 192. London: Charles Knight, 1829, 1831.

143 "Those of these hybrids. . . . both America and England." Cuvier, *The Animal Kingdom* (Biblio. 23), Volume 2, p. 447. Illustration from an engraving after a drawing by Thomas

Landseer, Charles Hamilton Smith, or one Griffiths, all three of whom are credited for the volume's illustrations. The print was first published by G. B. Whittaker, February 1825.

148 "'What in the name . . . like hotbed plants.'" Letter from Augustin Kennedy to Edward Hicks Kennedy, May 6, 1838 (H).

148 "'I will trie to pay it. . . .'" Letter from Edward Hicks to John Watson, March 16, 1839, Galerie St. Etienne.

149 "He went up to Scully's Hill. . . ." *Newtown,* a landscape by Thomas Hicks, Library Company, Newtown.

149 "With his first portrait. . . ." Second portrait of Edward Hicks by Thomas Hicks, exhibited in Williamsburg, 1960. John Jacob Carle Collection, Albemarle County, Virginia.

151 "The Quaker had directed. . . ." Last will of Joseph Rodman, proved September 1759, *New-York Historical Society's Collections: Abstracts of Wills* 5, pp. 333–34.

151–52 "The long silence. . . . to think of it." Letter from Edward Hicks Kennedy to Elizabeth Hicks, December 21, 1839 (H).

152 Short quotations from *Memoirs.*

152–53 "'I should love to see. . . . cockade.'" Letter from Edward Hicks to Rachel Hunt, November 1840 (S).

153 "Because of his 'great loss by fire.' . . ." Will of Joseph Worstall, 1832, proved February 1, 1841, 7528, Records Office, Doylestown.

153 "'. . . gratified. . . . national feeling.'" Letter from S. P. Lee to Edward Hicks, June 5, 1841 (H).

153 "A visit from Phebe Ann. . . ." Letters from Phebe Ann Hicks to Newtown, 1843; January 1844; March 1845; January 1846 (H).

153–54 "'. . . 'three moons. . . . too well repaid.'" Letters from Thomas Hicks to Elizabeth Hicks, July 22, 1841; February 1842; c. 1844 (H).

154–55 "'. . . 'sitter. . . . the soul's destiny.'" Letters from Thomas Hicks to Edward Hicks, July 17, 1843, and undated, 1843.

Memoirs

156 "'I am, this day, sixty-three. . . .'" First draft of *Memoirs* (S).

156 "There were four colonial generations. . . ." See Genealogy of Edward Hicks, pp. 266–67.

156 "'My grandfather Colonel Edward. . . .'" *Memoirs* (S).

158 "Just how deeply. . . ." Last wills of William Walton and Mary Sandford, and William and Mary (Walton) Ricketts, *New Jersey Archives* (Biblio. 133). See also Biblio. 2.

160 "Her epitaph appears earlier in the present book. . . ." See "Childhood and Youth," pp. 19–20.

160 "Having entrusted his children. . . ." Mary Hicks married John Searle, February 19, 1749. See Genealogy of Edward Hicks, pp. 266–67. For Searles of New York City, see Biblio. 27 and 29. For Searles of New Jersey, see Biblio. 88.

160 "With part of the money. . . ." O'Callaghan, *Calendar of British MSS* (Biblio. 64).

160 "'. . . 'the prettiest boys. . . .'" *Memoirs.*

160 "He began to woo Francina. . . ." Hornberger, "Mr. Hicks of Philadelphia" (Biblio. 124). See also Biblio. 144.

161 "Christ Church, Philadelphia. . . ." Scene of various Hicks family burials and weddings. Construction begun in 1724, finished 1744. Plans drawn by Dr. John Kearsley, M.D. (d. 1772), who supervised the construction. Steeple and bell were added in 1754, thanks to lotteries organized by Benjamin Franklin. At that time, Christ Church was one of the largest buildings in North America. Six Signers of the Declaration of Independence and many notables are buried in the churchyard, as is the painter's grandmother Violetta Hicks. See also Biblio. 136.

161 "Her father, John Jekyll. . . ." See Biblio. 28, 83, 137. For Shippens and Jekylls, see Biblio. 56, 136, 137.

161 "His widow Margaret. . . ." Margaret Shippen married John Jekyll, October 24, 1734.

161 "She must have grieved. . . ." Elizea Margareta Hicks, born November 13, 1759.

161 "It was therefore with mixed astonishment. . . . " Last will of Margaret Shippen Jekyll, proved July 31, 1764, *Logan Papers* 41 (P).

161 "Charles was none too willing. . . . was macabre." *New Jersey Archives* (Biblio. 133).

162 Feud between the Hicks and the Seabury families. Seabury Papers, General Theological Seminary.

162 "No more is heard. . . . " Whitehead Hicks (1728–1780) was mayor of New York City from 1766 to 1776, and a justice of the Supreme Court of New York, as a Royalist, before the surrender of Cornwallis (1776–80). For payment of Edward Hicks's debt, see *Logan Papers* 40 (P).

162 "To leave no doubt. . . . " Schlesinger, "Propaganda and the Philadelphia Press. . . . " (Biblio. 144).

163 "Governor Penn granted him . . . " *Logan Papers* 40 (P).

163 "His next drive to the county seat. . . . " Ely, *Genealogical History* (Biblio. 34).

163 "Thomas Bond, the first American. . . . " *Dictionary of American Biography* (Biblio. 27).

163 "A last will and testament. . . . " Last will of William Hicks: codicil, inventory, naming of Mary as guardian. *Logan Papers* 40 (P).

164 " . . . 'even more than ever. . . . amazingly well.' " Letter from Catherine Hicks to Isaac Hicks (H).

164 "The fact was that she had gone ahead. . . . " Ely, *Genealogical History* (Biblio. 34).

164 "On May 28, 1772. . . . " *Pennsylvania Gazette* (Biblio. 137).

165 "John Dickinson. . . . " *Dictionary* (Biblio. 27).

165 " . . . Catherine gave birth to Gilbert. . . . " Ely, *Genealogical History* (Biblio. 34).

165 "Guns were not yet booming. . . . " For Bucks County history, see Biblio. 7, 14, 34.

165 "The ledger of Isaac. . . . " (BC)

166 "Dickinson had no more than. . . . " *Logan Papers* 40 (P).

166–67 "In October, Gilbert was. . . . daughter Sally." Letters from Gilbert to Isaac Hicks. New York, April 5, 1780, and January 27, 1783; Digby, Nova Scotia, July 1784 (H).

167 "Four Lanes End became. . . . a young sniper." Josiah Betts Smith, "Historical Recollections of Persons, Land, Business and Events in Newtown, and other Places in the Middle and Lower Parts of Bucks County," typescript 1873–88 (BC).

167 "Six months later, in the heat. . . . " *Pennsylvania Archives* (Biblio. 136). See also *Deed Book D* 2, p. 18, Doylestown.

169 "For twenty years John De Normandie. . . . " Michael Jenks Papers, Folio 10 (BC).

169 "Moreover, the de jure partnership. . . . " When two acres were conveyed to Isaac in Newtown, 1793, he paid Dr. James De Normandie £ 15 for his share. *Pennsylvania Archives* (Biblio. 136).

169 "The death of Mary Hicks Searle. . . . " *New Jersey Archives* (Biblio. 133).

169 " 'Dickey, poor fellow. . . . ' " Letter from Isaac Hicks to Dickinson. *Logan Papers* 40 (P).

169 "Instead, he joined the 6th Regiment. . . . " Williams, *Soldiers of the American Revolution, Bucks County* (Biblio. 97).

169 "Before Isaac and Catherine were sent. . . . " Military service of Isaac and Giles Hicks. *Pennsylvania Archives* (Biblio. 136).

169 "Dickinson was relieved to hear from London. . . . " Letters from Major Edward Hicks to John Dickinson. *Logan Papers* 40 (P).

169 " . . . 'his excellency General Washington. . . . ' " Reeves, "Extracts from the Letter Books of Lt. Enos Reeves" (Biblio. 142).

170 " 'From Tobago, Giles ordered Dickinson. . . . ' " *Logan Papers* 40 (P).

170 "He died and was buried. . . . " For life-dates of the children of William and Francina Hicks, see Genealogy of Edward Hicks, pp. 266–67.

170 "John Barclay, husband. . . . " John Barclay, son-in-law of Mary Hicks Searle, was a merchant and kinsman of Hannah Mifflin, wife of the illustrious Thomas Mifflin (1744–1800), merchant and statesman.

170 "Ceronio presented his demand. . . . " *Logan Papers* 40 (P).

171 "His will bequeathed. . . . " Last will of Jacob Johnson Hicks, died October 29, 1792. Fernow, New York *Calendar* (Biblio. 36), p. 205.

171 "In 1781, he painted views. . . . " Volpi, *Nova Scotia: A Pictorial Record, 1605–1878* (Biblio. 93).

Sing Praises

172 "For his amusement Hicks painted and lettered. . . . " A set of alphabet blocks is at Friends Meeting, Arch Street, Philadelphia.

172 "While awaiting an order for more. . . . " Present whereabouts of Bible and stencils is unknown.

172 "In April, the *Journal* of Newtown. . . . " *Journal*, April 11, 1843 (BC).

172 "In an immaculate hand. . . . " Letter from Phebe Ann Carle to Edward Hicks, January 1, 1844 (H).

174 "By mid-September Edward. . . . " Letter from Edward to Sarah Worstall Hicks, September 15, 1843 (H).

174 " 'What will be the state of gentle. . . . super-fluities.' " Sermon, *Memoirs*.

175 "The merchant Richard Price sent. . . . " Letter from Richard Price to Edward Hicks, April 4, 1844 (H).

175 " 'Dear Joseph. . . . EDW. HICKS.' " Letter from Edward Hicks to Joseph Watson, September 22, 1844 (AARFAC).

176 "The source of the leopard, bear. . . . the stuff of his success." Roselle, *Samuel Griswold Goodrich, Creator of Peter Parley* (Biblio. 74).

179 "In a letter of mixed thanks. . . . " Letter from Samuel Swain to Edward Hicks (H).

182 "Richard Price rejected. . . . handle the disbursements." Ford, "The Publication of Hicks's Memoirs (Biblio. 115)."

184 "Illman himself had copied a drawing by Henry Hoppner Meyer." Bolton, *Early American Portrait Painters in Miniature* (Biblio. 11).

186 " 'It presented the variety of stoves. . . . ' " *The Democrat* (BC).

190 " 'The great male lion. . . . ' " Mather, *Edward Hicks: His Peaceable Kingdoms and Other Paintings* (Biblio. 61).

195 " . . . 'sausage and mince pie. . . . the cars for Trenton. . . . ' " Letter from Edward to Isaac Worstall Hicks, November 16, 1845 (H).

195 " 'Bub lays quiet at present. . . . little hope.' " Letter from Phebe Ann Carle to Elizabeth Hicks, March 1845 (H).

196 Quotations from *Memoirs*.

196 " 'He came home quite down. . . . ' " Letter from Isaac Worstall Hicks to Elizabeth Hicks, March 21, 1846 (H).

196 " . . . 'inflammation of the brest. . . . Depo in Trenton. . . . ' " Letter from Edward to Elizabeth Hicks, March 31, 1846 (H).

197 Short quotations from *Memoirs*.

202 "The English painter James Northcote. . . . ' " Northcote, *Daniel in the Lion's Den* (BC).

202 "It was for Northcote's Aesopian *Fables*. . . . " Northcote, James, R.A. *Fables, Original & Selected*. London, 1828. American editions published 1833 and later. Hicks copied the lion of the plate *The Lion and the Wolf* but he omitted the wolf for his late *Kingdom*s. The lion also appears in the Cornell and Krusner family Bibles but in a cruder form credited to Northcote by a plagiarist.

202 "Art historian Julius Held. . . . " Held, *Peter Paul Rubens: The Leopards* (Biblio. 48).

205 " 'Diligent in business. . . . reward in Heaven.' " *Memoirs*.

206 "He paused at Burlington to call on. . . . " Joseph Parrish, M.D. (1772–1840) was chief surgeon of the Alms House, Philadelphia, for some years.

206 Short quotations from *Memoirs*.

Ecstasy

208–23 Short quotations from *Memoirs*.

Before Sundown

224–26 Short quotations from *Memoirs*.

230 " 'I do not refer to the painting business. . . . and in the graveyard.' " Letter from Edward Hicks to Richard Price, April 1, 1807 (S).

231 "The bull appears in three other versions. . . ." For suckling lamb and ploughman, see *1800 Woodcuts by Thomas Bewick*, plates 7, 15. New York: Dover, 1962.

232 " 'My constitutional nature has presented. . . . *such business as they are capable of?* ' " "Acknowledgement" to Makefield Monthly Meeting, June 1849 (P).

233 " . . . 'the beautiful work of art.' . . . thousands. . . ." *The Democrat* (BC).

233 " 'My beloved Friend. . . . fresh as when uttered.' " Letter from Mary Lippincott to Edward Hicks, February 18, 1849 (H).

233 "The *Columbian Magazine* of Philadelphia. . . ." "Venerate the Plough" (Biblio. 148).

234 "The original tract, west of Newtown. . . . from the poem 'The Seasons' by James Thomson." Articles in *Newtown Enterprise:* Edward R. Barnsley on Cornell and Leedom families, February 21, 28, and March 6, 1952; Harry W. Van Horn on Cornell family, March 1980.

236–37 "At regular intervals. . . . compared with the wickedness of the world." Letter from Edward Hicks to Elizabeth, June 10, 1849 (H).

237–38 " 'I feel as if I ought to try. . . . from this world to the Heaven of Heavens.' " *Memoirs.*

240 " '*The Leedom Farm* exemplifies. . . . and trees in the middle distance.' " Quandt, Curator's Worksheet (AARFAC).

242 "Although the direct source was. . . . " Parley, *Tales of Animals,* Rare Books, Free Library, Philadelphia. Maréchal lion also appears in *The Menageries* . . . , Philadelphia: Cary & Hart, 1833.

244 "The museum appointed Miger. . . . " Cuvier and Lacépède, *La Menagerie du Muséum National.* . . . Paris, 1801.

244 "American illustrators helped themselves. . . . " Gilbert in juvenile published by Köllner. Free Library, Philadelphia. Gould in juvenile. Science Library, University of Virginia.

248 " . . . 'sweet disposition of mind. . . . ' " Letter from John Watson to a Friend, August 28, 1849. Edward R. Barnsley.

248 "That friend in need was Colonel Polk. . . . " "Book No. 1729, July 2, 1845, American Embassy, London: Letter of Mr. William Polk," in lieu of a passport for Thomas Hicks. "Destination France and Austria." U.S. National Archives record, Passport Division.

248–49 "With Isaac seated beside him. . . . were to be appraised and sold." Last will of Edward Hicks, Register of Wills, 1849, Doylestown.

249 "A solicitous letter awaited him. . . . " Ford, "The Publication of Hicks's Memoirs" (Biblio. 115).

249 "The death notice of the usual line or two. . . . " Edward Hicks obituaries (BC). Funeral crowds (P—Mss. Hough, 880).

250 "The paint shop fell to the wreckers. . . . " "Isaac W. Hicks is demolishing his carriage house on Penn Street. The second story of this building was the paint shop, occupied for many years by the well-known Edward Hicks, a talented and popular preacher of the Society of Friends. In this shop the many paintings of farm scenes, so common in this vicinity, were painted, together with his well-known pictures of Penn's Treaty, Washington Crossing the Delaware, &c. The building is quite a noted one in our borough, but one by one the old landmarks pass away. He will have a new building erected in the rear of his premises." *Newtown Enterprise,* July 10, 1873 (BC).

Bibliography

General

1. Alberts, Robert C. *Benjamin West*. Boston: Houghton Mifflin, 1978.
2. *American Genealogical Biographical Index to American Genealogical, Biographical, and Local History Materials*. Volumes 1–101, 1952–77. Middletown, Conn.: Godfrey Memorial Library.
3. Asbury, Francis. *Journal. . . .* Volume 1, p. 155. Nashville: Abingdon, 1950. Refers to Jacob Giles. See also *Maryland Index of Wills*. Volume 5, p. 208.
4. Barker, Virgil. *American Painting*. New York: Macmillan, 1950.
5. Barnsley, Edward R. *Historic Newtown*. Newtown, Pa., 1934.
 ———. *Newtown Library Under Two Kings*. Newtown, Pa., 1938.
6. Barrett, Walter. *The Old Merchants of New York City*. Volume 2. New York, 1885. Hicks family merchants.
7. Battle, J. H., ed. *History of Bucks County*. Philadelphia, 1887.
8. Beans, L. L. *Edward Hicks*. Privately printed, 1951.
9. Black, Mary C. *Edward Hicks, 1780–1849*. Introduction and chronology by Alice Ford. Williamsburg, Va.: Abby Aldrich Rockefeller Folk Art Collection, 1960. Exhibition catalog.
10. Bland, David. *A History of Book Illustration*. 2d rev. ed. Berkeley: University of California Press, 1969.
11. Bolton, Theodore. *Early American Portrait Painters in Miniature*. New York, 1921. Miniature of Jackson by Henry Hoppner Meyer.
12. Boydell, J. and J. *Catalogue . . . Engravers & Printsellers*. Page 38. London, 1803. Plates after oils by Rigaud.
13. Brey, Jane. *A Quaker Saga*. Philadelphia: Dorrance, 1967. Watson family *et al*.
14. Buck, William J. *History of Bucks County*. Doylestown, 1853.
15. Burr, Frederic M. *Alexander Anderson, M.D., the First American Wood Engraver*. New York, 1893.
16. Cahill, Holger. *American Folk Art: The Art of the Common Man in America, 1750–1900*. New York: Museum of Modern Art, 1932. Exhibition catalog.
17. Chambers, Walter. *Samuel Seabury*. New York, 1932. On New York Mayor Samuel Seabury, descendant of the Bishop Seabury.

18. Clark, Edward L., church warden, compiler. *A Record of the Inscriptions . . . in the Burial Grounds of Christ Church*. Page 38. Philadelphia, 1864. Violetta Hicks.

19. Comly, John. *Journal*. Philadelphia, 1853.

20. Corporation of London. *Works Belonging to the Corporation*. . . . London, 1906.

21. Croft-Murray, Edward. *Decorative Painting in England, 1537–1837*. Volume 2, *The Eighteenth and Nineteenth Centuries*, pp. 268–69. Los Angeles: Hennessey and Ingalls, 1970.

22. Cunningham, Allan. *The Lives of the Most Eminent British Painters and Sculptors*. Volume 1, pp. 328–91. New York: Harper and Brothers, 1842. James Barry.

23. Cuvier, Baron Frédéric. *The Animal Kingdom*. Volume 2, *The Class of Mammalia*, pp. 447–49. London, 1827. Hybrid lion-and-tiger cubs.

24. Davis, William W. H. See Ely, Warren S. (Biblio. 34).

25. Davison, R. A. *Isaac Hicks: New York Merchant and Quaker, 1767–1820*. Cambridge: Harvard University Press, 1964.

26. Day, Sherman. *Historical Recollections of the State of Pennsylvania*. 1843.

27. *Dictionary of American Biography*. Thomas Bond, John Dickinson, Samuel Seabury, Van Cortlandts, *et al.*

28. *Dictionary of National Biography*. Sir Joseph Jekyll.

29. Dix, Morgan. *A History . . . of Trinity Church*. . . . Volume 1, p. 295. New York, 1898–1950. William Walton on Staten Island, his style.

30. Drepperd, Carl. *Early American Prints*. New York, 1930. Delaware Water Gap.

31. Durand, John. *Asher B. Durand*. New York, 1894. Reprint. New York: Da Capo, 1970.

32. Earle, Alice Morse. *Stage Coach and Tavern Days*. New York, 1900.

33. Eberlein, Harold D. *Practical Book of Early American Arts and Crafts*. Philadelphia: Lippincott, 1916. Reissued in 1927 under altered title and without the fireboard by Hicks.

34. Ely, Warren S., and Jordan, John W., eds. *A Genealogical and Personal History of Bucks County, Pennsylvania*. Baltimore: Genealogical Publishing Co., 1975. Revised edition of same title by William W. H. Davis, 1905.

35. Evans, William B. *Jonathan Evans and His Time, 1759–1839*. Boston: Christopher Publishing Co., 1959.

36. Fernow, B. *New York Calendar of Wills: 1626–1836*. Baltimore: Genealogical Publishing Co., 1967. Fallible.

37. Fielding, Mantle. *American Engravers Upon Copper and Steel*. Philadelphia, 1917. See Stauffer, David McNeely (Biblio. 86).

38. Forbush, Bliss. *Elias Hicks: Quaker Liberal*. New York: Columbia University Press, 1956.

39. Ford, Alice. *Pictorial Folk Art, New England to California*. New York: Studio Publications, 1949.
 ———. *Edward Hicks, Painter of the Peaceable Kingdom*. Philadelphia: University of Pennsylvania Press, 1952. Reprint with additional appendices. New York: Kraus, 1970.

40. Fox, George. *Journal*. . . . Edited by John L. Nickalls. Cambridge, England, 1952.

41. Futhey, J. Smith, and Cope, Gilbert. *History of Chester County*. . . . Philadelphia, 1881. Benjamin Price *et al.*

42. Gifford, Edward S., Jr. *The American Revolution in the Delaware Valley*. Pages 44–45. Philadelphia: Pennsylvania Society of the Sons of the Revolution, 1976. Illustration of *Washington* by Lang after Sully.

43. Graves, Algernon. *The Royal Academy . . . Dictionary . . . 1769–1904*. Volume 6, pp. 229–300. London, 1906. On J. F. Rigaud.

44. Groce, George C., and Wallace, David H. *The New-York Historical Society's Dictionary of Artists in America (1564–1860)*. New Haven: Yale University Press, 1957.

45. Gummere, Amelia M. *The Quaker, A Study in Costume*. New York: Arno Press, 1968.

46. Gwynne, Stephen. *Memorials of an Eighteenth Century Painter (James Northcote)*. London, 1898.

47. Hamerton, Philip Gilbert. *Landscape*. Boston, 1885.

48. Held, Julius. *Peter Paul Rubens: The Leopards*. Privately printed, 1970.

49. Hicks, Edward. *Memoirs of the Life & Religious Labours of Edward Hicks, Late of Newtown, Bucks County, Pennsylvania.* Philadelphia, 1851. Includes a diary and two previously printed sermons.

50. Hicks, Elias. *Journal. . . .* Pages 101–5. New York, 1832.
———. *Letters.* New York, 1834. Includes letters to Edward Hicks.

51. Hinshaw, William Wade. *Encyclopaedia of American Quaker Genealogy.* Ann Arbor: Edwards Brothers, 1940. Volume 3: records of New York City, Long Island, *et al.* Volume 6: Goose Creek Meeting.

52. *Historical & Biographical Annals of Columbia and Montour Counties, Pennsylvania. . . .* Volume 1, pp. 648–49. Chicago, 1915. Gilbert Hicks of Catawissa.

53. Hoenstine, F. G. *Guide to Genealogical & Historical Research in Pennsylvania.* Volume 3, *Genealogical Society of Pennsylvania,* p. 111, item 682. 3d ed., 1972. "Marriages by Isaac Hicks, Bucks County, from 1773 to 1824."

54. Hunt, Gaillard. *The History of the Seal of the United States.* Washington, D.C., 1909.

55. Johnson, Samuel. *Poems of Various Subjects.* Philadelphia, 1835.
———. *The Triple Wreath, Poems. . . .* Newtown and Philadelphia, 1844. Frontispiece and portrait engraved by Edwin Ellis.
———. *Letter from Samuel Johnson, to Edward Hicks; with His Reply.* Pamphlet. Philadelphia, 1845.
All three contain the poem to Hicks.

56. Klein, Randolph Shipley. *Portrait of an Early American Family: The Shippens of Pennsylvania.* . . . Philadelphia: University of Pennsylvania Press, 1975. Intricate; identifies John Jekyll, unaccountably, as a Marylander.

57. Klingender, Francis. *Animals in Art and Thought: To the End of the Middle Ages.* Cambridge: M.I.T. Press, 1971.

58. Little, Nina Fletcher. *American Folk Art from the Abby Aldrich Rockefeller Folk Art Collection.* Williamsburg, Va.: Colonial Williamsburg, 1959. Exhibition catalog.

59. Martin, John Hill. *Chester & Its Vicinity, Delaware County. . . .* Philadelphia, 1877.

60. Mather, Eleanore Price. *Edward Hicks, Primitive Quaker: His Religion in Relation to His Art.* Pendle Hill Pamphlet no. 170. Lebanon, Pa.: Pendle Hill, 1970.
———, foreword. *Edward Hicks, A Gentle Spirit.* New York: Andrew Crispo Gallery, 1975. Exhibition catalog.

61. ———, and Miller, Dorothy C. *Edward Hicks: His Peaceable Kingdoms and Other Paintings.* Newark: University of Delaware Press, 1983. New York, London, and Toronto: Cornwall Books, in association with the Kennedy Galleries, New York, 1983. Catalogue raisonné.

62. Newman, E. P. *The Early Papers of America.* Racine, Wisc., 1967. On rattlesnake device.

63. *Newtown, 275th Anniversary, 1684–1959.* Preface by R. V. Hennessy. Newtown, Pa.: Newtown Anniversary Commission, 1959.

64. O'Callaghan, B. *Papers Relating to Long Island.* Volume 1, pp. 627–86. Albany, 1849.
———. *Documentary History of the State of New York.* Volume 3, pp. 395–538 and 919–58. Albany, 1849–51. New York City and Westchester.
———. *A List of Editions of the Holy Scripture . . . Printed in America Previous to 1860.* Albany, 1861.
———. *Calendar of British Mss in the Office of the Secretary of State, Albany, New York (1644–1776).* Part 2. Albany, 1865–66. Reprinted 1968.
Refer repeatedly to shipping transactions of Hicks, Walton, and allied families.

65. Penn, William. Quoted by Nickalls (see Biblio. 40) in his preface.

66. *Pennsylvania Colonial Records.* Series 1, p. 144. Reprint of 1852 ed. Sale of forfeited estate of Gilbert Hicks, search of house and removal of public books, succession of William Hicks to Crown offices held by Lawrence Growden. See also Index: Gilbert Hicks, Isaac Hicks, *et al.*

67. Pennsylvania Mutual Life Insurance Company. *The Independence Square Neighborhood.* Philadelphia, c. 1926.

68. Peters, Harry T. *America on Stone.* New York, 1931. Early lithography.

69. *Philadelphia City Directories, 1784– .* At Historical Society of Pennsylvania, Philadelphia.

70. Quandt, Eleanor S. "Technical Examination of Eighteenth Century Painting," in *American Painting to 1776*, edited by I. M. Quimby. Charlottesville: University of Virginia Press, 1971.

71. *Rhoads' Philadelphia Americana & Medical List, Sales Catalogue No. 34.* "Testimony of Disownment of Hicks by Fallsington Quarterly Meeting, October 9, 1828," p. 33. In "Hicks Research Material" box at Spruance Library, Bucks County Historical Society, Doylestown.

72. Richardson, George. *Iconology . . . Emblematic Figures.* London, 1779.

73. Roberts, Clarence V. *Early Friends Families of Upper Bucks.* Philadelphia, 1925.

74. Roselle, Daniel. *Samuel Griswold Goodrich, Creator of Peter Parley. A Study of His Life and Work.* Albany: State University Press, c. 1968.

75. Russell, Elbert. *The History of Quakerism.* New York: Macmillan, 1942.

76. Rutledge, Anna Wells, compiler and editor. *Cumulative Record of Exhibition Catalogues. The Pennsylvania Academy of the Fine Arts: 1807– 70. The Society of Artists, 1800–1814. The Artists' Fund Society, 1835–45.* Memoirs Series, no. 38. Philadelphia: American Philosophical Society, 1955.

77. Sabine, Lorenzo. *American Loyalists . . . in the Revolution.* Boston, 1847, 1854, 1864.

78. Scharff, J. T., and Westcott, T. *History of Philadelphia, 1609–1884.* 3 volumes. Philadelphia, 1884.

79. Sellers, Charles C. *Benjamin Franklin Portraits.* New Haven: Yale University Press, 1962.

80. Sewel, William. *The History of the . . . People Called Quakers.* Philadelphia, 1728.

81. Sheldon, George William. *American Painters.* New York, 1879. On Thomas Hicks, George Loring Brown, *et al.*

82. Silver, Rollo G. *The American Printer (1787– 1825).* Charlottesville: University of Virginia Press, 1967.

83. Simpson, Henry. *Lives of Eminent Philadelphians.* Philadelphia, 1859.

84. Sommer, Frank H., III. "Thomas Hollis" in *Prints in and of America to 1850.* Winterthur, Del.: Winterthur Museum, 1970. On "Liberty" figure.

85. Stabler, William. *Edward Stabler.* Philadelphia, 1846.

86. Stauffer, David McNeely. *American Engravers Upon Copper and Steel.* New York, 1907. Reprinted 1964. Supersedes Fielding (Biblio. 37).

87. Steiner, Bruce E. *Samuel Seabury (1729–96).* Athens, Ohio: Ohio University Press, 1971.

88. Stillwell, John E. *Historical & Genealogical Miscellany.* Volume 2, St. Mary's Church, Burlington, New Jersey, parish records and tomb inscriptions, 1780–85, pp. 49–147. New York, 1903. Reprint. Baltimore: Genealogical Publishing Co., 1970.

89. Stokes, I. N. Phelps. *American Historical Prints.* New York: New York City Public Library, 1933.

90. Thomson, James. *The Works of. . . .* London, 1750.

91. Tuckerman, Henry T. *Book of Artists.* New York, 1867. On Thomas Hicks.

92. Twining, Thomas J., compiler and publisher. *The Twining Family.* Fort Wayne, Ind., 1905.

93. Volpi, Charles de. *Nova Scotia: A Pictorial Record, 1605–1878.* Don Mills, Ont.: Longman Canada, 1974. Four scenes drawn by Major (later Lieutenant-Colonel) Edward Hicks.

94. Warner, Marina. *Queen Victoria's Sketchbook.* New York and London: Crown, 1979.

95. Watson, John F. *Annals of Philadelphia.* 3 volumes. Philadelphia, 1829, 1881.

96. Whittick, Arnold. *Symbols, Signs & Their Meaning.* Watertown, Mass.: Branford, 1971.

97. Williams, R. I. and M. C. *Soldiers of the American Revolution, Bucks County . . . Pennsylvania Archives . . . Record of Services.* Bound mimeo, p. 1414. Danboro, Pa., 1975. Isaac Hicks, Joseph Hicks, Joseph Rodman Hicks.

98. Wilson, Alexander. See Biblio. 149.

Periodicals

99. *The Analectic* XI (Philadelphia, June 1818). Frontispiece engraving of Benjamin Franklin after oil by David Martin.

100. Ayres, James. "Edward Hicks and His Sources." *Antiques,* February 1976.

101. Barnsley, Edward R. "Presses and Printers of Newtown Before 1868." *Bucks County Papers* 7 (1937).
————. "Agricultural Societies of Bucks County" and "Snapshots of Revolutionary Newtown." *Bucks County Papers* 8 (1938).

102. Brinton, Ellen Starr. "Benjamin West's . . . Penn's Treaty. . . . " *Bulletin of Friends Historical Association* 30 (1941).

103. Brooks, Alexander. "Portrait Painters Incognito." *Charm* (February 1925).

104. Bye, Arthur E. "Edward Hicks, Painter Preacher." *Antiques,* June 1936.
————. "Edward Hicks." *Bulletin of Friends Historical Association* 32 (1943).

105. Ciolkowska, Muriel. "American Primitives." *Artwork* (September–October 1927).

106. Cook, Lewis. "The De Normandie Family." *National Genealogical Society Quarterly* 65 (December 1977).

107. Dana, Robert S. "Morrisville and Its Vicinity." *Bucks County Papers* 3 (1903). On June 27, 1871, the *Daily State Gazette,* Trenton, N.J., referred to the Robert Morris Hotel sign as the work of Edward Hicks "about a half a century ago." Odds against the free attribution-by-hearsay are: the atypical lettering style instead of the Hicks Caslon; the representational style of the painting on the back; and the presence of the name of a sign painting company of Philadelphia that flourished long after the free traditional date for the sign, 1820. The state of the portrait of Robert Morris makes any attribution impossible. The oil that inspired the print copied by the painter is in the Historical Society of Pennsylvania collection.

108. Dresser, Louise. "The Peaceable Kingdom." *Bulletin of the Worcester Art Museum* 25, no. 1 (1934). Reprinted in *Design,* December 1935.

109. Eastburn, S. C. "Langhorne and Vicinity." *Bucks County Papers* 4 (1909).

110. Eberlein, H. D. "What Early America Had on Its Walls." *International Studio,* March 1925.

111. Ely, Warren S. "Bogart's Inn." *Bucks County Papers* 3 (1902).

112. Fackenthal, B. F. "Paintings . . . Bucks County Historical Society." *Bucks County Papers* 7 (1935).

113. Fleming, E. McClung. "From Indian Princess to Greek Goddess." *Winterthur Portfolio* 3 (1967).

114. Forbush, Bliss. "Love and Charity Greatly Abound." *Friends Journal* 2 (1956). On Hicks money crisis of 1817.

115. Ford, Alice. "The Publication of . . . Hicks's Memoirs." *Bulletin of Friends Historical Association* 50 (1961). Previously unpublished evidence.

116. *The Friend* (Orthodox) 2 and 3 (1829, 1830). On the ministry of Edward Hicks.

117. Fulton, Deogh. "Cabbages and Kings." *International Studio,* March 1925.

118. Hart, Charles H. "Life Portraits of Andrew Jackson." *McClure's Magazine,* July 1897.

119. Held, Julius S. "Edward Hicks and the Tradition." *Art Quarterly* 14 (1951). Influence of Potter on Hicks.

120. Hicks, Edward. "Sermon. . . . " *The Quaker* 2. Sermon delivered at Green Street Meeting, August 19, 1827. For other sermons, see Ford, *Edward Hicks, Painter of the Peaceable Kingdom* (Biblio. 39).

121. Hicks, Elias. "Sermons." *The Quaker* 4.

122. Hicks, George B. "Thomas Hicks." *Bucks County Papers* 4 (1909).

123. Hicks, Sarah Worstall. "Judge Gilbert Hicks." *Bucks County Papers* 7 (1937).

124. Hornberger, Theodore. "Mr. Hicks of Philadelphia." *Pennsylvania Magazine of History* . . . 31 (Philadelphia, 1907). Mystery of the poet "Lovelace" and his partial identification as a "Mr. Hicks." Previous to Ford's *Edward Hicks, His Life and Art,* the poet's full identity as William Hicks (c. 1731–72) was unknown.

125. Jenks, George A. "Old New Hope" and "The Newtown Library." *Bucks County Papers* 4 (1909).

126. Karlins, N. F. "Peaceable Kingdom Themes in American Folk Painting." *Antiques,* April 1976.

127. Kees, Ann. "The Peaceable Painter." *Antiques,* October 1947.

128. Kenderdine, Thaddeus S. "Papers Read Before the Centennial. . . . " *Centennial of Newtown Friends Meeting, 1815–1915,* Newtown, 1915.

129. Liedtke, Walter. "In Detail: Manet's *Le Déjeuner sur l'Herbe.*" *Portfolio* 5 (September 1983).

130. Lipman, Jean. "Print to Primitive." *Antiques,* July 1947.

131. Mather, Eleanore Price. "The Inward Kingdom of Edward Hicks." *Quaker History* 62 (1973).
———. "A Quaker Icon: The Inner Kingdom of Edward Hicks." *Art Quarterly* 36 (1973).

132. Nelson, Mrs. H. C. "Early American Primitives." *International Studio* (March 1925).

133. New Jersey Archives. Series 1. See *Newspaper Extracts* and *Wills* for Carey, Emmot, Ricketts, and Searle families.

134. New-York Historical Society Collections. See *Rivington's New York Newspapers: Excerpts from a Loyalist Press, 1773–83* 84 for news briefs concerning Hicks, Morgan, and Seabury families. See *Wills,* Volumes 25 and 27, for Ricketts, Rodman, Sandford, Van Cortlandt, and Walton families.

135. Nygren, Edward J. "The First Art Schools at the Pennsylvania Academy of the Fine Arts." *Pennsylvania Magazine of History . . .* 95 (1971).

136. Pennsylvania Archives. *Series 2,* Volume 8. Marriage records of various Hicks, Jekyll, and Shippen family members.
———. *Series 3,* Volume 26. Isaac Hicks land transfers.
———. *Series 5,* Volume 3. Numerous references to Giles Hicks.
———. *Series 6,* Volume 12. Expulsion of Isaac Hicks from Bucks County, April 16, 1781.

———. *Series 6,* Volumes 12 and 13. Gilbert Hicks estate.

137. *Pennsylvania Magazine of History . . .* 4, no. 101 (1880). Footnote on Jekyll and Shippen families. Quotes the *Pennsylvania Gazette* for obituaries of William Hicks (May 28, 1772) and Richard Penn Hicks (February 16, 1791).

138. Piers, Harry. "Artists in Nova Scotia." *Collections of the Nova Scotia Historical Society, Halifax* 18 (1914), p. 108.

139. Pullinger, Edna. "The Tomlinson-Huddleston House. . . . " *Journal of Bucks County Historical Society* 2 (1977–78).

140. Pullinger, Richard C. and Edna. "The House . . . Hicks Built in Hulmeville." *Journal of the Bucks County Historical Society* 2 (1977–78).

141. *Records of Christ Church, Philadelphia, 1709–1760* 16 (1892 until complete).

142. Reeves, Enos. "Extracts from the Letter Books of Lt. Enos Reeves." *Pennsylvania Magazine of History . . .* 31 (1929). Regarding Giles Hicks.

143. Ryan, P. M., ed. "Mathias Hutchinson . . . A Journey (1819–20)." *Quaker History* 68 and 69 (1979, 1980). Travel log.

144. Schlesinger, Arthur M. "Propaganda and the Philadelphia Press. . . . " *Pennsylvania Magazine of History . . .* 60 (1936). William Hicks (but not identified by Schlesinger) for the Penn "Proprietors."

145. Smith, Dr. Lettie. "Edward Hicks." *Bucks County Papers* 1 (1884).

146. Tatham, David. "Edward Hicks, Elias Hicks, and John Comly: Perspectives on the Peaceable Kingdom Theme." *American Art Journal* 13 (1981).

147. Tolles, Frederick B. "The Primitive Painter as Poet." *Bulletin of Friends Historical Association* 50 (1961).

148. "Venerate the Plough." *Columbian Magazine* 1 (Philadelphia, 1786).

149. Wilson, Alexander. "The Foresters; a Poem: Description of a Journey to the Falls of Niagara in the Autumn of 1803." *The Port Folio* 1–3 (1809–10). Reprinted by Simeon Siegfried in Newtown, 1818, as a thin volume entitled *The Foresters.*

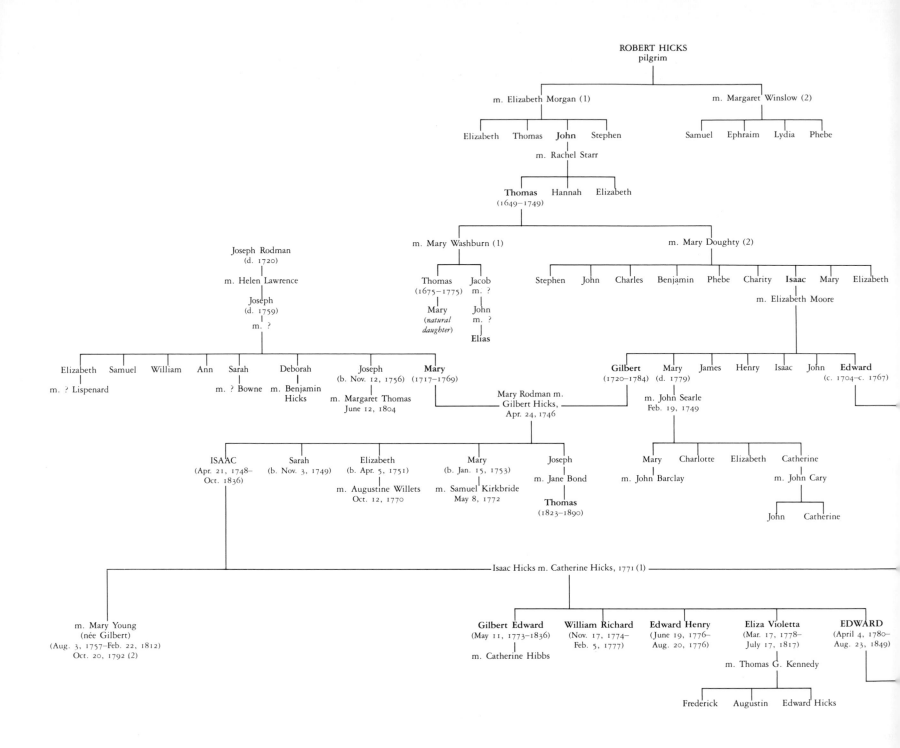

ROBERT HICKS
pilgrim

m. Elizabeth Morgan (1) m. Margaret Winslow (2)

Elizabeth Thomas **John** Stephen Samuel Ephraim Lydia Phebe

m. Rachel Starr

Thomas Hannah Elizabeth
(1649–1749)

m. Mary Washburn (1) m. Mary Doughty (2)

Joseph Rodman
(d. 1720)

m. Helen Lawrence Thomas Jacob Stephen John Charles Benjamin Phebe Charity **Isaac** Mary Elizabeth
 (1675–1775) m. ?
Joseph m. Elizabeth Moore
(d. 1759) Mary John
m. ? (*natural* m. ?
 daughter)
 Elias

Elizabeth Samuel William Ann Sarah Deborah Joseph **Mary** **Gilbert** Mary James Henry Isaac John **Edward**
 (b. Nov. 12, 1756) (1717–1769) (1720–1784) (d. 1779) (c. 1704–c. 1767)
m. ? Lispenard m. ? Bowne m. Benjamin Mary Rodman m. m. John Searle
 Hicks Gilbert Hicks, Feb. 19, 1749
 m. Margaret Thomas Apr. 24, 1746
 June 12, 1804

 ISAAC Sarah Elizabeth Mary Joseph Mary Charlotte Elizabeth Catherine
 (Apr. 21, 1748– (b. Nov. 3, 1749) (b. Apr. 5, 1751) (b. Jan. 15, 1753) m. Jane Bond
 Oct. 1836) m. John Barclay m. John Cary
 m. Augustine Willets m. Samuel Kirkbride **Thomas**
 Oct. 12, 1770 May 8, 1772 (1823–1890)
 John Catherine

 Isaac Hicks m. Catherine Hicks, 1771 (1)

m. Mary Young **Gilbert Edward** **William Richard** **Edward Henry** **Eliza Violetta** **EDWARD**
(née Gilbert) (May 11, 1773–1836) (Nov. 17, 1774– (June 19, 1776– (Mar. 17, 1778– (April 4, 1780–
(Aug. 3, 1757–Feb. 22, 1812) Feb. 5, 1777) Aug. 20, 1776) July 17, 1817) Aug. 23, 1849)
Oct. 20, 1792 (2) m. Catherine Hibbs
 m. Thomas G. Kennedy

 Frederick Augustin Edward Hicks

Genealogy of Edward Hicks

William Ricketts
(1600s)

m. ? Johnson

William
(d. 1735)

m. Mary Walton
(d. 1742)

Violetta
(c. 1705–
Dec. 22, 1747)

William
m. Elizabeth Emmot

issue, incl.
Polly

Elizabeth
m. Philip Van Horne

Mary
m. Stephen Van Cortlandt
(d. 1757)

Edward Hicks m.
Violetta Ricketts,
c. 1728–30

Catherine
(1745–1783)

Mary
(d. 1783)

m. Samuel Seabury
(1729–1796)
1756

issue

William
(c. 1731–1772)

m. Francina Jekyll
(d. Oct. 1770)
July 19, 1758

Charles

Edward
(d. after 1792)

m. Elizabeth Cornell

Anne
(d. 1773)

m. Benjamin Morgan

William Ricketts

Philip
(b. 1740)

m. Catherine De Peyster

Pierre
(1721–1814)

Elizea Margarita
(b. 1759)

Catherine
(c. 1760
–1784)

m. Stephen Ceranio, 1784

Giles
(c. 1762–
1786)

William
(c. 1763–
1772)

Edward
(*natural son*,
c. 1767–
1783)

Jacob Johnson
(1771–1792)

Richard Penn
(d. 1791)

Joseph Worstall
(1750–1841)

m. Susannah Hibbs

Sarah
(June 1, 1781–
Dec. 20, 1855)

Elizabeth
(b. 1779)

m. James Sleeper

Joseph, Jr.
(b. 1783)

m. Jane Heston

James
(b. 1786)

m. Jane Eastburn (1)

m. Sarah Smith (2)

John
(b. 1790)

Mary
(b. 1791)

Amos T.
(b. 1793)

m. Ann Chambers

Susannah
(b. 1797)

m. ? Phipps

Edward Hicks m.
Sarah Worstall,
Nov. 17, 1803

Mary
(Oct. 1804–Feb. 7, 1883)

Susan
(Nov. 9, 1806–1872)

m. John Jacob Carle
(d. Oct. 28, 1888)
May 17, 1832

Elizabeth
(Aug. 24, 1811–1892)

m. Richard Plummer

Isaac Worstall
(Jan. 20, 1809–Mar. 20, 1898)

m. Hannah L. Penrose

Sarah
(Dec. 23, 1816–1898)

m. Isaac Parry, Jr.

Phebe Ann
(Dec. 27, 1833–
Mar. 9, 1846)

Sarah
(b. Oct. 6, 1836)

Silas J.
(Mar. 2, 1841–
Sept. 21, 1843)

Edward Hicks
(June 1, 1844–
Mar. 14, 1877)

John J., Jr.
(b. Aug. 24, 1847)

m. ? Willets

Exhibitions

1882
Bucks County Bi-Centennial Celebration,
Doylestown, Pennsylvania, August 31–September
2. Exhibited were six paintings by Edward Hicks.
A seventh oil attributed to him—a portrait of
E. H. Kennedy—was by Thomas Hicks.

1926
*A Gallery of National Portraiture and Historical
Scenes,* Pennsylvania Academy of Fine Arts, Phila-
delphia, June 13–October 10. *Grave of William
Penn* was exhibited.

1930
*American Primitives . . . Paintings of Nineteenth-
Century Folk Artists,* Newark Museum, November
4–February 1, 1931. *Penn's Treaty* was included.

1932
*American Folk Art, the Art of the Common Man in
America, 1750–1900,* Museum of Modern Art,
New York. Shown were *Peaceable Kingdom,* no. 21
(c. 1835), and *Grave of William Penn,* no. 22
(1847).

1935
Edward Hicks, National Committee on Folk Arts
of the United States, Folk Arts Center, Brooklyn,
New York, spring. First one-man exhibition.

1946
American Paintings, Tate Gallery, London, June
14–August 2. Hicks's first appearance abroad.
Peaceable Kingdom hung near oils by West and
Copley. Exhibition organized by the U.S. De-
partment of State.

1960
*Edward Hicks, 1780–1849: A Special Exhibition
Devoted to His Life and Work,* Abby Aldrich
Rockefeller Folk Art Collection, Colonial
Williamsburg, Virginia, September 30–October
30. Exhibition organized by Mary C. Black,
Curator, and included forty-three paintings. Ac-
companying catalog by Black, with an introduc-
tion and chronology by Alice Ford (Biblio. 9).

1966–67
Hicks, Kane, Pippin, Museum of Art, Carnegie
Institute, Pittsburgh, Pennsylvania, October
21–December 4, 1966, and tour to Corcoran
Gallery, Washington, D.C., January 6–February
19, 1967. Exhibition included thirty-five paint-
ings by Hicks.

1972
*Four American Primitives: Hicks, Kane, Moses,
Pippin,* A.C.A. Galleries, New York, February
22–March 11.

1975
Edward Hicks, A Gentle Spirit, Andrew Crispo
Gallery, New York, spring. Exhibition of thirty
oils, with a catalog including a foreword by
Eleanore Price Mather (Biblio. 60).

1980
Edward Hicks Bicentennial, Newtown Historic
Association, Court Inn, Newtown, Pennsylvania,
April 20. A Commemorative Meeting to mark
the two-hundredth anniversary of Edward Hicks,
born April 4, 1780, in Four Lanes End.

Index

Figures in italics indicate illustrations